THE DRAWING BOOK

THE DRAWING BOOK

By Wendon Blake/Drawings by Ferdinand Petrie,
John Lawn, and Uldis Klavins

WATSON-GUPTILL PUBLICATIONS/NEW YORK
PITMAN HOUSE/LONDON

Copyright © 1980 by Billboard Ltd.

Published in the United States and Canada by Watson-Guptill Publications,
1515 Broadway, New York, N.Y. 10036

Library of Congress Cataloging in Publication Data
Blake, Wendon.
 The drawing book.

 1. Drawing—Technique. I. Petrie, Ferdinand,
1925– II. Lawn, John. III. Klavins, Uldis.
IV. Title.
NC730.B53 1980 741.2 80–18788
ISBN 0–8230–1365–0

Published in Great Britain by Pitman House Ltd.,
39 Parker Street, London WC2B 5PB
ISBN 0–273–01611–3

Manufactured in U.S.A.

First Printing, 1980

CONTENTS

Delights of Drawing. When the great Renaissance painter Pontormo was asked which is the greater art, painting or sculpture, he replied without hesitation: "Drawing!" Drawing is pure pleasure because it's the simplest, quickest, most spontaneous way to make a picture. You need nothing more than a pencil and a scrap of paper to record some memorable image or express a powerful emotion. And it rarely takes more than an hour or two to execute a drawing that you may treasure all your life. (Some of the world's greatest drawings were executed in minutes!) The drawing tool glides over the paper with such ease and spontaneity that the artist's most intense personal feelings pour out like the song of a bird.

Drawing for Painting. Aside from the joy of learning to draw for its own sake, you'll find that your paintings will improve enormously when you learn to draw skillfully. You *must* be able to make an accurate sketch on the canvas or sheet of watercolor paper before you start to paint. But drawing also sharpens the powers of observation you need to make a successful painting. As you learn to draw, you develop the ability to record the shapes, proportions, and contours of subjects as simple as an apple or as complex as the human figure. By studying the play of light and shadow on solid forms, you learn how to render a rock, a tree, or a human head so that it really looks three-dimensional. And drawing is a rapid, efficient way to record pictorial ideas which you can turn into paintings later.

Learning by Doing. In this book, you'll watch three noted artists, Ferdinand Petrie, John Lawn, and Uldis Klavins, demonstrating a wide variety of drawing operations, step by step. First you'll see the sequence of steps in drawing simple still-life objects. Then you'll see how to apply these techniques to drawing landscapes, portraits, and figures. In these demonstrations, each illustration shows a stage in the progress of the drawing, while the accompanying text describes the exact drawing procedure. Having watched "over the artist's shoulder," you should then try the process yourself. Don't copy the drawing in the book, but find a similar subject and attempt a similar drawing, using the same methods you've seen in the demonstration. Set up a still life of objects from your kitchen. Go outdoors and draw rocks, clouds, trees, and other growing things. Ask your family and friends to pose for you, or join a sketch class where you can draw a professional model. The more drawing you do, the more quickly you'll learn.

How This Book Is Organized. You'll find that this book is divided into four parts: *Starting to Draw,*

Landscape Drawing, Portrait Drawing, and *Figure Drawing.* Artists Petrie, Lawn, and Klavins demonstrate how to draw in pencil, chalk, and charcoal.

Starting to Draw. Part One begins by training your powers of observation. You'll learn how to measure and establish the proportions of your subjects. You'll learn simplified perspective and how light and shade work. You'll learn to visualize various subjects as simple geometric forms. And then you'll watch Ferdinand Petrie draw a series of step-by-step demonstrations, beginning with simple kitchen still lifes and then going on to flowers, landscapes, and portraits.

Landscape Drawing. Part Two shows you how to apply what you've learned in Part One—about measurement, proportion, perspective, light and shade—to drawing a variety of outdoor subjects. Showing you how to visualize the forms of the landscape as simple geometric shapes, Petrie begins by demonstrating how to draw components of the landscape like a rock or a tree stump and then moves on to more elaborate step-by-step demonstrations of complete landscapes and coastal subjects, from a clump of trees to surf breaking on a rocky shore.

Portrait Drawing. Part Three begins by showing you the forms and proportions of the male and female head, seen from various views. Then John Lawn demonstrates how to draw the eye, nose, mouth, and ear from different angles. He demonstrates the basic steps in drawing a complete head. And then he shows how to put these techniques to work in drawing ten complete portraits, step by step.

Figure Drawing. Part Four starts by showing the proportions of the male and female figure, seen from various angles. Then Uldis Klavins demonstrates how to draw various parts of the male and female figure, step by step: the torso, arm and hand, and leg and foot. After demonstrating the steps in drawing a complete male and female figure, Klavins then shows you how to execute ten complete figure drawings of the male and female nude in various poses, seen from many different angles, and with a variety of lighting effects.

Background Material. Throughout the four parts of *The Drawing Book,* you'll also find guidance about how to "warm up" by using such techniques as contour drawing and gesture drawing; how to explore the variety of ways to create line and tone with pencil, chalk, and charcoal; how to light your subject and interpret the lighting effects of nature; and how to preserve finished drawings so you'll enjoy them for years.

Keep It Simple. The best way to start drawing is to get yourself just two things: a pencil and a pad of white drawing paper about twice the size of the page you're now reading. An ordinary office pencil will do—but test it to make sure that you can make a pale gray line by gliding it lightly over the paper, and a rich black line by pressing a bit harder. If you'd like to buy something at the art-supply store, ask for an HB pencil, which is a good all-purpose drawing tool, plus a thicker, darker pencil for bolder work, usually marked 4B, 5B, or 6B. Your drawing pad should contain sturdy white paper with a very slight texture—not as smooth as typing paper. (Ask for cartridge paper in Britain.) To get started with chalk drawing, all you need is a black pastel pencil or a Conté pencil. And just two charcoal pencils will give you a good taste of charcoal drawing: get one marked "medium" and another marked "soft." You can use all these different types of pencils on the same drawing pad.

Pencils. When we talk about pencil drawing, we usually mean *graphite* pencil. This is usually a cylindrical stick of black, slightly slippery graphite surrounded by a thicker cylinder of wood. Artists' pencils are divided roughly into two groupings: soft and hard. A soft pencil will make a darker line than a hard pencil. Soft pencils are usually marked B, plus a number to indicate the degree of softness—3B is softer and blacker than 2B. Hard pencils are marked H and the numbers work the same way—3H is harder and makes a paler line than 2H. HB is considered an all-purpose pencil because it falls midway between hard and soft. Most artists use more soft pencils than hard pencils. When you're ready to experiment with a variety of pencils, buy a full range of soft ones from HB to 6B. You can also buy cylindrical graphite sticks in various thicknesses to fit into metal or plastic holders. And if you'd like to work with broad strokes, you can get rectangular graphite sticks about as long as your index finger.

Chalk. A black pastel pencil or Conté pencil is just a cylindrical stick of black chalk and, like the graphite pencil, it's surrounded by a cylinder of wood. But once you've tried chalk in pencil form, you should also get a rectangular black stick of hard pastel or Conté crayon. You may also want to buy cylindrical sticks of black chalk that fit into metal or plastic holders.

Charcoal. Charcoal pencils usually come in two forms. One form is a thin stick of charcoal surrounded by wood, like a graphite pencil. Another form is a stick of charcoal surrounded by a cylinder of paper that you can peel off in a narrow strip to expose fresh charcoal as the point wears down. When you want a complete "pal-ette" of charcoal pencils, get just three of them, marked "hard," "medium," and "soft." (Some manufacturers grade charcoal pencils HB through 6B, like graphite pencils; HB is the hardest and 6B is the softest.) You should also buy a few sticks of natural charcoal. You can get charcoal "leads" to fit into metal or plastic holders like those used for graphite and chalk.

Paper. You could easily spend your life doing wonderful drawings or ordinary white drawing paper, but you should try other kinds. Charcoal paper has a delicate, ribbed texture and a very hard surface that makes your stroke look rough and allows you to blend your strokes to create velvety tones. And you should try some *really* rough paper with a ragged, irregular "tooth" that makes your strokes look bold and granular. Ask your art-supply dealer to show you his roughest drawing papers. Buy a few sheets and try them out.

Erasers (Rubbers). For pencil drawing, the usual eraser is soft rubber, generally pink or white, which you can buy in a rectangular shape about the size of your thumb or in the form of a pencil, surrounded by a peel-off paper cylinder like a charcoal pencil. For chalk and charcoal drawing, the best eraser is kneaded rubber (or putty rubber), a gray square of very soft rubber that you can squeeze like clay to make any shape that's convenient. A thick, blocky soap eraser is useful for cleaning up the white areas of the drawing.

Odds and Ends. You also need a wooden drawing board to support your drawing pad—or perhaps a sheet of soft fiberboard to which you can tack loose sheets of paper. Get some single-edge razor blades or a sharp knife (preferably with a safe, retractable blade) for sharpening your drawing tools; a sandpaper pad (like a little book of sandpaper) for shaping your drawing tools; some pushpins or thumbtacks (drawing pins in Britain); a paper cylinder (as thick as your thumb) called a stomp, for blending tones; and a spray can of fixative, which is a very thin, virtually invisible varnish to keep your drawings from smudging.

Work Area. When you sit down to work, make sure that the light comes from your left if you're right-handed, and from your right if you're left-handed, so your hand won't cast a shadow on your drawing paper. A jar is a good place to store pencils, sharpened end up to protect the points. Store sticks of chalk or charcoal in a shallow box or in a plastic silverware tray with convenient compartments—which can be good for storing pencils too. To keep your erasers clean, store them apart from your drawing tools—in a separate little box or in a compartment of that plastic tray.

Pencils. You can do a lot of drawing with just these four pencils, which will allow you to test out the feel of graphite pencil, charcoal, and chalk. At the top is a good, all-purpose graphite pencil marked HB—it's like a common office pencil. (As you read this book, remember that artists usually refer to graphite pencils as just *pencils*.) Next is a graphite pencil with a thicker, softer lead that makes a broader, blacker line. This is graded 6B. Third is a medium-grade charcoal pencil; the charcoal is encased in a paper cylinder that you gradually tear away to expose the point. At the very bottom is a pastel pencil; this is simply a long strip of chalk encased in a wooden cylinder like that of a graphite pencil.

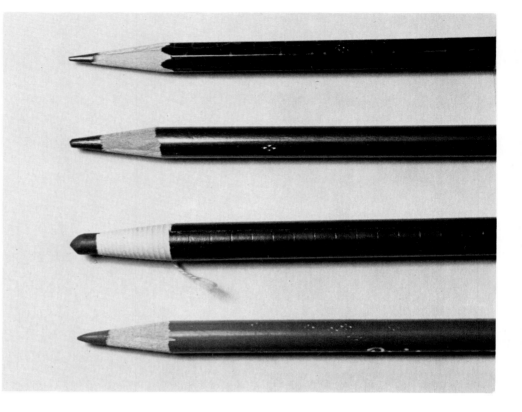

Erasers (Rubbers). Four kinds of erasers generally used are, from left to right: the common soap eraser, best for cleaning up broad areas of bare paper; a harder pink eraser in pencil form, ideal for making precise corrections on small areas of a graphite-pencil drawing; a bigger pink eraser with wedge-shaped ends for making broader corrections on graphite-pencil drawings; and a square of kneaded rubber (putty rubber) that's best for chalk and charcoal drawings. Kneaded rubber squashes like clay for erasing broad areas or getting into tight corners. When you work with kneaded rubber, press the eraser down on the paper and then pull away. Scrub back and forth only when necessary.

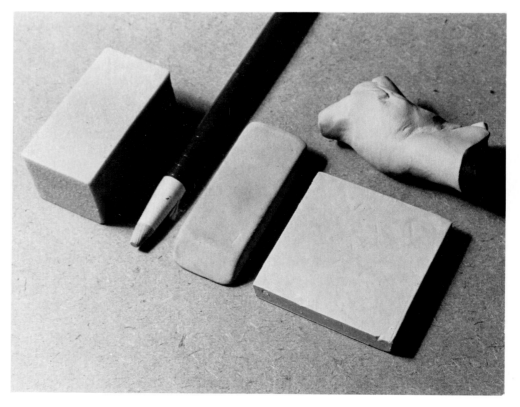

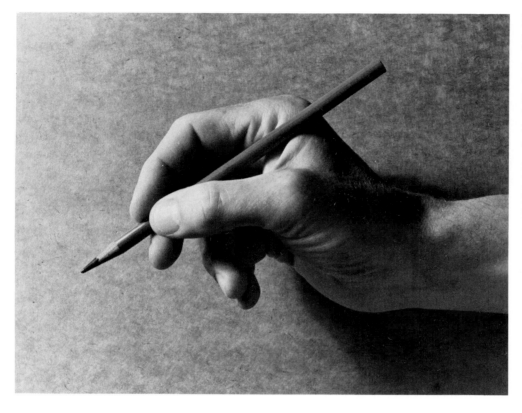

Holding the Pencil. There are two ways to hold a pencil. The most common method is to grip the pencil just as you would when signing your name. However, it's important to grip the pencil a bit farther back from the point, as you see here. This will give you a bolder, freer line. In fact, you might like to experiment with holding the pencil even farther back—particularly if you're making a large drawing, such as a life-size head.

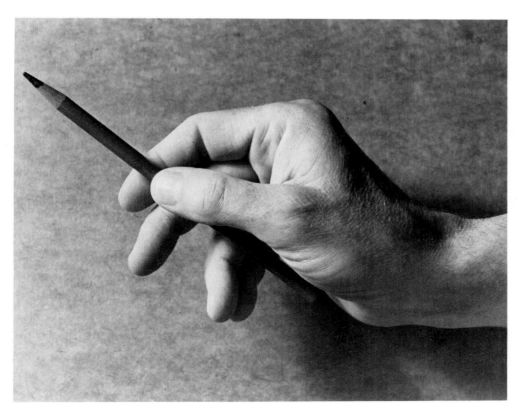

Another Way. Many professionals hold the pencil as an orchestral conductor holds his baton. This grip encourages you to work with bold, rhythmic, sweeping strokes. Since it's best to work on a vertical or diagonal surface—rather than putting your drawing paper flat on a table—you may find this a more convenient grip. Try holding the pencil this way and moving your entire arm as you draw.

Drawing Board and Pad.
Drawing paper generally comes in pads that are bound on one edge like a book. Most convenient is a spiral binding like the one you see here, since each page folds behind the others when you've finished a drawing. By itself, the pad won't be stiff enough to give you the proper support, so get a wooden drawing board from your art supply store—or simply buy a piece of plywood or fiberboard. If you buy your drawing paper in sheets, rather than pads, buy a piece of soft fiberboard to which you can *tack* your paper.

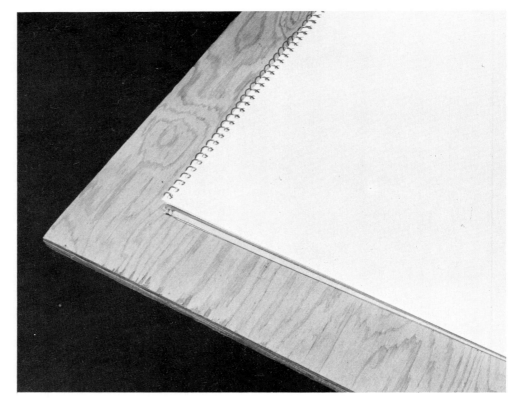

Storage. Store your pencils, sticks of chalk, and charcoal sticks with care—don't just toss them into a drawer where they'll rattle around and break. The compartments of a plastic silverware container provide good protection and allow you to organize your drawing tools into groups. Or you can simply collect long, shallow cardboard boxes—the kind that small gifts often come in.

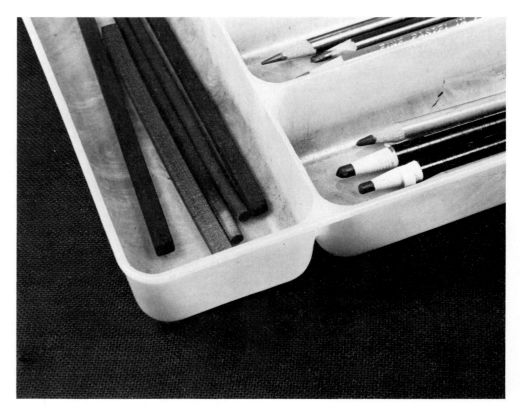

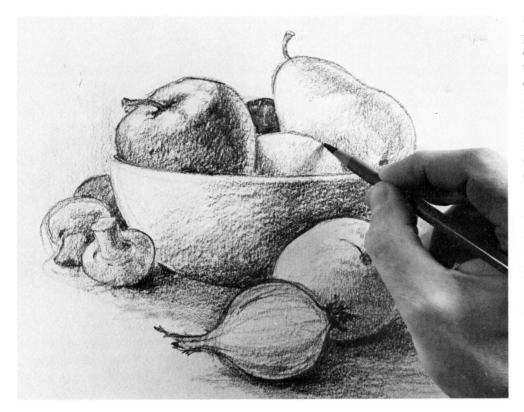

Good Light. You need plenty of light for drawing, of course, but pay special attention to the direction the light comes from. If you're right-handed, make sure that the light comes over your left shoulder. Conversely, if you're left-handed, it should come over your right shoulder. The direction of the light is important because you want to be certain that your hand and drawing tool won't cast a distracting shadow on the drawing. In this photograph, the artist is right-handed and the light is coming from the left. The pencil casts no shadow.

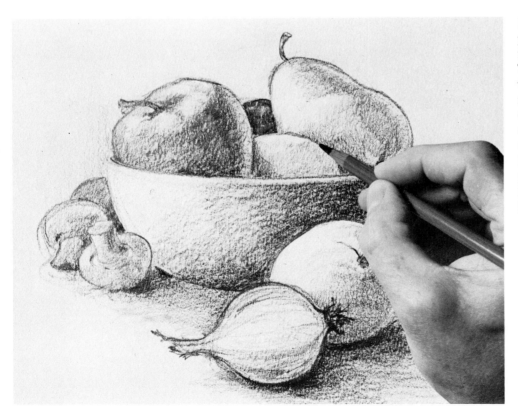

Bad Light. Here's what happens when the light comes from the wrong direction. The artist is right-handed and the light comes from over his right shoulder. The pencil casts a distinct shadow on the drawing, and the artist's hand casts a big shadow over the lower part of the drawing paper. Obviously, it's a lot harder for him to see what he's doing.

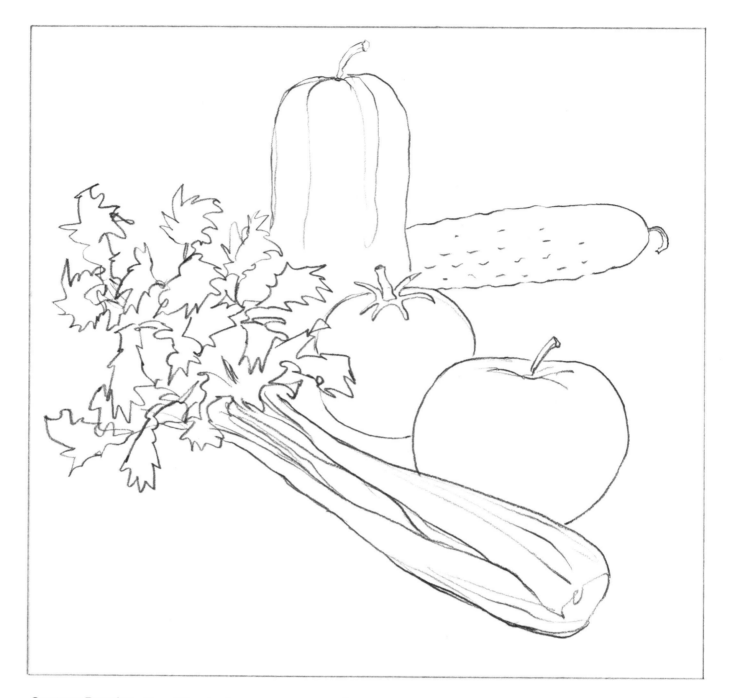

Contour Drawing. One of the simplest ways to get started is to arrange a few household objects on a tabletop and make some contour drawings in pencil. Just sharpen your pencil to a crisp point and draw the edges of the shapes with continuous, wiry lines. Try to imagine that the point of the pencil is your fingertip, which you carefully move around the edge of the shape that you're drawing. Don't look at your drawing too often. As much as possible, keep your eye on the subject while you draw. Contour drawing is good training because it teaches you to look carefully and draw shapes simply.

WARMING UP

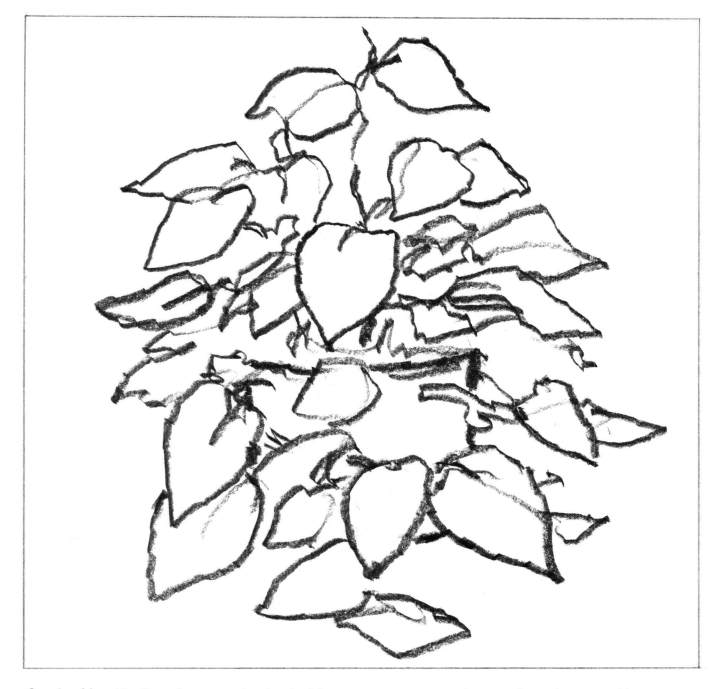

Groping Line. The lines of a contour drawing don't have to be slim and elegant. You can learn just as much by drawing with a thick line that gropes its way slowly around the shapes. Take the thickest pencil you've got—or find any pencil with a blunt point—and draw some more household objects, such as this leafy plant. Once again, pretend that the point of the pencil is your fingertip, moving around the edge of the shape. Move the pencil very slowly, feeling your way across the paper almost the way you'd grope your way around a darkened room. In fact, it's not a bad idea to pretend that your hand is in darkness: try looking at the subject without looking at the drawing at all, while your hand gropes its way across the paper. This is really another kind of contour drawing—another way of developing your ability to visualize and record shapes very simply.

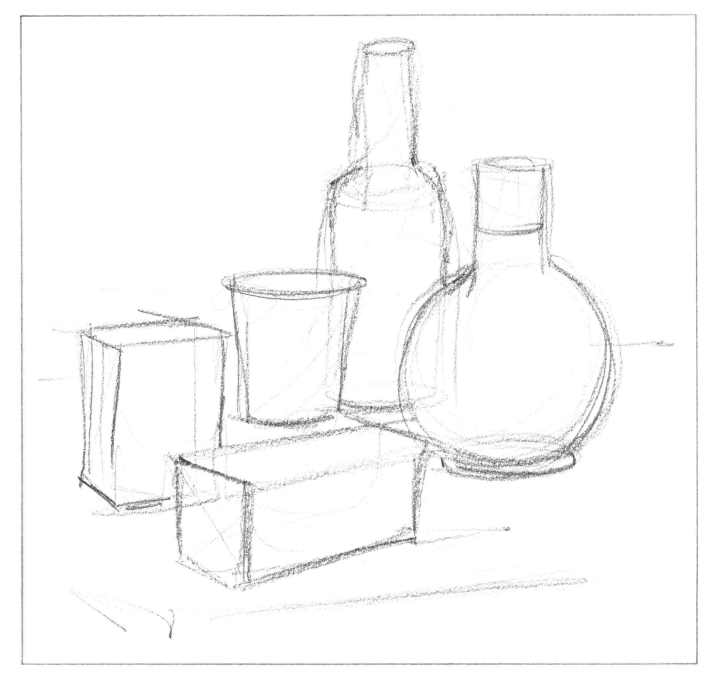

Scribbling. Drawing with big, scribbly lines doesn't necessarily produce a masterpiece, but it's another useful warm-up technique. Work rapidly, swinging your entire arm, and move around the forms with bold, rapid pencil strokes. Go over the lines as many times as you want, scribbling back and forth. Don't move the pencil carefully around each shape as in contour drawing; instead, try to capture the shape with a few large sweeps of the drawing tool. Quite naturally, without even thinking about it, you'll find that you visualize your subjects as a series of simple geometric shapes. Here, the bottles and the glass become spheres and cylinders, while the boxes become cubical. This is important because one of the secrets of successful drawing is knowing how to simplify your subject to geometric shapes. (You'll learn more about that later.)

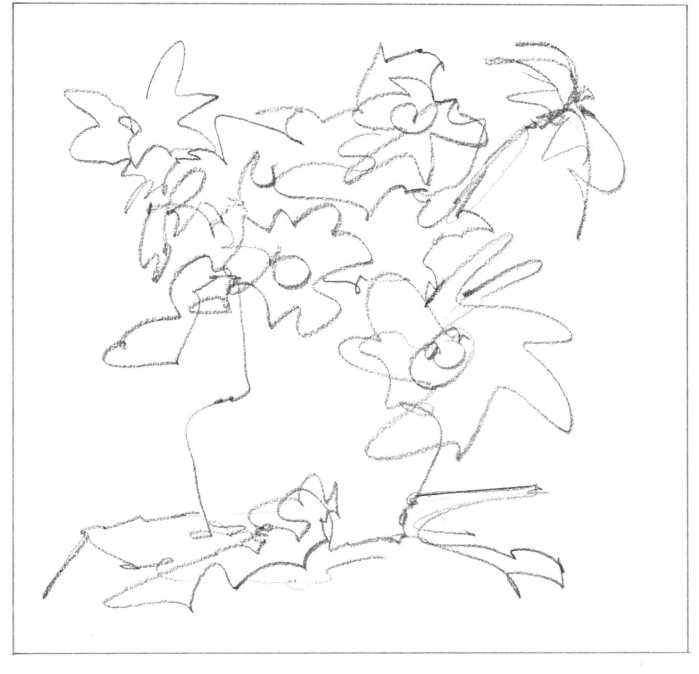

Gesture Drawing. Like scribbling, gesture drawing is a rapid process. However, the purpose of gesture drawing isn't to capture the geometric *form* of the subject, but its "movement." Of course, this vase of wildflowers is sitting quietly on a tabletop. But your *eye* moves rapidly over the subject, traveling in zigzags or graceful arcs or straight lines, depending upon the subject's form. Thus, the subject does communicate a sense of movement after all, and the purpose of a gesture drawing is to capture this dynamic feeling. Pick up a pencil and race swiftly over the subject as your eye moves. Don't stop to render shapes or contours precisely, but allow your pencil to dance freely over the paper, following the movement of the subject as a dancer follows the music. Every subject has a kind of inner vitality which is more than the eye sees—and gesture drawing helps you discover it.

Setting Up. Unless your drawing pad is large and stiff, rest the pad on a drawing board. If you're working with loose sheets of drawing paper, make a stack of several sheets and tack them to a piece of soft fiberboard. Resting on several other sheets, the top sheet will feel more resilient and responsive to your drawing tool. When you're working at home, prop your drawing board against the back of a chair or a stack of books so that your drawing surface will be vertical or slanted. Try to avoid drawing on a horizontal surface such as your lap or a tabletop. Your hand will move more freely on an upright or slanted surface, and you can see your subject more easily. If your budget permits, you might want to buy an upright drawing easel or a drawing table with a top that tilts to whatever angle you find comfortable.

Move Your Whole Arm. Drawing is like playing tennis: move your whole arm, not just your fingers or your wrist. If you watch a professional at work, you'll be surprised to discover that he moves his entire arm, from the shoulder down, with a rhythmic motion, even when he's drawing something quite small. If you move just your fingers or your wrist, your lines will have a cramped, fidgety feeling. If you move your whole arm, even small lines will have a rhythmic, swinging feeling.

Warming Up. Drawing is also like a sport in the sense that it's wise to warm up. A life-drawing class in an art school usually begins with a series of quick poses—from one to five minutes—that force the student to record what he sees with a few rapid strokes. Even if you're working at home, whether your subject is a still life or a model, start with a few quick sketches to loosen up. Your line will be freer, bolder, and more decisive for the rest of the drawing session.

Start with the Big Shapes. Always begin by drawing the biggest, simplest shapes of your subject with a few bold lines. Draw the boxlike shape of the rock or the egg shape of the head before you worry about the precise contours. When you've got the general shape and proportions right, then you can begin to sharpen the contours. In the same way, "rough in" the broad shapes of the shadows. When you're sure about the broad, overall contours and the large areas of light and shadow, then you can begin to think about making your lines and tones more precise. Save details—like the cracks in the rock or the sitter's eyelashes—for the very end.

Vantage Point. Before you start to draw, move around a bit and decide where you'd like to stand or sit.

A slight change in your vantage point might make a tremendous difference in your drawing. Even if your subject is something as simple as a few pieces of fruit on a table, the lighting and composition may change dramatically if you move just one step to the right or left. From one angle, you may see a lot of light on the shapes, but not much shadow. From another angle, you'll see more shadow. And the shapes may look a lot more dramatic from a different vantage point. Standing or sitting can also make a big difference. Some portrait sitters will look far more attractive if they're seated while you're standing, so you look at them from slightly above. When you're drawing the figure, distance is important. If you get too close, it's hard to see the total figure and your drawing may be distorted because you're working piecemeal, first focusing on the torso, then on the limbs, and then on the head. Step back a few paces so you can see the whole figure. When you're drawing outdoors, it's even more important to keep moving until you find the right vantage point. Those trees might look much more dramatic if you walked around them until you saw them silhouetted against the sun. Climbing a cliff might give you a more sweeping view of the shore, while drawing that same cliff from the bottom will make the rock formation look taller and craggier against the sky.

Organizing Your Own Life Class. To pay for a professional model, you can join with a group of friends to organize your own life class, sharing the cost of the model. Place the model where the light from a big window or a skylight strikes the figure from one side and from slightly in front, producing what's known as three-quarter lighting—often called "form lighting" because it's easiest to see the three-dimensional shapes. If you don't have enough natural light, place lighting fixtures where they'll give you the best three-quarter light. Try to find lighting fixtures that will give you a soft, diffused light that looks like natural light—avoid harsh spotlights and photographic floodlights. If you start with a series of short poses, remember that these poses can be tiring; give the model a five-minute rest period every fifteen minutes. When you switch to longer poses, the model can probably hold a simple standing pose for twenty minutes and a reclining pose for twenty to thirty minutes before taking a break. The model's comfort is important: keep the studio warm; give the model a private room (or at least a screen) for changing clothes; encourage the model to tell you if a pose turns out to be a problem; and be sure to invite the model to share your coffee or tea break.

PART ONE

STARTING TO DRAW

DRAWINGS BY FERDINAND PETRIE

Starting to Draw. Learning to draw what you see is one of life's most delightful accomplishments. And it's a surprisingly simple accomplishment. It's probably true that great artists are born, not made, but drawing what you see is a skill that anyone can learn. Yes, anyone! Creating a masterpiece takes genius, of course, but a simple, accurate drawing doesn't even take talent—just reasonable intelligence and the willingness to work. Learning to draw is like learning a sport or a musical instrument: the whole secret is steady practice. If you make the decision to set aside two or three hours for a drawing session at least once a week—preferably two or three times a week—you discover that your drawing skill increases gradually, but steadily. Obviously, the more often you draw, the more quickly you'll learn, so you'll learn twice as fast if you increase your schedule from once a week to twice a week. When you get into the habit of drawing regularly, you'll make the marvelous discovery that it's not work at all, but pure joy. You'll find that drawing is a pleasure for its own sake. And if your goals is to improve your painting, you'll find that your painting skills leap ahead as you develop a greater command of drawing.

Drawing Is Logical. The ability to draw what you see isn't some magical, intuitive talent, but a simple, logical process. If you can learn to draw a few geometric shapes—cubes, cylinders, spheres, and cones—you can learn to draw practically anything. A tree trunk, for example, is basically a cylinder, while the mass of leaves often looks like a ragged sphere with holes punched in it. In the same way, a rock formation often looks like a collection of broken cubes, while many evergreens are basically cones. And if you look at portrait drawings of Renaissance artists, you'll find that these master draftsmen often visualized the head as an egg, which is really just an elongated sphere. In the pages that follow, you'll learn to draw these basic geometric shapes and then you'll see how to convert them into the forms of nature.

Developing Your Observation. As artists and art teachers have been saying for centuries, learning to draw begins with learning to *see*. So you'll begin by learning how to measure height, width, and proportions in your mind's eye. Then you'll learn the elements of perspective, since a knowledge of perspective will help you draw objects that really look three-dimensional. Since the world is full of color, but drawings are black and white, it's also essential to learn about *values*—a word which needs some explanation. When you look at the colors of nature, you have to pretend that your mind is a camera loaded with black-and-white film that re-cords the hues of nature as black, white, and various shades of gray. Value is the comparative darkness or lightness of your subject. Thus, a deep green pine tree has a dark value, which you'd draw as a dark gray. A sunlit beach is apt to have a light value, which you'd draw as a pale gray—or perhaps leave the paper untouched so that the sand comes out white. Learning to make accurate value judgments will not only benefit your drawing, but will make a tremendous difference in the accuracy of your paintings.

Drawing Basic Forms. Your next step is to learn how to draw those basic forms—the cube, cylinder, cone, sphere, and egg—and transform them into specific shapes such as a basket, books, a jar, an evergreen, an apple, and a head. You also learn how to construct nongeometric forms as the basis for drawing erratic shapes such as mountains and foliage.

Drawing Methods. When you've learned how to draw these basic forms, noted artist Ferdinand Petrie demonstrates, step by step, how to put this knowledge to work in complete, handsome drawings. He shows you how to draw cubical objects in a still life of sliced bread; cylindrical objects in a still life of kitchen objects like jars, pots, and bottles; rounded objects in a still life of vegetables and fruits; and nongeometric forms in a study of a rumpled cloth. Each of these demonstrations shows the four essential stages in completing an accurate drawing.

Demonstrations. Building on this foundation, you'll learn how to do complete drawings of still lifes, landscapes, and portraits. Step by step, Petrie shows you how to draw a more complex still life of kitchen objects; a vase of wildflowers; an "outdoor still life" of rocks; a hilly landscape; the richly textured form of driftwood; a dramatic cliff; a male portrait head; a fallen tree; a wooded island; and a female portrait head. Each demonstration is presented in logical steps which you can then apply in your own drawings.

Drawing Media. Each of these step-by-step demonstrations is executed in one of three media—pencil, chalk, or charcoal. Demonstrations are planned to give you a survey of the various ways of using each of these drawing media. You'll see how to build contours and tones with lines, strokes, blending, and varied combinations of these methods. The demonstrations are executed on various types of paper so you'll see how pencil, chalk, and charcoal behave on a variety of drawing surfaces.

Measuring Height. To draw an object, you must know how to measure its proportions. Here's the traditional way to do it. To judge the height of a vase on a tabletop, for instance, hold a pencil in a vertical position and point your arm at the vase. Keep your arm straight; don't bend it. Align the top of the pencil with the top of the vase and slide your thumb down till it aligns with the bottom of the vase. (It's easier if you close one eye.) You can see that the height of the vase is roughly two-thirds the length of the pencil.

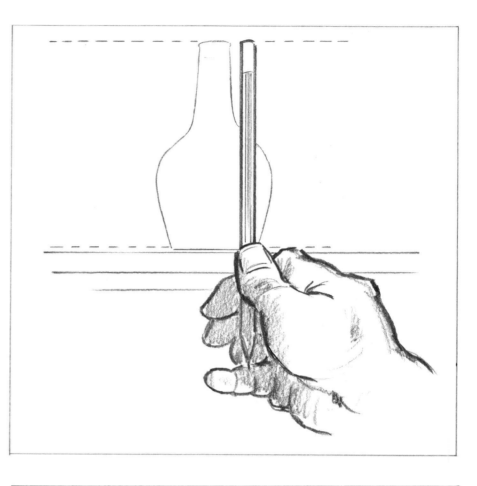

Measuring Internal Dimensions. Now you want to compare the total height of the vase to the height of the neck. Still holding the pencil at arm's length and aligning the top of the pencil with the top of the vase, move your hand upward along the pencil until your thumb aligns with the bottom of the neck. You can see that the neck is about one-third the total height of the vase. Remember not to step forward or backward between measurements. Always stand in the same spot and keep your arm absolutely straight so your measurements will be consistent.

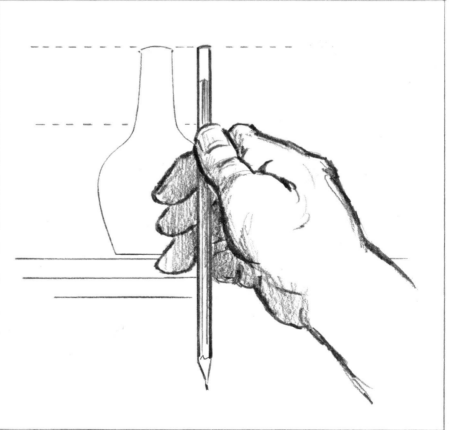

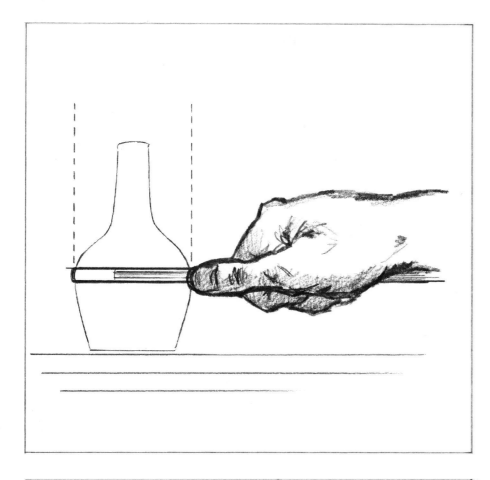

Measuring Width. Having established the two most important vertical dimensions of the vase, you now want to compare height to width. Standing in the same spot and pointing your arm straight at the vase, turn your wrist so the pencil is horizontal. Align the end of the pencil with one side of the vase and move your thumb until its tip lines up with the other side of the vase. Remembering your previous measurements, you'll find that the width of this vase is roughly half the height.(Another way of putting it is that the vase is two units high and one unit wide.) With practice, you may eventually be able to perform all these measurements in your head, without the aid of the pencil. But it's a good idea to start out with the thumb-and-pencil method.

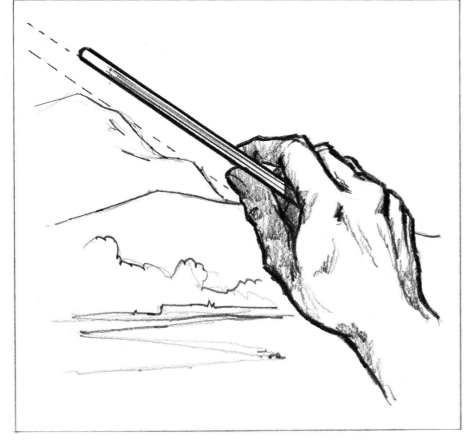

Determining Slope. The thumb-and-pencil method is also a good way to determine the angle of a sloping form such as the side of a hill. Just hold the pencil at arm's length and turn your wrist until the pencil lines up with the slope of the shape. Then quickly swing over to your drawing paper and draw a slanted guideline that approximates the slope of the pencil. Draw the hill over the guideline, which you can then erase when you're satisfied with the shape of the hill. Whenever you use the thumb-and-pencil method to measure proportion, don't hesitate to draw guidelines. It's easy enough to erase them later on.

Boxes. To develop your ability to judge proportions, accumulate some ordinary cardboard boxes and arrange them on a tabletop. (You may want to strip off the distracting printed wrappings.) Then use the thumb-and-pencil method to measure all the edges. The box at the left is a cube: when you measure each face of the box, you'll find that the height and width are approximately the same. On the upright box, each plane is roughly three units high by one unit wide. The proportions of the horizontal box are more subtle: measure them yourself.

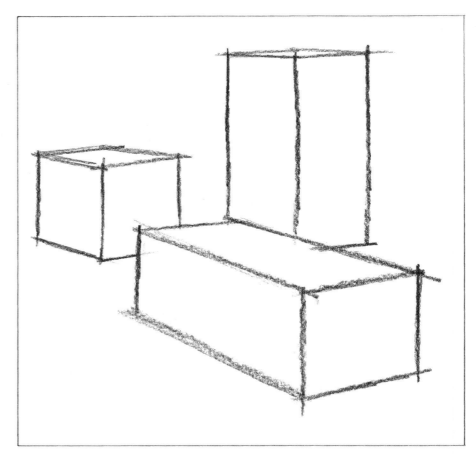

Bottles. Boxes are a lot easier to measure than bottles, of course, but once you've learned how to measure boxes, you can use the same technique on more complex forms. When you look at a cylindrical object, for instance, ask yourself what kind of box it would fit into. Actually, the proportions of these cylindrical shapes are surprisingly similar to those of the boxes in the previous drawing. With a few adjustments, these cylinders would slide quite comfortably into the boxes. To draw these cylindrical shapes, you might even want to start out by drawing boxes—and then draw the cylinders inside them.

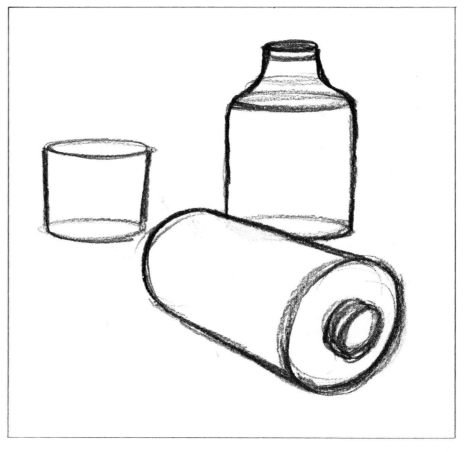

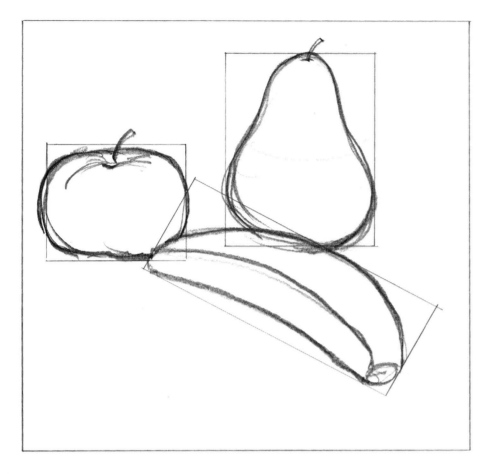

Fruit. When you draw rounded forms—such as this apple, pear, and banana—you can also play the box game. Imagine what sort of box each shape would fit into. You can even draw the boxes. Like the cylindrical shapes at the bottom of the opposite page, the curving forms of these fruits would fit quite comfortably into the boxes at the top of the facing page.

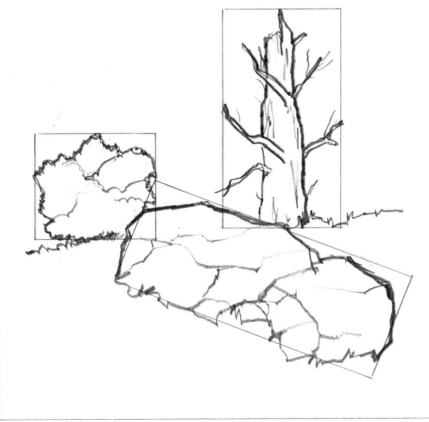

Trees and Rocks. You can also use boxes to guide you in drawing irregular forms like bushes, broken tree trunks, and rock formations. The bush at the left would fit into a box which was more or less cubical. The tree trunk would need a box approximately two units high by one unit wide. And the slanting rock formation would fit into a box whose length was roughly two and one-half times its height. Even when you're outdoors drawing a landscape, there's nothing wrong with drawing boxes as guidelines, then erasing them later.

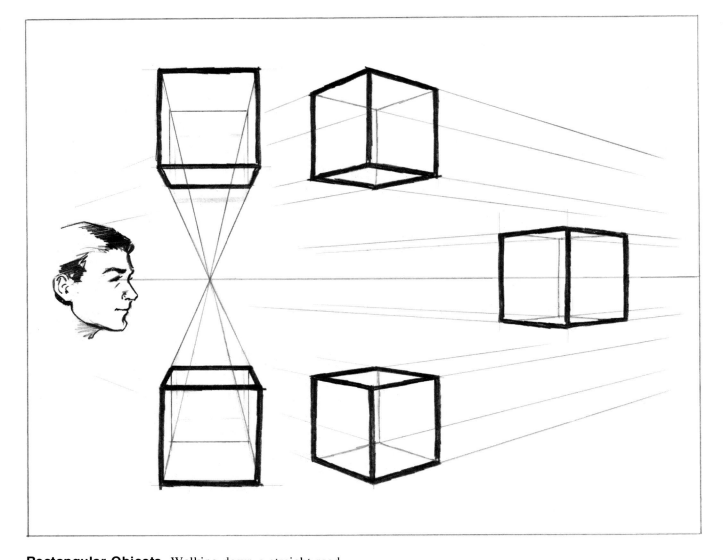

Rectangular Objects. Walking down a straight road, you've certainly noticed that the parallel sides of the road seem to converge as they recede into the distance. The same is true of all straight, parallel lines, whether the object is as big as a wall or as small as a book. This phenomenon is called perspective. When you stare *straight ahead,* your eye establishes an imaginary horizontal line known as the eye level; you can see this line across the center of this illustration. Every straight line you draw is related to this eye-level line in some way. Study the boxes in this drawing. Two are above the eye-level line, two are below, and one is right on the line. Notice that all horizontal lines are parallel to the eye-level line, while all the vertical ones are perpendicular to it. The big difference is in the slanted lines. When a box is *above* the eye-level line, all diagonal lines converge downward toward the line. And when a box is *below* the eye-level line, all the slanted lines converge upward to it. The box at the extreme right is interesting because its top is above the eye-level line while its bottom is below; so the top lines converge downward and the bottom lines converge upward.

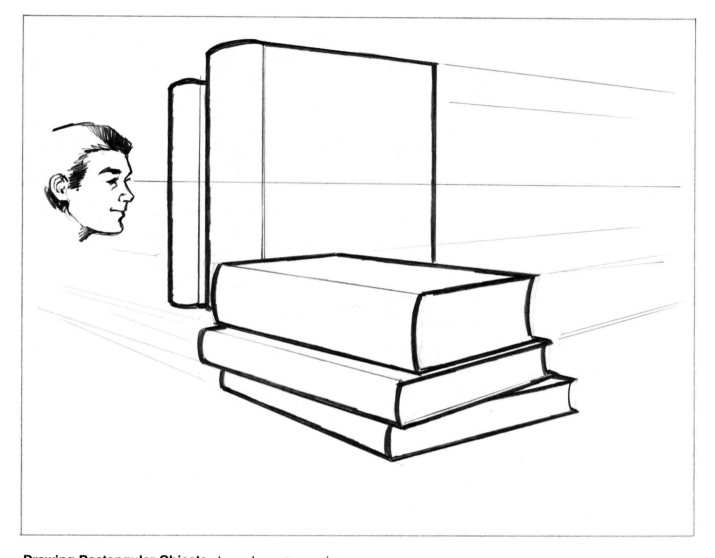

Drawing Rectangular Objects. A good way to practice perspective drawing is to make a pencil drawing of some books on a tabletop. Sit down so that your eye-level line roughly lines up with the back edge of the table. Thus, the tops of some of the books will be above your eye-level line, while some of the other shapes will be below it. (Remember that your eye-level line changes as you move: it's higher when you stand up and lower when you sit down.) The vertical lines of the upright books are at right angles to the eye-level line. Their top edges are above the eye-level line, so they slant downward. The three books lying flat on the table are below the eye-level line, so all the slanted lines converge upward. Of course, you're not going to spend your life drawing boxes and books, so why is the study of perspective so useful? Although there aren't many neat, box-like shapes in nature, you'll soon discover that there are plenty of lines that are subject to the rules of perspective. You'll find lots of horizontal lines (such as the edge of a table or a distant shoreline) that should be parallel to your eye-level line. You'll find that there are many vertical lines (such as the sides of a drinking glass or a tree trunk) that will be roughly perpendicular to it.

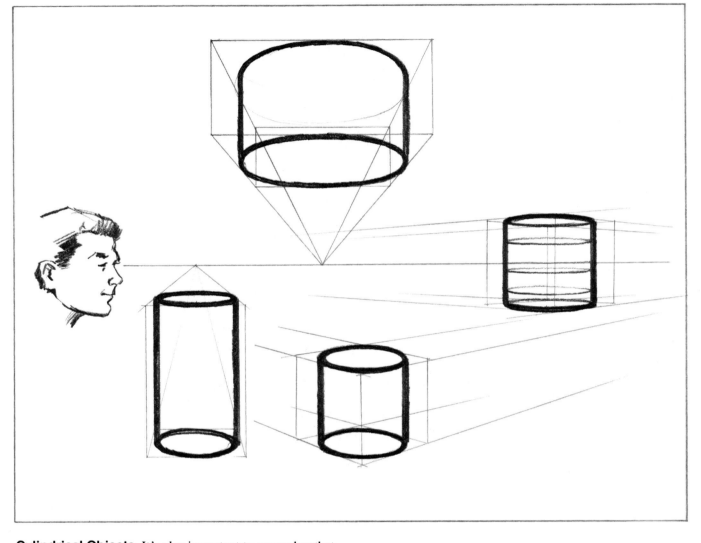

Cylindrical Objects. It's also important to remember that cylindrical objects obey the rules of perspective, just as cubical ones do. The vertical sides of a cylindrical object are at right angles to your eye-level line. This is equally true of all the cylinders in this drawing, whether they're above or below the line. We tend to see the tops and bottoms of cylindrical forms as ellipses. The important thing to remember about ellipses is that they gradually become flatter as they approach the eye-level line. Conversely, they become rounder and more open as they move farther away from it. You can see this most dramatically in the cylinder at the lower left, where the top ellipse is distinctly flatter than the bottom one, which is much farther away from the eye-level line. In this illustration, boxes have been drawn around the cylindrical forms to show you how cylinders and boxes conform to the same rules.

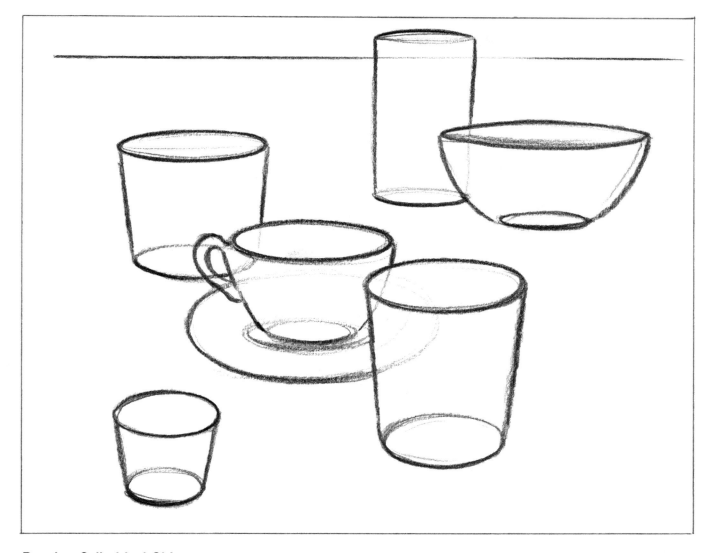

Drawing Cylindrical Objects. To test out what you've learned about the perspective of cylindrical objects, arrange a group of kitchen containers on a table: glasses, bowls, cups, saucers, whatever. Try drawing them in pencil from a standing position; then draw them again from a seated position, so you can see how things change as your eye-level line moves up or down. In this drawing, the eye-level line happens to coincide with the back edge of the tabletop, which you can see near the top of the drawing. Therefore, everything is below the eye-level line except for the top of one glass. The important thing to notice is how the shapes of the ellipses change as they approach the eye-level line:

the ellipses at the bottom of the drawing are much rounder than the ones closer to the eye-level line. Once again, you may be wondering why the perspective of ellipses is worth studying, since you certainly won't be spending your life drawing cups and glasses. But you'll find that nature actually contains many rounded and cylindrical forms that obey these rules. A tree stump is an obvious example. But have you also noticed that the tops of clouds tend to be rounder than the bottoms, which are closer to your eye level? And when you look at a series of tidal pools on a beach, have you noticed that the ones closest to you look round, while the distant ones look flat?

Fruit: One View. Everything you draw relates to your eye-level line in some way. Make some pencil drawings of fruit to see how this works. Shown here are some pieces of fruit below your eye-level line: you're standing up and looking down at them. You see the tops of all the shapes. You also see the big shadows from above.

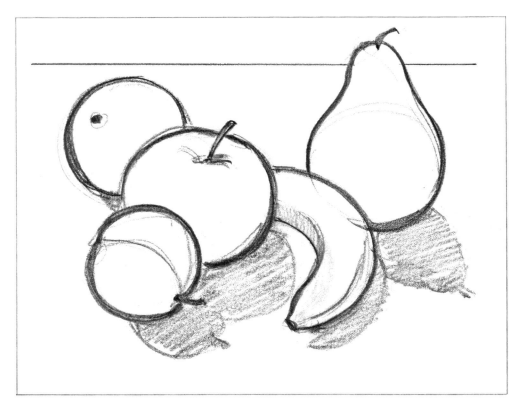

Fruit: Another View. Now, if you sit down so your eye-level line drops, you'll draw a totally different view of those same pieces of fruit. This drawing shows how you'd see them from the side; all the shapes change radically. The shapes of the shadows are particularly interesting: when you looked at the shadows from above, they were far below your eye-level line and their shapes were round; now the shadows are close to the eye-level line and they're a lot flatter. Remember the perspective of ellipses?

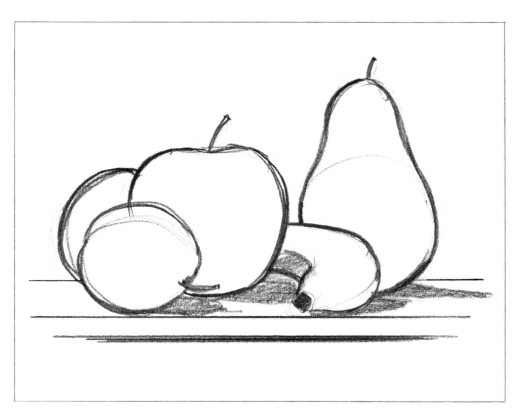

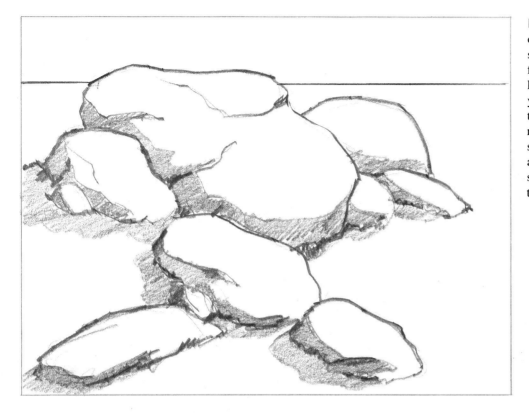

Rocks: One View. Now go outdoors and find some shapes that you can draw from several different eye levels. Climb some rocks so your eye level is fairly high; then look down at some other rocks and draw them. You see a lot of their tops and just a bit of their sides. You also see a lot of the shadows that they cast on the ground.

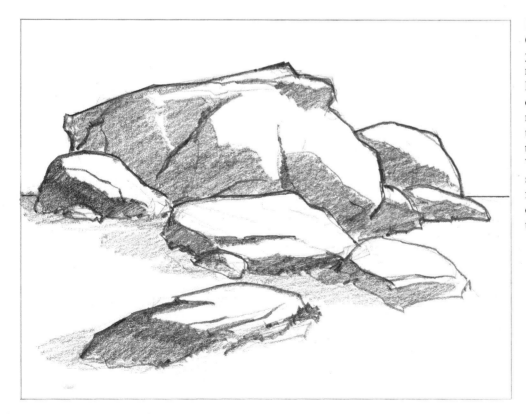

Rocks: Another View. Climb back down and seat yourself in front of that same rock formation, so your eye level drops. Now, when you draw the same rocks, you see more of their sides and less of their tops. The shadows on the ground are also flatter. Whether you're drawing a still life or a landscape, it's fascinating to discover how a change in eye level creates a totally new picture.

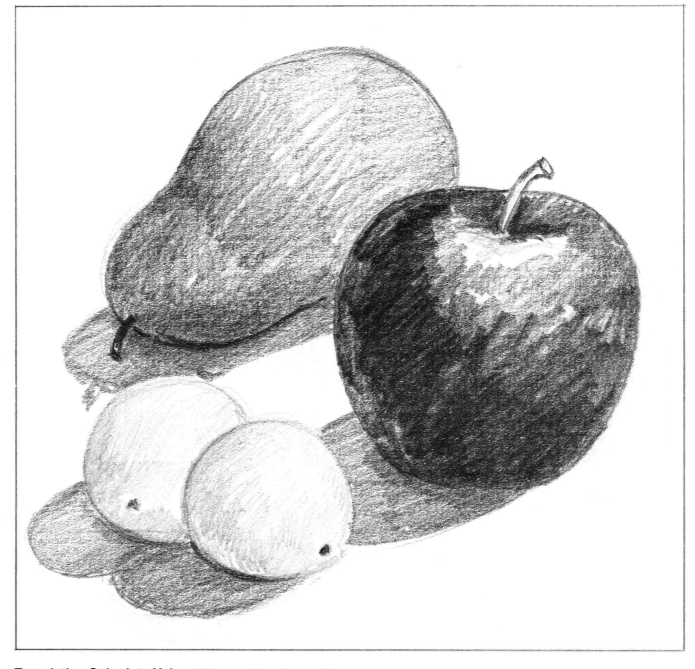

Translating Color Into Value. When you draw in pencil, chalk, or charcoal, you're translating the colors of nature into black, white, and various shades of gray. You have to pretend that your eye is a camera loaded with black-and-white film. The film records the colors of nature as black, white, and tones of gray. That imaginary roll of film is converting the colors of nature into what artists call *values*. Every color has a value. As you can see here, a red apple is fairly dark, almost black, while a green pear is a medium gray, and two yellow lemons register as a very pale gray, almost white. It's a good exercise to go around the house drawing objects of different colors and trying to determine the correct value for each object.

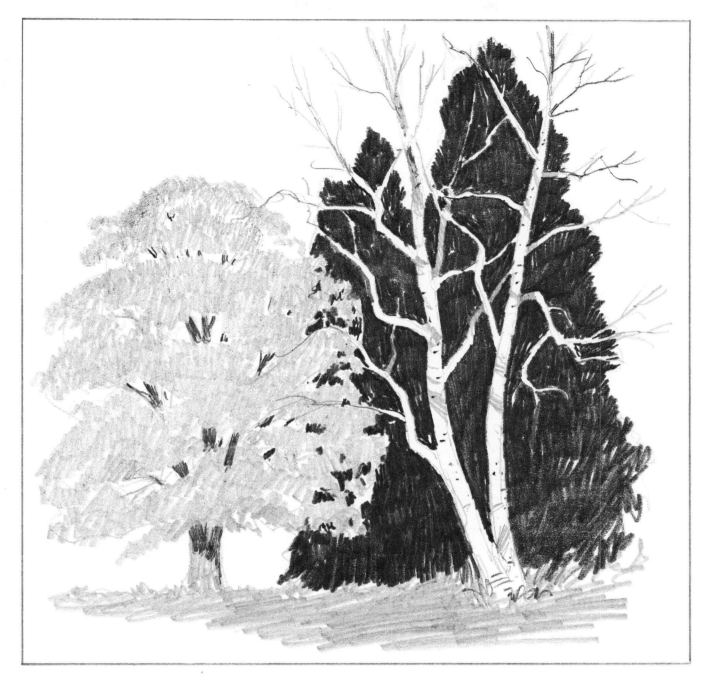

Finding Values Outdoors. Go outdoors with your sketch pad and try to translate the values of the landscape into black, white, and various shades of gray. The dark green of an evergreen will probably be a deep gray—almost black. Silhouetted against that dark shape, the pale trunk of a birch will look white or a very pale gray. In this pencil drawing, the light green foliage of the deciduous tree at the left becomes a soft gray, while the slightly darker green of the grass becomes a darker gray. There are no formulas for judging values. A deciduous tree isn't always a light gray, for example. With the sun behind it, that same soft green foliage may turn very dark and you'll want to draw it as a deep gray or even black. On an overcast day, the dark green foliage of the evergreen may look paler and you might draw it as a soft gray.

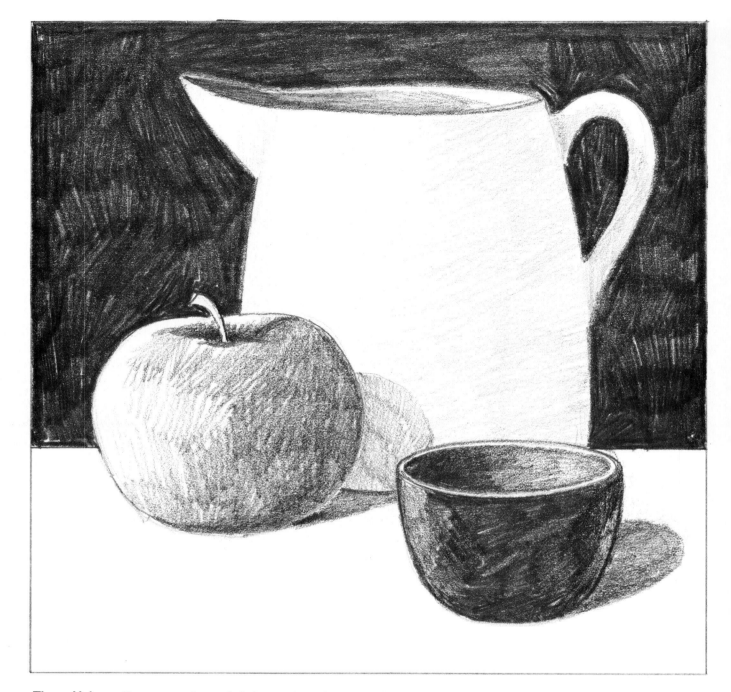

Three Values. Nature contains an infinite number of colors which, in turn, can become an infinite number of values. It's hopeless to try to record every subtle variation in value. Besides, too many different values make a confusing picture. Artists normally try to simplify a picture down to just a few values, which are easier to draw and also make a more satisfying pictorial design. If the subject is fairly simple, you can make a surprisingly good picture by concentrating on just three values. Half-close your eyes and you'll see that this picture consists mainly of a blackish gray that appears in the background and in the cup at the lower right; a medium gray on the apple, within the openings of the pitcher and cup, and in the shadows; and the white of the paper on the pitcher, the tabletop, and the lighted side of the apple. When you reopen your eyes and look at the picture more carefully, you'll see that there are hints of other values, such as the pale shadow on one side of the pitcher and the variations within all the tones. But the artist has visualized this still life as essentially a three-value picture.

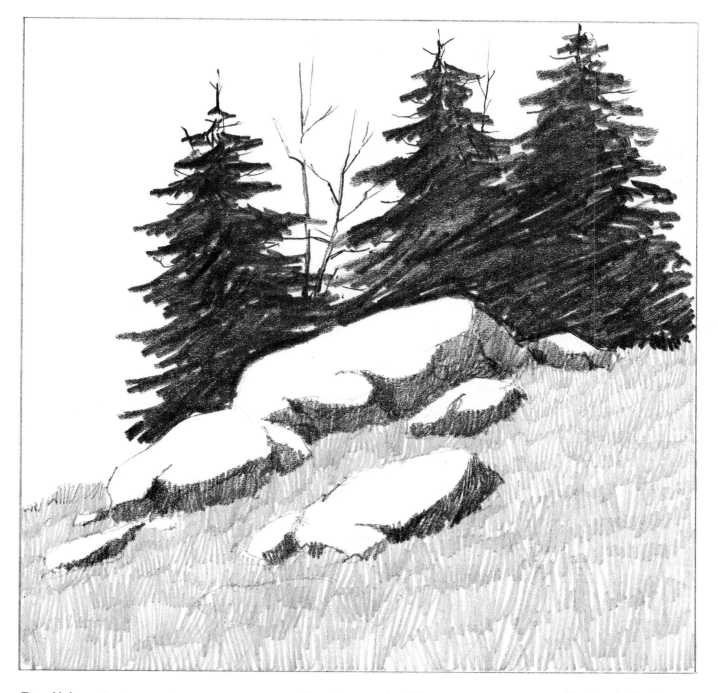

Four Values. Outdoors, values are even more complicated than they are indoors, so it's even more important to find a way to simplify the colors of nature to just a few values. Three values may not be enough, but four will often do the job. Once again, half-close your eyes so you'll see this picture as broad patches of tone. There are just four basic values: the dark gray of the evergreens; the lighter gray of the shadowy sides of the rocks; the still lighter gray of the grass; and the bare white paper of the sky and the sunlit tops of the rocks. When you open your eyes and look at this landscape drawing more closely, you can see hints of other values within all the tones, but it's essentially a four-value picture. This is an important lesson to carry over into your landscape *painting*. Many successful landscape artists train themselves to visualize the landscape in four broad tones: dark, light, and two so-called middletones. The four-value system is one of the most effective ways to create a bold, dramatic pictorial design.

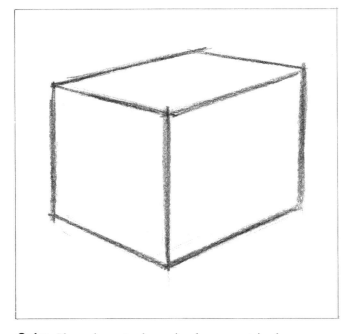

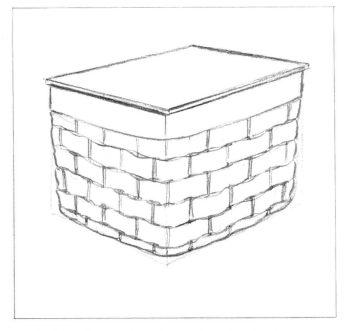

Cube. If you learn to draw simple, geometric shapes, you can draw almost anything. A surprising number of objects around you are cubes or variations of that basic shape. Practice drawing cubes from different angles.

Basket. Look around the house for cubical objects. This basket, with its flat wooden top, is essentially a cube, even though its sides taper a bit. At first glance, the lines of the interwoven straw look irregular, but they actually follow the cubical shape very faithfully. Start out by making line drawings, in pencil, of cubical objects like this basket.

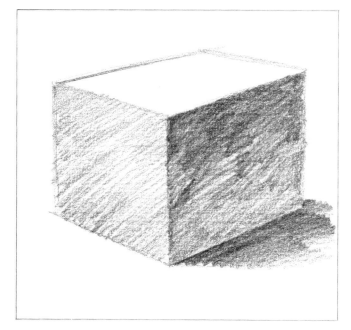

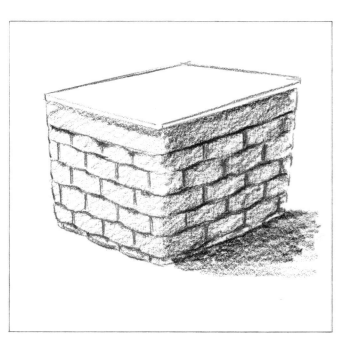

Cube in Light and Shade. When you study the effects of light and shade on a cube, you're apt to see five distinct tones. The top plane of this cube is the *light*; the left is the *halftone* (often called the *middletone*); the right plane is the *shadow*, within which there's a hint of *reflected light* at the bottom; and the dark tone on the table top is the *cast shadow*.

Basket in Light and Shade. You can see the same tones on the planes of the cubical basket: the lighted top, the halftone at the left, the shadow and hint of reflected light at the right, and the shadow which the basket casts on the table-top. Reflected light, shown here at the lower right, usually comes from some secondary light source, such as a distant window.

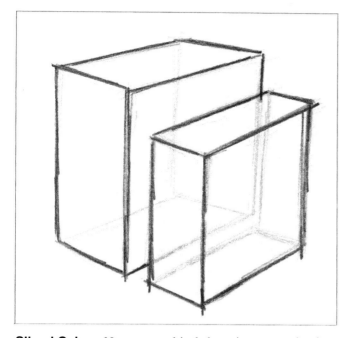

Sliced Cubes. Not every cubical shape is a neat cube, but many shapes are slices of cubes. Practice drawing cubes that you slice into different shapes. Pretend that these slices are transparent and draw *all* the edges—even those on the far side, which you couldn't see if the slices were opaque. And don't forget about perspective!

Books. These books are just slices of cubes. The big slice in the preceding drawing at left has been further sliced up to make two books. Notice how the top edges of the books conform to the rules of perspective. Hunt around the house for shapes that look like slices of cubes—as varied as possible—and draw them with crisp pencil lines.

Sliced Cubes in Light and Shade. When you break up the cube into slices, each slice contains the same five tones as the original cube. Once again, you can see the light, half-tone (or middletone), shadow, reflected light, and cast shadow. Notice how the cast shadow is darkest right next to the object that casts it—and grows paler as it moves away.

Books in Light and Shade. Here's how the five tones appear on those books. But bear in mind that the distribution of the five tones will change with the direction of the light. If the light were coming from the lower right, the shadow sides would be transformed into the lighted sides. The other planes would change too. And the cast shadow would be at the left.

Step 1. Assemble some cubical shapes, set up a still life, and draw them in pencil. This loaf of bread, bread board, and knife are all variations—or slices—of the simple cube. At the beginning, just draw the cubical shapes with straight lines and don't worry about whether they look like a loaf of bread, a bread board, and a knife. Just visualize them as geometric shapes—and remember to draw the slanted lines in perspective. Don't use a ruler. Draw the lines freehand and don't worry about making them too neat. You can go over a line several times until you get it right.

Step 2. When you're satisfied that the geometric forms are fairly accurate, go over the original lines with heavier strokes to convert those geometric forms into your actual subject. Here, the artist uses the straight lines of Step 1 as convenient guidelines for drawing the soft curves of the bread, the rounded corners of the bread board, the rounded end of the knife handle, and the slanted tip of the knife blade. Whatever subject you choose for this exercise—it doesn't have to be a loaf of bread—start out by drawing simple geometric forms with straight lines, and then draw the more irregular lines of the subject right over them.

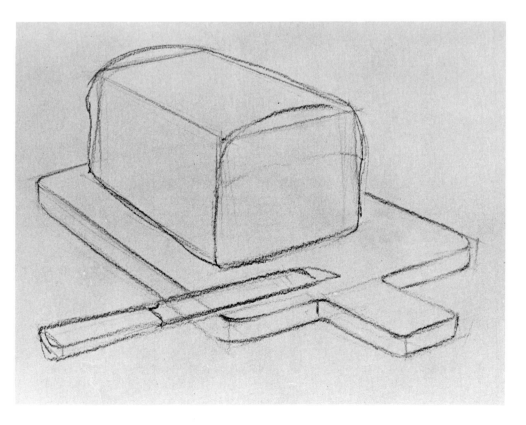

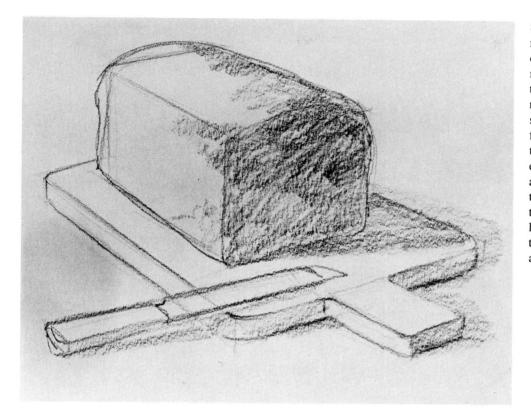

Step 3. After the artist has redrawn the actual contours of the subject over the original guidelines, he blocks in the broad areas of tone with rough, casual strokes. The shadow plane of the loaf is facing you, and you can see the reflected light at the lower edge of this plane. You can also see the shadow cast by the loaf on the board. Where the top and left sides of the loaf meet, the light and halftone flow softly together along the curve.

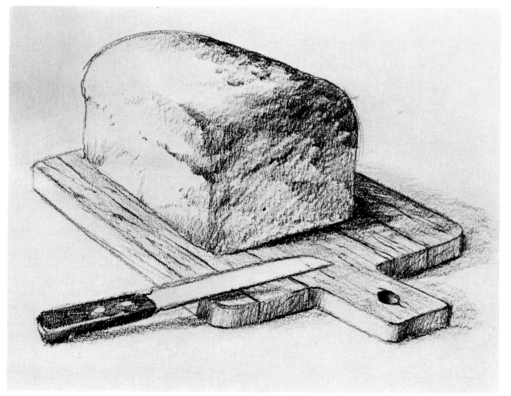

Step 4. Having drawn the shapes accurately and indicated the broad distribution of light and shade, you can then concentrate on the precise details that complete the drawing. The artist sharpens the lines a bit more and erases the guidelines; adds darker strokes where necessary; suggests the texture of the bread and the grain of the bread board; and defines the knife more precisely, carefully indicating the tones of the handle. Notice that the darkest edges of the bread board and knife handle all face the lower right, as does the shadowy end of the loaf. The lightest planes of the loaf and bread board are at the left.

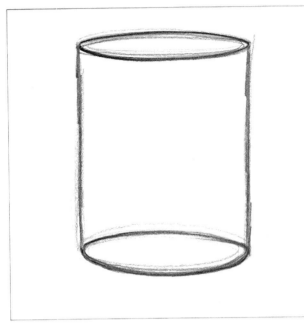

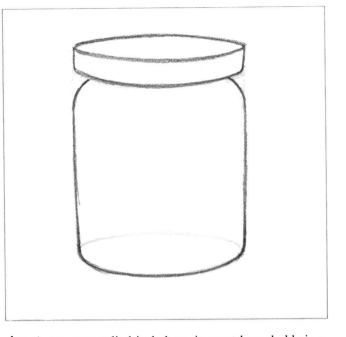

Cylinder. Another common geometric form is the cylinder, which occurs throughout nature. A tree trunk is essentially a cylinder; so are your neck and thighs. Practice drawing cylinders with sharp pencil lines. Don't worry about making neat, elegant drawings. Keep going over the lines until you get them right—as the artist has done in this illustration.

Jar. A common cylindrical shape in most households is a jar. Draw as many different cylindrical shapes as you can find in your home. If they're not made of glass, *pretend* they're transparent so you can draw the elliptical tops and bottoms. Remember the perspective of ellipses. In this jar, as in the cylinder on the left, the top ellipse is shallower than the one at the bottom.

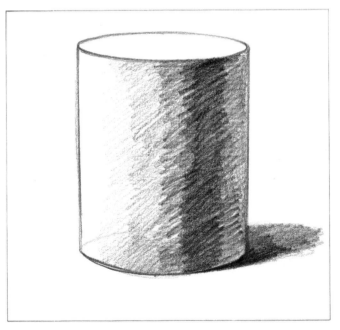

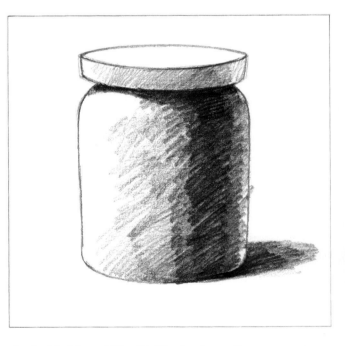

Cylinder in Light and Shade. Find an opaque cylindrical form—such as a roll of paper towels—and study how light and shade wrap around the form. On the cylinder in this drawing, you see the progression from light to halftone (or middletone) to shadow to reflected light. The cylinder casts a shadow to the right. On a cylinder, unlike a cube, these tones flow into one another.

Jar in Light and Shade. The jar shows the same progression from light to halftone to shadow to reflected light. The same sequence of tones appears on the lid, which casts a shadow over the neck of the jar. Don't hesitate to draw the gradation of tones with free, scribbly strokes, as the artist has done here. Neat drawing is less important than careful observation.

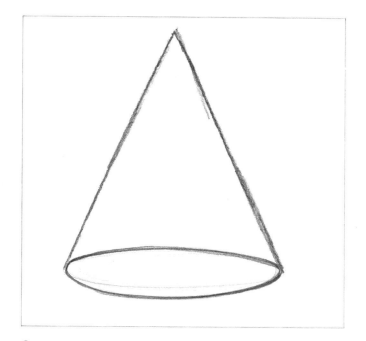

Cone. A cone is very much like a cylinder in the sense that the base is circular and the sides are round—but the sides taper to a point. Precise conical shapes aren't as common in nature as cylinders, but many cylindrical shapes actually have tapering sides and therefore are a cross between a cone and a cylinder. Practice drawing cones of different shapes.

Evergreen. Outdoors, perhaps the most common conical shape occurs in various evergreens. The foliage may make the form *look* ragged, but it's essentially a cone. Hills, mountains, and dunes are often *flattened* cones, by the way. Go for a walk and see what cones you can find to draw.

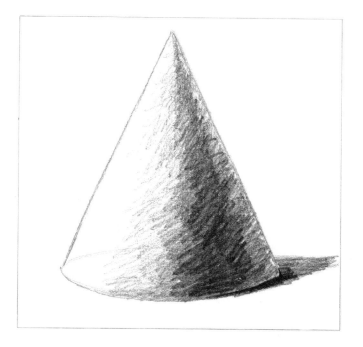

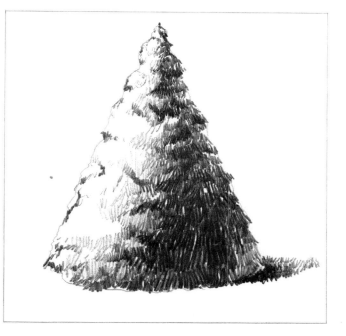

Cone in Light and Shade. When you study the gradation of light and shade on a cone, you'll see the same progression of tones that you see on a cylinder: light, halftone (or middletone), shadow, reflected light, and cast shadow. After you practice drawing imaginary cones in line, try rendering them in gradations of tone with loose, casual strokes.

Evergreen in Light and Shade. The foliage of the evergreen blurs the gradation of light and shade, but if you squint to blot out the distracting detail, you'll see the same tones that you find on the imaginary cone. The hint of reflected light at the right is apt to come from the sky. Although it's broken up by the grass, the cast shadow also moves from dark to light.

Step 1. Collect a group of cylindrical household objects—jars, glasses, cups, pitchers, bottles, bowls—and set up a still-life arrangement something like this one. Work with a pencil again. Begin by drawing all the objects as simple geometric shapes. Some of the shapes will be true cylinders like the glass in the center, while others will look more like the lower part of a cone, tapering toward the top like the pitcher at the right. Don't forget about the perspective of ellipses. Ellipses are hard to draw, so draw the curves again and again until they seem reasonably accurate. Don't hesitate to keep going over the lines.

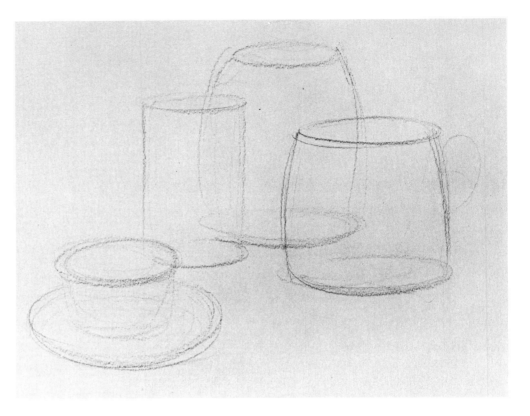

Step 2. When you're sure that the geometric forms are correctly proportioned, go over the guidelines of Step 1 with firmer lines to sharpen the contours. As you do, convert the cylinders into actual household objects. It helps if you pretend everything is transparent and draw one shape through another; it's easier to draw something if you can see the whole shape. Later on, you can erase some of those lines if you find them distracting. But even the most skilled professional artists use all sorts of guidelines—and often don't bother to erase them. Notice how the lower ellipses are rounder and more open than the ones at the top of the picture, which are closer to the eye-level line.

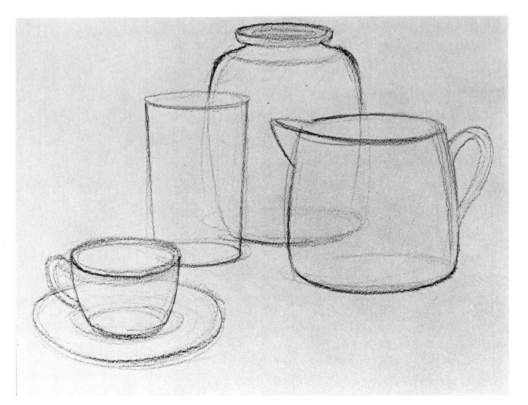

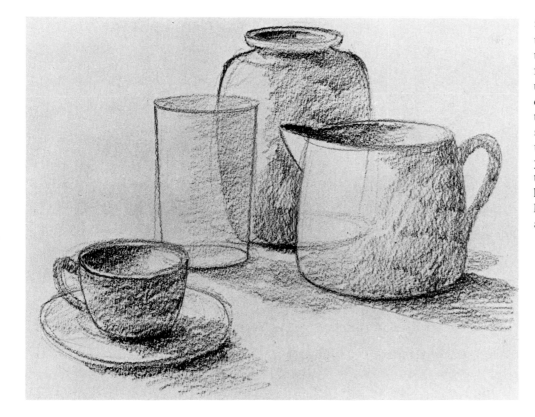

Step 3. After you've defined the shapes in Step 2, block in the broad tones with rough, free strokes. Although you've used the tip of the pencil to draw the contours, it's easier to block in the tones with the side of the lead. At this stage, the tones are quite rough, but you can already begin to see the gradation from light to halftone to shadow to reflected light. And the cast shadows are clearly indicated too.

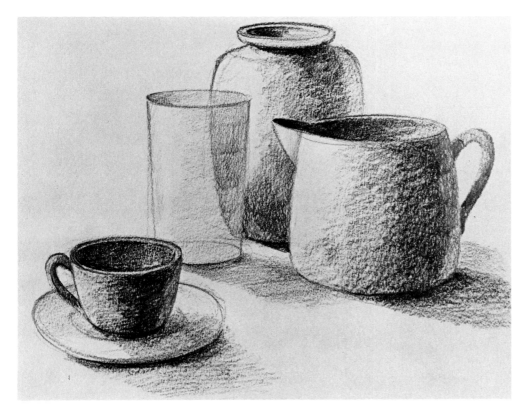

Step 4. It's best to save all the really precise work for the final stage of the drawing. Now's the time to sharpen certain contours with the point of the pencil—such as the cup and saucer, which need to be drawn more precisely. You can also use the side of the pencil to strengthen the darks—such as the inside of the pitcher—and to build up the shadow tones so you have a smoother gradation of light and shade. Finally, you can use the eraser to lighten some tones and remove distracting guidelines.

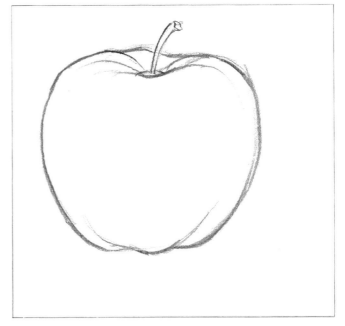

Sphere. The sphere is another simple geometric form that occurs constantly in nature, from tiny pebbles to big boulders, from a single bud to a round mass of foliage. Practice drawing spherical shapes, swinging your whole arm with rhythmic movements. The sphere doesn't have to be perfect, just reasonably round. Don't hesitate to go over the line again and again.

Apple. The apple, like many fruits, is essentially a sphere. To draw it, you start out by drawing a simple sphere like the one at your left; then go over the lines, making the necessary adjustments to convert the sphere into an apple. Try the same process with other spherical fruits, such as peaches, plums, oranges, lemons, and anything else you can find in the kitchen or in the fruit market.

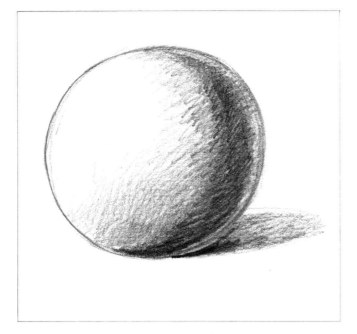

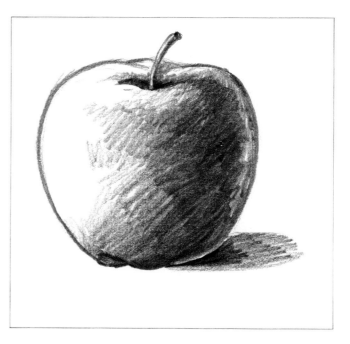

Sphere in Light and Shade. Light and shade wrap around the sphere as they do around a cylinder. From left to right, you can see light (the bare paper), halftone (or middletone), shadow, and reflected light on the sphere, plus the shadow that the sphere casts on the table. When you've practiced drawing spherical shapes in line, then practice adding light and shade with broad strokes.

Apple in Light and Shade. Those five tones wrap around the real apple just as they do around the geometric sphere. After you've drawn the apple in line, add these tones to make the apple look round. Look at the apple carefully: the tonal pattern will be more irregular on the apple than on a sphere, since the *shape* of the apple is irregular.

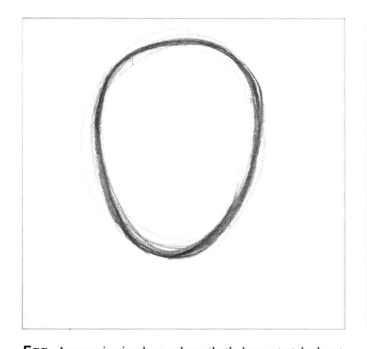

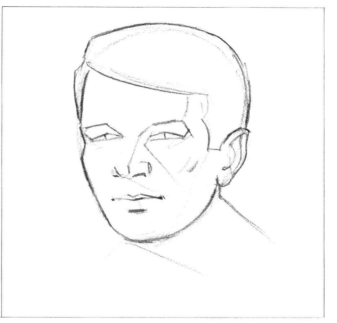

Egg. An egg is simply a sphere that's been stretched out and slightly narrowed at one end. Many fruits and vegetables are egg-shaped, and so are many trees, rocks, and flowers. Practice drawing eggs just with round, rhythmic movements of the pencil, the way you practiced making circles. Keep moving the pencil around and around until the shape looks right.

Head. The most familiar egg-shaped object is the human head. Practice drawing some heads. You'll find that it's easier if you start out by drawing the shape of an egg. Notice that the eyes are halfway down from the top of the egg; the tip of the nose is midway between the eyes and chin; and the center line of the mouth is almost halfway down from the nose to the chin.

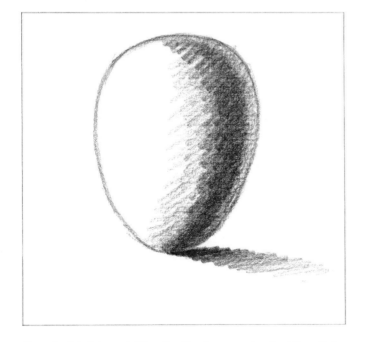

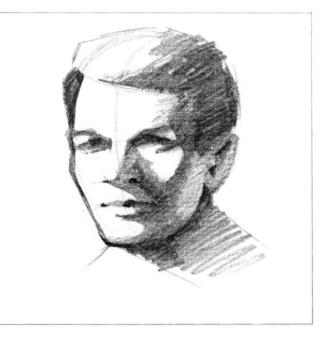

Egg in Light and Shade. Having practiced adding light and shade to the sphere, it should be easy for you to do the same thing to your line drawing of an egg. You can make the egg look rounder if your pencil strokes seem to curve around it. And the cast shadow on the table will look flatter if the strokes seem to lie flat on the table.

Head in Light and Shade. The tones on the human head may be harder to identify because they're broken up by the features. Look carefully at your model: the tones are really there, although they may be distributed a bit differently. Here, the forehead contains the usual progression of light, halftone (or middletone), shadow, and reflected light, while the cheek jumps more abruptly from light to shadow to reflected light.

Step 1. Make a pencil drawing of rounded objects by assembling a still life of fruit, vegetables, and perhaps a bowl from the kitchen. Draw the bowl as the lower half of a sphere—with an ellipse at the top. The fruits and vegetables are all basically spherical, although they probably won't be perfectly round—some will be shaped more like eggs. Draw the geometric shapes with light, rhythmic lines, going over the lines several times if necessary. The shapes will look rounder if you move your whole arm.

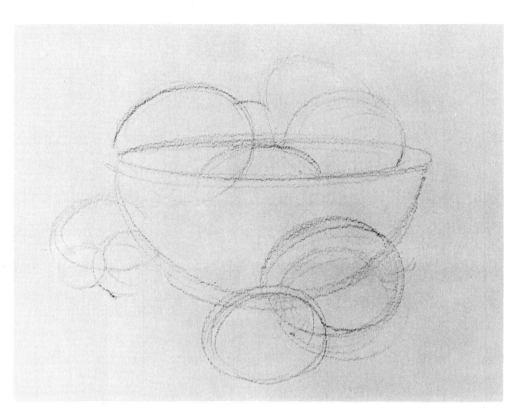

Step 2. When you're satisfied with the spheres and egg shapes, go back over them with darker lines, converting the geometric shapes into a real bowl, fruit, and vegetables. You'll have to change some of the curves to make your subject look more realistic, as the artist has done here with the apple and pear in the bowl, and with the onion in the foreground. Notice that the stems of the mushrooms at left are cylinders with slightly concave sides; the ends of the stems are ellipses. Don't erase the guidelines left from Step 1 just yet.

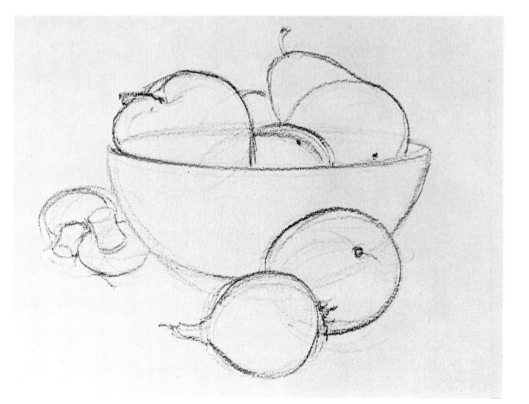

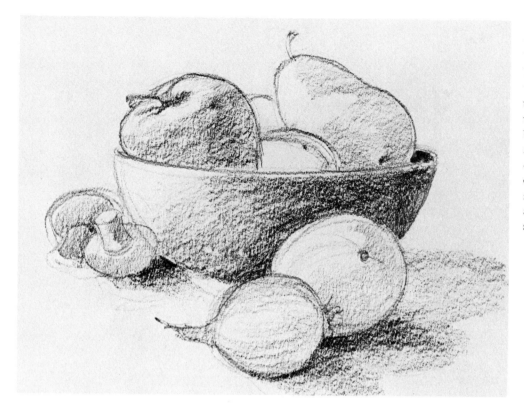

Step 3. Now, working with the side of the pencil to make broad strokes, block in the broad tonal areas. Notice that the shadows are darker when the subject is darker—such as the red apple or the wooden bowl. Conversely, shadows are more delicate on a pale object like the pear and onion. The light, halftone, shadow, and reflected light are also more obvious on dark shapes.

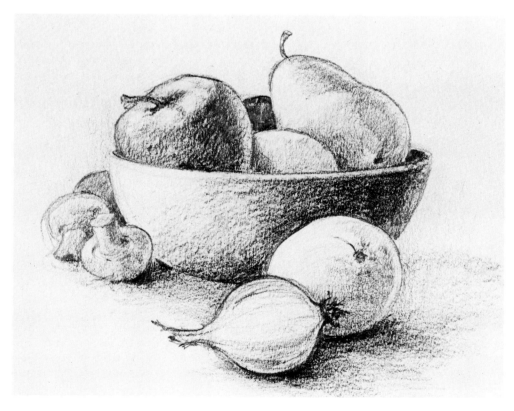

Step 4. In this final stage, you can draw more precise lines to define the contours of your subject as realistically as possible. You'll probably want to flatten some of the curves, adding dents and other irregularities. You can also strengthen the halftones, shadows, and cast shadows with the side of your pencil. Finally, you may want to use an eraser to brighten some of the reflected lights and eliminate the guidelines that you originally drew in Step 1. This is the time to add stems and other final details.

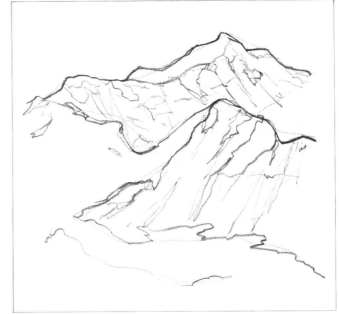

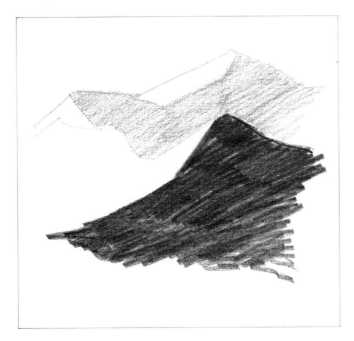

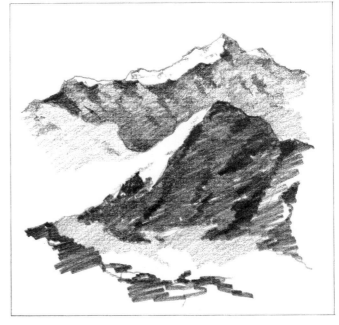

Broken Forms. Nature certainly contains some shapes that are difficult to visualize as basic geometric forms. You have to look carefully at the shape and try to come up with your own simple form that will do the same job as the cube, cylinder, or sphere. In this drawing, study how the artist has simplified some jagged, broken peaks to a few simple shapes.

Mountains. Having drawn a few simple shapes to act as guidelines, the artist then goes back over the lines and converts the basic shapes to real mountains with all their cracks and crags. No matter how complicated a shape may look, it's always best to start with a few simple guidelines—then add the complex details of nature over them.

Broken Forms in Light and Shade. Once you've learned how to visualize complex, irregular shapes as a few simple forms, it's a lot easier to visualize the pattern of light and shade in the same way. Those jagged mountains really have just two big patches of light, one area of pale shadow on the distant peak, and a darker shadow on the near peak.

Mountains in Light and Shade. When the artist adds tone to his realistic line drawing of the mountains, he visualizes these tones as simply as the drawing at left. The shadow sides of these mountains are just two tones: a pale one in the distance and a darker one in the foreground. Into these broad planes of shadow the artist draws additional detail.

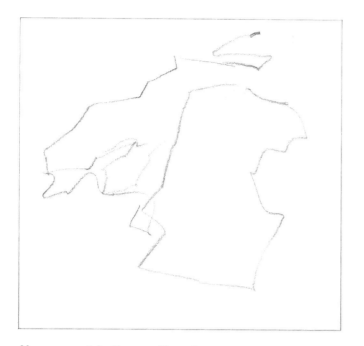

Nongeometric Forms. You often encounter subjects that seem to have no form at all because everything is lost in complex detail. But if you ignore detail and concentrate on the silhouette, you *can* create a simple shape that will help you make a convincing drawing. Here's a mass of foliage translated into a surprisingly simple shape.

Foliage. Having found the simple shape underlying all that detail, you can then convert the shape to a realistic line drawing. The wiggly line is reasonably faithful to the shapes, but also suggests the detail and texture of the foliage: the expressive pencil line moves carefully around the silhouette, suggesting the texture of leaves without drawing a single leaf!

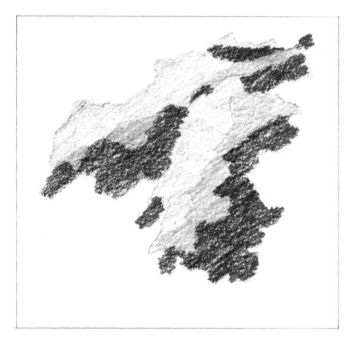

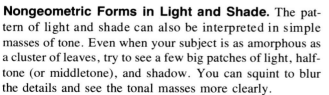

Nongeometric Forms in Light and Shade. The pattern of light and shade can also be interpreted in simple masses of tone. Even when your subject is as amorphous as a cluster of leaves, try to see a few big patches of light, halftone (or middletone), and shadow. You can squint to blur the details and see the tonal masses more clearly.

Foliage in Light and Shade. Keeping those big areas of light, halftone, and shadow fixed in your mind, you can render the foliage realistically but simply. Notice how the artist clusters his strokes so that they, too, become masses of light, halftone, and shadow. Even in a highly detailed drawing, always remember the big, simple shapes.

Step 1. To learn how to draw irregular shapes, it's good practice to start with a pencil drawing of a crumpled paper bag or a towel thrown down in a heap, like this one. At first glance, the folds of the cloth may seem hard to draw, but try to reduce the subject to a few simple shapes and render them with a minimum number of lines. Here, the artist starts out with just three shapes that will guide his drawing. Right now, those shapes look nothing like the rumpled towel, but that doesn't matter. The important thing is to visualize the shapes simply.

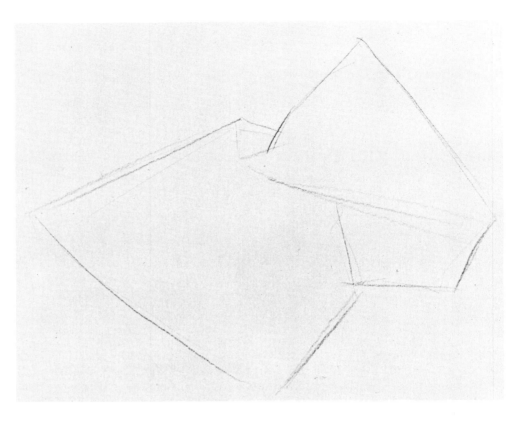

Step 2. Now the sharp point of the pencil moves back over the guidelines of Step 1 to draw the contours of a more realistic towel. Straight lines are converted into curves, additional folds and other details are suggested, and the subject begins to look like a realistic—but simplified—line drawing of a real piece of cloth. You can still see the original guidelines of Step 1. It's best to keep these lines until the drawing is finished: they'll help you keep your eye on the big shapes.

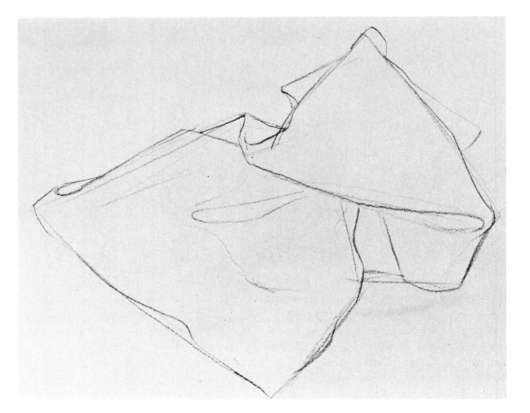

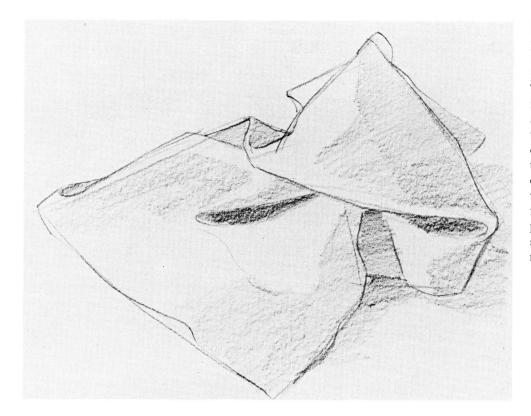

Step 3. Now the side of the pencil moves over the paper and makes broad strokes that suggest the large tonal areas. The artist simplifies the tones into three values: the light areas, which are bare paper; the halftones, which he renders as a pale gray by moving the pencil lightly over the drawing paper; and the darks, which he places in the deep folds, pressing harder on the pencil. He also suggests cast shadows on the tabletop beneath the towel.

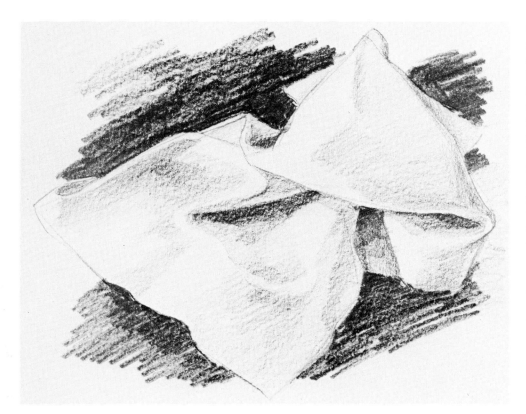

Step 4. The side of the pencil moves back into the halftones and shadows, deepening the tones selectively to make a richer, more realistic pattern of light and shade. Now the folds of the towel look more solid and three-dimensional. The sharp point of the pencil refines some contours here and there. To make the towel really stand up from the dark wood of the tabletop, the side of the pencil scrubs a dark tone around the cloth. The sharp point of a pink rubber eraser removes the guidelines of Step 1. But see how closely the finished drawing follows those original guidelines.

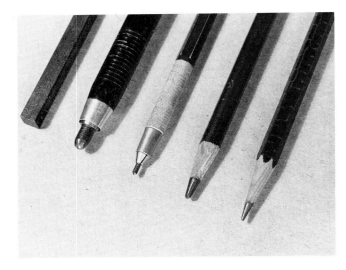

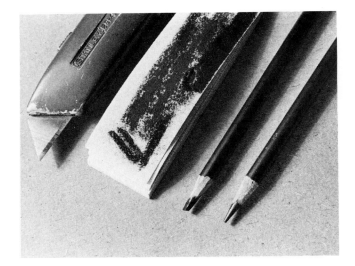

Pencils. The common graphite pencil actually comes in many forms. Looking from right to left, you see the all-purpose HB pencil; a thicker, softer pencil that makes a broader, blacker mark; a metal holder that grips a slender cylindrical lead; a plastic holder that grips a thick lead; and finally, a rectangular stick of graphite that makes a broad, bold mark on the paper. It's worthwhile to buy some pencils *and* two or three different types of holders to see which tools feel most comfortable in your hand.

Knife and Sanding Block. The pencil at the right has been shaped to a point with a mechanical pencil sharpener. The other pencil has been shaped to a broader point with a knife and sandpaper. The knife is used to cut away the wood without eliminating too much of the lead. Then the pencil point is rubbed on sandpaper to create a broad, flat tip. Buy a knife with a retractable blade that's safe to carry. To the right of the knife, you see a sandpaper pad that you can buy in most art-supply stores; it's like a little book, bound at one end, so you can tear off the graphite-coated pages.

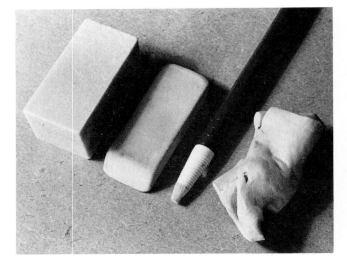

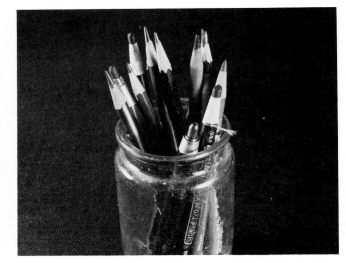

Erasers (Rubbers). Four different erasers are useful for pencil drawing. Looking from right to left, you see a piece of kneaded rubber (putty rubber) that you can squeeze to make any convenient shape; a harder pink rubber eraser in pencil form that get into tight corners; a broader pink rubber eraser, the most useful one for pencil drawing; and a block of soft rubber called a soap eraser, generally used for cleaning margins and areas of bare paper. To use the kneaded rubber, press it against the paper and pull it away. The others are used with a scrubbing motion.

Storing Pencils. If you use your pencils frequently, store them in a jar, points upward, next to your drawing board. Don't just scatter them around. The jar makes it easier to find the particular pencil you want—and the points will be protected. If you have a lot more pencils—and you don't use them every day—keep them in a drawer, either in shallow boxes or in the compartments of one of those plastic containers used for storing silverware.

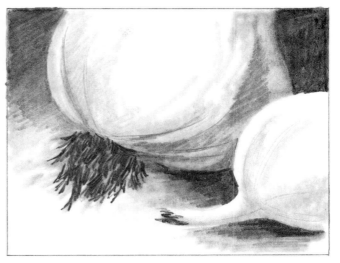

Lines and Strokes. The most common pencil-drawing method is to draw slender lines around the contours of your subject, using more lines to build up some tones, and building other tones with broad strokes. In this close-up detail of a larger drawing, you can see how the artist uses multiple lines to render the delicate tones and textures on the rounded shapes of the onions. The slender lines are made with the tip of a sharp HB pencil. Then the artist picks up a softer, darker 2B pencil, shaped to a flatter point, and renders the background tones with broader, darker strokes.

Blending. Pencil strokes are easy to smudge with your fingertip or with a tool called a stomp—a paper cylinder that you can buy in art-supply stores. Working with the same two pencils that he used in the drawing at the left, the artist lays-in his tones with free strokes; then he goes over these strokes with his fingertip (or with a stomp) to blend the strokes into soft tones. The dark tones around the onions are then reinforced with broad strokes of the softer, darker 2B pencil. The sharp tip of the HB pencil draws the roots of the big onion.

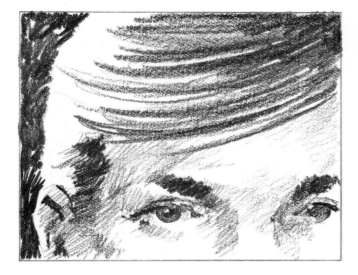

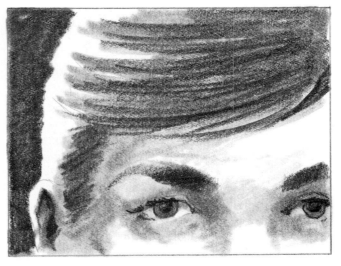

Lines and Strokes on Rough Paper. The texture of the drawing paper makes a big difference. A sheet of rough paper has what's called a *tooth*—a texture that breaks up the lines and strokes, making them look more ragged. This close-up section of a portrait is drawn entirely with a 2B pencil. The sharp point of the pencil glides lightly over the paper, making quick, parallel groups of strokes to suggest the delicate shadows on the face. Then the artist uses the side of the lead and presses harder to create the darks of the eyes, hair, and background.

Blending on Rough Paper. To create softer, smoother tones, the artist first draws the delicate shadows on the face with strokes of the 2B pencil—and then he blends them with his fingertip. The strokes merge softly into one another. The dark background is also blended. The artist exploits the rough texture of the paper to draw the hair and eyebrows with ragged strokes. The blended areas on the rough paper are livelier and more irregular than the smudged areas on the onions, which are drawn on smoother paper.

Step 1. The best way to practice all that you've learned so far is to set up a complete still life of objects from your kitchen. Find a variety of geometric shapes: cubical objects, such as cardboard boxes; cylindrical forms, such as glasses and jars; rounded shapes, such as apples and other pieces of fruit; and irregular shapes, such as leafy vegetables. The first step is to draw all these objects as simple, geometric shapes. Work with light strokes, using the tip of a sharp HB pencil. Concentrate on proportions and geometric shapes. At this stage, don't worry about making the shapes look like the real subjects.

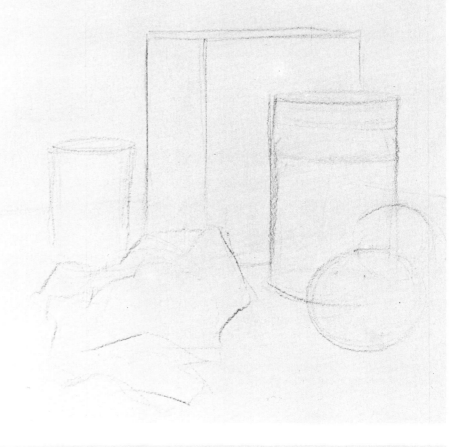

Step 2. Now, working with the point of the same HB pencil, go over the original guidelines to make the shapes look more like boxes, jars, fruit, vegetables, or whatever. Notice how the artist reshapes the apple, flattening some contours and breaking others, since no fruit is ever exactly round. Having drawn the cabbages as a few simple shapes in Step 1, the artist now converts geometric contours into leaves. And the cylindrical jar drawn in Step 1 has now been divided into a body and a lid, which is like a slice of a cylinder.

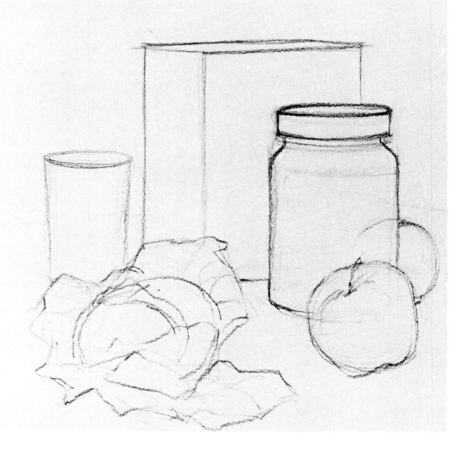

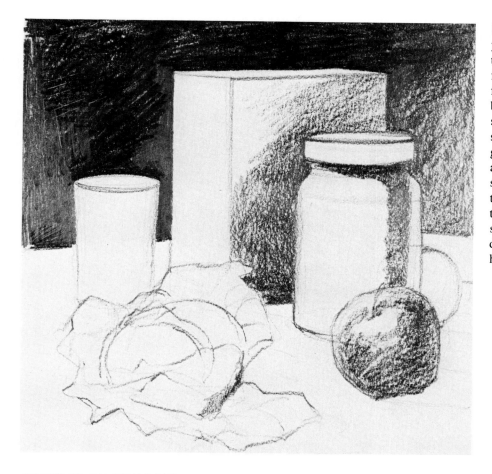

Step 3. This is the stage at which you begin to block in the general distribution of the darks with broad, free strokes. Here, the artist reaches for a softer, darker 3B pencil and blocks in the tones with broad strokes, using the side of the lead. To suggest the darker areas of the background, he presses the lead hard against the paper. He works on a sheet of drawing paper with a distinct texture that breaks up the strokes, so they seem to flow together on the sides of the box, jar, and apple. The darker strokes, where he presses harder, stand out more clearly.

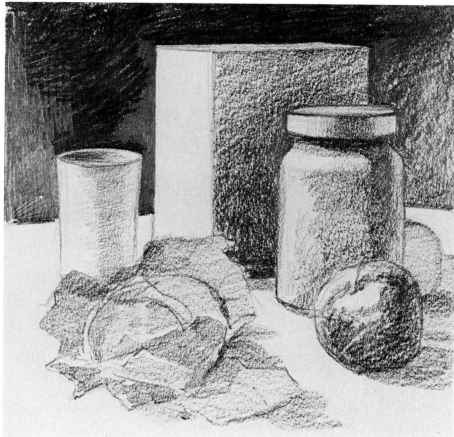

Step 4. The artist continues to cover the shapes with broad, simple tones. At this point, he pays no attention to precise detail, but moves his 3B pencil freely over the paper, visualizing his tones as big patches. Notice how the tones are scrubbed loosely over the complex form of the cabbage—without paying too much attention to the precise contours of the leaves. Now you begin to see *gradations* of tone, such as the light, halftone (or middletone), shadow, and reflected light on the jar and apple. Naturally, the gradation of tone is much softer on the pale surface of the glass.

Step 5. Having established broad patches of tone throughout the drawing, the artist starts strengthening the tones. Pressing harder on the 3B pencil, he darkens the shadows on the jar, apple, and glass. He also looks carefully for the darks on the cabbage leaves and strengthens them selectively. He goes back over the cast shadows on the tabletop. And finally, he begins to strengthen the contours of the leaves, jar, and apple with the sharp point of the HB pencil, with which he also adds the stem of the apple.

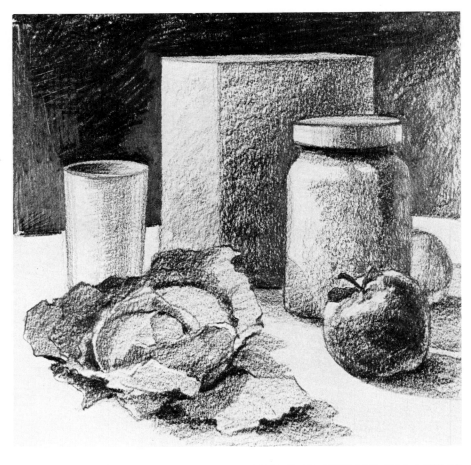

Step 6. The artist continues to build up the tones and contours of the cabbage, which is now more distinct and three-dimensional. The cylindrical shape of the glass is also strengthened with delicate pencil strokes that move vertically from top to bottom; the pencil is used very lightly, suggesting a soft gradation from light to halftone to shadow to reflected light. Notice how a hint of shadow has been added to the lighted plane of the box. The cast shadows under the cabbage are defined more distinctly, so the cabbage really stands up from the table.

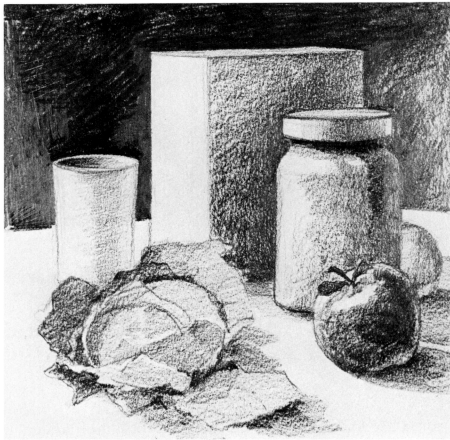

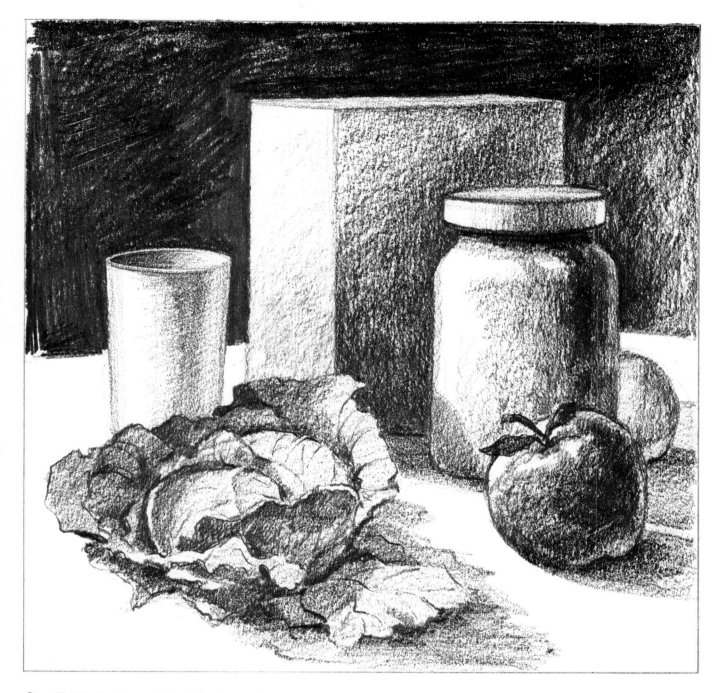

Step 7. This final stage is the right time to deepen tones and add details. Picking up a thick, dark, soft 5B pencil, the artist darkens the background with broad, bold strokes. With this same pencil, he moves back into the shadow areas of the box, jar, and apple; now the gradation of light, halftone, shadow, and reflected light is obvious. The side of a 3B pencil strengthens the tones of the cabbage leaves and deepens the shadows on the glass. The tip of the same pencil moves carefully around the leaves, delineating the edges and adding linear details within them. The sharp point of the HB pencil darkens the edges of the box, jar, and apple in the same way. Notice how the cast shadows are extended and strengthened to make all the objects rest more firmly on the tabletop. To strengthen the lights, a chunk of kneaded rubber is squeezed to a pointed tip which the artist presses down carefully and then pulls away from the patches of light on the apple, jar, box, and glass. A wedge of pink rubber cleans and brightens the lighted areas of the table.

Step 1. A vase of wildflowers will give you a good opportunity to draw a combination of geometric and irregular forms—and also to try out a combination of lines, strokes, and blending. The first step, as always, is a simple line drawing that visualizes the shapes as basic geometric forms—or nongeometric forms that you have to create by observing the subject carefully. Here, the artist visualizes the vase as a cylinder and many of the flowers as circular shapes. The drapery doesn't quite fit any geometric form, so the artist draws a few simple shapes as guidelines. Some of the smaller flowers are also irregular in shape. This preliminary drawing is done with an all-purpose HB pencil, on fairly smooth drawing paper.

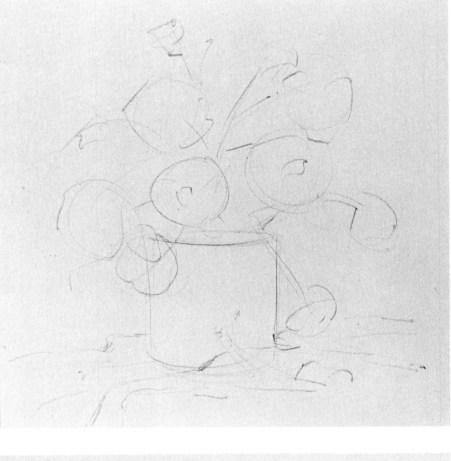

Step 2. Pressing more firmly on the point of the HB pencil, the artist moves over and within the guidelines of Step 1 to draw his subject more realistically. He strengthens the lines of the cylindrical vase and converts the guidelines of the drapery to folds. Within the shapes of the circular flowers, he draws radiating petals and circular centers. The leaves are suggested as jagged, irregular shapes. As the artist defines the shapes of the more irregular flowers, he sees them as resembling broken eggshells. Although the lines are more precise than in Step 1, he still draws with light, casual movements. He doesn't make his lines too tight and wiry.

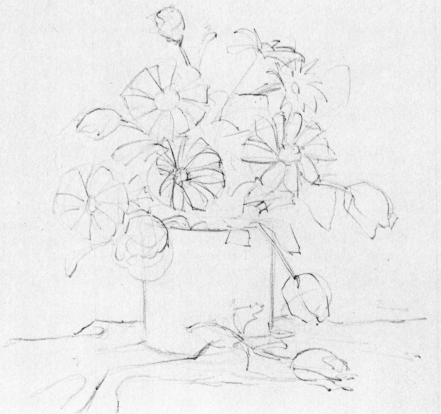

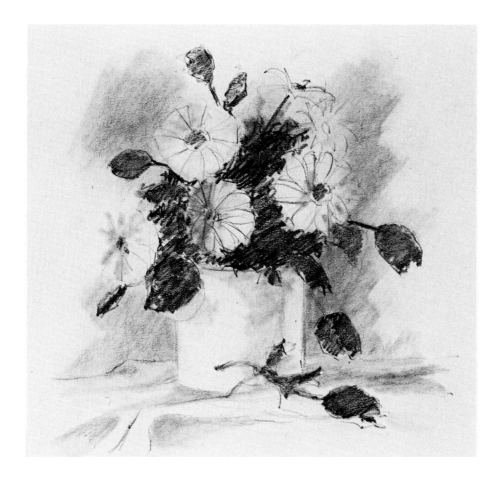

Step 3. To establish the distribution of tones, the artist uses the side of a 3B pencil and scrubs in parallel slanted lines with quick strokes. The dark mass of leaves between the lighter flowers is literally scribbled in with a rapid back-and-forth movement, paying no attention to detail. The egg-shaped flowers are darkened with the same kind of strokes. The side of the pencil moves more lightly over the paper to suggest the shadows on the pale flowers, the vase, the drapery, and the background. To make the pale shadows still softer and more delicate, the artist rubs his fingertip over the strokes and blends them into a more continuous, even tone.

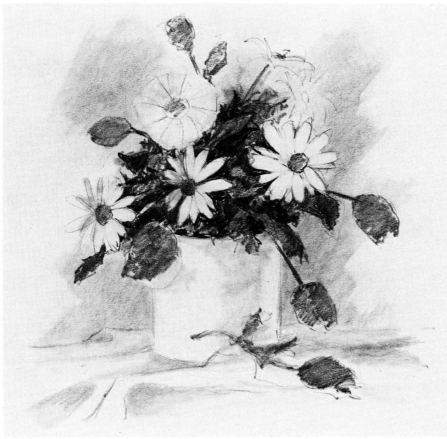

Step 4. Having established the main tonal areas of the drawing, the artist begins to define the smaller shapes more precisely. He extends the dark tones of the leaves into the spaces between the petals of the paler flowers, working with the point of the pencil to get these dark shapes exactly right. He also redraws the edges of some of the petals themselves and begins to suggest individual leaves within the dark mass. The dark centers of the pale flowers are more precisely defined too.

Step 5. The artist continues to strengthen the shapes of the lighter flowers. Now the pale flower at the top becomes more distinct as he extends the shadow tone around the petals and darkens the center. A darker flower is drawn in silhouette at the upper right with loose strokes that don't define the petals too precisely. The tip of a pink eraser (in pencil form) cleans the petals of the pale flowers so they contrast more brightly with the dark, leafy mass behind them. Now the pattern of light and shadow is clearly defined. So are the most important shapes in the picture: the pale flowers. But everything is drawn very broadly. The picture is mostly patches of tone with few distinct lines and very little detail.

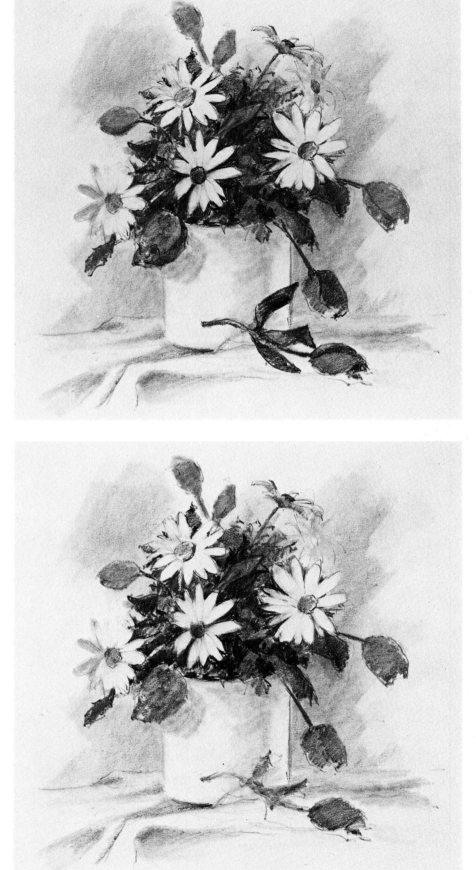

Step 6. At last, the artist begins to sharpen some of the darker shapes. With the point of the HB pencil, he defines the leaves and the dark flowers more distinctly. The dark, jagged shape on the tabletop now becomes a fallen flower with three leaves. He also defines the edges and the stems of the egg-shaped flowers that hang down from the bouquet. Crisp lines also strengthen the petals and the centers of the pale flowers. But the pale flower at the left and the dark ones at the top are still just touches of tone.

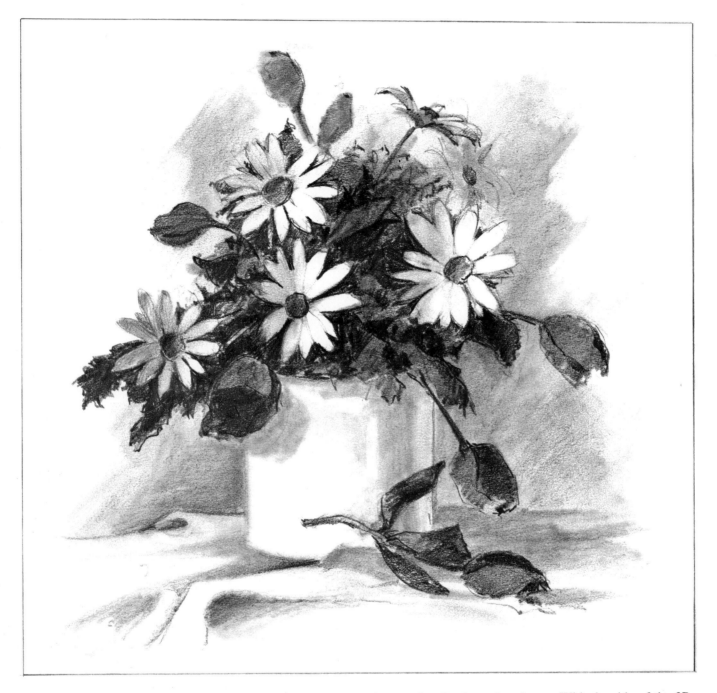

Step 7. Once again, the really precise work is saved for the final stage. A 3B pencil moves into the dark, leafy mass to strengthen the tones, suggest the leaves more distinctly, and darken the edges of the pale petals. The artist blends this dark mass with his fingertip. He uses his graphite-covered finger—like a brush—to carry shadows across the pale flowers. Then the sharp point of a 2B pencil goes over the contours of the flower shapes and strengthens their centers. The dark egg-shaped blossoms also have more distinct edges now, but they're not as clearly drawn as the pale

flowers that dominate the picture. With the side of the 3B pencil, the artist goes over the background tone, the shadows on the vase, and the tones between the folds on the tabletop—and then he blends these tones with a fingertip so the strokes disappear. The wedge-shaped pink eraser brightens the lighted areas of the background, vase, and tabletop. A kneaded rubber eraser is pressed to a point to brighten the lighted petals. And a soap eraser is moved over the outer edges of the drawing to make the bare paper look bright and clean.

Step 1. When you're ready to start drawing outdoors, choose some simple shapes like rocks: solid, geometric shapes with distinct planes of light and shadow. Their shapes are so simple that you can often visualize them with just a few lines—as the artist does here. To draw the bold shapes and rough textures of rocks, the artist has chosen a sheet of rough drawing paper that has a distinct, ragged tooth. His pencils are in the 4B–6B range, with thick, soft leads that make broad, dark strokes. He starts out by visualizing the rocks as a few big, blocky shapes. The distant hills are flattened cones. The base of the rock formation is traced with a zigzag line that curves into the foreground, where the artist suggests more rocks with a few bold lines.

Step 2. Over the guidelines of Step 1, the artist draws the shapes of the rocks more carefully. The three big rocks above the center of the picture, which form the focal point of the drawing, are visualized as cubes with broken sides. The smaller rocks in the immediate foreground also look like fragments of cubes. The big rock formation on the right is drawn as one irregular mass. Within the shapes of the rocks, the artist uses a slightly lighter line to suggest the division between plane in light and shadow. Notice how the patches of foliage above the rocks are drawn as jagged shapes; later they'll be filled with strokes to suggest clumps of weeds.

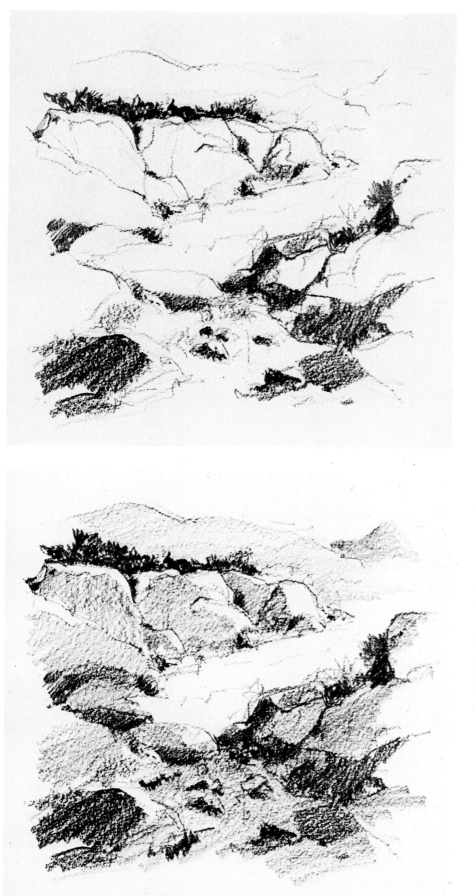

Step 3. Now the artist begins to indicate the strongest darks. With broad, heavy strokes of a thick pencil, he blocks in the dark shadows on the rocks in the immediate foreground; suggests the darkest cracks among the more distant rocks; and scribbles in a dark tone that suggests the texture of the weeds on top of the rocks. Study the foreground shadows and you'll see that the artist pays particular attention to the *shapes* of the shadows—he doesn't just scribble in a lot of dark strokes at random.

Step 4. After blocking in the darkest notes in the picture, the artist covers the lighter shadow areas by passing the pencil gently over the surface of the paper. Now there's a clear distinction between the light and shadow planes of the rock formation in the distance. The entire foreground is covered with a veil of soft shadow too. The distant hills become a soft, smoky silhouette. The sky and the patch of sunlight in the middleground are bare paper. The entire picture is drawn in just three values: a dark gray, a more delicate gray, and the white paper.

Step 5. The artist decides to strengthen the shadow falling across the foreground in order to create a stronger break between shaded and sunlit areas of the picture. Most of the foreground is now darkened with broad strokes. Notice how the rough texture of the paper suggests the rugged surface of the rocks. Moving back to the sunlit rocks, the artist begins to add touches of tone within the shadows to make the rocks look more solid and three-dimensional. The sunlit patch of ground is enlivened by a few dark touches that suggest pebbles. In the same way, pebbles are also suggested in the immediate foreground.

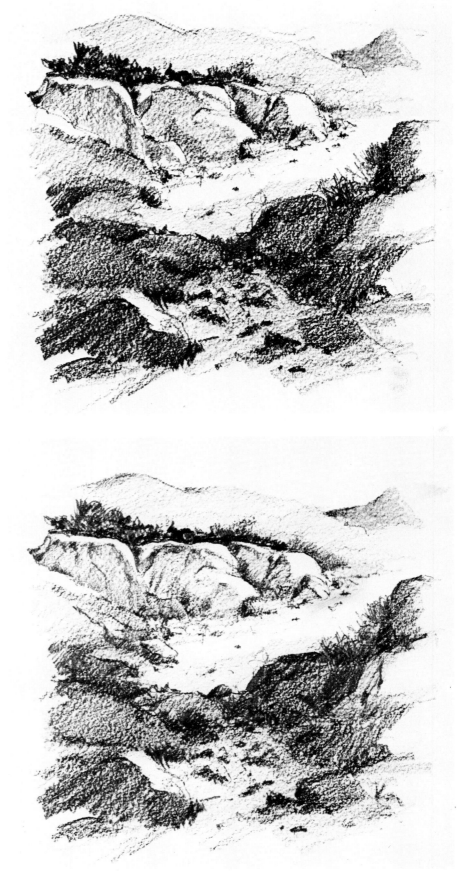

Step 6. The artist continues to develop the distant rocks with lines and touches of tone that suggest cracks and other surface irregularities. Just a few strokes indicate shadows on the sides of the distant hills. Moving into the foreground, the artist begins to add strokes that convert the big patch of shadow into rocky forms. The edges of foreground rocks become more distinct as he carries dark strokes along the contours. He also draws dividing lines between the rocks on the left. Compare the small rock in the lower right with Step 5: by adding a triangle of shadow on the left side, the artist transforms an area of shadow into a blocky boulder half-buried in the soil.

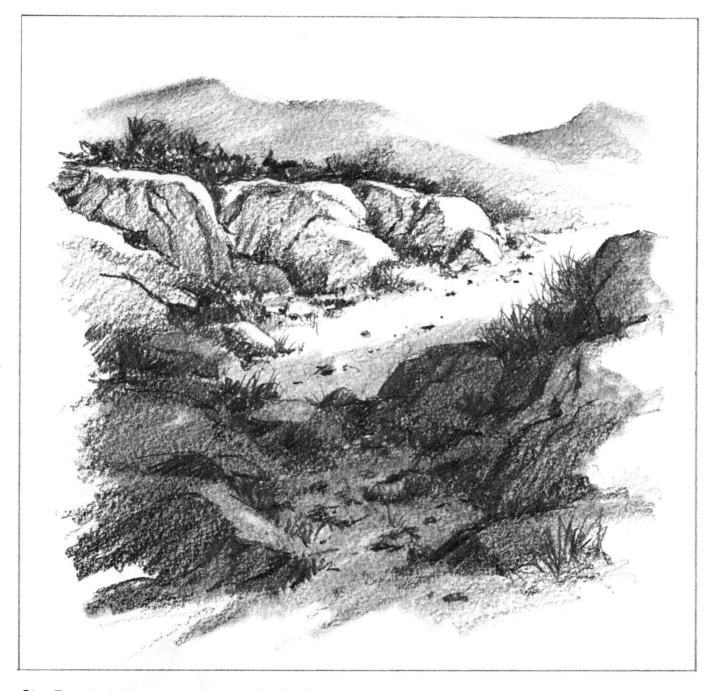

Step 7. In this final stage, the artist moves his thumb over the entire foreground, blending the strokes into a rich, continuous shadow tone. He doesn't rub *too* much—he doen't want the strokes obliterated, just blurred and softened. He does the same thing with the distant hills, blending the strokes into an irregular, smoky tone that still retains some of the rough texture of the paper. The sunlit slope of one hill is erased with a single sweep of kneaded rubber. Now the final step is to strengthen the darks and add crisp lines for details. The grass at the top of the distant rocks is darkened with quick, scribbly strokes. Then the shadow sides of the rocks are darkened, and more cracks are added with the sharp point of the pencil. The sunlit tops of those rocks are cleaned with kneaded rubber, squeezed to a point. Small pencil strokes suggest more grass and pebbles at the base of the sunlit rocks. Moving down into the foreground, the artist darkens the shadows and adds slender, arc-like strokes for weeds and blades of grass. Throughout the finished drawing, the texture of the paper enhances the roughness of the subject.

Step 1. After drawing an "outdoor still life" such as a rock formation, choose a more panoramic landscape subject. In this demonstration, the artist draws a stream winding across a meadow with trees and hills in the distance. He begins with a simple line drawing of the biggest shapes in the picture: the hills that look like flattened cones; the ragged, irregular shape of the mass of trees; and the zigzag contours of the stream. Notice that he draws the shoreline with particular care, paying special attention to the long, horizontal shapes of the land. The grassy foreground is merely suggested with a few wispy lines.

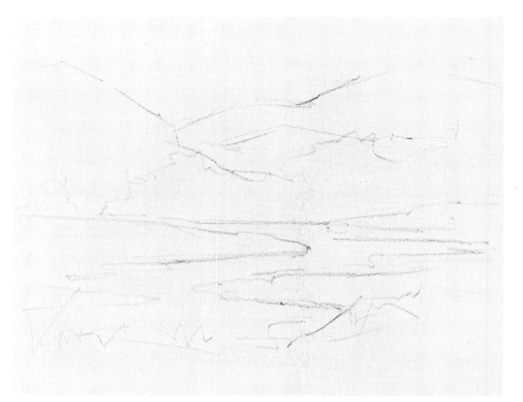

Step 2. Pressing harder on the HB pencil point, the artist goes over the guidelines of Step 1 to draw the forms with greater precision. The hill at left is actually covered with foliage and the strips of land are covered with grass and weeds, so he redraws their contours with wiggly lines. He uses the same kind of line to delineate the mass of trees at the base of the hills. In the immediate foreground, he adds the shapes of some rocks; two of them look like slices of cubes and one is more rounded, like a slice of a sphere. Scribbly lines suggest foreground weeds. He doesn't strengthen the contour of one distant hill, but simply lays a veil of soft tone over it by making vertical strokes with the side of his pencil.

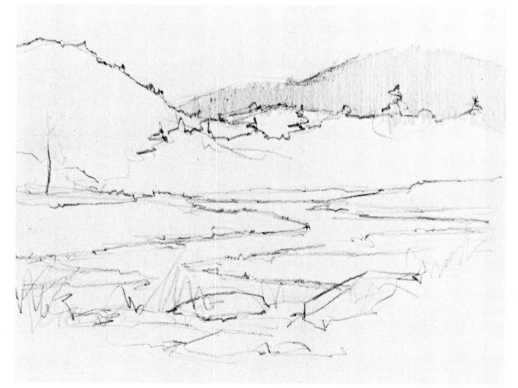

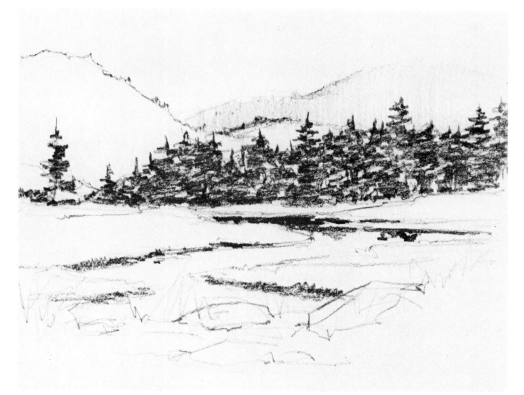

Step 3. Now the artist begins to place his strongest darks on the drawing paper. With the side of the lead of a 3B pencil, he scribbles in the texture of the trees with short, horizontal strokes, then suggests trunks with a few vertical strokes. He indicates the dark reflections of the trees in the stream and traces the dark edges of the shoreline. He also darkens the top of the small hill just above the trees with rough, irregular strokes.

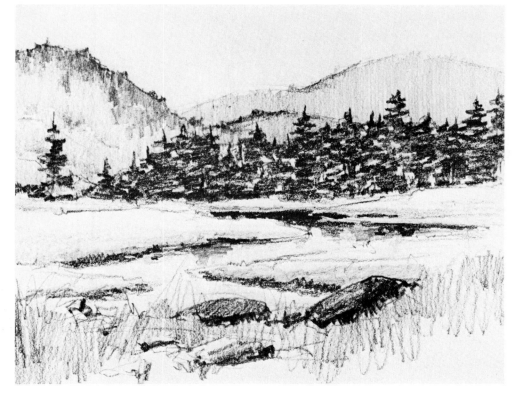

Step 4. Still working with the side of the 3B pencil, the artist adds the strong darks of the rocks in the foreground, making a clear distinction between the lighter tone of the sunlit tops and the darker, shadowy sides. The next step is to add the middletones— the grays that fall between the dark values and the white of the paper. The artist covers the big hill on the left with vertical strokes suggesting the tone and texture of foliage. He begins to indicate some middletones on the patches of land with long, horizontal strokes. And he darkens the foreground with broad, scribbly, vertical strokes that suggest the texture and detail of the grass and weeds. Some lighter reflections are added to the water.

Step 5. Having covered the drawing paper with patches of tone indicating the general distribution of darks, lights, and middletones, the artist now moves back into these areas to strengthen the tones. The big hill at the left is solidified with broad, vertical strokes made with a 3B pencil—with the end of the lead sandpapered to a squarish shape. With this same pencil, he darkens the small hill just behind the trees. The thick lead of a 6B pencil darkens the trees with short, horizontal strokes, and also darkens the foreground rocks and the reflection in the stream. The stream and the surrounding land are darkened with long, horizontal strokes, made by the side of the 3B pencil lead.

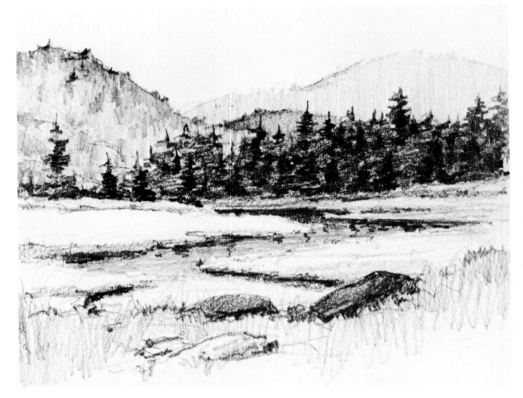

Step 6 (Close-up). Here's a close-up of the final stage in which the artist concentrates on the details of the foreground. The sharp point of the HB pencil reinforces the contours of the rocks and covers the foreground with slender, wispy, curving strokes for grass and weeds. The side of the pencil lead darkens the ground to suggest shadows at the base of the weeds The steam is darkened in the same way. The point of the pencil moves along the shoreline, drawing short, vertical strokes to suggest the grass and then carries the reflections of the grass down in to the water with horizontal and vertical strokes.

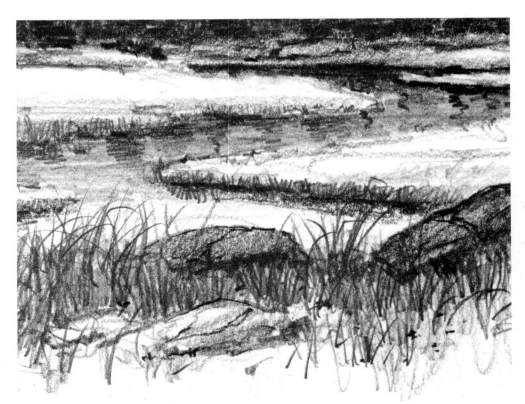

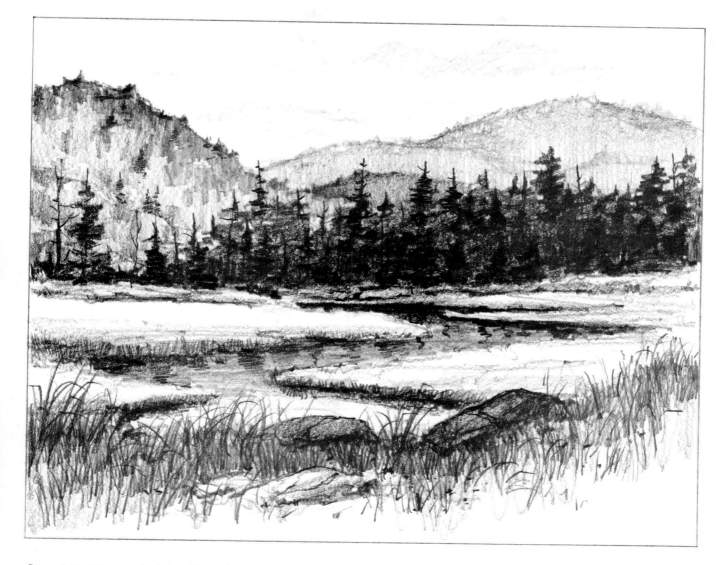

Step 6. In this overall view of Step 6, you can see how all the final details are added. The sharp point of the HB pencil works back into the trees to add some trunks and branches. A single dead tree is added at the extreme left with crisp, dark strokes. Reflections of trees are carried down into the water with dark, wiggly strokes. Soft, scribbly strokes are added to the top of the pale, distant hill to suggest foliage— but the hill is just barely darkened by these strokes, so it still looks far away. Just below the trees, the land is darkened to suggest the shadows of the dark mass of evergreens. The stream is now a dark zigzag in contrast with the sunlit patches of shore. (Notice how the parallel banks of the stream gradually converge as they recede into the distance, obeying the rules of perspective.) The artist suggests blades of grass only along the shoreline, not over the entire meadow; the strokes along the shoreline are just enough to make you imagine the grassy texture of the land. In the same way, the grassy foreground is only partially covered with slender strokes; the artist actually left a lot of bare paper, but he gives you just enough grass and weeds to suggest more detail than he really draws. By now, you've discovered a fairly predictable sequence of operations in these demonstrations. First the artist draws the shapes with simple guidelines. Then he goes over these lines to define the shapes more precisely and make the subject look more realistic. Next he blocks in the darks with broad strokes. Then he also uses broad strokes to block in the middletones. Having established the shapes and the broad pattern of light and shade, the artist goes on to complete the picture by strengthening tones, sharpening contours, and adding details.

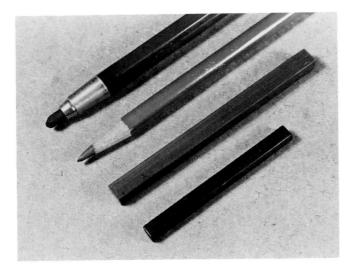

Chalks. Here are four kinds of chalk. Looking from the lower right to the upper left, you see the small, rectangular Conté crayon; a larger rectangular stick of hard pastel; hard pastel in the form of a pencil that's convenient for linear drawing; and a cylindrical stick of chalk in a metal holder. All these drawing tools are relatively inexpensive, so it's a good idea to try each one and see which you like best.

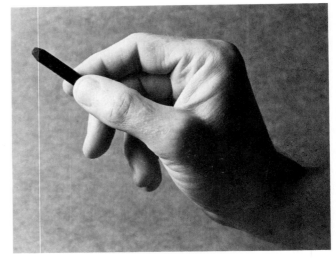

Holding the Chalk. Hold the stick of chalk the way a conductor holds his baton—*not* the way you'd normally hold a pencil. Holding a piece of chalk like a baton encourages you to make big, rhythmic movements that will give your drawing a feeling of boldness and freedom. If you're drawing with a pastel pencil or a stick of chalk in a metal holder, you may find it more comfortable to hold the tool like a pencil; but these tools also feel comfortable in the baton grip.

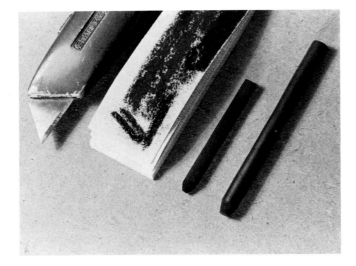

Shaping Chalk. As they come from the art-supply store, the cylindrical stick of chalk (at the extreme right) and the rectangular crayon (just to its left) both have blunt ends. You can shape them with a sharp knife blade or a razor blade, or you can rub them on a sandpaper pad to bring them to a point or a wedge shape. Although it's convenient to buy a sandpaper pad in an art-supply store, you can just as easily use any fine-grain household sandpaper.

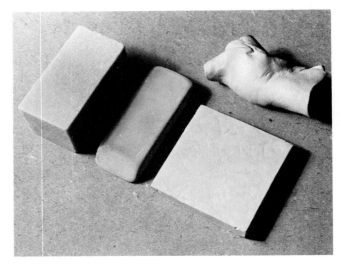

Erasers (Rubbers). For chalk drawing, the most useful eraser is kneaded rubber (putty rubber) that comes in a gray rectangle (lower right) and squeezes like clay to any shape you like (upper right). To lighten a tone or stroke, press down the eraser and lift away. A gentle scrubbing motion should remove the chalk that doesn't come off when you press and lift. If the last bit of chalk still resists the kneaded rubber, you can resort to the harder wedge of pink rubber (center). To clean up patches of bare paper that may turn gray while you're drawing, you can use a blocky soap eraser (left).

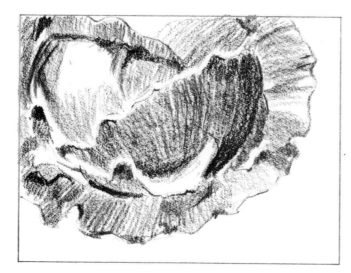

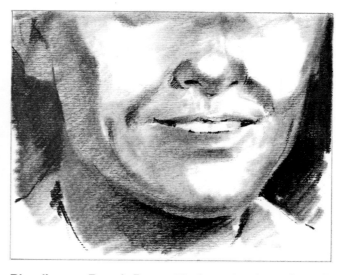

Strokes on Drawing Paper. When you're learning to render light and shade, begin by seeing what strokes look like on ordinary drawing paper (cartridge paper in Britain). A stick of chalk will make a variety of strokes. The blunt end will make broad strokes, while the sharp corner of the chalk will make quite slender lines. You can see both in this drawing of a cabbage. To darken your strokes, you simply press harder on the chalk or go back over the strokes several times. The drawing paper has a slight texture that adds vitality to the chalk mark.

Strokes on Charcoal Paper. Now look at the same subject drawn with broad strokes, made by the blunt end of the chalk on the rougher texture of charcoal paper. Compare this broad-stroke technique with the thinner strokes in the illustration at left. Notice how the distinct, ribbed texture of the charcoal paper roughens and breaks up the strokes to give a bolder effect. Charcoal paper isn't just for charcoal drawing—it works just as well for chalk and even for pencil.

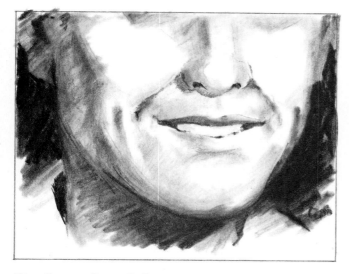

Blending on Smooth Paper. Your fingertip (or a cylindrical paper stomp) will soften and blend chalk strokes to give you more delicate gradations of tone. This illustration is a section of a portrait drawn with Conté crayon on fairly smooth paper. The tones are first roughed in with broad strokes, using the blunt end of the crayon. Then a finger is moved over the strokes, lightly enough to blur them but not heavily enough to eradicate the strokes entirely. The tones grow softer and richer, but the drawing retains the lively, expressive character of the strokes.

Blending on Rough Paper. Hard pastel and pastel pencil blend more softly than Conté crayon. Here, the same head is drawn with hard pastel on rough-textured paper. The tooth of the paper breaks up and softens the strokes, which are then blurred and blended with a fingertip so that they virtually disappear. The finger works like a brush and the chalk responds like paint. The result is soft, continuous tone, with very little trace of the original chalk strokes.

Step 1. For your first experience with chalk drawing, look for an "outdoor still life" subject—something with a big, simple shape that you can draw with bold, expressive strokes. In this demonstration, the artist draws a piece of driftwood on a beach with dark evergreens in the distance. The subject has an irregular, nongeometric shape, which the artist indicates with a few curving guidelines. The distant evergreens at the upper left are also ragged shapes, which the artist suggests with quick, zigzag lines. The curve of the ground beneath the driftwood is indicated with short, curving lines. And the distant horizon is a single horizontal line. These first guidelines are made with the sharp corner of the chalk.

Step 2. In the first step, the artist searches for simple forms that capture the overall design of the subject. In the next step, still working with the sharp corner of the chalk, he studies the subject carefully and goes over the guidelines of Step 1 to record the intricate contours of the actual subject. He presses harder on the chalk so the lines are sharper and darker. Now the subject begins to look like real wood. However, the artist still concentrates on the major shapes and pays no attention to precise details—which he's saving for later.

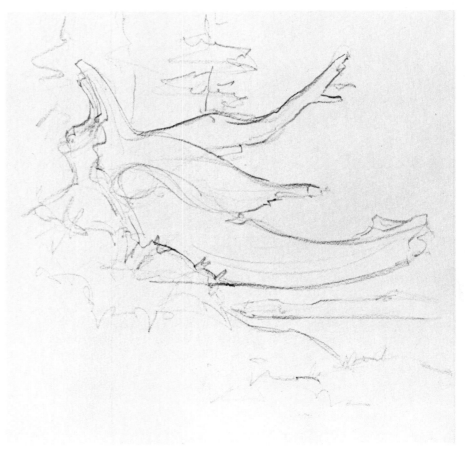

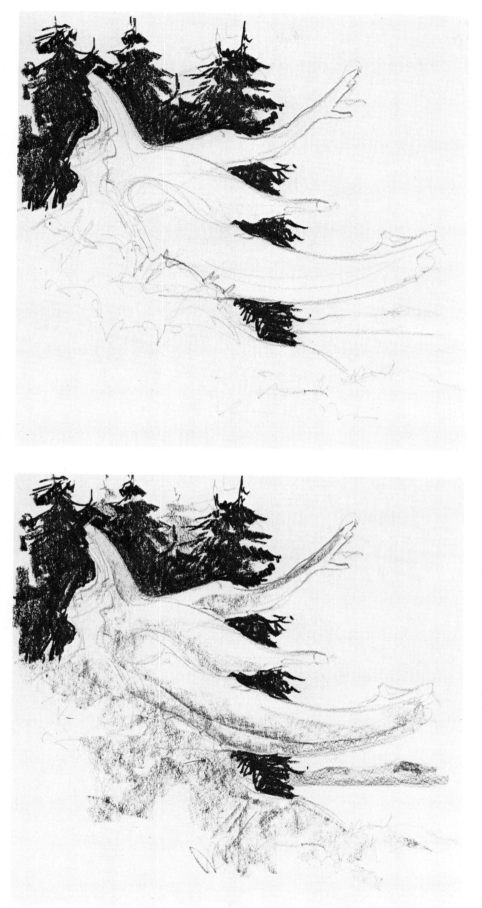

Step 3. The strongest dark notes in the picture are the distant evergreens, and these come next. Working with the blunt end of the chalk and pressing hard against the paper, the artist blocks in the dark tones with short, expressive strokes. Some of the strokes have a scribbly character, while others are short curves—all carefully planned to communicate the rough, spiky character of the evergreen foliage. The sharp corner of the chalk is used for thinner, crisper strokes. The driftwood becomes a bright silhouette against the darkness of the trees.

Step 4. After the darks come the middletones that fall between the strongest darks in the drawing and the areas of paper that will be left pure white. The blunt end of the chalk skates swiftly over the paper in long, curving strokes to render the shadows on the driftwood. The distant shoreline in the lower right is drawn with horizontal strokes. For the rough, irregular shadow tone on the ground beneath the driftwood, the artist takes a broken piece of chalk and places it flat on the paper using the *side* of the stick to make broad strokes.

Step 5. By the end of Step 4, the darks, middletones, and lights have all been identified. In the upper left, you can even see some very distant trees indicated with soft gray strokes. Now the artist begins to strengthen the tones of the driftwood. Pressing harder on the blunt end of the chalk, he deepens the shadows on the wood with long, curving strokes. He models the wood as if it were a group of curving cylinders: there's a distinct gradation of tone from light to half-tone to shadow to reflected light. With scribbly strokes, he begins to suggest the grass beneath the driftwood. He uses the sharp corner of the chalk to strengthen some of the edges of the wood.

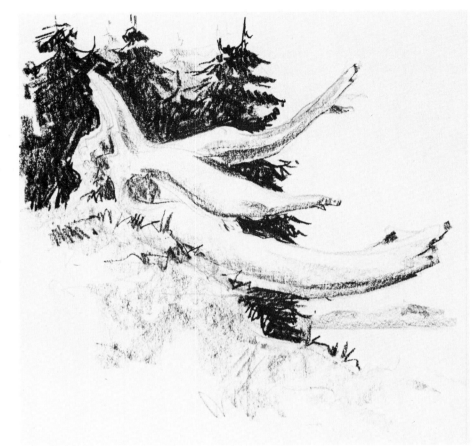

Step 6. To suggest the texture of the driftwood, the artist goes back over the curving shapes with lighter strokes that curve in the same direction as the darker shadow strokes. Now the wood begins to look realistic and three-dimensional, even though it contains virtually no detail. More dark scribbles are added with the corner of the chalk to indicate grass on the ground. And the broken chunk of chalk is used once again to darken the ground with broad strokes.

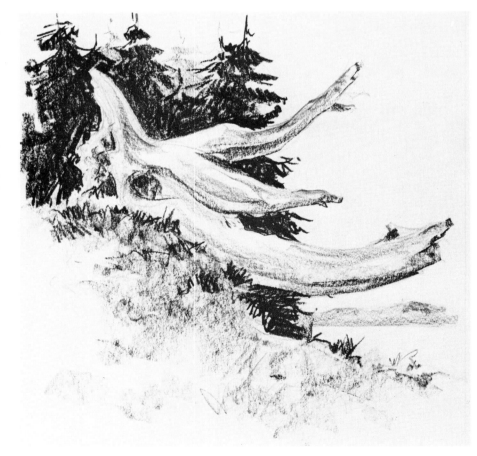

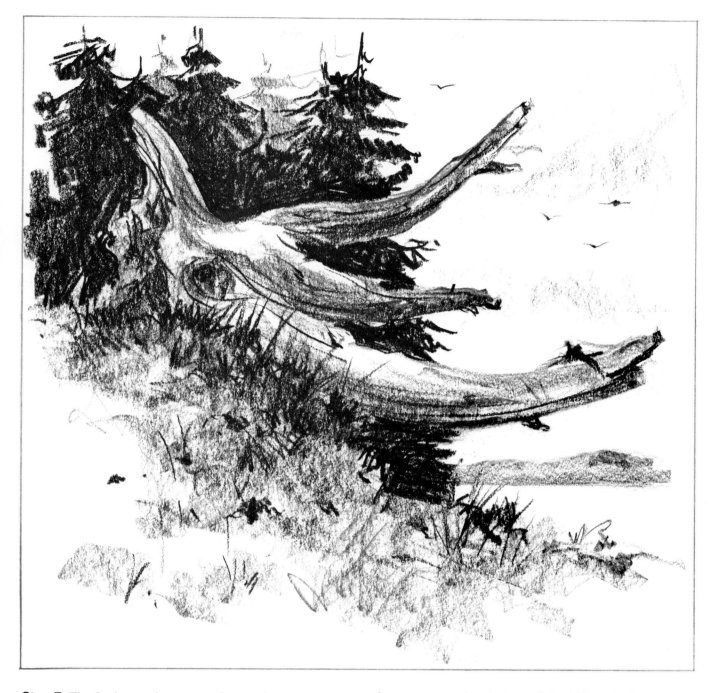

Step 7. The final operations are to deepen the tones, suggest more texture, and add detail. With the blunt end of the chalk, the artist darkens the trees adjacent to the driftwood, accentuating the contrast between the dark trees and the lighter wood. Broad, curving strokes darken the shadows on the wood itself, making the forms look rounder and more solid. The sharp corner of the chalk then draws crisp dark lines over the wood to suggest cracks and other broken textures. The artist draws sharp, slender lines to indicate blades of grass overgrowing the base of the driftwood. The broken chunk of chalk is placed on its side once again and moves with quick back-and-forth strokes to darken the ground. The same piece of chalk is moved lightly over the sky to indicate a few indistinct clouds. And the corner of the chalk draws gulls in the sky—with just two curving strokes for each gull. The patches of light on the driftwood are cleaned and brightened with kneaded rubber, which also brightens the bare parts of the sky and ground.

Step 1. Rendering a massive shape like a cliff is a good opportunity to try out a chalk-drawing technique that relies on broad strokes. In this first stage, the artist sketches the shapes of the cliff, rocks, and shoreline with the sharp corner of a stick of hard pastel. In drawing the near cliffs, the artist simply indicates their outline, paying no attention to the internal detail of the rock formation, which will come later. He handles the distant rocks in the same way. The shoreline is simply a quick zigzag. However, the rock in the foreground is distinctly blocky: lines suggest the top and two side planes.

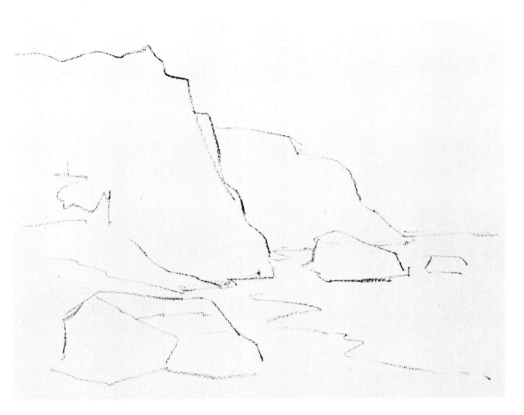

Step 2. The artist wants to make sure that the more distant cliff really seems far away, so he begins with the soft tone of this shape. He picks up a small piece of chalk—either a broken chunk or a stub that's been worn down—and rubs the side of the chalk lightly over the cliff, depositing a thin layer of tone. He then blurs this tone with his fingertip, carefully staying inside the lines he drew in Step 1. Coated with chalk, his fingertip can be used like a brush, so he does this to suggest the tone of the distant sea, making a single horizontal stroke with his fingertip and depositing a soft veil of tone at the horizon.

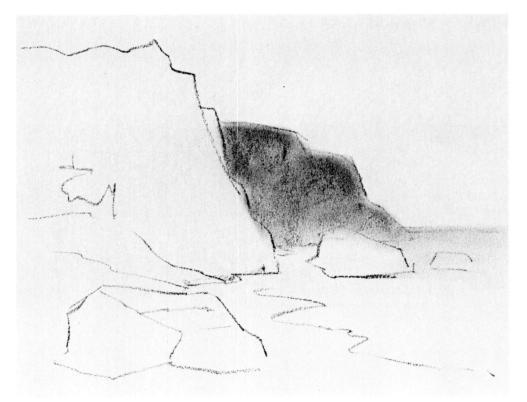

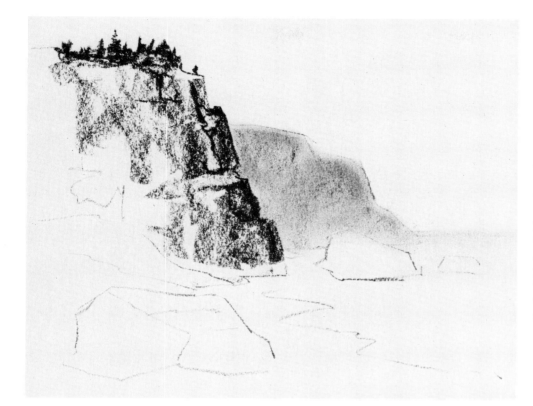

Step 3. Still working with the side of the short piece of chalk, the artist begins to draw the near cliff with broad strokes. (He's working on rough-textured drawing paper that breaks up the strokes of the chalk, suggesting the granular texture of the rocks.) At the edge of the cliff, the artist changes his grip on the chalk and works with the squarish end of the stick, pressing harder to make darker, more precise strokes. At the top of the cliff, he presses hard on the corner of the chalk to make short, irregular strokes that suggest trees silhouetted against the sky.

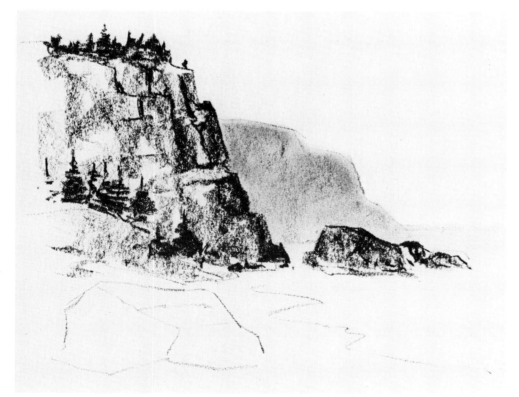

Step 4. Again working with the flat side of the short piece of chalk, the artist moves to the left, continuing to block in the rocky slope with broad strokes. In the same way, he blocks in the dark shapes of the rock formation in the water at the foot of the cliff. The sharp corner of the chalk is pressed hard against the paper to delineate the big, shadowy cracks in the side of the cliff, and to suggest the evergreens farther down. Notice how the trunks of the evergreens are drawn with vertical strokes, while the foliage is drawn with horizontal ones.

Step 5. Moving into the immediate foreground, the artist follows the same procedure in drawing the big rock on the lower left. He begins by drawing the tones with the side of the chalk, then shifts to the sharp corner to reinforce the outlines and draw the cracks. In all these rocky areas, he leaves patches of bare paper between the strokes to suggest the play of light and shade. Turning the chalk on its side once again and pressing very lightly against the paper, he moves his drawing tool gently along the edge of the shore, following the guideline he drew in Step 1. Now the edge of beach becomes a soft tone, while the water remains bare paper.

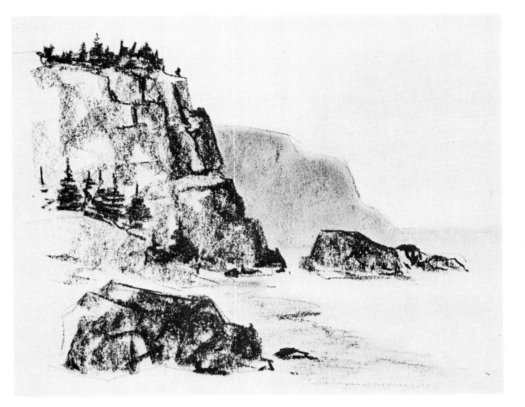

Step 6 (Close-up). Here's a life-size section of the finished drawing. You can see that the artist goes back to work on the dark cliff once again, working with the side of the chalk to deepen the tone, and pressing particularly hard on the sharp end of the chalk to strengthen the shadowy edge of the cliff and the dark cracks. He also darkens the distant cliff just a bit and blends the tone with his fingertip. He adds more horizontal strokes to darken the foliage of the evergreens at the lower left.

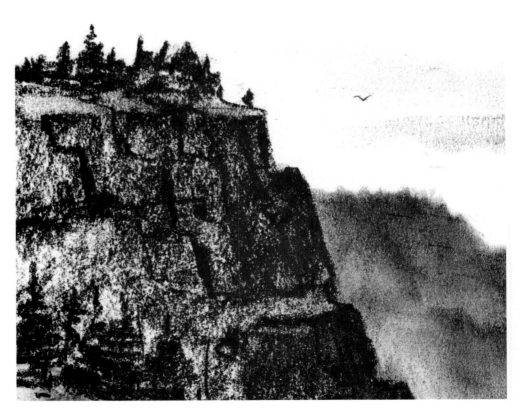

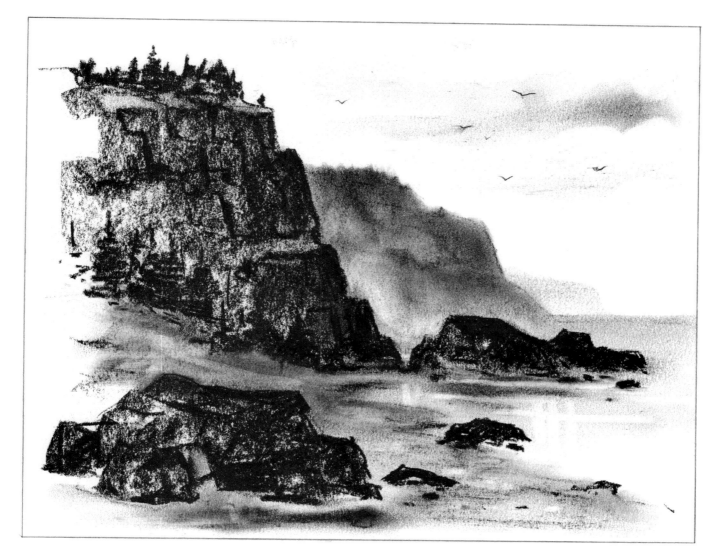

Step 6. Here's an overall view of the completed drawing. The artist darkens the big rock formation at the lower left by pressing hard on the side of the chalk, then strengthens the edges and the cracks with dark strokes, using the sharp corner of the stick. He strengthens the form of the low rock formation in the water—at the foot of the dark cliff—in the same way. Small rocks of various sizes are added to the shoreline with dark strokes. He moves the side of the chalk along the beach once again to strengthen the tone, then blends this tone with a fingertip. Thus, the rough, granular texture of the rocks contrasts nicely with the softer, smoother texture of the sand. While his fingertip is still coated with black chalk, the artist uses his finger like a brush to place a soft tone over the water. He also uses his blackened fingertip to suggest clouds in the sky with a few dark smudges, and to indicate a small, pale, very remote headland just above the horizon at the right-hand side of the picture. Notice how a dark smudge of chalk beneath the low

rocks in the water suggests a reflection; the same thing happens beneath the big rock formation at the lower left, where a smudge suggests a reflection in the wet sand. The sharp corner of the chalk draws a few gulls in the sky—one curving stroke for each wing. A wad of kneaded rubber is squeezed to a sharp point to pick out a few bright lines in the water. Then the kneaded rubber is squeezed to a blunt shape and used for cleaning the bare areas of the sky and water: the rubber is carefully pressed down and pulled away to lift any gray traces of chalk that might have been left by the side of the artist's hand as he worked on the drawing. In this landscape, the artist has reversed the usual sequence of operations by starting with the pale tones in the distance, moving to darker tones in the middleground, and then concentrating on the darkest tones in the foreground. He does this to ensure that the drawing has the proper sense of distance, which depends upon strong contrast between the pale and dark shapes.

Step 1. Chalk is a wonderful medium for drawing portraits because the strokes can be smudged so easily to create rich, soft flesh tones. It's best to start with a simple line drawing that visualizes the head as an egg. The artist draws the egg tilted slightly, since the head is leaning forward a bit. He adjusts the shape of the egg so that it comes closer to the actual form of the sitter's head. The lines of the forehead and jaw are flattened on the left. On the right, the side of the egg is extended to suggest the curve of the jaw. The upper half of the egg is also extended at the right to suggest the back of the head. And the top of the head is flattened to conform to the shape of the hair. Next the artist draws guidelines for the features. A vertical center line is crossed by horizontal guidelines for the eyes, nose, mouth, and lower lip. The eyes are halfway down from the top of the head; the underside of the nose is midway between the eyes and chin; the line between the lips is one-third of the distance down from the nose to the chin, while the lower lip is midway between nose and chin.

Step 2. Over the guidelines of Step 1, the artist begins to draw the actual contours of the head with darker lines. (Step 1 is drawn with light touches of the sharp corner of the chalk; slightly stronger pressure is applied to the chalk in Step 2.) The chalk moves around the contours of the face, tracing the curves of the forehead, brow, cheek, jaw, and chin. The artist draws the hair as a big, curving shape. He adds the line of the back of the neck and then lightly suggests the edge of the collar that encloses the neck. Turning to the features, he places the eyes, the underside of the nose, and the dividing line of the mouth on the guidelines of Step 1. Then he adds the eyebrows, the line of the nose, and the lines that radiate from the corners of the nose along the undersides of the cheeks. Down the side of the face—on your right—he draws a curving line that carefully traces the division between the lighted front plane and the shadowy side plane of the head. This guideline becomes important in the next step.

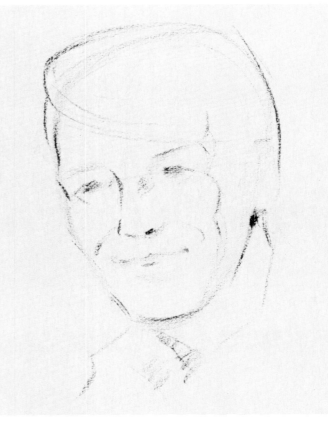

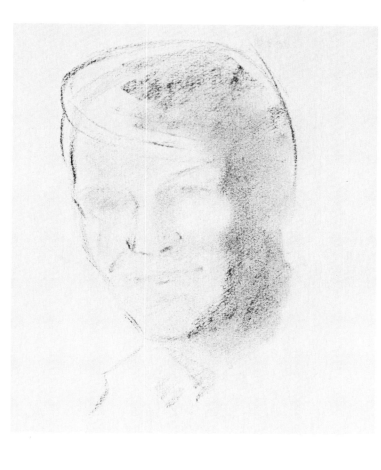

Step 3. Picking up a short piece of chalk that's been broken or worn down, the artist turns the chalk on its flat side to begin blocking in the tone of the hair and the shadow side of the face and neck. Working with broad strokes, he moves the chalk carefully from the hair down to the brow, cheek, jaw, and neck, following the guideline that appears in Step 2. Now, working with the squarish end of the chalk—which will make a narrower stroke than the flat side—the artist begins to suggest the paler tones on the forehead, within the eye sockets, along the side of the nose, beneath the cheeks, under the nose, and on the chin. He blends and softens all the tones on the face with a fingertip. At this point, you can see that he's working on rough-textured paper that breaks up and softens his strokes. Textured papers in general, and charcoal paper in particular, are ideal for drawing portraits in chalk.

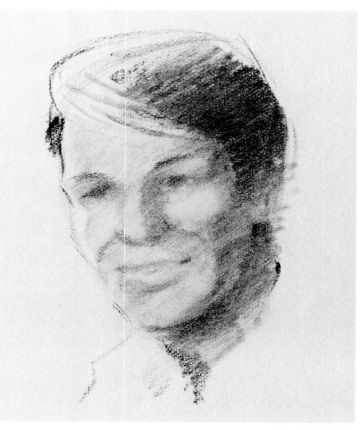

Step 4. Having suggested the general distribution of tones on the head, the artist begins to strengthen these tones with a stick of chalk that's been worn down (or perhaps sandpapered down) to a slightly rounded, blunt end. He darkens the hair with parallel strokes, pressing harder on the chalk for the deeper tones. He continues to work with parallel strokes as he deepens the shadow tones on the side of the face, neck, and nose. (He works freely, and some of these strokes actually go beyond the contour of the face at the right—but these strokes will soon blend into shadow. The end of the chalk darkens the eyes and eyebrows; strengthens the lines of the underside of the nose, cheeks, and mouth; and darkens the lower lip and chin. Once again, a fingertip goes over these strokes to soften and blend the tones. The kneaded rubber eraser is pressed gently against the lighted areas of the cheeks, nose, lips, and jaw to strengthen the contrast between light and shadow.

Step 5. Having established the general distribution of tones in Steps 3 and 4, the artist can now begin to strengthen these tones selectively and start work on the features. Working with the blunt end of the chalk, he thickens the eyebrows, darkens the eyes, and deepens the shadows in the eye sockets. He strengthens the darks that surround the nose, cheeks, mouth, and jaw. He darkens the shadow beneath the chin. And he adds a few lines to define the nostrils. But he still saves the really detailed work for the final stages.

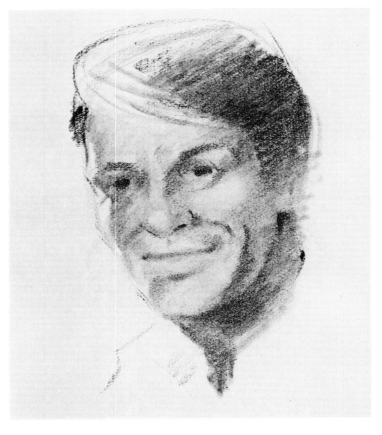

Step 6. At this point, the artist is ready to begin work on the details of the features. With the sharp corner of the chalk, he indicates the shape and texture of the eyebrows, and then he moves down to draw the eyelids with crisp, dark lines. He darkens the pupils and the corners of the eye sockets. The nostrils and the other side of the nose are drawn more distinctly, while dark lines sharpen the lines that radiate from the nostrils along the undersides of the cheeks. The lines of the lips are strengthened too, and the shadow beneath the lower lip is darkened. The inner detail of the ear is suggested, and the contour of the earlobe is strengthened by placing a shadow beneath it at the corner of the jaw. The chalk strengthens that important edge where the lighted front plane of the face meets the shadowy side plane. The hair is darkened with horizontal, scribbly strokes. And the artist begins to darken the neck with scribbly strokes that he'll blend and soften in the final stage.

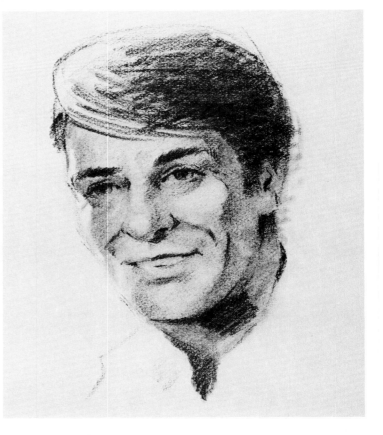

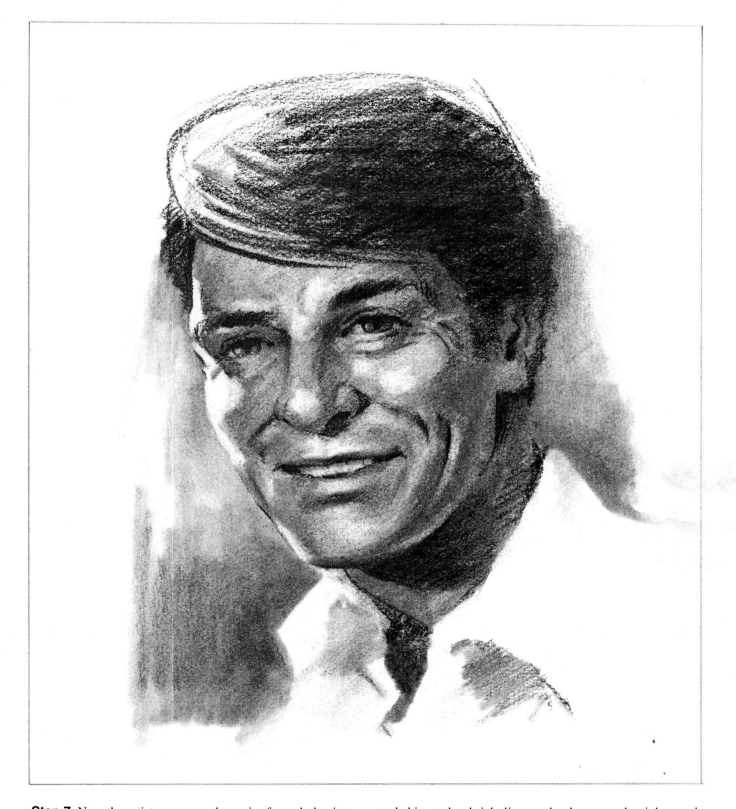

Step 7. Now the artist goes over the entire face, darkening and blending the tones. He darkens and blends the forehead, cheeks, nose, mouth, jaw, and neck. The shadowy side of the face is darkened and blurred into the lighter tones, so they flow smoothly together. The artist presses the kneaded rubber eraser against the brow (just above the bridge of the nose), cheeks, tip of the nose, upper and lower lips, and chin. The eraser wipes away the light lines around the jaw and chin, makes bright lines under the eye at the right—and even lightens the teeth. The sharp corner of the chalk indicates the eyelashes, the wrinkles at the corners of the eyes, the dark corners of the mouth, the lines between the teeth, and the dark crease along the jaw. The artist surrounds the face with broad strokes to form a background tone, which he then blurs with his thumb.

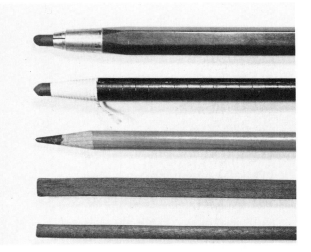

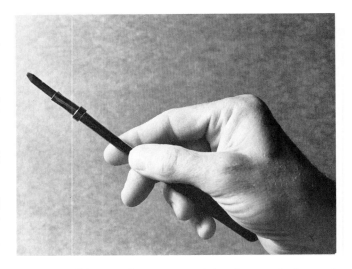

Charcoal. This versatile drawing medium comes in many forms. Looking up from the bottom of this photo, you see a cylindrical stick of natural charcoal; a rectangular stick of the same material; a charcoal pencil; another kind of charcoal pencil—made of paper which you gradually tear away as you wear down the point; and a cylindrical stick of compressed charcoal in a metal holder. The natural charcoal is very crumbly, smudging and erasing easily, so it's good for broad tonal effects. A charcoal pencil—or a cylindrical stick in a holder—is usually better for drawing with firm lines, but it doesn't blend as easily.

Holding Charcoal. When a stick of natural charcoal breaks or wears down to a small piece, you can buy a holder to grip that last fragment. Handle the holder as you'd grip a brush, keeping your fingers far back from the point so you'll draw with bold lines. If you're just working with a stick of natural charcoal—no holder—grip it the same way, but keep your fingers somewhat closer to the tip or the stick will break. When you draw with a charcoal pencil, you can try this same grip or you can hold it the way you handle a pencil to sign your name.

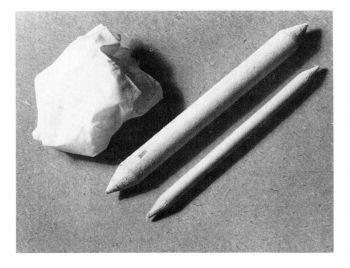

Stomps and Cleansing Tissue. To blend charcoal and push the blended tones into tight corners, you can buy stomps of various sizes in any good art-supply store. A stomp is made of tightly rolled paper with a tapered end and a sharp point. Use the tapered part for blending broad areas and the tip for blending smaller areas. A crumpled cleansing tissue can be used to dust off an unsatisfactory area of a drawing in natural charcoal. (It's harder to dust off the mark of a charcoal pencil.) You can also use the tissue for spreading a soft tone over a large area.

Erasers (Rubbers). Charcoal erases easily, so kneaded rubber (putty rubber) is what every artist uses. Kneaded rubber comes from the art-supply store in a square shape which is then squashed—like clay or putty—to make whatever shape you need. You can make a big, round wad for erasing large areas, or squeeze the eraser to a point to eliminate a small area. You can lift most tones by pressing down the eraser and then pulling it away. Scrub back and forth only when necessary—and rub as lightly as possible—since this action abrades the surface of the paper.

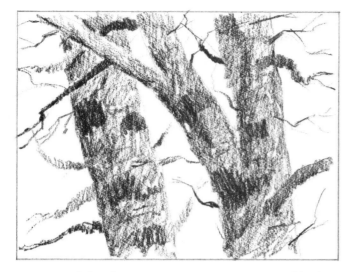

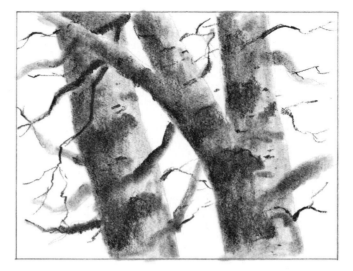

Lines and Strokes. The simplest way to draw with charcoal is to combine slender lines with broader strokes on common drawing paper (cartridge paper in Britain). In this section of a landscape drawing, the thick, blunt end of a medium charcoal pencil is scribbled back and forth to render the tones of the tree trunks. The artist presses harder to make the darker tones on the trunks. Then he switches to the sharp, slender point of a hard charcoal pencil to draw the branches and twigs with more precise lines.

Lines and Tones. To produce soft, blurry tones—like blended oil paint—the artist again works with medium and hard charcoal pencils, then blends the tones with a stomp. First he draws the lighter tones of the tree trunks and blends his strokes with the stomp. Then he draws the darker patches and blends them again. The thicker branches are also blended with the point of the stomp, but the narrow twigs are drawn with charcoal-pencil lines and left untouched by the stomp. It's important to know when to stop blending—or your drawing will look mushy.

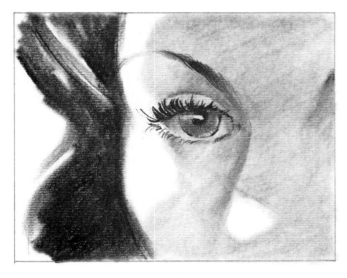

Charcoal Paper. Made specifically for charcoal drawing—but equally good for chalk and pencil—charcoal paper has a slightly ribbed surface that's extremely tough. The surface is lovely for blending soft flesh tones, as you can see in this section of a portrait. You can also do lots of erasing without damaging the paper, as shown in the lighted areas of the face. The surface is equally fine for broad strokes like the hair and precise lines like the eyes in the picture.

Rough Paper. Rough-textured papers—with even more tooth than charcoal paper—are also fine for charcoal drawing. These irregular surfaces make blended areas more lively; notice the pebbly texture of the shadow on the skin. Broad strokes, like the hair, look even bolder on this kind of paper. And sharp lines—like the eyelashes and the eyebrow—look rough and vital.

Step 1. Charcoal is excellent for drawing with bold strokes that express the rugged textures of outdoor subjects, such as foliage, tree trunks, grass, and rocks. This "outdoor still life" includes all these elements. The artist begins by drawing the forms very simply with the sharpened point of a hard charcoal pencil. He doesn't press too hard on the pencil, but lets the point glide lightly over the drawing paper, tracing the contours with relaxed, casual strokes. He concentrates on the silhouette of the fallen tree trunk, and draws the distant evergreen as a jagged shape without detail. In drawing the foreground rocks, he keeps in mind their blocky character and indicates the planes of light and shadow.

Step 2. Pressing harder on the pencil and drawing more carefully, the artist follows the guidelines of Step 1 to define the exact contours of the tree trunk and the rocks. He suggests only a few details, such as the big cracks in the trunk, plus some small branches and twigs. Along the bottom edge of the trunk, a zigzag line suggests the grass that overlaps the wood. The same kind of line suggests the grassy bases of the rocks at the lower left. He does no further work on the outline of the distant evergreen because the original guidelines will disappear in the next step.

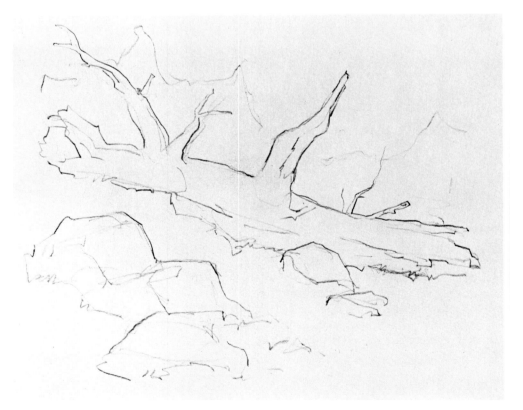

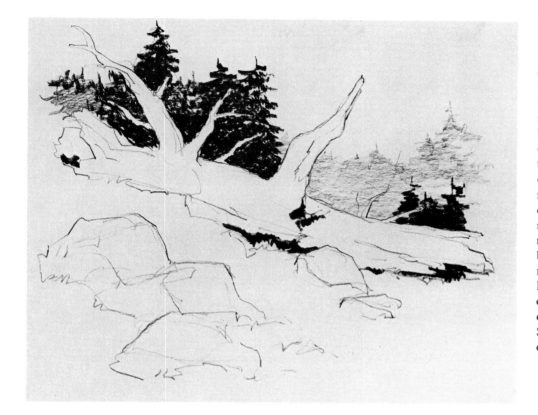

Step 3. Now the artist begins to block in large masses of tone. He starts with the darkest notes in the picture: the clumps of evergreens, plus the few touches of deep shadow on the tree trunk and beneath it. He uses a soft charcoal pencil—which makes a thick, black mark—and indicates the foliage with short, irregular strokes. The same pencil scribbles patches of shadow on the tree trunk. A medium charcoal pencil blocks in the pale tone of the more distant evergreens with light horizontal strokes that overlap and merge to form a continuous tone. Throughout Step 3, he works with the side of the charcoal-pencil lead.

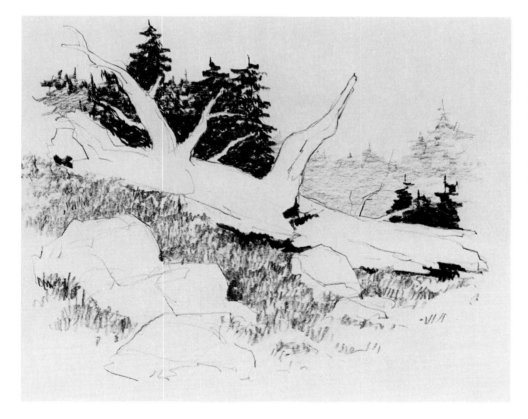

Step 4. Moving into the foreground, the artist suggests the grass with the side of the medium charcoal pencil. The texture of the grass is indicated with scribbly up-and-down strokes. Between the strokes, there are lots of empty spaces to suggest the play of light and shade on the grass. These scribbles overlap the lower edge of the tree trunk and the rocks at the left, where the contours of the solid shapes disappear among the foliage.

Step 5. Until now, the trunk has remained bare paper, but the artist is ready to begin work on the shape of the trunk itself. Visualizing the trunk as a ragged cylinder, he renders its shadowy underside with long strokes, using the side of the medium charcoal pencil. The strokes move along the length of the trunk, suggesting not only shadow but the texture of the bark. With darker strokes, he blocks in the shadow of the broken branch silhouetted against the sky and places a shadow farther to the left, under the other broken branch. The tree trunk begins to show the gradation of tones we expect to see on a cylinder.

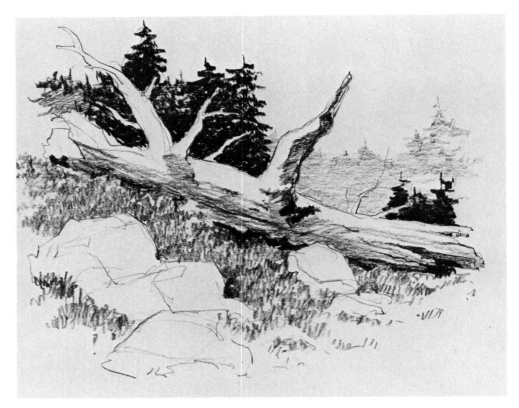

Step 6. Again working with the side of the medium charcoal pencil, the artist blocks in the shadows on the rocks. Now there's a clear distinction between the sunlit top planes and the shadowy sides. The rocks are visualized as broken cubes, and we begin to see the distribution of light and shadow that we would expect on a cube. At the far left, the end of the broken tree is darkened with free strokes that run down the length of the trunk. On the grass, to the right of the foreground rocks, the artist begins to add suggestions of cast shadows.

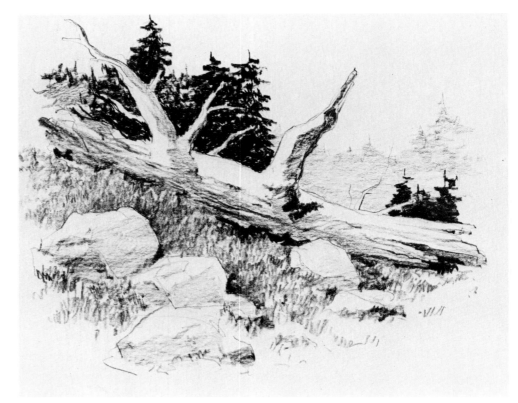

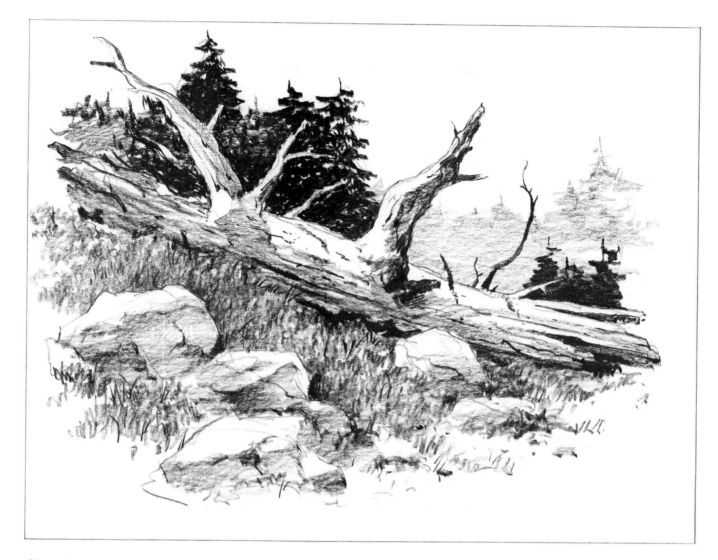

Step 7. Continuing to work on the rocks, the artist strengthens the tones with the side of a medium charcoal pencil. The shadow planes are partly darkened—at the top—and remain lighter farther down, so the shadow contains a hint of reflected light from the distant sky. Moving back into the grass, the artist darkens the tone with another layer of scribbly strokes. The darker grass strengthens the sunlit silhouettes of the rocks. The shadows on the tree trunks are reinforced with additional strokes that re-emphasize the texture of the bark. Finally, working with the sharp point of the hard charcoal pencil, the artist adds crisp lines to suggest detail. Here and there, he draws individual blades of grass in the foreground—but not too many. He draws cracks in the rocks. He moves along the tree trunk, adding more cracks and suggestions of texture. He darkens the contours of the two broken branches silhouetted against the sky—one at the upper left and the other at the center of the picture—and strengthens the shadows. Toward the right, he adds some slender dark branches silhouetted against the pale tone of the distant evergreens; each of these branches casts a slim shadow on the tree trunk. It's important to bear in mind that this entire picture, with its rich variety of tones, is drawn with just three charcoal pencils: hard, medium, and soft. Charcoal smudges so easily that the beginner is tempted to always blend his tones, even when blending isn't suitable for the subject. There are many subjects that are best drawn with a variety of strokes and no smudging at all—like this one.

Step 1. The right landscape subject often gives you an opportunity to combine delicate blending with crisp lines and broad strokes in a charcoal drawing. To demonstrate this combination of techniques, the artist chooses a distant wooded island surrounded by mist and framed by trees in the foreground. He draws the shape of the island as a simple, jagged silhouette, adding a few horizontal lines for the shoreline. Applying just a bit more pressure to his hard charcoal pencil, he draws the trunks and branches of the trees, again concentrating on their silhouettes. A casual, wandering line defines the shape of the ground at the foot of the foreground trees.

Step 2. With Step 1 as a guide, the artist redraws the contours of the trees with firmer, more precise lines. Working with the sharpened point of the hard charcoal pencil, he searches for the small irregularities that lend realism to the trunks and branches. He adds a few rocks to the shape of the land at the bases of the foreground trees. Then he looks more carefully at the shapes on the distant shore and reinforces the guidelines of Step 1 with more exact contours—bearing in mind that these lines will disappear when he begins to apply tones in later steps.

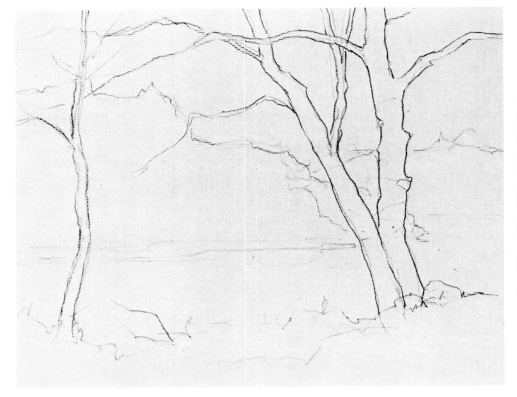

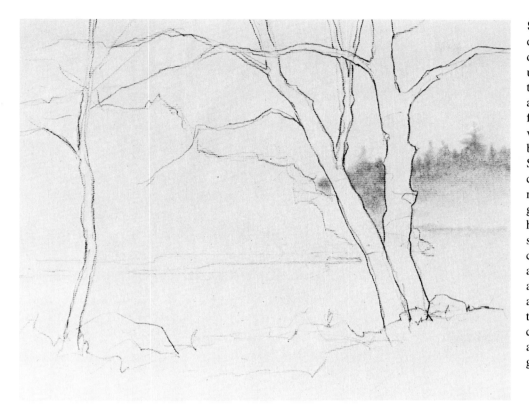

Step 3. It's important for this drawing to have a feeling of deep space, which depends upon strong contrast between the pale shapes in the distance and the dark shapes in the foreground. So the artist reverses the usual process and begins with the palest tones. Switching to a medium charcoal pencil, he indicates the most distant mass of evergreens with light strokes that he smudges carefully with a stomp, using its charcoal-covered tip to draw the trunks and branches silhouetted against the sky. Look closely at this tone and you can see the ribbed texture of the charcoal paper, which is ideal for a drawing in which you're going to do a lot of blending.

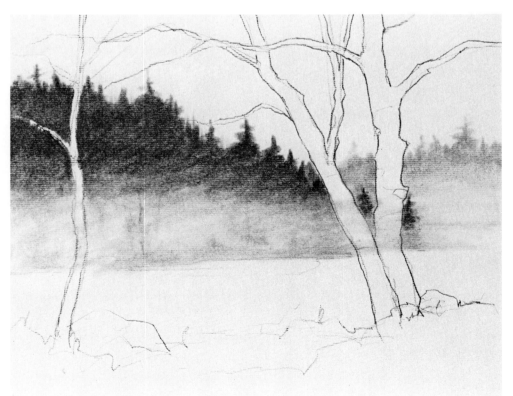

Step 4. Going on to the darker mass of trees on the big island, the artist again uses the side of the medium charcoal pencil to block in his tones. He applies more pressure to the strokes at the top of the mass of evergreens and less pressure toward the bottom, where the island disappears into the mist. He blends the tones with the slanted end of the stomp, again using its charcoal-covered tip to draw the tops of the trees, which are soft and blurred. To lighten the misty lower half of the island, he uses a wad of soft cleansing tissue, which doesn't remove the tone completely but leaves a soft gray veil.

Step 5. Using the sandpaper block to sharpen the point of a soft charcoal pencil, the artist draws the dark trunks and branches of the trees in the immediate foreground. He uses the tip of the stomp to blend the thick trunks and produce a solid, dark tone but carefully avoids blurring their edges, which he reinforces with the tip of the pencil. At the top of the picture, some of the slender branches are drawn with the pencil point and some with the blackened tip of the stomp.

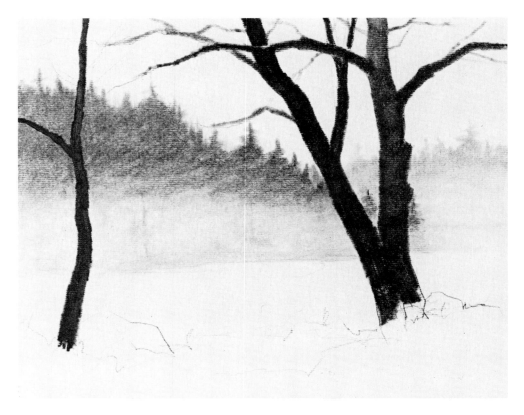

Step 6. The broad side of the thick, soft charcoal pencil blocks in the dark tone of the immediate foreground with heavy, ragged strokes. The sharpened end of the pencil strengthens the contours of the rocks and adds a few dark strokes to suggest blades of grass silhouetted against the pale tone of the water—which is still just bare paper. The artist uses his fingertip to blend the foreground tones *slightly*, but stops rubbing before he eradicates the important strokes suggesting the texture of the ground.

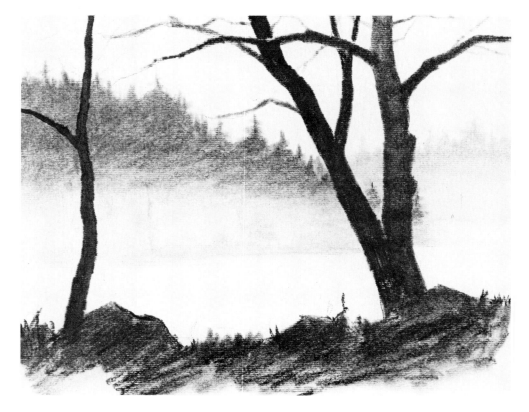

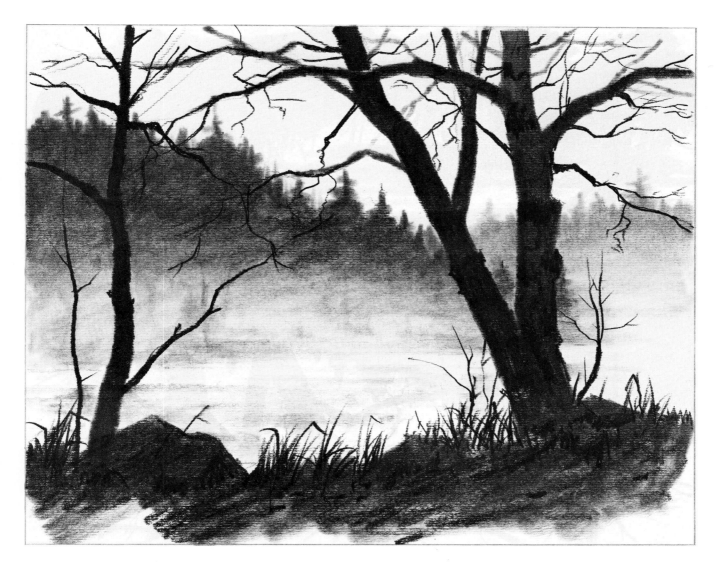

Step 7. To darken the upper section of the misty, wooded island, the artist goes back over the area with the side of the soft charcoal pencil and then blends his strokes with the slanted side of the stomp. He also uses the stomp to create soft gradations from dark to light where the lower half of the island disappears into the mist. And he uses the sharp, blackened tip of the stomp to redraw the silhouettes of the individual trees at the top of the island. He carries a few horizontal strokes across the water and softly blends these with a fingertip, moving in the same direction. Then he sharpens a medium charcoal pencil to reinforce the dark shapes of the tree trunks and add dark branches. To add the slender twigs, the medium pencil draws crisp strokes across the top of the picture. The medium pencil also draws the dark blades of grass silhouetted against the pale tone of the water. Look closely at the dark tree trunks on your right and you'll see that the sharpened end of the soft charcoal pencil has scribbled some textural detail into them. Like so many successful landscapes, this is a picture in four values: the white paper of the sky and water, the pale gray of the distant evergreens on the right, the darker gray of the bigger wooded island, and the blackish tone of the trees and grass in the foreground. And this is a particularly good example of how you can combine soft, blended tones with crisp lines.

Step 1. Charcoal is an excellent portrait medium because it smudges as easily as oil paint—and so you can get soft, velvety flesh tones and beautiful gradations from light to shadow. If you like to do lots of blending, a portrait head is the perfect subject. Once again, the artist begins with the classic egg shape. He draws a vertical center line—slightly curved—to help him locate the features. Then he draws horizontal guidelines to locate the eyes halfway down the head, the nose halfway between the eyes and chin, the mouth one-third down from the nose to the chin, and the lower lip midway between the nose and chin.

Step 2. The natural charcoal blends *and* erases so easily that the artist can try a surprising technique. With a stick of soft, natural charcoal, he draws a light tone over the entire face and blends this tone with his thumb. The face is covered with a pale gray tone—still preserving a hint of the original guidelines—which he can lighten with kneaded rubber and darken with additional strokes as he goes along. He blocks in the darks of the hair and the shadow on the neck, blending these slightly with his finger. You can see the texture of the rough drawing paper, which breaks up and enlivens the blended tones.

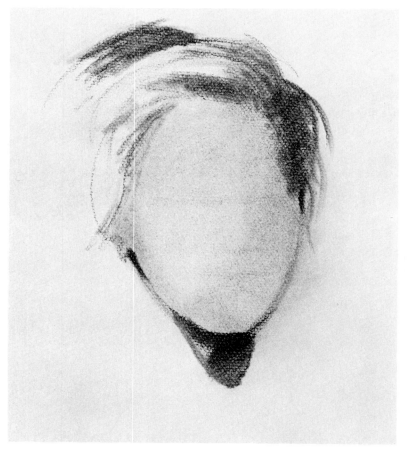

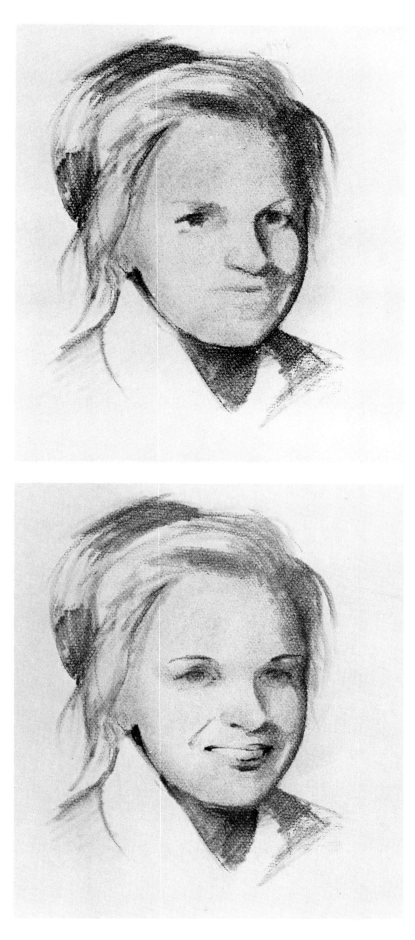

Step 3. Sharpening his stick of natural charcoal on a sandpaper block, the artist blocks in the tones of the eyes, nose, and mouth, paying particular attention to the curving shapes of the shadows on the cheek at the right. He blends these tones carefully with a fingertip. Then he extends the shape of the hair with dark strokes, suggests a few hanging curls with curving strokes on the left, and indicates the shoulders.

Step 4. Having blocked in the major tonal areas, the artist begins to strengthen the contours of the features with the sharpened end of the charcoal stick. He indicates the lines of the eyebrows, eyes, nostril and lips. But he keeps these lines pale and tentative. At this point, all the tones remain soft, and detail is still kept to a minimum.

Step 5. The artist begins to strengthen the tones on the face and hair, and starts to define the features with darker strokes. He carries some dark strands of hair down the shadow side of the face, and then he softens the strokes of the charcoal stick with a fingertip. He deepens all the shadows on the dark side of the face with small strokes and blends them to form soft, smoky tones. The he picks up the kneaded rubber and presses it carefully against the forehead, cheeks, nose, upper lip, jaw, and chin to lift away some of the gray tone that first appeared in Step 2. Magically, the skin begins to glow. Sharpening the charcoal stick, the artist darkens the lines of the eyebrows, eyes, nostrils, and mouth. He strengthens the contour of the shadowy cheek and jaw. And he extends the hair at the left with strokes that he blurs with a fingertip.

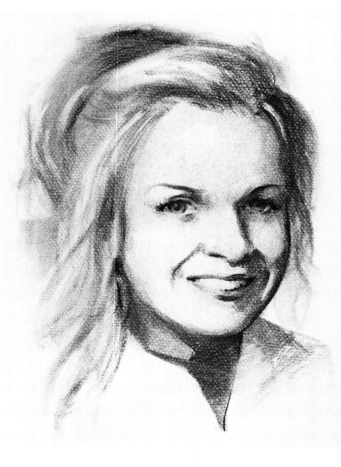

Step 6. As the face grows lighter, it needs surrounding darks to dramatize the pale tone of the skin. So the artist changes the color of the dress, blocking in a dark tone with broad strokes that he blends slightly with a fingertip—without actually obliterating the strokes. He then darkens the hair crowning the pale forehead. (The strokes of the sharpened charcoal curve to match the movement of the hair.) At the left, the shadows on the hair are deepened with curving strokes and then the kneaded rubber, squeezed to a point, picks out some light. Notice how the kneaded rubber is also used to brighten the sitter's teeth and to pick out the whites of the eyes.

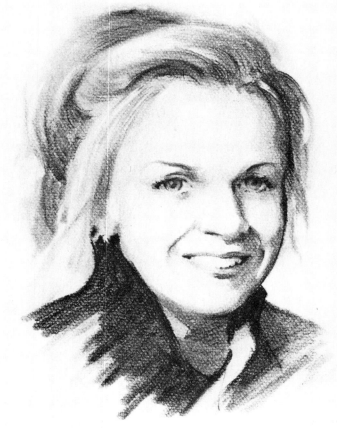

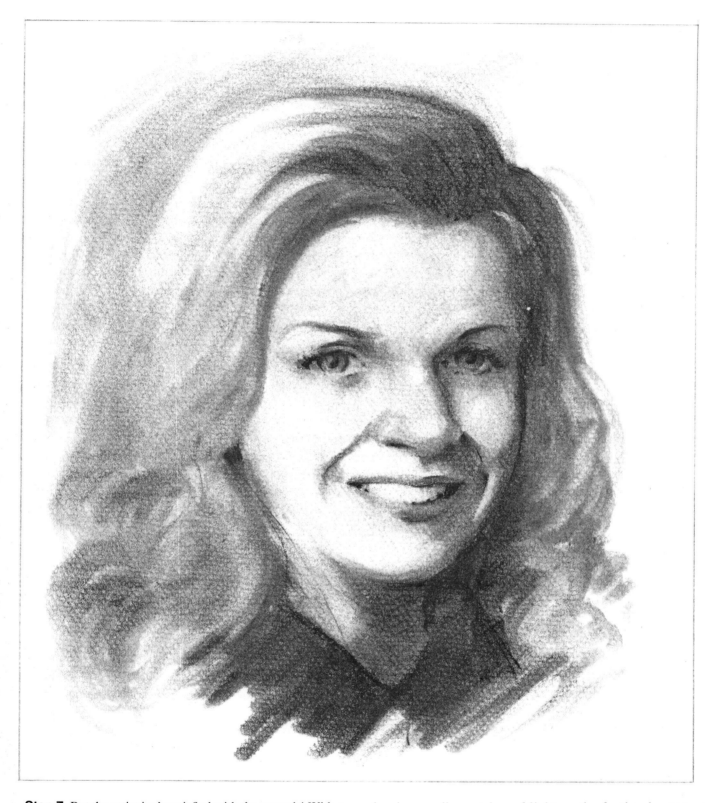

Step 7. But the artist isn't satisfied with the portrait! With a cleansing tissue, he wipes away the hair at the left, leaving a soft gray tone. Working into this tone with broad strokes, he carries the hair down over the shoulder and then blurs the strokes with a fingertip. The kneaded rubber wipes away the light on the hair. At the right, he brings the hair down to the shoulder with long, curving strokes, blended with a fingertip. His blackened finger blends darker tones into the skin, leaving smaller patches of light on the forehead, nose, cheeks, upper lip, and chin—brightened by touches of the kneaded rubber. The eraser lifts the dark tone of the collar to create a patch of light on the neck. The line of the collar is redrawn. The final portrait exhibits the rich darks, smoky grays, and luminous lights that are typical of a good charcoal drawing.

Permanence. A drawing made on a thin sheet of paper may not look as rugged as a leathery oil painting on thick canvas—but a drawing is every bit as durable as an oil painting if you take proper care of that sheet of paper. Drawings by the great masters of Europe have been preserved for five hundred years or more, and the brush drawings of the Japanese and Chinese masters, executed on paper as thin as gossamer, are even older. Works of art on paper are amazingly durable if you work with the right materials, do a good job of matting and framing, and store your drawings with reasonable care.

Choosing the Right Paper. Some papers yellow and crumble in a few years, while others remain white and resilient for centuries. Inexpensive papers are usually made of wood which is ground to pulp. These mass-produced wood-pulp papers often start out snow white (or come in lovely colors), have interesting surfaces, and respond beautifully to your drawing tools. But such papers deteriorate with the passage of time. In the beginning, it's wise to buy lots of inexpensive paper so you can draw, draw, draw, without worrying about the cost. The more paper you use up, the more rapidly you'll learn. However, once you reach the stage when you're not just practicing but want to make drawings to save and enjoy for a lifetime—or perhaps exhibit and sell—then you should switch to "100 percent rag" paper. Although few papers are still made of rags (as they were in the last century), manufacturers of the fine papers still use the phrase "100 percent rag" to designate durable paper that's made from chemically pure cellulose fibers.

Drawing Tools and Fixatives. Graphite pencil, black chalk, and charcoal are totally permanent in the sense that they won't fade or change color with the passage of the years. However, they'll smudge if you pass a careless hand over the drawing. Applying a coat of fixative is the simplest method of protecting a drawing from such damage. Fixative is a thin varnish that's virtually invisible. You can buy fixative in spray cans or in bottles. The bottled kind is sprayed with a mouth atomizer that you can buy in any art-supply store. A few artists object to fixative because they say that it darkens the drawing slightly, but the difference is minute. A can or bottle of fixative is standard equipment in the studios of most professionals.

Matting. A mat (called a mount in Britain) is essential protection for a finished drawing. The usual mat is a sturdy sheet of white or tinted cardboard, generally about 4 in. (100 mm) larger than your drawing on all four sides. Into the center of this board, you cut a window slightly smaller than the drawing. You then "sandwich" the drawing between this mat and a second board the same size as the mat. Thus, the edges and back of the picture are protected and only the face of the picture is exposed. When you pick up the drawing, you touch the "sandwich," not the drawing itself.

Boards and Tapes. Unfortunately, most mat (or mount) boards are made of wood pulp, which contains corrosive substances that will eventually migrate from the board to discolor your drawing paper. Just as you buy 100 percent rag, chemically pure paper for drawings that you want to last, you've also got to buy chemically pure, museum-quality mat board, sometimes called conservation board. Ideally, the backing board should be the same chemically pure board as the mat. But if your budget is limited, the backing board can be less expensive "rag-faced" illustration board, which is a thick sheet of chemically pure, white drawing paper with a backing of ordinary cardboard. Chemically pure mat board is normally white or cream color, but some manufacturers make it in other colors that you may consider more flattering to your drawings. Too many artists paste their drawings to the mat or backing board with masking tape or Scotch tape. Don't! The adhesive stays sticky forever and will gradually discolor the drawing. The best tape is the glue-coated cloth used by librarians for repairing books. Or you can make your own tape out of strips of discarded 100 percent rag paper and white library paste.

Framing. If you're going to hang your drawing, the matted picture must be placed under a sheet of glass (or plastic) and then framed. Most artists prefer a simple frame—slender strips of wood or metal in muted colors—rather than the heavier, more ornate frames in which we often see oil paintings. If you're going to cut your own mats and make your own frames, buy a good book on picture framing, which is beyond the scope of this book. If you're going to turn the job over to a commercial framer, make sure he or she uses museum-quality mat board or ask the framer to protect your drawing with concealed sheets of rag drawing paper inside the mat. Equally important, make sure that he or she doesn't work with masking tape or Scotch tape—which too many framers rely on for speed and convenience.

Storing Unframed Drawings. Unframed drawings, with or without mats, should always be stored horizontally, never vertically. Standing on its end, even the heaviest paper or the stiffest mat will begin to curl. Store unframed drawings in envelopes, shallow boxes, or portfolios—kept flat in a drawer or on a shelf.

PART TWO

LANDSCAPE DRAWING

DRAWINGS BY FERDINAND PETRIE

Landscape Drawing. Strolling outdoors with a sketchbook under your arm and a few pencils in your pocket—that's an artist's idea of heaven on earth. To wander through the woods, climb a mountain path, or walk barefoot on the beach, absorbing the beauty of nature, is a joy in itself. But the pleasure of the outdoors becomes infinitely greater when you have the skill to record the beauty of nature on drawing paper. The tools and techniques of drawing are so simple, the process so rapid and spontaneous, that drawing is the ideal medium for capturing your emotional response to nature. A landscape drawing can be anything from a five-minute sketch of a single tree to a panoramic landscape of mountains that may take an hour or more. You can return from a morning's walk with several finished drawings or a dozen rapid sketches that may be lovely in themselves or may form the basis for paintings created in the studio.

Indoors or Outdoors. Although some people are outdoor artists and others are indoor artists, it's important to remember that the best landscapes always *start* outdoors, even if they're finished in the studio. The only way to learn how to draw a cliff or a cloud is to go out and find it. There's no substitute for firsthand knowledge of your subject. Working on location will strengthen your powers of observation and train your visual memory. So it's important to spend as much time as you can drawing outdoors, even if those drawings are nothing more than small, quick studies for bigger drawings or paintings which you hope to develop indoors. Those on-the-spot drawings—no matter how rough and crude they may turn out to be—will have a freshness and authenticity that you can get only by looking straight at the subject. If you decide to use these outdoor sketches as the basis for more work indoors, the *finished* drawing or painting will have a feeling of reality that you can never get by working just from memory or imagination.

Learning to See. The first few pages of *Landscape Drawing* are planned to train your powers of observation. You'll learn how to measure the height, width, and slope of various landscape elements, such as trees and rock formations. You'll learn how to judge the proportions of typical landscape forms such as boulders, trees, and clouds. The elements of linear and aerial perspective will be explained. And you'll learn how to judge values—the comparative lightness or darkness of your subject—so you can convert the colors of nature into the black-and-white tones of a drawing in pencil, chalk, or charcoal.

Starting with Basic Forms. Every contemporary landscape painter remembers Cézanne's famous observation that all the complex shapes of nature are based on a few simple geometric forms. So you'll learn how to visualize cubical forms as the basis for drawing landscape elements such as rocks and cliffs; cylindrical and conical forms as the basis of tree trunks and hills; rounded forms as the basis of boulders and masses of foliage. You'll also learn how to construct simple non-geometric forms as the basis for drawing objects with erratic shapes, such as a snow-covered tree or a mass of flying surf at the seashore. The noted artist Ferdinand Petrie draws a series of step-by-step demonstrations to show you the four fundamental stages in transforming cubical, cylindrical, rounded, and irregular shapes into typical forms of nature such as a rocky shore, a tree stump, trees, and windswept clouds.

Demonstrations. Petrie then shows you how to put all these techniques to work in a series of ten step-by-step demonstrations of complete landscape and coastal subjects: the rich texture and detail of trees; the intricate forms of a meadow with the broad shapes of hills in the distance; a stream winding among rocks and trees; a beach with the complex shapes of rocks; the rugged forms of mountains; the drama of surf crashing against a rocky shoreline; the soft, yet solid shapes of a snowy landscape; a shadowy pine forest; the still water of a pond surrounded by the diverse forms of the landscape; and finally, the rhythmic contours of sand dunes on a beach.

Drawing Media. These landscape demonstrations are organized according to medium, in three groupings: pencil, chalk, and charcoal. The demonstrations present a wide range of drawing techniques to show you the many ways of rendering contour, light and shade, texture, and detail in these versatile drawing media. Petrie's demonstrations show you how to render the forms of nature with various combinations of lines, strokes, and blended tones. Interspersed among the demonstrations are actual-size close-ups which show you many ways of rendering form with various types of pencil, chalk, and charcoal on different drawing papers.

Finding Your Own Way. These varied drawing tools, techniques, and surfaces are presented to help you find your own way. Fortunately, pencils, chalk, charcoal, and most drawing papers are inexpensive, so you're free to try as many alternatives as possible. Gradually, you'll discover which materials and methods seem most natural to you.

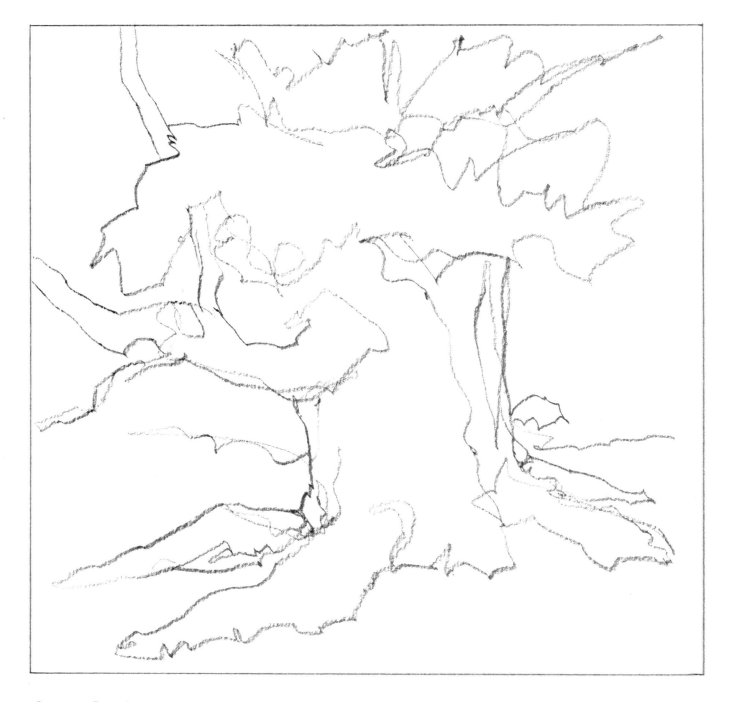

Contour Drawing. Like an athlete, an artist needs to warm up. Warm-up exercises not only get you into the swing of drawing, but they also strengthen your powers of observation and encourage you to draw with free, relaxed movements. One of the classic warm-up exercises is *contour drawing*. Choose some subjects with big, interesting shapes—such as this tree stump—and let your eye move gradually around the edges of the shapes. As the eye moves around the shapes, draw their contours with a sharply pointed pencil, letting the pencil rove across the paper as your eye roves over the subject. Draw with a relaxed, wandering line. Try not to look at the paper too much, but keep your eye on the subject. Let the pencil ''feel'' its way over the paper as your eye ''feels'' its way around the shapes. Forget about details and draw just the big forms. Contour drawing teaches you to look at shapes carefully and draw them simply.

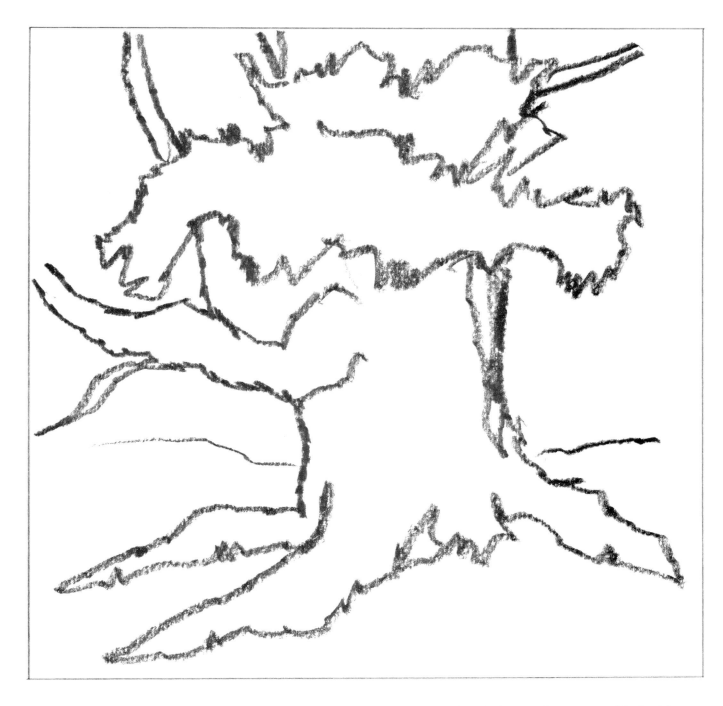

Groping Line. Now try another contour drawing with a thick, blunt pencil—or any pencil that's been worn down to a blunt point. Let your eye move *very* slowly around the shapes of the subject, while the pencil gropes its way slowly across the paper. Try to draw with as few lines as possible. And do your best to keep your eye on the subject while you draw. Don't look at the paper too often. Don't worry if your line looks thick and clumsy—in contrast with the thinner, more elegant line of the first contour drawing. A drawing doesn't have to be elegant to be beautiful. A thick line can also be powerful and expressive. The value of this groping-line exercise is to make you slow down, look carefully, and capture the essential shapes of your subject without fussing about details.

Scribbling. Now try a warm-up exercise that's radically different from contour drawing and the groping-line exercise you've just done. Working with a sharply pointed pencil once again, let your eye wander over the subject while your hand scribbles round and round on the drawing paper. Keep the pencil moving, whizzing back and forth, up and down in zigzags and circles. You're not trying to trace the precise contours of each shape, but trying to capture the *overall shape* of the subject with rapid, intuitive movements of your pencil. Your scribbled drawing will look a lot messier than the other drawings you've made—but the scribbles will also have a lot of vitality and spontaneity. And that's what this warm-up exercise teaches you: to draw freely and spontaneously, trusting your intuition and simply "letting go." In its own way, this scribbled drawing of the tree trunk is just as good as the more careful contour drawing and groping-line drawing.

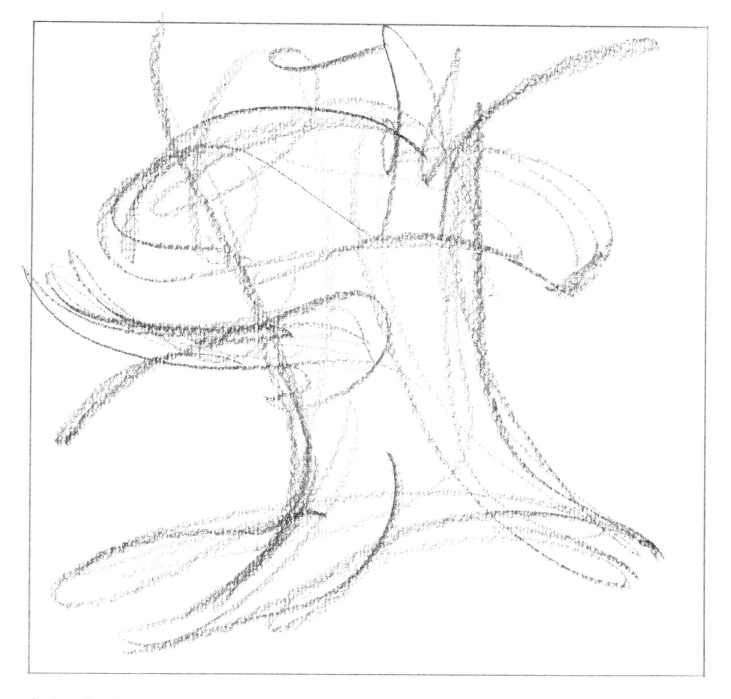

Gesture Drawing. Although the subject doesn't actually move, artists often talk about the *movement* of the form. In reality, it's your eye that moves, gliding rhythmically over the form. The forms actually create a path for the eye, telling it where to go. Although the forms don't really move, they communicate a *sense* of movement. It's this sense of movement that you try to capture in what artists call a *gesture drawing*. Let your eye move quickly over and around the shapes of the subject while your pencil glides over the paper like an ice skater, repeating those big, sweeping eye movements. You can place one rhythmic line over another, letting the pencil move in long, sweeping lines like a skater's tracks on the ice. The purpose of this final warm-up exercise is to teach you to look for the "inner life" of your subject—its internal movements and rhythms—and then capture this quality with bold, spontaneous movements of the pencil.

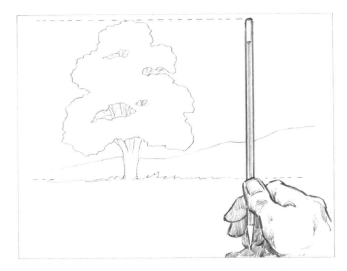

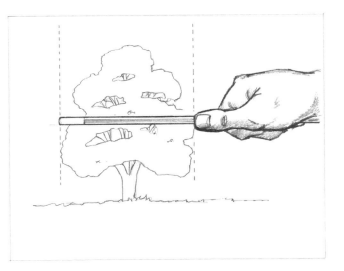

Measuring Height. Before you can draw any shape, you must be able to measure it. That is, you must know how its height relates to its width—and how its internal dimensions relate to the total shape. One tried-and-true method is to hold a pencil at arm's length in front of the subject, aligning the top of the pencil with the top of the shape and sliding your thumb down to align with the bottom of the shape. (Be sure to hold the pencil absolutely vertical and don't bend your elbow.) This gives you the overall height of the subject.

Measuring Width. Now, standing in exactly the same spot, turn your wrist so the pencil is horizontal. One end of the pencil should align with one side of the shape. Slide your thumb across the pencil until the tip of the thumb aligns with the *other* side of the shape. Now you have the width of your subject. Comparing the first measurement with the second, you see that the width is roughly three-quarters the height. Another way to put it is that the tree is about four units high by three units wide.

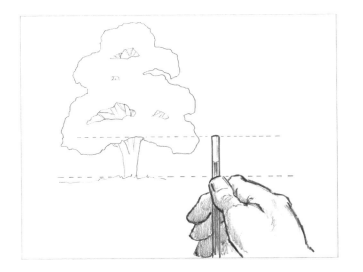

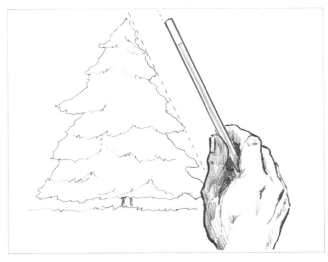

Measuring Internal Dimensions. Within that overall shape, there may be a smaller shape that you also want to measure—such as the trunk of this tree. Repeating the procedure for measuring height, you'll discover that the exposed section of the tree trunk is about one-quarter of the total height of the tree from the ground to the top of the leafy mass. At some point, you may be able to make these measurements in your head—without the aid of the thumb-and-pencil method—but this method is a good way to start.

Measuring Slope. Nature contains slanted shapes that you can also measure with a pencil. Hold the pencil to line up with the slope of the form—such as this cone-shaped evergreen. With the angle of the pencil firmly fixed in your mind, swing over to the drawing paper and draw a quick line that matches the angle at which you were holding the pencil. Using the slanted line as a guide, draw the zigzag shape of the tree right over that guideline.

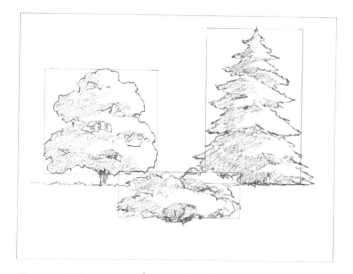

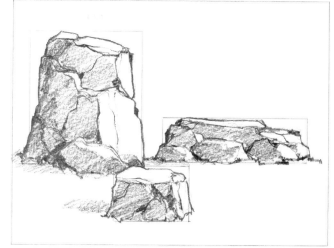

Trees. When you measure by the thumb-and-pencil method, you're really playing the game of putting shapes into imaginary boxes. When the height and width of your subject are the same, that subject will fit neatly into a square box, like the tree at left, which is one unit high by one unit wide. The evergreen at the right could be put into a box approximately two units high by one unit wide: that is, the height is about twice the width. And the low shrub in the middle would need a box that's about three units wide by one unit high: the width is three times the height.

Rocks. Blocky shapes such as rocks are particularly easy to fit into imaginary boxes when you want to measure proportions. The tall rock at the left fits into a box four units high by three units wide: the width is three-quarters the height. The low rock formation at the right fits into a box about three units wide by one unit high: the width is three times the height. And the small rock in the center foreground fits into a box that's four units wide by three units high: the height is three-quarters the width.

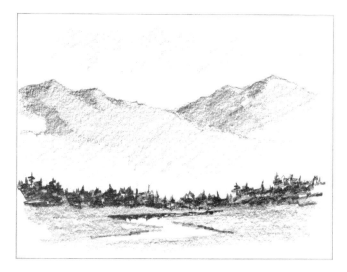

Clouds. Because clouds are big, soft, and puffy, you may think that it's harder to put their shapes into boxes. But the method is essentially the same. The cloud at the left fits into a squarish box, while the tall cloud at the center fits into a box whose height is roughly twice the width, and the low cloud at the right fits into a box whose width is roughly three times the height. You could also use the thumb-and-pencil method to measure the internal shapes: the round puff at the top of the vertical cloud in the center is roughly one-quarter the cloud's total height.

Landscape. When you focus on a specific segment of the total landscape to draw a picture, you're drawing an imaginary frame around that piece of landscape. Within that imaginary frame, there are proportions that you can measure. The tops of the mountains are about one-third the distance from the top edge of the frame to the bottom one. And the dark line of the trees is about three-quarters of the way down. That line of trees is also about two-thirds of the way down from the tops of the mountains to the bottom edge of the picture.

River. You've certainly observed the phenomenon called linear perspective. The parallel sides of roads, railroad tracks, and the tops and bottoms of walls all seem to converge as they recede into the distance. Although the natural landscape has very few straight lines comparable to those of a man-made landscape, the rules of perspective still apply. The shoreline is far from straight, but you have to remember linear perspective in order to draw the wandering shape of this stream.

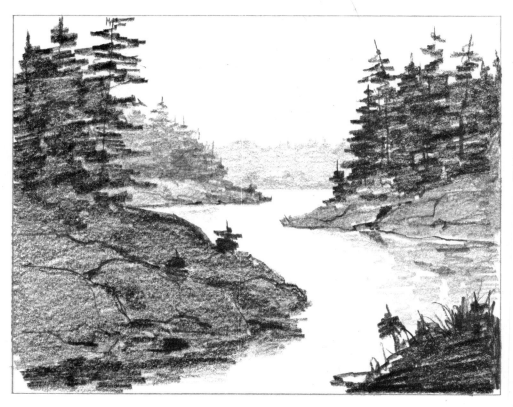

Perspective Diagram. The edges of the stream aren't exactly parallel, of course, but this diagram of the stream shows how the lines of the shore do seem to converge as they move back into the distance. No, this perspective diagram isn't mathematically perfect—nor is it meant to be. And you don't have to draw a neat, linear-perspective diagram every time you draw a stream or a path across a meadow. Just look at your subject carefully and try to *imagine* the perspective lines receding, so your drawing has a convincing sense of space.

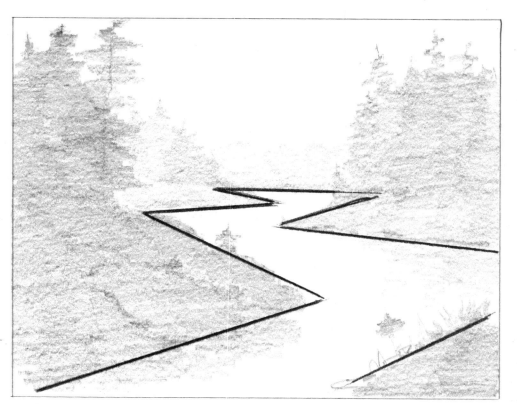

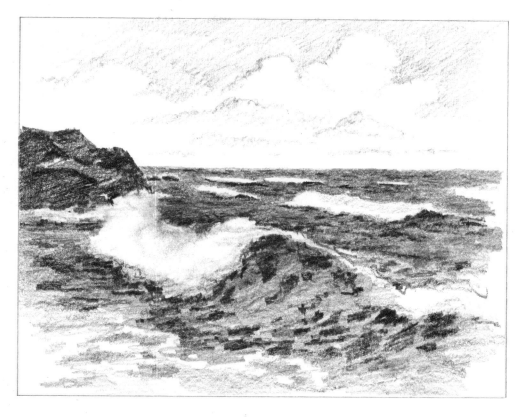

Waves and Clouds. Even a wave, with its rapid movement and curving shape, obeys the rules of linear perspective. At first glance, those imaginary perspective lines may be hard to visualize, but look at the diagram below to see how the lines work.

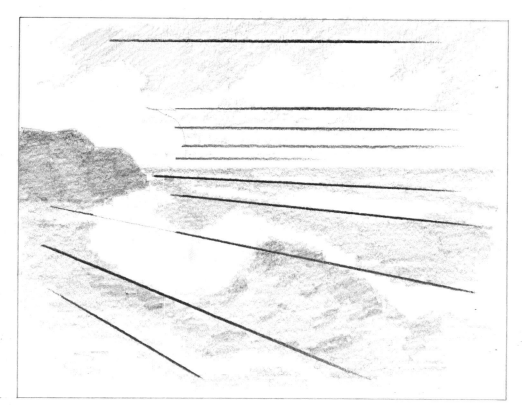

Perspective Diagram. If you draw imaginary lines across the tops and bottoms of the waves, you'll see that these lines seem to converge as they move toward the horizon. It's also interesting to note that the perspective lines in the foreground are distinctly diagonal, while they become more horizontal in the waves just below the horizon. And just as the waves look thinner and flatter as they approach the horizon, so do the clouds. The diagram shows that the clouds high in the sky are round and puffy, but they grow flatter toward the horizon.

Headlands. There's also another kind of perspective that's important when you draw landscapes. Aerial perspective is the tendency of objects to grow paler and less detailed as they recede into the distance. In this coastal scene, the nearby headland in the foreground is the darkest and shows the strongest contrast between light and shadow; you can also see the details of the rocky shapes most clearly. The more distant headland—in the middleground—is paler, shows less contrast between light and shadow, and the details of the rocks are not as easy to see. The remote headland on the right-hand side of the picture is simply a pale gray shape with no contrast and no detail.

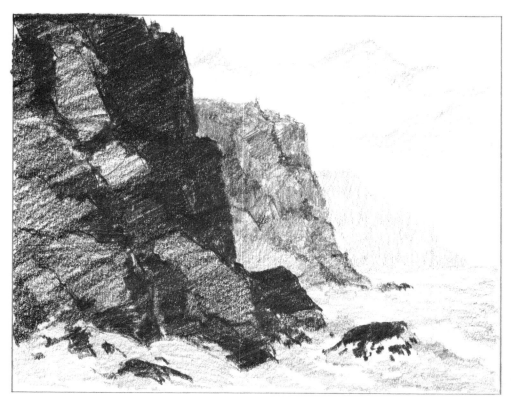

Perspective Diagram. It's often helpful to visualize your landscape as a series of planes or zones, as shown in this diagram. First there's the dark, distinct headland in the foreground. Then there's the paler headland in the middleground. Next, there's the very pale headland in the distance. And finally, the palest plane of all is the sky, with its slight hint of clouds.

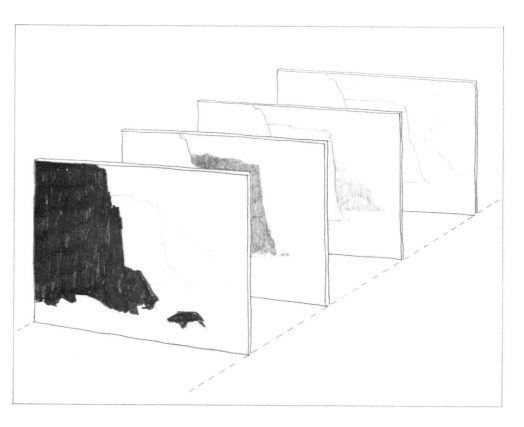

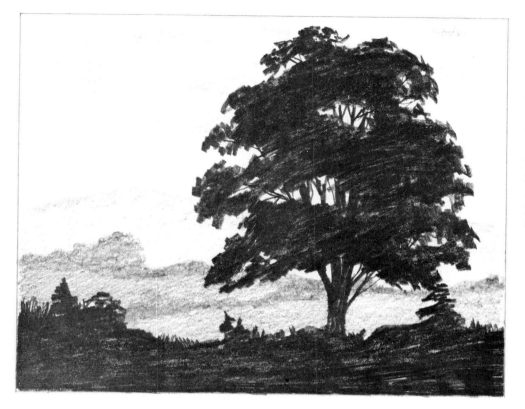

Trees and Hills. Here's another example of aerial perspective in a landscape. The tree and the grassy fields in the foreground are darkest, most distinct, and most detailed. The field and foliage in the middleground are paler, less distinct, and less detailed. The hill in the distance is simply a pale gray shape. And the sky is bare white paper with an indication of pale clouds.

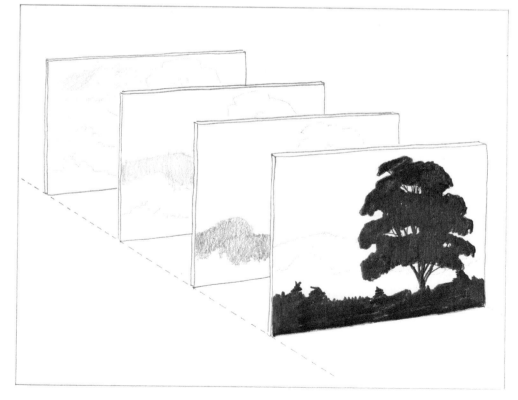

Perspective Diagram. This diagram shows the four planes or zones that appear in the landscape above. You can see the dark, precisely detailed foreground; the paler, less detailed middleground; the very pale, highly simplified hill in the distance; and the even paler sky. Those four planes won't always be so distinct in every landscape you draw, but always look for an opportunity to apply the rules of aerial perspective to give your landscapes a convincing feeling of space, atmosphere, and distance.

Value Scale. Drawings are generally done in black-and-white media, such as pencil, chalk, and charcoal. This means translating the colors of nature into shades of gray, plus black and white. These tones of black, white, and gray are called *values*. Theoretically, the number of values in nature is infinite, but most artists find it convenient to simplify nature to about ten values: black, white, and eight different shades of gray. To fix this "palette" of tones firmly in your mind, draw a series of boxes and fill them with nine different tones, starting with the palest possible gray and ending with black. The tenth value, pure white, is just the bare paper.

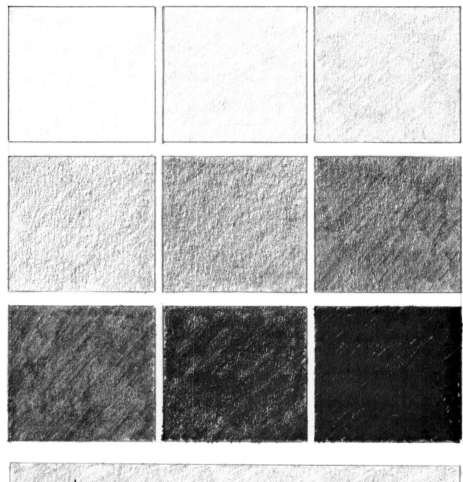

Selecting Values. With the *value scale*, as it's called, on paper and firmly fixed in your mind, you're better prepared to translate the colors of nature into the tones of pencil, chalk, or charcoal. Pretending that your eye is a camera loaded with black-and-white film, look at your subject and decide which colors become which tones on the value scale. The dark green evergreens are likely to be a deep gray, just next to black. The sky and the shadows on the snow are the third or fourth tone of gray. The frozen stream actually contains two different tones of dark gray. And the sunlit patches of snow are white—which means they're bare paper. As you can see, ten values are far more than you need to make a convincing picture. Just a few values will do.

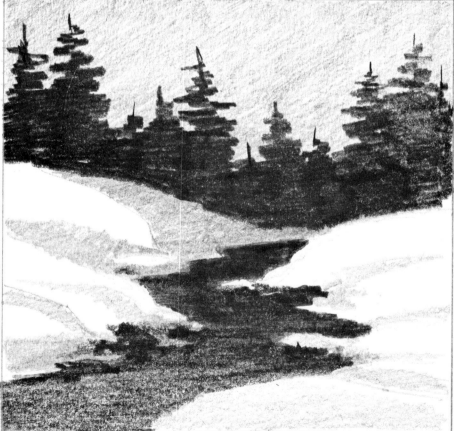

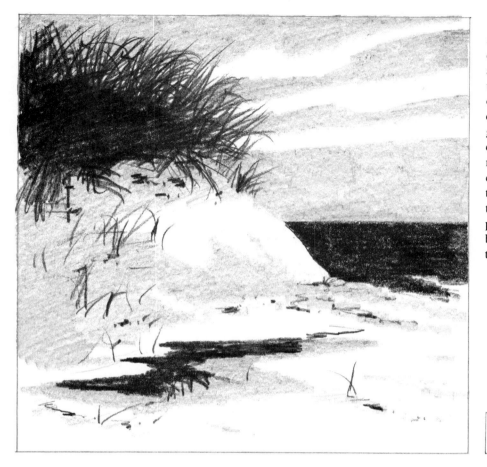

Drawing in Three Values. Some artists feel that just three values are enough to make a good landscape—and they purposely simplify the values of nature to just three tones. This coastal landscape consists of a very dark gray for the distant water, the grass at the top of the dune, and the dark reflection in the tidal pool; a much paler gray for the dark strips of cloud in the sky and the shadow on the sand; and the bare white paper for the sunlit edges of the clouds and the patches of sunlight on the sand. Look back at the value scale and see which tones the artist has selected.

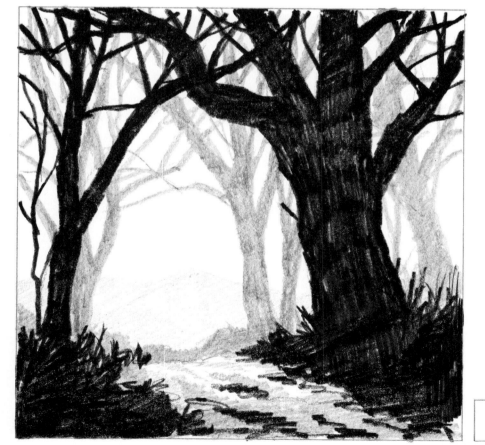

Drawing in Four Values. Others feel that four values are simple enough yet allow more flexibility. Here, the distant sky is bare white paper; the remote hill is a pale gray; the trees at the far edge of the forest are a darker gray; and the trees and grass in the foreground are dark gray—almost black, but not quite. Again, glance back at the value scale and see which tones the artist has chosen from his mental "palette."

High Contrast. In studying your subject and choosing your tones from the value scale, it's important to decide how much contrast you see between the tones of nature. On a sunny day, you'll see a high-contrast picture. That is, you'll see bright whites, dark grays or blacks, plus various shades of gray between those two extremes. Another way to put it is that this subject gives you a *full range* of values.

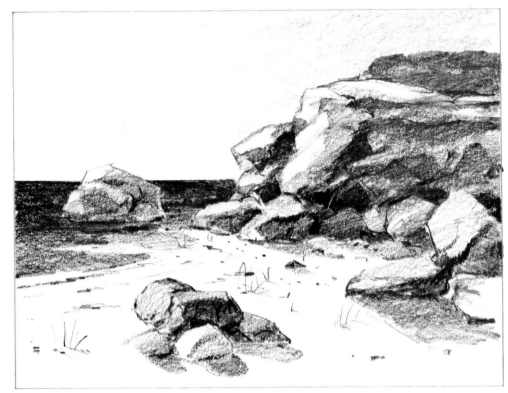

Low Contrast. On an overcast day, with the sun concealed behind a gray cloud layer, the same subject will present a much more *limited value range*. The light areas of the picture aren't nearly as bright and the darks aren't nearly as dark. The whole picture consists of grays: a pale gray for the lightest area, a not-too-dark gray for the darkest areas, and a couple of medium grays in between. Looking back at the value scale, you'll see that the tones of a high-contrast picture are widely scattered on the scale, while the tones of a low-contrast picture are close together on the scale.

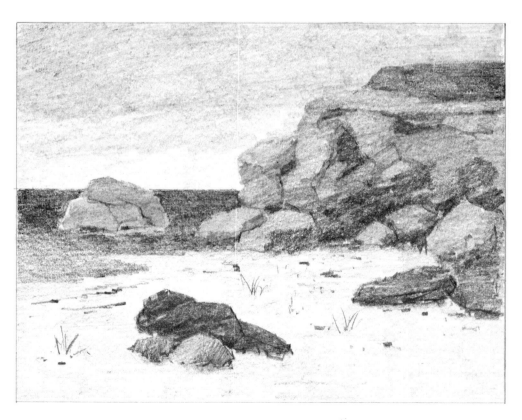

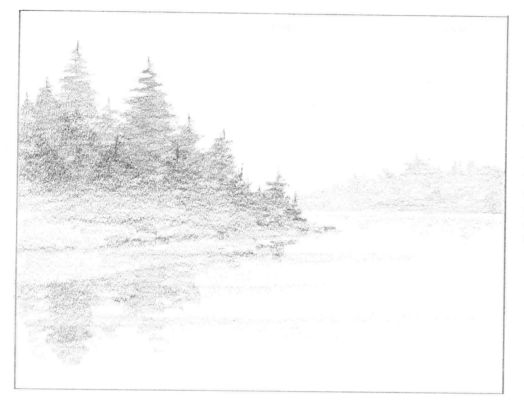

High Key. Artists also talk about the *key* of the landscape. When the overall tone of the landscape is generally pale, it's called a *high-key* picture. In this case, the values are apt to come from the beginning of the value scale—pale grays and possibly white. Even the darkest tones in the picture—the trees on the shoreline at the left—are relatively pale. Foggy coastlines and misty landscapes are often in a high key.

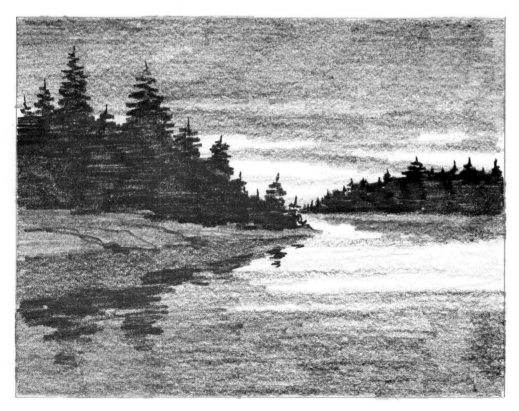

Low Key. In contrast with a high-key subject, a *low-key* picture is predominantly dark, drawing most of its values from the dark end of the scale. A change in light or weather can convert the same subject from a high key to a low one, as you see here. Now the trees are a deep gray (almost black) and the lighter tones of the sky, water, and shore are still fairly dark. Only the strips of light in the sky and water come from the light end of the value scale. It's interesting to note that the high-key picture above is a low-contrast subject, while this low-key landscape has higher contrast.

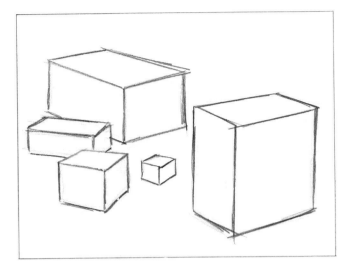

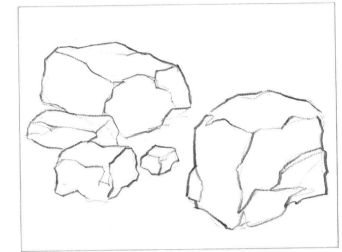

Cubes. Geometric forms are the basis of many shapes in nature, so it pays to practice drawing cubes and other blocky shapes. You can collect a variety of boxes around the house, scatter them on top of a table, and draw them from various angles. Start out drawing them with pencil lines. Keep your pencil sharp and don't hesitate to go over the lines several times until they're accurate. Don't use a ruler, but draw freehand. The lines don't have to be perfect.

Rocks. If you can draw those boxy shapes with reasonable accuracy, you can easily draw the blocky forms of rocks, which have top and side planes just like boxes—although the planes of the rocks will certainly be more irregular. You can begin to draw each rock by drawing a box (like those at the left) and then going back over the straight lines to transform the shapes into rocks. As you've already learned, it's also easier to visualize *proportions* if you start out with imaginary boxes.

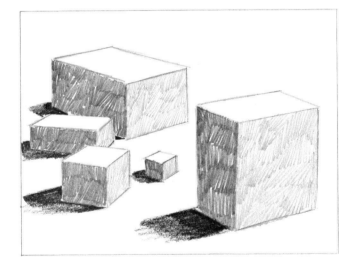

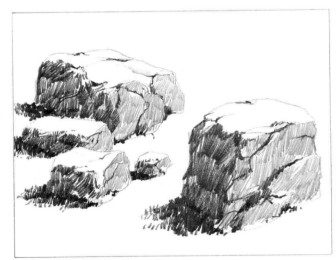

Cubes in Light and Shade. When you've had enough practice drawing boxes with pencil lines, render the tones on the top and side planes of the boxes with the side of the pencil lead. Generally, you'll find that each plane of the box has its own value. In this case, the top plane catches the light and is the palest value; one side plane is a light gray halftone (or middletone); and another side plane is a darker gray, representing the shadow side of the block. The block also casts a shadow on the tabletop—darkest right next to the block and gradually growing paler as the shadow moves away.

Rocks in Light and Shade. Keep these three planes in mind when you draw the values on real rocks. The planes won't be neat—nor will they be quite so obvious—but look carefully and you'll find them. In these rocks, as in the boxes at your left, the top plane is the light, one side plane is the halftone (or middletone), and another side plane is the shadow. The order of these planes *can* change when the light comes from a different direction: when the sun is low in the sky, one side plane could become the light and the other two planes, the halftone and shadow.

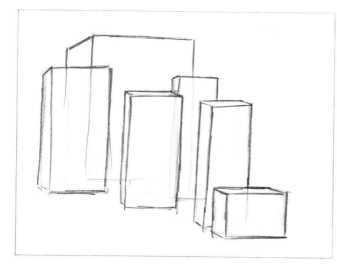

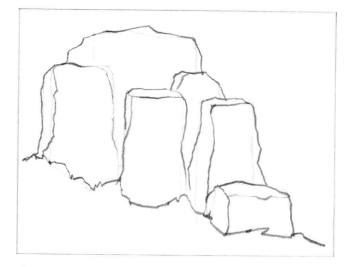

Oblongs. Imagine cubes sliced into pieces of various shapes and you have a number of oblongs. If you can find several long, slender boxes around the house, draw them just as you drew the cubical shapes on the previous page. It's helpful to draw these boxes as if they were made of glass, so you can see through them to the boxes behind. Draw the whole box, even if part of it is concealed by the box in front.

Cliff. Lofty rock formations, such as cliffs, often look like collections of oblongs. When you draw these natural shapes, keep those tall, slender boxes in mind. In fact, you can actually begin by drawing the shapes of the cliff as a series of oblongs, then go over the guidelines with more irregular lines that capture the rocky character of the subject.

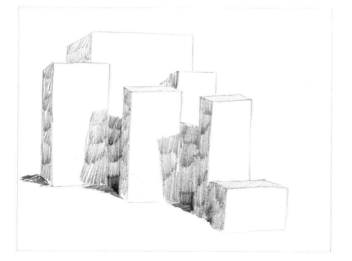

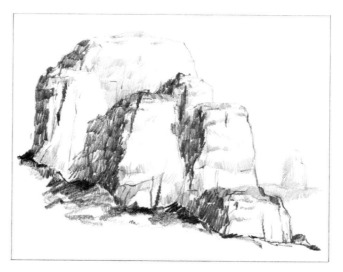

Oblongs in Light and Shade. Use the side of your pencil to block in the tones on the three planes of those tall boxes, and pay particular attention to the shadows that the boxes cast on one another. The light strikes the boxes from the front, so the frontal planes are the lightest value, the top planes are the halftones (or the middletones), and the side planes are the shadows. The cast shadows aren't a solid, even tone, but contain some reflected light picked up from a secondary light source, such as a distant window at the left.

Cliff in Light and Shade. The same tonal pattern appears on the cliffs, which are essentially oblongs. Of course, the planes of light, halftone, and shadow aren't as neat on these rugged rocks, but you can still see them clearly. Notice that the cast shadows contain a hint of reflected light picked up from the sky.

Step 1. When you go outdoors to draw, look for natural forms to which you can apply what you've learned about drawing cubical shapes. In the first few lines of his drawing of a rocky headland, the artist visualizes the subject as a huge cube with a slanted top plane. The smaller rock at the extreme right is also a kind of cube with slanted sides. And the foreground rocks are slices of cubes. These first few pencil lines are simply guidelines over which the actual shapes of the headland and rocks will be drawn more precisely.

Step 2. Going back over the pale guidelines with firmer, darker strokes of the pencil, the artist draws the realistic contours of the headland and rocks. He looks for the erratic turns and breaks in the contours—the irregularities that make the shapes look more rocky. But he doesn't erase the original guidelines just yet, keeping in mind the simplified geometric forms that he drew in Step 1.

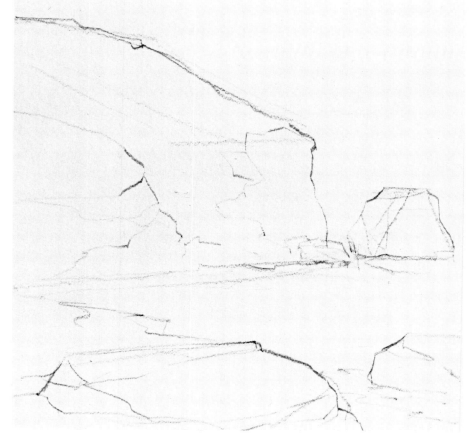

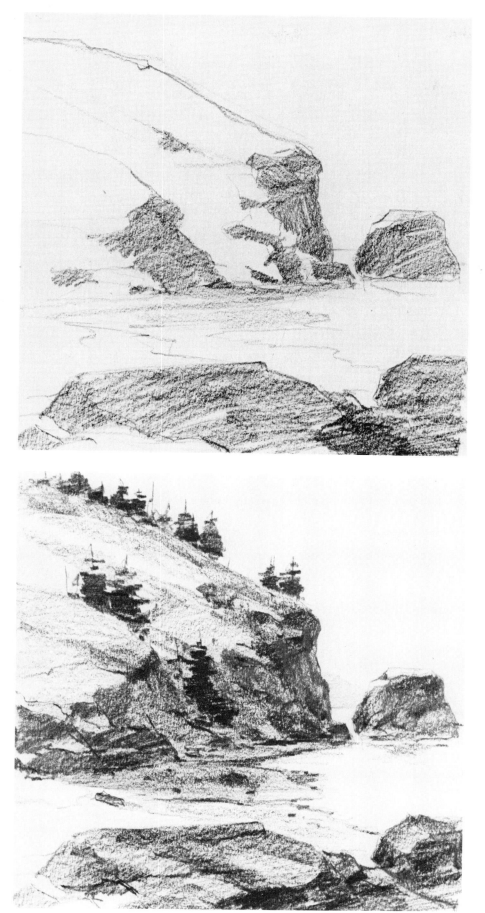

Step 3. Working with the side of the pencil, the artist blocks in the shapes of the shadows with broad, rough strokes. Now the big headland is clearly divided into planes of light and shadow, with the brightest light falling on the top plane. The rock to the right of the headland also has a lighted top plane and a shadowy side plane. The foreground rocks don't seem to receive as much direct light from the sun, so their top planes are darker than that of the headland, while the side plane (suggested in the lower right) is darker still.

Step 4. Continuing to work with the side of the pencil, the artist adds the middletones (or halftones)—those values which fall between the lights and shadows—reinforcing the blocky shapes of the cliff and rocks. He also darkens the shadowy side planes of the rocks, emphasizing their blocky shapes. So far, the artist has concentrated on the big shapes of light, shadow, and halftone that make the shapes look solid and three-dimensional. Now he finishes the drawing by adding the cracks and other details within the rocks, plus the trees and the shoreline.

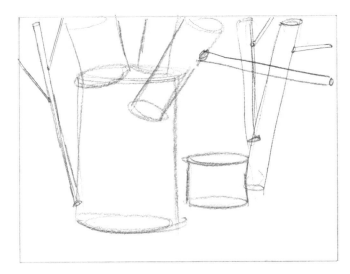

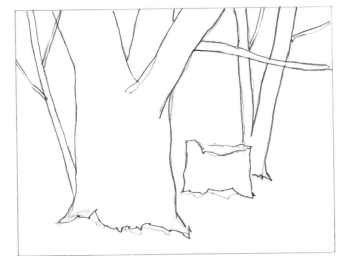

Cylinders. In outdoor subjects, cylindrical shapes are just as common as blocky shapes. Trees and branches are essentially cylindrical, although the simple geometric shapes may be concealed under the distracting detail of foliage and bark. When you look at a group of trees, try to visualize the trunks and branches as a collection of cylinders, some upright, some slanted and some horizontal. In fact, it's helpful to draw these cylinders with pencil lines.

Tree Trunks. When you've drawn these cylinders, you have convenient guidelines over which you can draw the actual shapes of the living trees with sharper, darker pencil lines. Now you can look for the irregularities in the contours—the bumps and dips that make the shapes of the trees and branches look real. But don't forget that the shapes are still basically cylindrical.

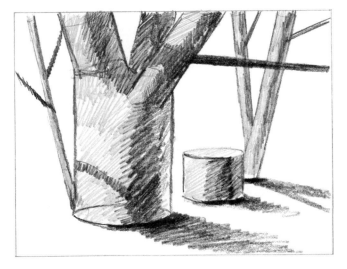

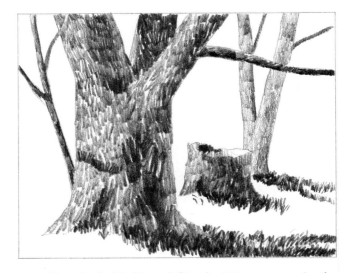

Cylinders in Light and Shade. In contrast with cubical shapes—where there are distinct planes of light, halftone, and shadow—the tones all run together on a cylinder. From left to right on the cylindrical shapes in this picture, you can see the gradual transition from the lighted left side of the tree to the halftone (or middletone) to the shadow to the reflected light within the shadow. (In outdoor subjects, shadows often contain light reflected from the distant sky or bounced off the mirrorlike surface of nearby water.) These cylindrical shapes cast curving shadows on one another.

Tree Trunks in Light and Shade. When you render the gradations of light, halftone (or middletone), shadow, and reflected light on tree trunks and branches, remember how the light wraps around a geometric cylinder. Don't be distracted by the texture of the bark. You can draw the bark with small, distinct strokes that convey the texture—but press harder on the pencil as you move from light to shadow, then make the strokes lighter as the shadow curves around to pick up the reflected light. The cast shadow on the ground is broken up by the grass, but you can draw this shadow with small "grassy" strokes.

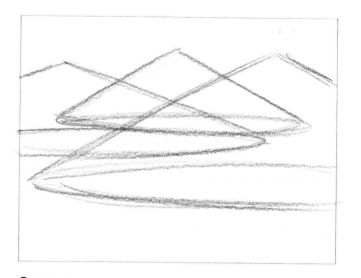

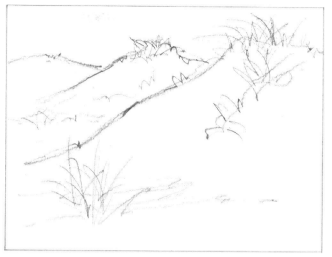

Cones. A cone is closely related to a cylinder in the sense that both have curving sides—but the sides of the cone taper, while the sides of the cylinder remain roughly parallel. Practice drawing cones. Imagine that they're made of glass so you can see one behind the other—and so you can draw their elliptical bottoms. In this way, you get into the habit of visualizing cones as solid, three-dimensional forms. Ellipses are particularly hard to draw, so swing your arm with free, rhythmic movements, and don't hesitate to keep going over the lines.

Dunes. Sand dunes—like hills—are often flattened cones with irregular sides. When you draw sand dunes, remember their basic geometric shape even if that shape seems to disappear under the realistic contours of the sand. You can actually begin by drawing geometric cones and then draw the dunes over them. Or you can draw the dunes directly and keep the cones in your head.

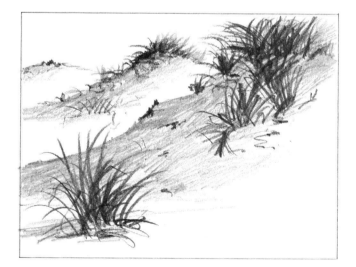

Cones in Light and Shade. Light, halftone (or middletone), and shadow wrap around cones very much as they do around the curving sides of cylinders. Those gradations can be subtle, so observe them carefully. On the dark side of the nearest flattened cone in this illustration, notice how the strokes become slightly denser to indicate the change from halftone to shadow—and then the strokes become more open to suggest reflected light at the left.

Dunes in Light and Shade. When you render the pattern of light and shade on the actual dune, remember the behavior of the tones on the geometric cones. Like the imaginary cones at left, the conelike shapes of the dunes pick up the sunlight on their right-hand sides and then curve gradually around into halftone and shadow. There isn't always a neat gradation from light to halftone to shadow to reflected light. In this case, reflected light appears throughout the shadow. The artist leaves some spaces between pencil strokes to suggest reflected light from the sky.

Step 1. An "outdoor still life," such as these two tree stumps, offers a good chance to draw cylindrical forms in nature. The artist begins by visualizing the stumps as short, thick, tilted cylinders with elliptical tops. The root at the left is a slender, tapered cylinder, something like a cone. The sharpened point of the pencil moves lightly over the paper so that these guidelines can be erased at a later stage in the drawing.

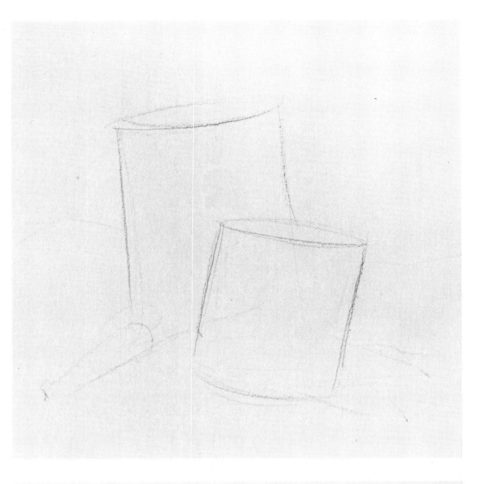

Step 2. Using the cylindrical shapes of Step 1 as a guide, the artist looks carefully at his subject and draws the ragged contours of the weathered wood over the pale lines. He doesn't follow the original guidelines *too* faithfully, but departs from them freely to create a more realistic drawing of the two stumps. He draws the jagged, broken tops of the stumps right over the elliptical guidelines—but he remembers that the ellipses are there. The root at the left no longer looks very cylindrical or conical, but the artist will remember the geometric form when he adds tone to the root.

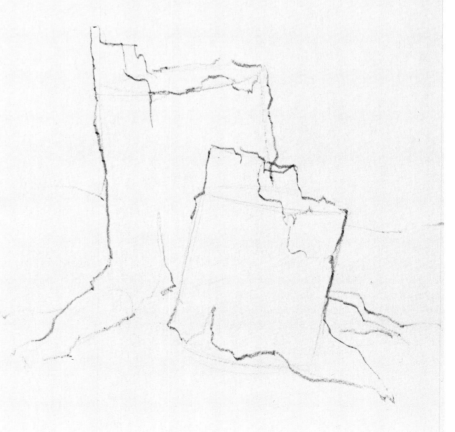

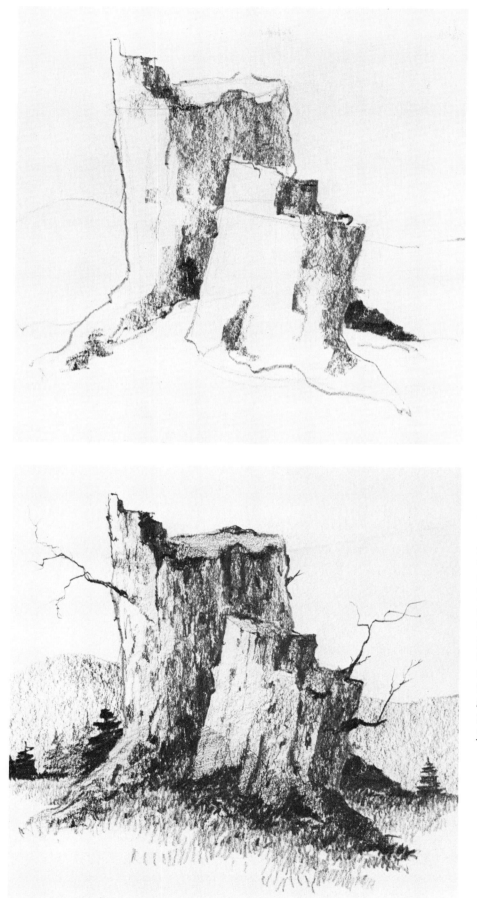

Step 3. Working with the side of the pencil, the artist carries broad strokes down the stump to establish the big shapes of the darks. Now there's a clear distinction between the light and shade on each large cylinder, as well as on the root at the left. At the tops of the stumps, strong darks are placed with the ragged shapes as they turn away from the light. A single root at the right is entirely in shadow, so this tone is blocked in.

Step 4. Pressing harder on the side of the pencil, the artist darkens the tones on the cylindrical stumps to make the shapes look three-dimensional. Although the tones are interrupted by the broken texture of the weathered wood, the strokes suggest the gradual right-to-left gradation: light, halftone (or middletone), shadow, and reflected light within the shadow. The darkest shadows are placed within the cracks and where the stumps overlap. The artist's final step is to draw small details, such as the twigs and cracks, which come *after* he's rendered the gradation of light and shade that makes the subject look solid.

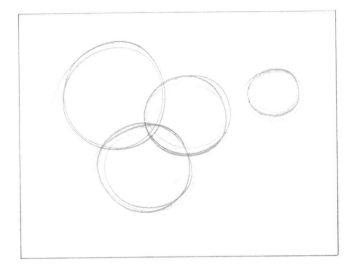

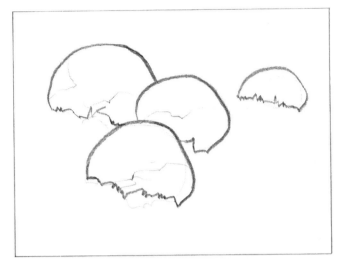

Spheres. Another basic geometric form that occurs constantly in nature is the sphere. Although there aren't many *perfect* circles in nature, practice drawing circles with the point of your pencil. The secret of drawing a really round circle is to swing your whole arm, starting from the shoulder, not from the wrist or elbow. Keep repeating that circular movement, going around and around, going over each circle again and again until the shape seems right. Your circles won't be geometrically perfect, but practice will make them round and full, which is what matters.

Rounded Rocks. Boulders are often irregular spheres, flattened here and there, and partly buried in grass or dirt. Once you've learned how to draw a circle with quick, rhythmic movements, you can draw circular guidelines and then build realistic boulders over these round shapes. Or you can go directly to work drawing the irregular contours of the boulders themselves.

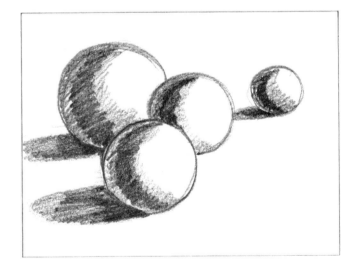

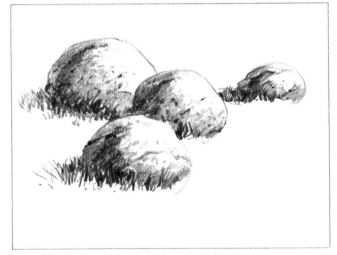

Spheres in Light and Shade. A sphere, like a cylinder, is a rounded form, so the tones wrap softly around the sphere and seem to flow together. Rendering the gradations of light and shade on a sphere takes practice. Put a tennis ball—or any kind of pale ball—near a window so that it receives strong light, and then practice rendering the tones with broad strokes, made with the side of the pencil. Exaggerate the areas of light, halftone (or middletone), shadow, and reflected light, as you see here, so they remain firmly fixed in your memory.

Rounded Rocks in Light and Shade. When you draw real boulders scattered in a grassy field, the rocky textures will be rough and irregular, making the gradation of light and shade harder to see. Render the tones with rough, irregular strokes, but vary the strokes so that they're lighter or darker to match the tonal areas you've seen on the tennis balls. Like the geometrically perfect balls at the left, these boulders are lit from the right, so there's a right-to-left gradation of tone from light to halftone to shadow to reflected light.

Spheres (Plus Cylinders). Trees and shrubs rarely look exactly like spheres, but it's often helpful to visualize them as spherical forms, just as it's helpful to visualize their trunks as cylinders. If the mass of foliage looks as if it would fit into a circle, you can begin with a circular guideline and then chop holes into the geometric form when you draw the actual tree.

Trees. The leafy masses of these three trees are all roughly circular, although the actual outline of the trees contains big gaps and doesn't look circular at first glance. The trunks are basically cylindrical, even though each trunk diverges to form branches above and spreads slightly at the bottom of the cylinder where the roots go underground. These spherical and cylindrical forms will become more apparent when you add light and shade to the trees.

Spheres (Plus Cylinders) in Light and Shade. Before you start to add tone to the trees, remember what you've learned about the gradation of light, halftone (or middletone), shadow, and reflected light on spheres and cylinders. Remember, too, that a rounded form casts a rounded—or elliptical—shadow on the ground.

Trees in Light and Shade. The tones of the leafy masses follow the same progression as the tones on the geometric sphere. Although your pencil strokes can look rough and irregular—to convey the texture and detail of the leaves—place your lighter strokes in the halftone areas, your darker strokes in the shadows, and allow some space between the strokes to suggest reflected light within the shadows. Follow the same sequence of tones when you render the cylindrical trunks and branches. Group your "grassy" strokes to make the shadows look like rough ellipses.

Step 1. Drawing outdoors, you often find trees and rocks with shapes that are essentially round. In this landscape drawing, the artist begins by drawing circular guidelines with light touches of a sharpened pencil. Then, working within the simple geometric shapes, he constructs the realistic shapes of the trees and rocks. Notice how the irregular outlines of the trees move back and forth over the circular shapes but still remain roughly faithful to the circle. The rocks really start out as half circles, since the lower part of the rock is buried in the ground, and then the artist draws flatter, more angular lines over the half circles.

Step 2. Using the side of the pencil, the artist blocks in the big shapes of the darks. The sunlight comes from the sky in the upper left, so the darks appear on the right sides and on the undersides of the leafy masses—and on the right sides of the boulders. The cylindrical tree trunks are mostly in shadow. As he blocks in the tones, the artist keeps in mind the behavior of light and shade on spherical forms.

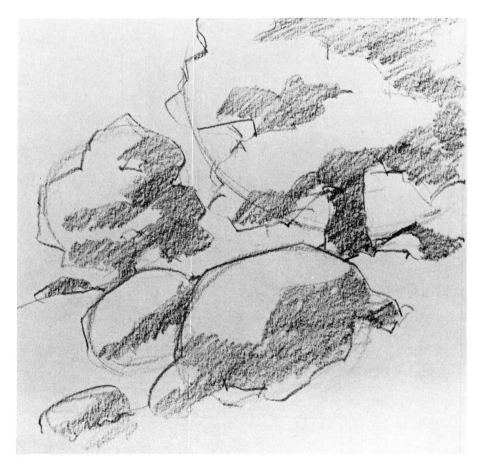

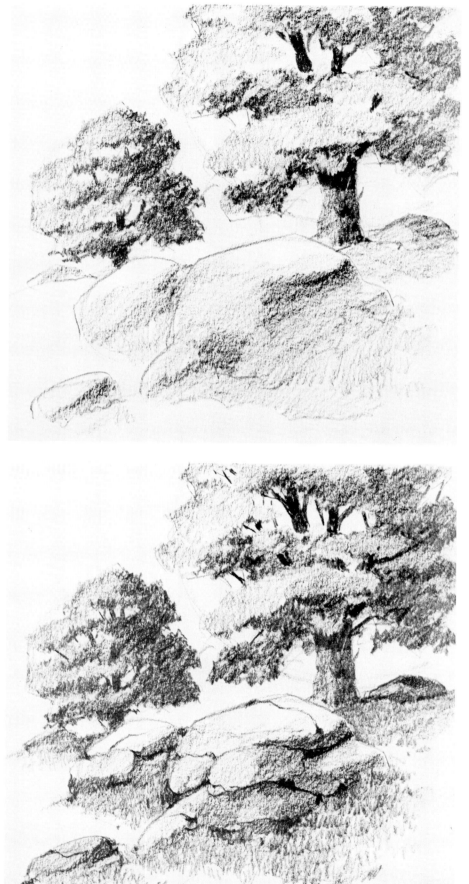

Step 3. Now the artist adds the half-tones (or middletones) and strengthens the darks. Although the tones are obviously broken up by the clusters of foliage, it's easy to see how the tones on the smaller tree at the left behave like the gradations on a sphere. The tones on the big tree trunk at the right are like the gradations on a cylinder. The artist establishes a strong distinction between the lighted tops and shadowy sides of the rocks, which now look blockier—like spheres that have been flattened. Notice how the shadow sides of the rocks grow lighter toward the right, where they pick up some reflected light from the sky.

Step 4. So far, the artist has been working entirely with big masses of tone. Now he goes back to add the details and strengthen the tones in the final stage of drawing. He adds more branches to the trees, broadens and darkens the shadows on the leaves, and suggests individual leaves with quick strokes made by using the side of the pencil. He scribbles in the grass with short vertical strokes. And most interesting of all, he takes the big geometric shapes of the rocks and breaks them into smaller shapes by adding cracks and stronger shadows. Half-close your eyes and you'll see that the clusters of rocks here are really quite faithful to the simplified geometric shapes of the rocks in Steps 2 and 3.

Construction Lines. Obviously, there are landscape subjects that you *can't* start out by drawing as cubes, cylinders, or spheres. Although you can't find a geometric shape that does the job, you *can* study your subject carefully and draw simple shapes that will act as guidelines. Here's how you might visualize some clumps of snow on the branches of a tree.

Snow-Covered Branch. Having drawn the simplified shape with free, rapid strokes, you can go back over those guidelines with more precise strokes that render the snow, foliage, and branches more realistically. When you erase the original guidelines, you have an accurate line drawing of your subject—handsome even without light and shade.

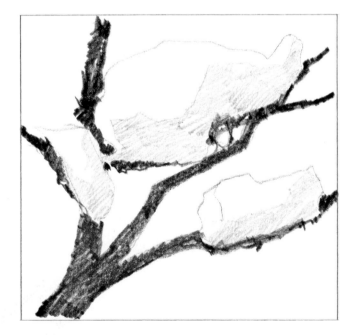

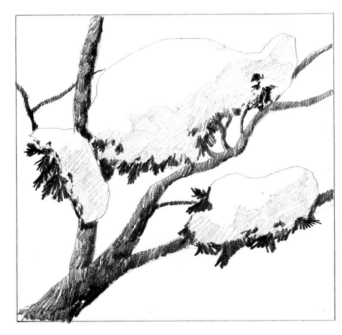

Light and Shade. On this irregular form, light and shade won't behave as they do on geometric forms, but study each shadow carefully and you'll find that it does have its own distinct shape. Begin by sketching the simple shadow shape and filling it with tone—or just keep the simplified shape of the shadow in mind when you make a realistic drawing like the one at right.

Snow-Covered Branch in Light and Shade. The realistic line drawing at the top of the page becomes three-dimensional as the artist adds tones to the masses of snow, as well as to the branches and foliage. The clumps of snow aren't soft, shapeless masses, but have distinct planes of light and shadow which give them a feeling of realism and solidity.

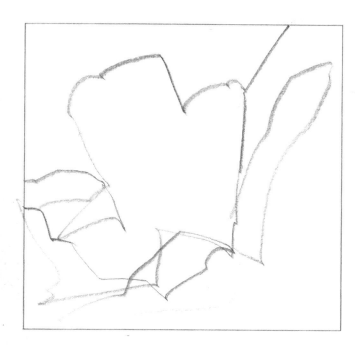

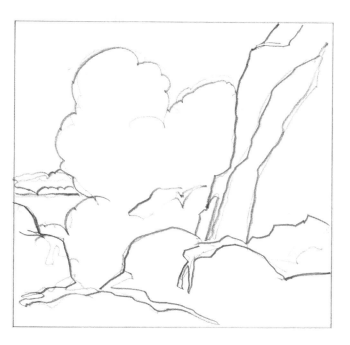

Construction Lines. Some nongeometric shapes seem hard to draw because they keep moving and changing—such as a crashing wave. Keep your eye on the exact spot where wave after wave hits the same rock formation, and you'll find that the leaping surf assumes a similar shape again and again. Fix that shape firmly in your mind and record the contours with a few rapid strokes.

Surf. Don't worry if your first rapid, highly simplified drawing doesn't look much like surf and rocks. Now you can go back to work, observing the surf and rocks more carefully and converting the simplified shapes to a more realistic line drawing. The important thing to remember is that the shape of the surf isn't vague and fluffy, but just as solid as the rocks.

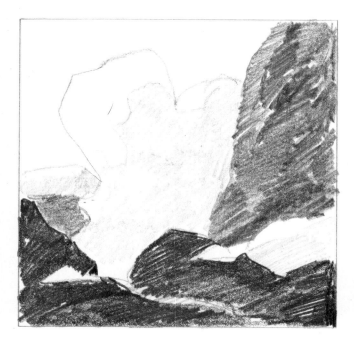

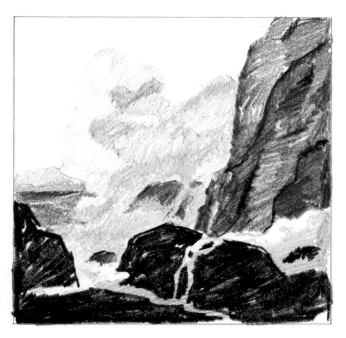

Light and Shade. Now study the distribution of light and shade on the surf as it continues to break against the rocks. Like any other solid form, the surf has distinct planes of light and shadow. You can make a highly simplified sketch of the light and shadow shapes—as you see here—or just keep these shapes in mind when you do a more realistic drawing like the one at right.

Surf in Light and Shade. Here's a more realistic drawing of the light and shade on the surf and rocks. The tonal areas are rendered with broad strokes, made with the side of the pencil. The original line drawing is erased. Now the planes of light and shadow stand by themselves, equally distinct on the pale form of the surf and the darker forms of the rocks.

Step 1. Because clouds often have fuzzy edges and change constantly as they're pushed along by the wind, they may seem vague and shapeless at first glance. But every cloud has a distinct shape, even though it may not be a geometric one. Here, the artist concentrates on the broad outlines of a few cloud shapes—paying no attention to the intricate contours—and quickly records these outlines with a minimum number of strokes. At this stage, the clouds don't look soft and puffy, but that doesn't matter. What's essential is to put some guidelines on paper as rapidly as possible. The clouds can be made rounder and softer in the next stage.

Step 2. By the time the guidelines of Step 1 are on the paper, the clouds have already begun to change form as they move across the sky. Still working quickly, the artist studies the moving shapes in the sky and draws freely around the guidelines with rounder, more precise strokes that produce a more realistic rendering of the clouds. He doesn't follow the guidelines slavishly, but arrives at a kind of compromise between the highly simplified shapes of Step 1 and the rounder, softer, more intricate shapes of the clouds. Step 1 also contains guidelines for the hills, which he reinforces here.

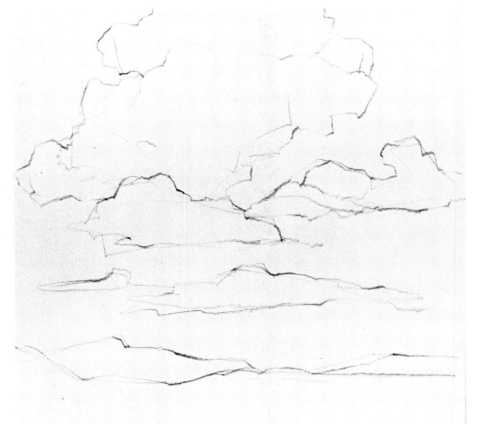

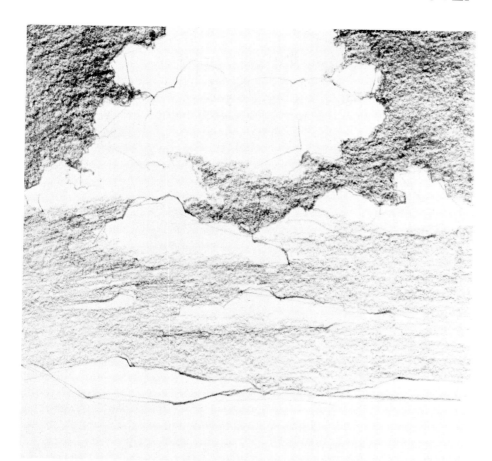

Step 3. Working with the side of the pencil, the artist moves around the cloud shapes with broad, rough strokes that are broken up by the texture of the paper. He fills the cloudless areas of the sky with tones that surround the cloud shapes and make them more distinct. Notice how the sky grows darker at the zenith and paler at the horizon.

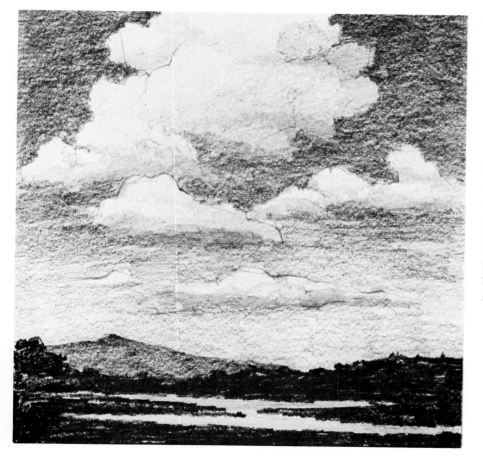

Step 4. Finally, the artist blocks in the shadow areas of the clouds with broad strokes that are paler than the surrounding sky. He doesn't scrub in patches of tone indiscriminately, but remembers that a cloud is a solid, three-dimensional form with clearly defined areas of light and shadow. In this drawing, the light strikes the clouds from above and to the left, which means that the shadow areas will be on the right sides and along the bottoms of the forms. The completed clouds look soft, but as round and solid as any geometric form. The artist finishes the drawing by darkening the shapes of the landscape with broad horizontal strokes, using the side of the pencil.

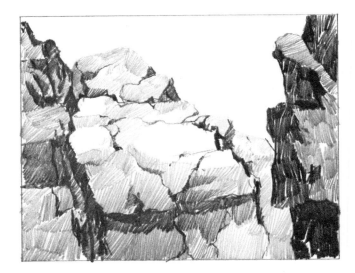

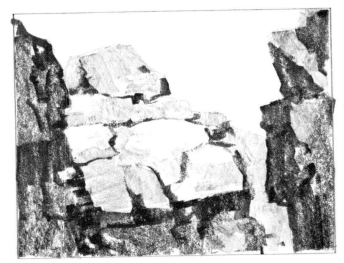

Slender Strokes. There are many ways to render landscape forms with a graphite pencil. Working with the sharpened tip of the pencil, you can build up the halftones and shadows with groups of parallel strokes, as you see here. Notice the direction of the strokes: some move across the tops of the rocks, while others slant down the diagonal planes and move down over the vertical planes. The artist presses lightly on the pencil for the halftones, leaving spaces between the strokes. For the darker tones, he presses harder on the pencil and leaves less space between the strokes.

Broad Strokes. The pencil can be used in a totally different way to draw the same subject. You can use the side of the lead or you can sandpaper the tip to a broad, flat shape for making wider strokes—like the strokes made by the squarish end of an oil-painting brush. In this study of the same rock formation, the artist creates blocks of tone by laying broad strokes side by side. He puts less pressure on the pencil for the paler tones and presses harder for the dark tones. He places the pale strokes side by side, but piles one stroke over another for the darker areas.

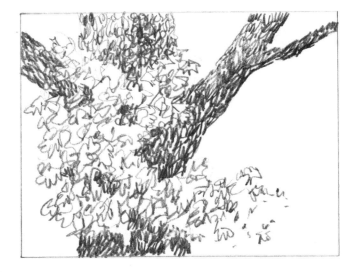

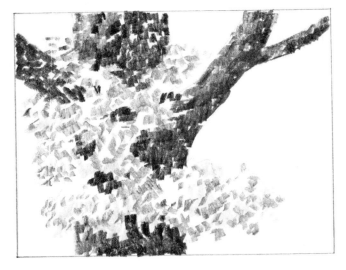

Scribbled Strokes. The movement and direction of your pencil strokes will also make an important difference in the character of the drawing. To render the rough bark of a tree and the lively detail of the foliage, you might choose short, scribbled strokes like those in this drawing. The artist moves his pencil quickly back and forth, placing his strokes close together to suggest the dark tone and rough texture of the branches. He uses a more open scribble—with more space between and around the strokes—to suggest the paler tone and the lacy texture of the leaves.

Straight Strokes. Now, blunting his pencil point on a sandpaper block, the artist renders the tone and texture of the same branches with short, thick strokes. He packs his strokes densely, side by side, applying less pressure in the lighted areas and pressing harder on the shadow sides of the branches. He lets the strokes show distinctly to suggest the roughness of the bark. He uses the same kind of strokes to suggest the cluster of leaves, but then he allows more space between the strokes, allowing the bare paper to show through to suggest the flicker of sunlight on the foliage.

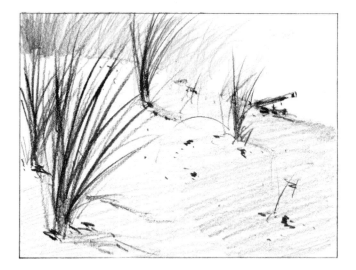

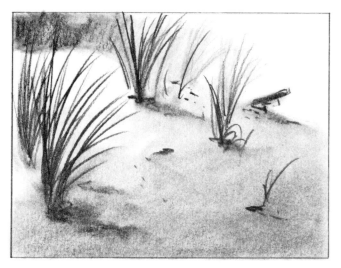

Modeling with Strokes. In this close-up of a section of a large landscape, you can see how the artist uses long, parallel strokes to model the form and suggest the gradation of light and shade on a sand dune. The parallel strokes move diagonally over the shape of the dune to suggest the slant of the beach. At the same time, the strokes gradually grow darker as they move toward the lower right, suggesting the gradation from sunlight to halftone to shadow. The clumps of beach grass are drawn with sharp, curving strokes, paler in the distance and darker in the foreground.

Modeling by Blending. Here's an alternate way to model the solid form of the dune. Beginning with strokes similar to those in the illustration at left, the artist blends the strokes with a fingertip—or with a stomp—so that the strokes disappear and merge into a soft, velvety tone. Once again, the tone is darkest at the right and at the lower edge of the picture to suggest the gradation from light to halftone to shadow. The beach grass in the foreground is drawn with distinct strokes, while the distant clump of grass in the upper left is blended and looks more remote.

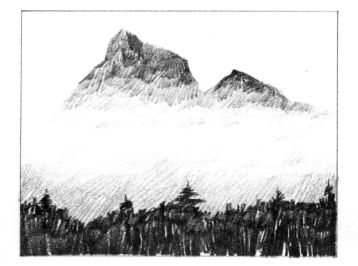

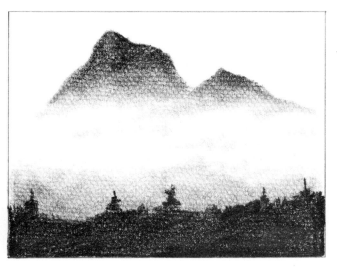

Strokes on Rough Paper. Rough paper tends to blur and soften the pencil stroke, so this surface is particularly effective when you want to create a sense of atmosphere and distance in a subject like these misty mountains. The artist works with clusters of strokes. He lets the pencil point glide lightly over the textured paper to produce the evanescent tones where the mountains fade into the mist. He really bears down strongly on the point to draw the dark trees, and then he moves softly over the paper to suggest the misty tones above them.

Blending on Rough Paper. Textured paper also lends itself to the soft, blended tones made by a fingertip or a stomp. Here, the artist redraws the misty mountains with strokes similar to those in the drawing at left, but this time he blends them until the strokes disappear and form a soft veil of tone. You'll find it particularly easy to create beautiful blended tones on rough paper. And, as you see here, the texture of the paper shows through the blended tones, making them look more vibrant.

Step 1. Certainly one of the most common landscape elements—and one of the most beautiful to draw—is the bold form of a tree in full leaf. Such a tree is full of intricate texture and rich detail, which you must force yourself to ignore in the first stages of your drawing. Observe how the artist draws the masses of leaves as big, jagged shapes, paying no attention to individual leaves but concentrating entirely on a highly simplified outline. He also looks for gaps where the sky shines through the leaves. And he makes a quick, relaxed contour drawing of the trunk and branches, concentrating on the major shapes and omitting the smaller branches that will appear later. Just a few lines suggest the ground, rocks, and distant hill.

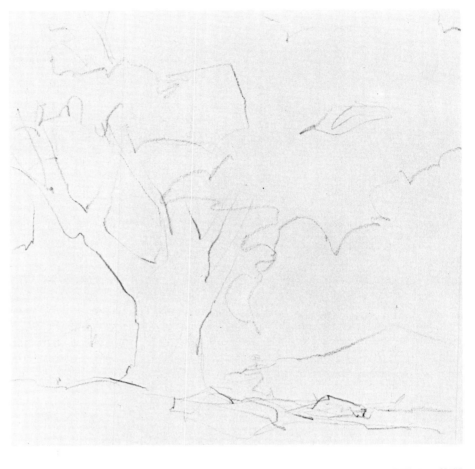

Step 2. Pressing harder on the point of his pencil, the artist goes back over the leafy shapes with short, curving, expressive lines that begin to suggest foliage—but he still doesn't draw a single leaf. He also studies the trunk and branches more closely, drawing the shapes more precisely and indicating some more branches. Finally, he strengthens the contours of the foreground rocks, the shrubs, and the hill in the lower right. The drawing is accurate, but still very simple.

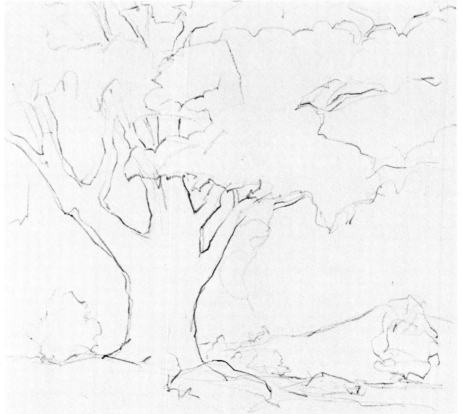

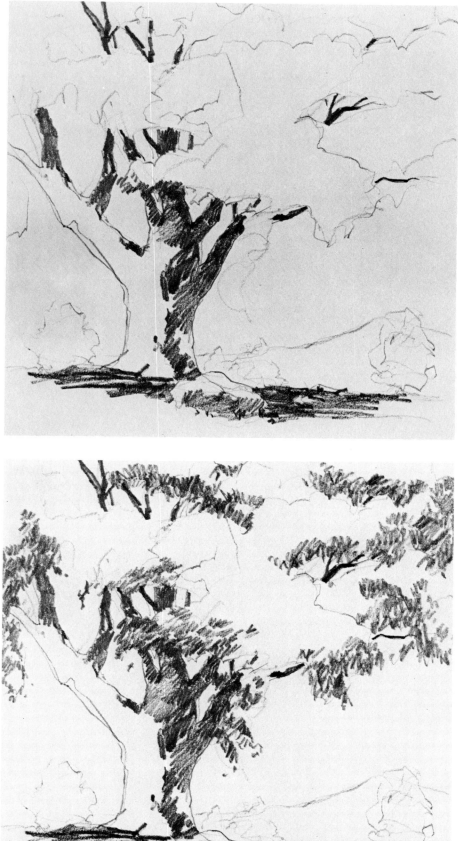

Step 3. The next step is to block in the shapes of the darks. The line drawing has been done with an HB pencil, but now the artist reaches for a softer, darker 3B pencil, which he turns sideways to block in the tones with the side of the lead. He works with broad parallel strokes to create patches of tone. After covering the shadow areas of the main trunk, he moves upward to indicate the shadowy branches showing through the gaps in the foliage. With long, horizontal strokes, he suggests the shadow that the tree casts on the ground. And he blocks in the shadowy side plane of the rock in the foreground.

Step 4. Still concentrating on the shadow, the artist switches his attention to the masses of leaves. The shadows appear on the undersides of the leafy masses; the artist draws them with dark, scribbly strokes that actually suggest the texture of the leaves. As he moves the pencil back and forth, he changes direction slightly to suggest the irregular clusters of foliage. Not a single leaf is actually drawn, but the expressive strokes give you the feeling that the leaves are really there.

Step 5. The artist moves on to the lighted areas of the trunk, the big branch at the left, and the foliage above. Notice how he works with clusters of parallel strokes that suggest patches of tone on the trunk and branch, while also conveying the texture of the bark. The pale groups of leaves are also drawn with clusters of pencil strokes, but these clusters are smaller and keep changing direction. Some leafy strokes are slanted, while others are more horizontal or vertical. And some strokes are straight, while other curve slightly. This random pattern of leafy strokes is a very simple means of suggesting rich texture and detail. The artist also adds tone to the lighted top of the foreground rock.

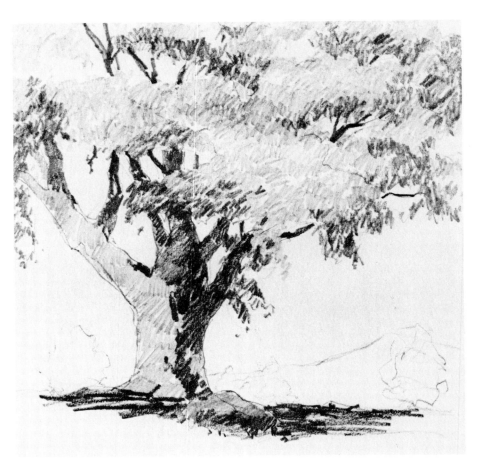

Step 6. Having established the broad distribution of tones on the tree and in the foreground, the artist can now begin to strengthen these tones and suggest more detail. Pressing harder on the side of the 3B pencil, he piles stroke over stroke to darken the shadow sides of the trunk and branches, also suggesting a few cracks in the trunk. (Notice how the trunk is modeled like a cylinder, with a hint of reflected light at the right.) The artist also builds up the dark undersides of the leafy masses with darker, denser, scribbly strokes. He adds more dark branches in the gaps between clusters of leaves. He covers the distant hills and trees with broad, pale strokes that make them seem remote. And a few touches of the pencil suggest grass.

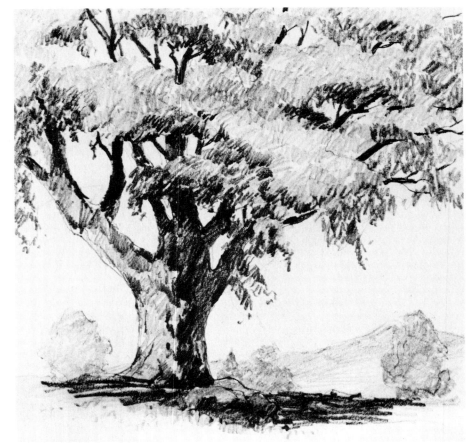

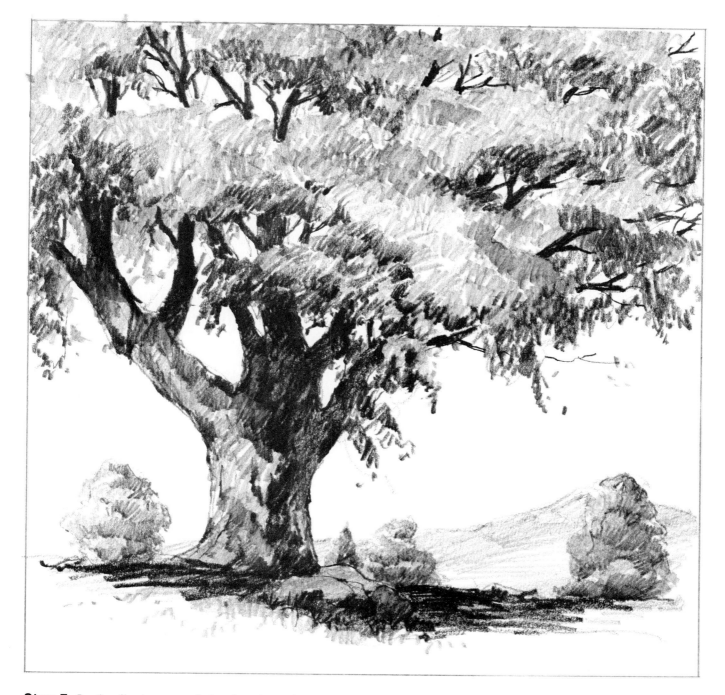

Step 7. In the final stage of the drawing, the artist continues to deepen the tones and add detail and texture. Smaller clusters of strokes enrich the texture of the thick trunk and lower branches. The shadowy undersides of the leafy masses are darkened with short, scribbly strokes— most apparent on the right. The sharp point of a 2B pencil adds slender twigs among the foliage; you can see these most clearly on the right and toward the top of the picture. Here and there, a quick touch of the pencil suggests a single leaf hanging down from the mass of foliage and silhouetted against the sky. The side of the HB pencil darkens the shadow on the ground with horizontal strokes. Pressing more lightly on the pencil, the artist adds shadows to the distant trees and darkens the slope of the distant hill—but these remain distinctly lighter than the big tree. The landscape obeys the rules of aerial perspective: foreground objects are darker and more detailed, while the shapes in the distance are paler and show a minimum of detail. This demonstration is also a good example of a drawing in which a wealth of texture and detail is rendered very simply: the artist relies primarily on clusters of broad strokes, made by the side of the pencil.

Step 1. It's important to explore all the different kinds of strokes that you can make with a graphite pencil. A subject such as a meadow—with rocks, trees, and hills in the distance—will challenge you to find varied combinations of lines and strokes to suit the various parts of the landscape. As always, it's best to start with a very simple line drawing of the main shapes, as the artist does here. It's really impossible to suggest the intricate detail of the meadow at this stage, so the artist draws just the distant rock formation and suggests the trees and one hill beyond. He works with the sharp point of a 2B pencil, gliding lightly over the surface of the drawing paper.

Step 2. Now he sharpens the contours of the rock formation and draws the shapes more precisely, looking for the divisions among the rocks. He also draws the spiky shapes of the trees more distinctly but doesn't define them too precisely, since the preliminary line drawing will soon be covered with broad strokes. A few slanted lines place the hills in the distance. And a very important scribble establishes the division between the shadowy foreground of the meadow and the sunlit field beyond—a division which won't become apparent until the final stage of the drawing.

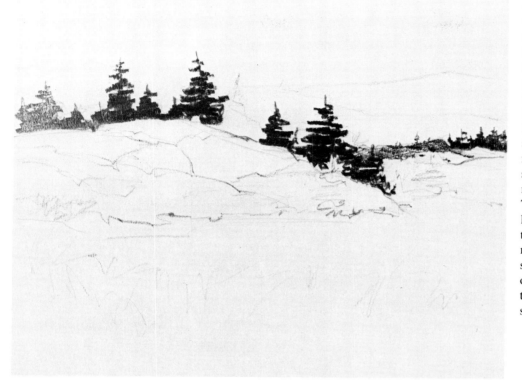

Step 3. With a thick, dark 4B pencil sandpapered to a flattened tip, the artist begins by drawing the darkest notes in the landscape: the evergreens above the rock formation. He draws the clusters of foliage with broad, horizontal lines, allowing gaps of sky to show through. He applies more pressure on the pencil to suggest that some trees are nearer and darker than others. The trees at the extreme left—and the strip of very distant trees at the extreme right—are drawn with lighter strokes to suggest the effect of aerial perspective. The trunk of each tree is a single slender, vertical stroke.

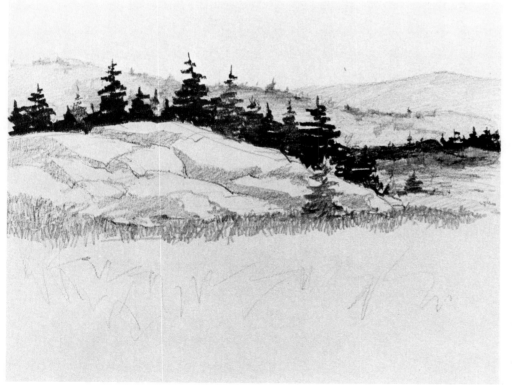

Step 4. With the side of the 2B pencil, the artist blocks in the shadow planes of the rock formation. The sunlit tops and the shadowy sides are clearly defined. He begins to suggest the grass at the base of the rock formation with short, scribbly vertical strokes. He adds paler trees above and below the rocks, again working with horizontal strokes for the masses of foliage. Letting the side of the pencil glide lightly over the paper, he covers the distant hills with tone and suggests a few trees on the long slope behind the darker trees. Notice how the nearest hill at right—the low one crowned with a slender grove of trees—is darker than the hills beyond.

DEMONSTRATION 2. MEADOW

Step 5. The artist covers the entire meadow with clusters of slender strokes, using the tip of the 2B pencil. He applies very little pressure, moving the pencil rapidly up and down, and changing direction slightly so that some clusters lean to the left and others, to the right. The scribbly marks of the pencil are short and dense in the distance, gradually growing longer as they approach foreground. You already have a distinct sense of distance, since the foreground grasses are taller and more distinct than those in the distance. The artist darkens the low hill at the right with vertical strokes.

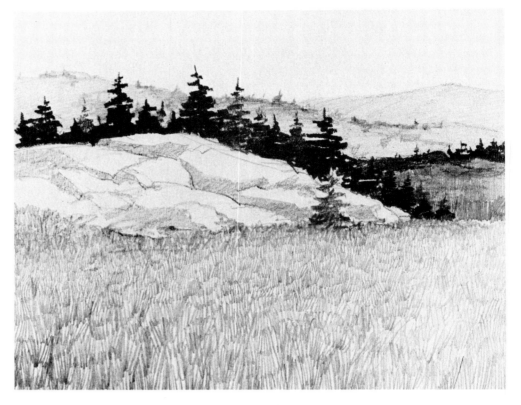

Step 6. Moving away from the foreground for a moment, the artist concentrates on the rocks and trees in the middleground. Pressing hard on the point of a 3B pencil, he draws the cracks between the rocks with strong, dark strokes and begins to darken the shadows within these cracks. He breaks up the original forms to suggest more rocks than were there before. He draws the trunks and branches of some leafless trees at the left along the top of the rock formation, also adding more evergreens at the extreme right. The rock formation casts a shadow on the meadow at the extreme left, which the artist suggests by adding short, dark strokes to the grass.

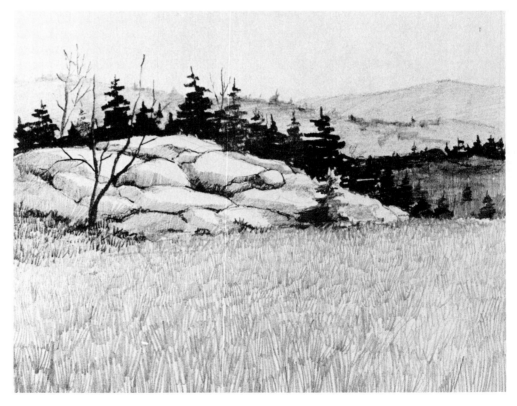

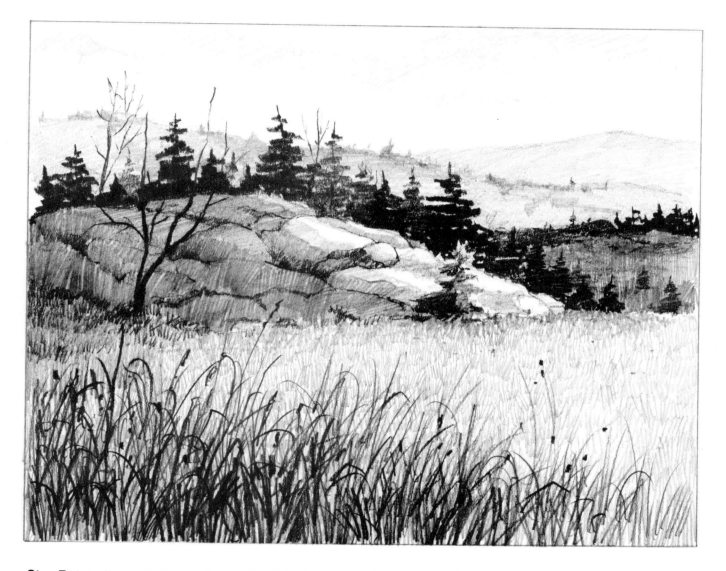

Step 7. Actually, most of the rock formation is in shadow, but the artist waited to add this big patch of shadow until he'd defined the shapes of the rock in Steps 1 through 6. Now he goes back over the rock formation with broad parallel strokes to cover almost all of the rocks with shadow, leaving only a few patches of sunlight. Suddenly there's a much more dramatic contrast between the shadowy rocks and the sunlit meadow. To make the one bare tree stand out against the shadowy sides of the rocks, he darkens the trunk and branches. But now the artist remembers the scribbly line that appeared across the foreground in Step 2—and which has long since disappeared. That scribbly line established the division between the dark weeds and grasses in the immediate foreground and the sunny area of the meadow beyond. With the sharpened point of the 2B pencil, the artist adds the rich detail of the weeds and grasses at the lower edge of the picture, working with a lively pattern of slanted and curving strokes, some dark and some light, always leaving gaps between the strokes to let the sunlight shine through. The intricate detail of the meadow is kept entirely in the foreground; the sunlit area is left alone. Too much detail would confuse and distract the viewer—and the artist knows just when to stop. A few groups of slanting strokes suggest clouds in the sky, and the drawing is done. Now, before going on to the next demonstration, see how many different kinds of strokes you can find in this study of the meadow. Compare the broad, rough, horizontal strokes of the trees; the patches of straight, slender strokes representing the shadow side of the rock formation; the slender, scribbly strokes of the meadow; the long, crisp, rhythmic strokes of the grasses and weeds in the foreground; and the soft slanted strokes that represent the distant hills and sky.

Step 1. To learn how pencil behaves on rough paper, find a landscape subject that contains a variety of textures—like this demonstration combining the smooth texture of water, the rough texture of a rocky shore, and the surrounding detail of trees. This subject is rich in detail, but the artist begins with a very simple line drawing of the main shapes. He draws the edges of the shore and the shapes of the shoreline; the trunks of the trees on either side of the stream; and the masses of foliage—all with a minimum number of lines. The artist visualizes everything as simple shapes in which the subject is barely recognizable.

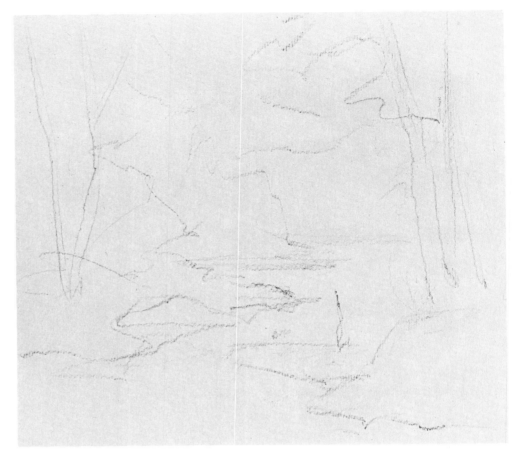

Step 2. Working with the same sharply pointed HB pencil he used in Step 1, the artist carefully converts those first few lines into a realistic line drawing of the complete landscape. The shoreline rocks, fallen tree trunk, upright trunks, and distant, tree-lined shore emerge clearly. The pencil lines are still relaxed and casual. They're not too precise because the artist knows that they'll soon disappear under strokes and masses of tone. Notice how this line drawing already begins to obey the rules of aerial perspective: the rocks, trees, and fallen tree trunk in the foreground are drawn with more precision and detail than the simple masses of the distant shoreline.

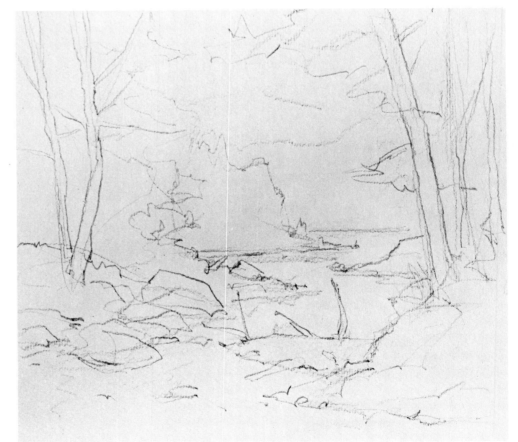

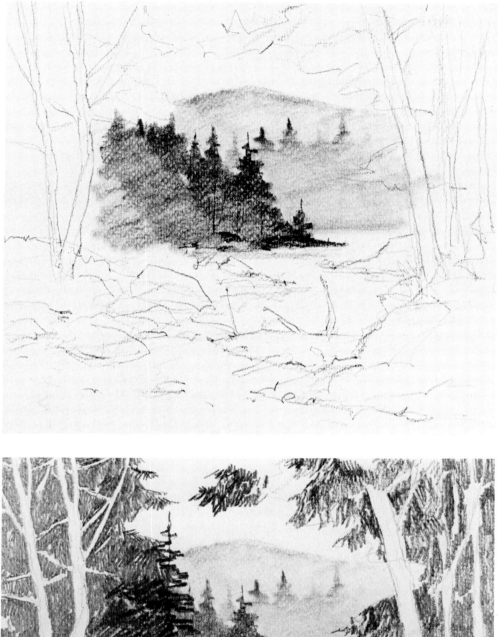

Step 3. Because he wants his drawing to have a sense of deep space, the artist starts with the most distant forms. He moves the side of a 4B pencil lightly over the textured paper and blends the strokes with his finger to create veils of tone for the distant hill and the tree-covered shoreline. For the nearer, darker shoreline, he presses harder on the pencil and blends the tones lightly, allowing some strokes to show. He presses just a bit harder on the pencil to suggest the shapes of some evergreens—drawing the foliage with horizontal strokes and the trunks with vertical ones. The shapes of the distant landscape are in correct aerial perspective.

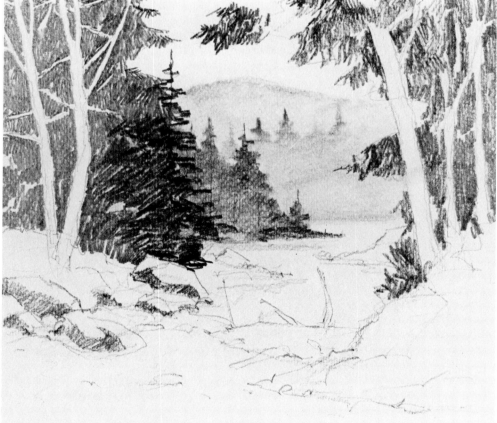

Step 4. Moving to the middleground, the artist switches to a slightly harder 2B pencil which will draw more precise strokes. Working around the tree trunks on each side of the stream, the artist draws clusters of parallel strokes to suggest the foliage behind and around the trees. To draw the foliage at the right, he presses harder on the pencil and draws more distinct strokes to suggest that the foliage is closer to the foreground. With parallel slanted strokes, the artist blocks in the shadowy sides of the rocks at the left. Pressing really hard on the pencil, the artist adds a new element to the picture: he creates a dark evergreen to the left of the stream.

Step 5. The artist blocks in the shadow planes of the rock formation at the lower right and adds grass to both shores with clusters of short vertical strokes—packing these strokes densely together to suggest the shadow beneath the tree at the left. Moving upward, he models the pale tree trunks at the left like crooked cylinders: you can see the gradation from light to dark. The trees at the right have a rough, patchy tone, which the artist renders with clusters of dark and light strokes. Piling a dense layer of new strokes on the dark evergreen at the left, the artist deepens the tone of the foliage. Between the two groups of trees, he adds some smaller rocks that jut out into the stream.

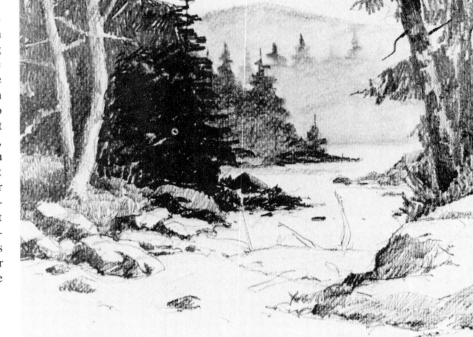

Step 6. The artist moves to the foreground. He draws the fallen tree trunk in the stream with a sharply pointed 2B pencil, emphasizing the crisp detail of the trunk and branches —and modeling the tones—with clusters of slender, distinct lines. With the side of a thick, soft 4B pencil, he darkens the shadow planes on the rock formation at the lower right and then adds broad, wiggly strokes to the water, suggesting the movement of the stream and the lively reflection of the trees at the left. He blends these tones with a stomp, making more wiggly lines with the darkened tip of the stomp. Then he adds even darker reflections over the blended tones at the lower left.

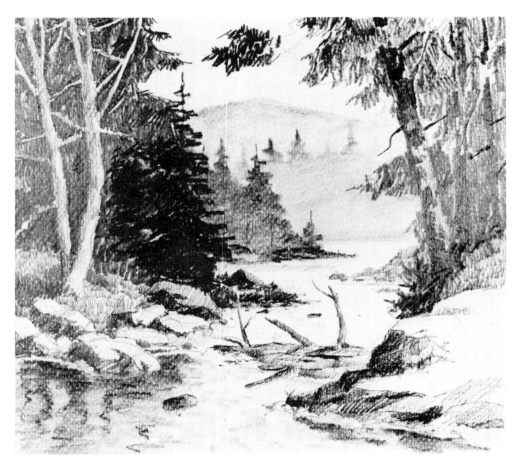

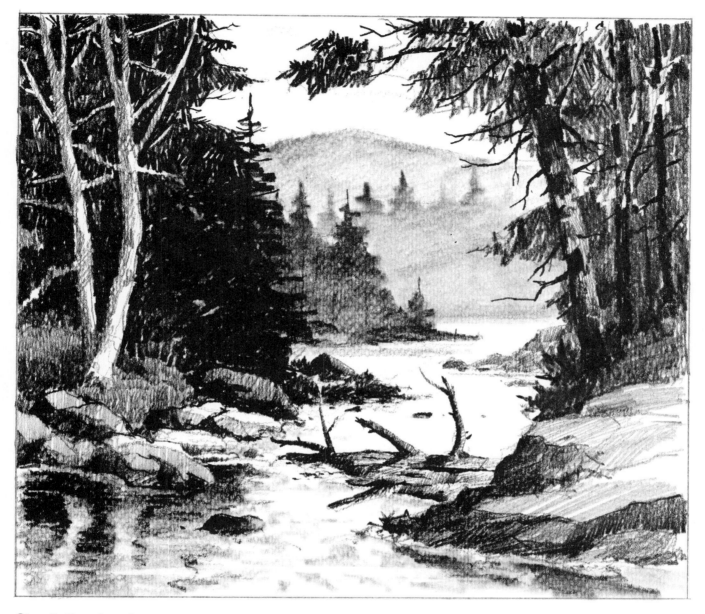

Step 7. Now the artist moves back over the entire picture with a sharply pointed 3B pencil to add crisp touches of detail, and with a blunt-tipped 4B pencil to darken the tones. Fresh clusters of parallel strokes darken the foliage. The pointed pencil adds more branches and twigs. Now the pale tree trunks at the left stand out more brightly against the dark background of the foliage. To make the darker trunks at the right stand out too, the thick pencil darkens the trunks with vertical black strokes. The sharp pencil moves downward to darken the grass with dense clusters of vertical strokes—which are also carried over the rocks at the left, leaving occasional patches of bare paper to suggest flashes of sunlight. Clusters of slanted strokes darken the tops of the rocks on the lower right, again leaving an occasional patch of bare paper to suggest sunlight. The sharp pencil strengthens the jagged contours of the fallen tree trunk in the stream, darkens the cracks in the trunk, and deepens the shadows. The sharp pencil also adds wiggly strokes on the lower left to darken the reflections. The stomp blends some of these strokes but leaves others intact—and then the

graphite-coated point of the stomp adds soft, wiggly strokes to the sunlit center of the stream. Finally, the artist goes back over the pale hill silhouetted against the sky and the tree-covered shoreline in the distance, to darken these shapes very slightly; the stomp blends the pencil strokes into soft, misty tones. To emphasize the contrast between the darks of the shoreline and the sunlit areas of the water and sky, the artist squeezes a kneaded rubber eraser to a narrow wedge shape and carefully cleans the areas of bare paper. The sharp point of a pink rubber eraser is drawn across the foreground stream to suggest bright lines of sunlight reflected in the water. Finally, the tip of the kneaded rubber eraser is squeezed to a point to brighten the sunlit patches on the tree trunks and rocks at the left. Notice how the rough texture of the paper performs two very different functions. The tooth of the paper enlivens the rich pattern of strokes that render the foliage, grass, and rocks. And the pebbly texture of the paper lends a soft, airy quality to the smudged sections—in the water and in the distant hills.

Step 1. One of the great advantages of textured paper—whether it's charcoal paper or something even rougher—is that you can do a lot of blending without making the drawing look vague and blurry. The texture of the paper makes the blended tones look bold and vital. A coastal landscape, with its smooth sand and rugged rocks, will give you a good chance to combine soft blending with bold strokes. In this preliminary line drawing, the artist concentrates entirely on the silhouettes of the big rock formations and the zigzag lines of the shore. The lines are drawn lightly with an HB pencil; they'll disappear under firmer lines in Step 2.

Step 2. Studying the shapes of the rocks and shoreline more closely, the artist draws the exact contours with darker lines. The artist is free to redesign nature when necessary, so he decides that the big central rock is too low—and he dramatizes the form by pushing it higher into the sky. Inside its dark contours, as well as those of the smaller rock on the lower left, he draws lighter lines to suggest the division between light and shadow. This division will become more apparent in Step 3. Notice how carefully he draws the shape of the tidal pool that wanders across the beach in the foreground.

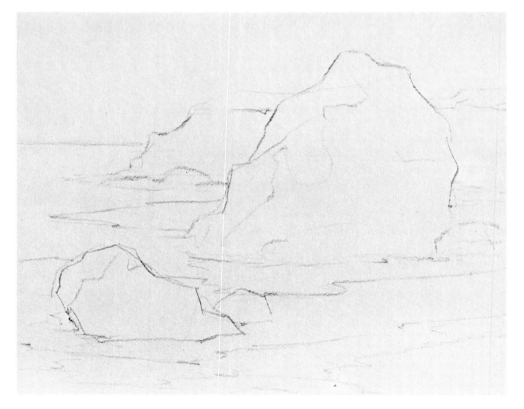

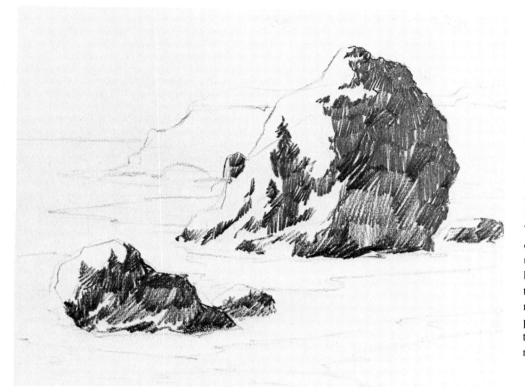

Step 3. The artist squares up the tip of a 2B pencil by rubbing it against a sandpaper pad. Then he renders the shadowy sides of the foreground rocks with clusters of parallel strokes. Notice how the groups of strokes change direction slightly to suggest the ragged, irregular shape of the rock. Compare the rendering of the shadows here with the delicate line that divides light from shadow in Step 2. That line in Step 2 may look casual, but it becomes a very useful guide when the artist begins to render the tones in this step. Observe how the rough paper breaks up the pencil strokes and emphasizes the rugged texture of the rocks.

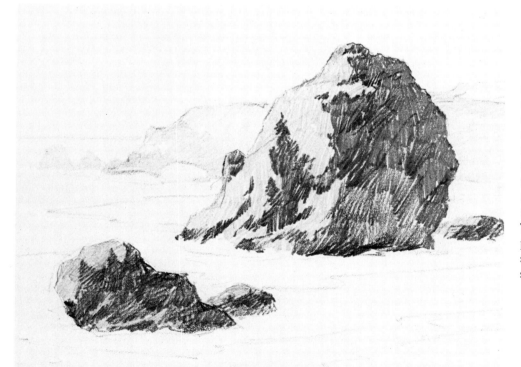

Step 4. Pressing lightly on the squarish end of the same pencil, the artist covers the lighted planes of the rocks with clusters of parallel pale strokes. As he's done in the shadows, he changes the direction of the clusters to suggest the irregular shapes of the rocks. Moving into the distance, he adds a still paler tone to the rocky headland and to the small rocks in the sea at the tip of the headland. To render this pale tone, the pencil glides lightly over the surface of the paper; the strokes are almost invisible.

Step 5. It's easy to blend the broad strokes of a soft pencil. So now the artist picks up a 4B pencil with a blunted tip and lets it skate very lightly over the pebbly surface of the paper to darken the tones of the beach—leaving bare white paper for the tidal pool. He blends these pale strokes with a stomp, merging them into delicate gray shapes. He also goes over the shape of the distant headland with the stomp, making the tones softer and more remote. The drawing begins to display a dramatic contrast between the rough strokes of the rocks and the soft, blended tones of the sand.

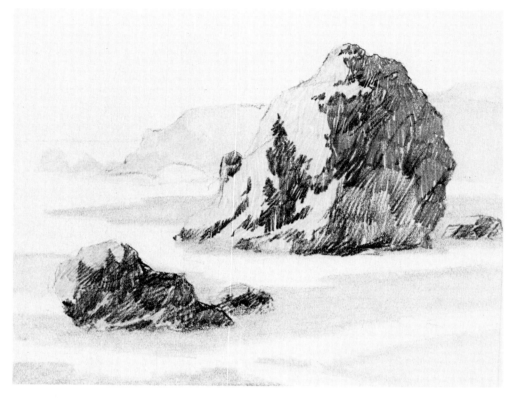

Step 6 (Close-up). Here's a close-up of a section of the finished drawing. In this final step, the artist accentuates the dramatic contrast between the blended tones of the beach and the boldly textured tones of the rocks. With a thick, soft, blunt-ended 4B pencil, the artist blackens the shadow planes of the rocks with clusters of scribbly diagonal strokes. Then he darkens the lighter planes as well, using the side of a 2B pencil. He darkens and blends the sand, and then adds a reflection in the tidal pool with the 4B pencil, blending the edges of the reflection with the stomp.

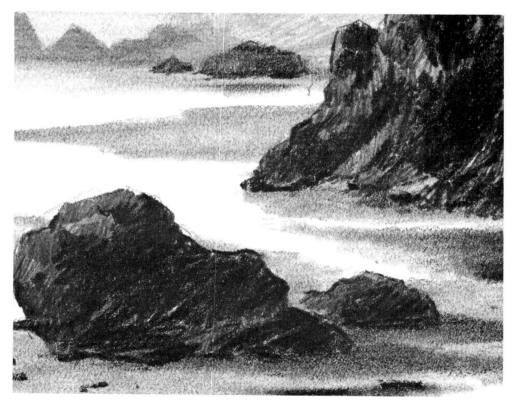

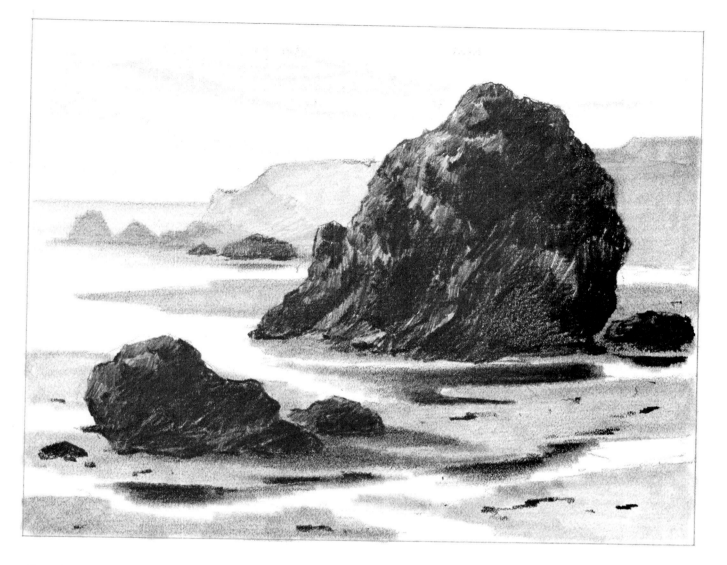

Step 6. This overall view of Step 6 shows how the artist has blackened the big rock with broad strokes of the 4B pencil. Notice how the pencil strokes are drawn in clusters, allowing hints of white paper to show through in order to suggest areas of the rock that receive more light. The tooth of the paper breaks up the strokes and adds to the illusion of texture in the rocks. The strips of sand have all been darkened slightly and blended with the stomp. Shadows are added to the right of the foreground rocks—with pencil strokes carefully blended by the point of the stomp. The tidal pools, which reflect light from the sky, remain bare paper, but the soft pencil has added the dark reflections of the rocks. These reflections are carefully blended with the stomp. The soft pencil travels lightly over the shape of the distant headland to add just a bit more tone; once again, the headland is blended with the stomp to produce a smooth gray tone. A few light pencil strokes suggest the edge of the sea at the left; these strokes are blended with the tip of the stomp. Finally, the blackened end of the stomp is used like a thick pencil to draw some streaky clouds in the sky. When you do a lot of blending with your fingertip or with a stomp, the white areas of the paper tend to become a bit gray as your hand moves over the drawing. So, to brighten the sky and the strips of bare paper representing the sunlit water, the artist uses two different erasers. He squeezes the kneaded rubber to a point that can get into the intricate shapes of the tidal pools and the foreground. To clean the broader areas of the sea and sky, he uses a wedge-shaped pink rubber eraser. The pink eraser tends to leave tiny crumbs of rubber on the surface of the paper. The artist doesn't brush these away with his hand, which might smudge the drawing, but blows them away. The finished drawing displays a wonderful contrast between the rugged strokes of the pencil, the delicate veils of tone produced by blending, and the brightness of the bare paper.

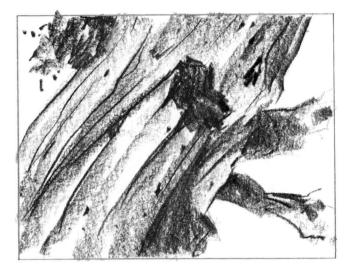

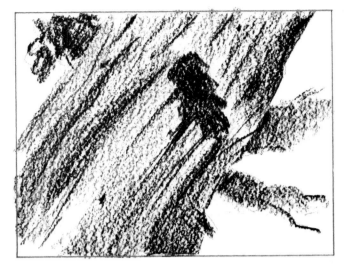

Strokes on Smooth Paper. When you draw with chalk, you'll find that the same subject will look radically different when it's drawn on different kinds of paper. Ordinary drawing paper (cartridge paper in Britain) is relatively smooth but does have a slight texture, which is apparent in this close-up of a tree taken from a larger landscape drawing. Although this texture enlivens the strokes, the marks of the chalk are crisp and distinct on the surface of the sheet. The lines are drawn with a sharp corner of the chalk, while the tones are drawn with the flat end of the chalk.

Strokes on Rough Paper. When the artist switches to rough paper, the pebbly texture of the sheet breaks up the marks made by the chalk. The broad strokes of the flat end of the chalk become wide blurs of tone. You can still see the crisp lines made by the sharp corner of the stick, but these lines are rougher and less distinct. Obviously, you should choose smoother paper for careful, precise drawings, while a rough sheet is best for drawings with bolder strokes and less detail.

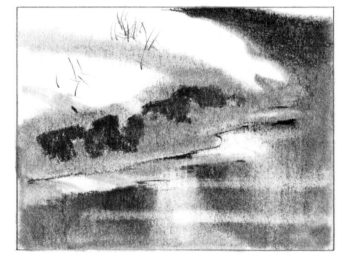

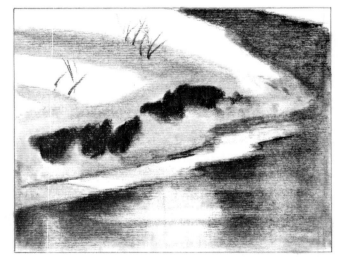

Blending on Smooth Paper. When you apply chalk strokes to smooth paper and smudge them with your fingertip or a stomp, the slight texture of the paper does come through, just as it does when you draw lines and strokes. But the texture of the paper lends a soft, irregular quality to the tones, rather than dominating the drawing. The blended tones have a slightly furry quality, as you can see in this close-up of a snow bank at the edge of a frozen stream.

Blending on Rough Paper. Here's the same subject drawn on the ribbed surface of charcoal paper. Once again, the artist starts with strokes of chalk and then blends them with a stomp. The tooth of the charcoal paper is more insistent than that of ordinary drawing paper, so the texture of the sheet appears in all the tones, making the tones softer and the shapes slightly less distinct. Charcoal paper, by the way, has a very hard surface that will take a lot of blending—and a lot of erasing when necessary.

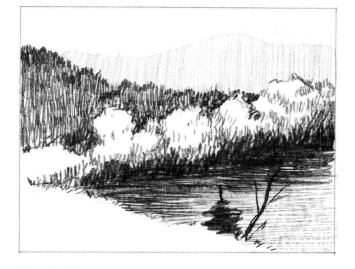

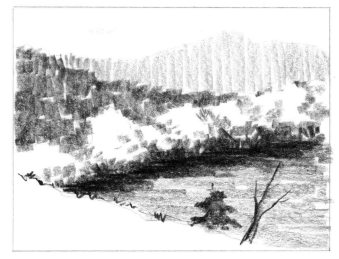

Slender Strokes. The sharp corner of the chalk can build tones with quite slender lines. And chalk in pencil form will make lines as slender as a graphite pencil. In this small section of a larger landscape, all the tones are created with clusters of slim lines. The sharp corner of the chalk glides lightly over the paper to create the palest tones, then presses harder to create the darker ones. The chalk marks are packed tightly together to create the strongest darks.

Broad Strokes. The flat end of the chalk will make broad, squarish strokes. Here's the same subject with the tones rendered in clusters of broad strokes. For his palest tones, the artist presses lightly on the chalk and leaves gaps between the strokes. He presses harder on the chalk and packs the strokes tightly together to create darker tones. The direction of the strokes is also important: notice that the slopes of the mountains are drawn with vertical strokes, while the flat water is drawn with horizontal ones.

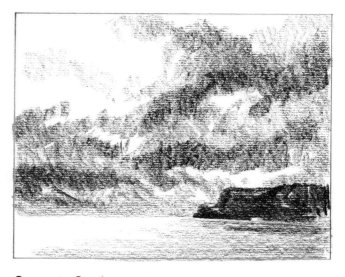

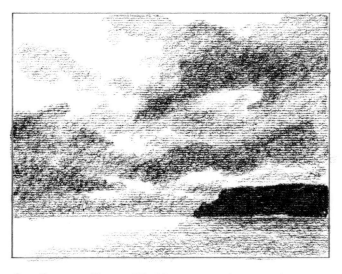

Separate Strokes. When you start a drawing, it's important to decide just what kind of strokes you expect to make. You can keep all your strokes separate and distinct, as you see in this group of clouds from a larger coastal landscape. Although the artist groups and overlaps his strokes, you can see the marks of the chalk quite distinctly. The lively pattern of independent strokes gives a feeling of movement and turbulence to the sky. And the ribbed texture of the charcoal paper roughens the chalk marks, making the clouds seem softer and more atmospheric.

Continuous Tone. Working on rough-textured paper—such as charcoal paper—you can let your strokes flow together softly so that the viewer doesn't see the individual chalk marks. The technique is to move the chalk lightly back and forth over the paper, never pressing hard enough to let a distinct stroke show. To darken an area, you go over it several times with light strokes so that the granules of chalk pile up very gradually. This technique is easiest on a rough-textured sheet, since the tooth of the paper shaves off and grips the granules of chalk.

Step 1. This demonstration drawing of mountains and evergreens will give you an idea of the variety of marks you can make with a stick of chalk—ranging from slender lines made with the sharp corner to broad strokes made with the squarish end or the flat side. As always, the artist begins with a very simple line drawing, using the sharp corner of the chalk. He draws the silhouettes of the cliffs, which look like irregular squares. He visualizes the cluster of evergreens at the foot of the cliff as a single mass—and he encloses this mass with just a few lines. The cluster of evergreens on the left-hand side of the picture is suggested with a zigzag line.

Step 2. Still working with the sharp corner of the chalk, the artist draws the contours of the cliffs more carefully. Along the top and side of the big cliff on the right, he draws a second line to suggest strips of light. At the bases of the rocky shapes, he moves inside the original guidelines to draw shapes that look more like trees, although he still works with just a few casual lines, knowing that they'll soon be covered with heavier strokes of tone. At the extreme left, he adds a rough vertical stroke to suggest a tree trunk that will show more clearly at a later stage of the drawing.

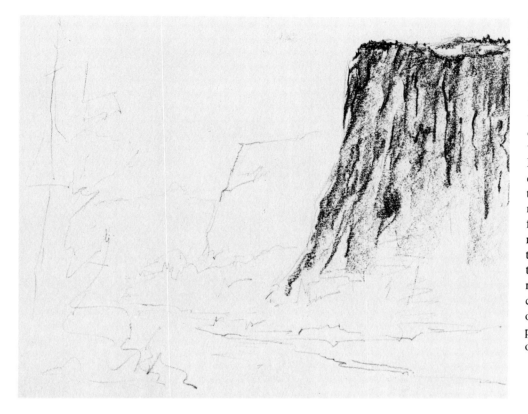

Step 3. With the squarish end of the chalk, the artist begins to block in the shadows on the face of the big cliff. Then, turning the chalk so that the sharp corner touches the paper, he draws deep, dark cracks that run in wavy vertical lines down the cliff. He also begins to sharpen the contours of the top. Although the overall shape of the cliff is more or less square, the rocky forms on its face look like irregular cylinders—on which the artist suggests the gradation from light to shadow to reflected light that you see on cylindrical forms. At the top of the cliff, you can see the patch of light that the artist outlined in Step 2.

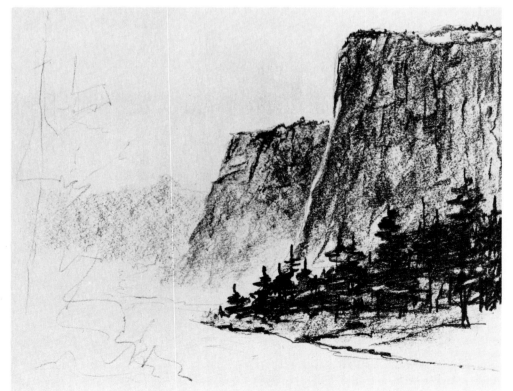

Step 4. The artist picks up a short chunk of broken (or worn-down) chalk. With the flat side of the broken stick, he darkens the big cliff and blocks in broad tones on both the central cliff and the pale mountain in the distance. He uses a sharp corner to draw more cracks. With the squarish end of the stick, he draws the dark foliage with thick horizontal lines. Then he draws slim vertical lines for the trunks with the sharp corner of the chalk. He places a shadow on the shore beneath the trunks with the flat side of the chalk, and then he draws the shoreline with the corner.

Step 5. Pressing more lightly on the square end of the chalk, the artist draws the paler, more distant mass of evergreens, adding a few crisp strokes with the corner of the stick to suggest a few trunks. He also uses the squarish end of the stick to block in the reflections of the evergreens in the water with horizontal strokes. Notice that the reflections are lighter than the trees.

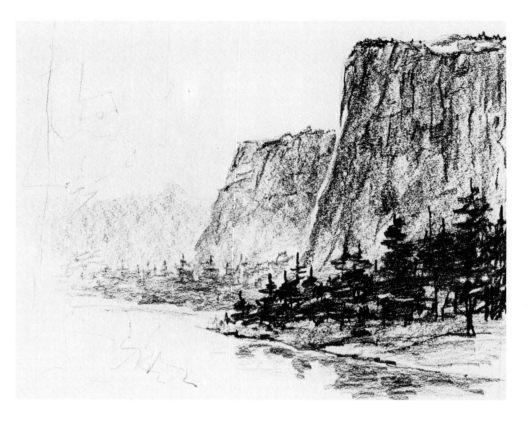

Step 6. As the stick of chalk wears down, its tip becomes blunt and slightly rounded, making a stroke which is thick but no longer squarish. Now the artist draws the dense foliage of the evergreens at the left, making clusters of horizontal and diagonal strokes with the blunt end of the chalk. He leaves spaces between the strokes to suggest the light of the sky breaking through the foliage. Then, working with the sharp corner of a fresh piece of chalk—or sharpening a worn piece on the sandpaper pad—he adds crisp vertical lines to suggest trunks and a few branches.

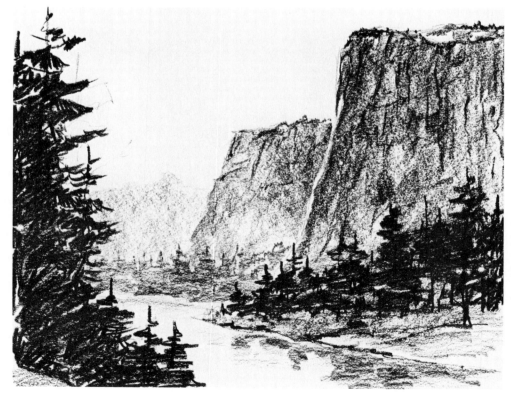

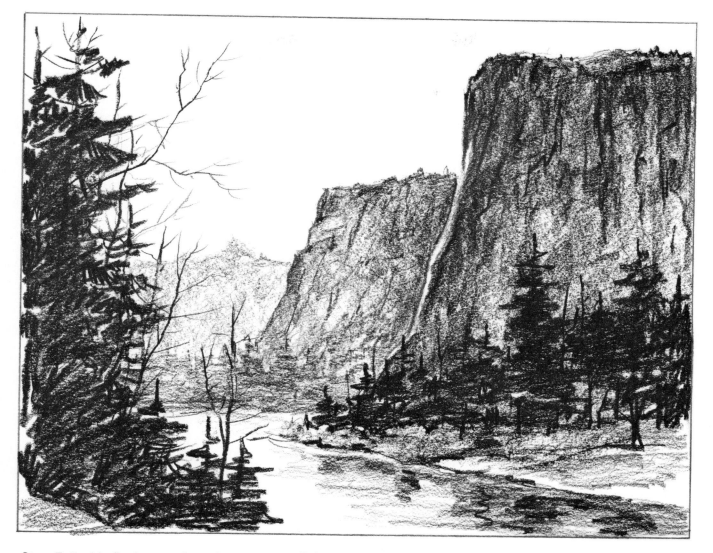

Step 7. In this final stage, the artist goes over all three mountainous shapes with the flat side of a short chunk of chalk, darkening them with broad strokes. With the sharp corner, he adds more cracks to the two nearby mountains, but he remembers the rules of aerial perspective and adds no details to the pale, distant mountain. With the blunt end of a worn stick, he darkens all the trees with a dense layer of horizontal strokes and then darkens the shoreline and reflections on the right in the same way. Heavy zigzag strokes suggest the reflections of a few individual trees in the stream. Finally, the artist sharpens the chalk to a point and adds the precise lines of branches and twigs to the cluster of trees at the extreme left. This part of the picture is closest to the viewer, so that's where the artist concentrates his precise details—remembering the rules of aerial perspective once again.

Step 1. Like charcoal, chalk lends itself equally well to crisp lines, broad strokes, and blended tones. A seascape, combining the rugged forms of rocks and the softer forms of water, is a good subject for exploring this combination of chalk-drawing techniques. In his preliminary line drawing, the artist draws the hard, distinct shapes of the rocks and the softer, less distinct shapes of the surf and waves with equal care. Although the sea keeps moving, the waves and surf assume repetitive shapes, which the artist studies carefully and then draws quickly with curving lines. Of course, many of these lines will eventually disappear when the tones of the surf are blended.

Step 2. Working over and within the guidelines of Step 1, the artist draws the rocks in more detail. He adds smaller shapes within the big shapes that were defined in the original guidelines. He draws the distant waves more precisely but avoids adding more lines to the soft, curving shape of the foam between the rocks, since this soft shape will be rendered with blended tones rather than lines or strokes.

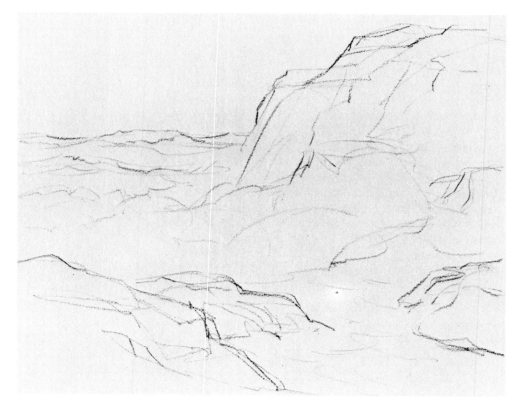

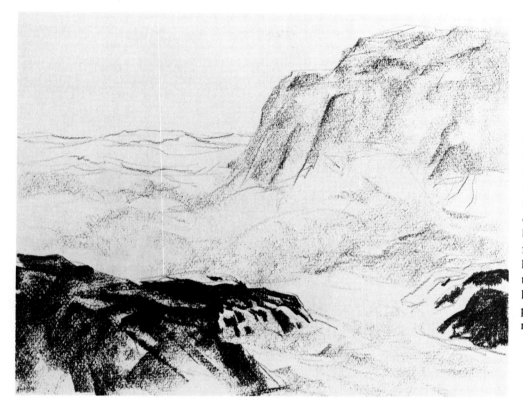

Step 3. Reaching for a short piece of chalk, the artist uses the flat side of the stick to suggest tones on the distant rock formation on the right and to block in the soft, blurry shadows on the surf between the rocks. Pressing harder on the side of the chalk, he begins to block in the darks of the rocks at the left. Then he uses the squarish end of a fresh stick to draw more distinct strokes on both rock formations in the foreground. Here and there, he uses the corner of the stick to add a sharp line. Notice how he leaves areas of bare paper to suggest foam running over the rocks.

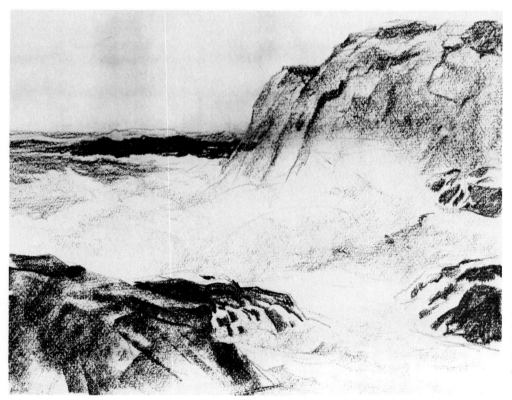

Step 4. With a blunt-ended stick, the artist draws the shadowy faces of the distant waves. Look at the strokes carefully and you'll see that the actual chalk marks are slightly wavy. Irregular strips of bare paper are left for the bands of foam at the crests of the waves. Along the lower edge of the oncoming foam at the center of the picture, the artist uses the side of the chalk to suggest the shadow cast by the wave on the foaming water between the rocks. With the side of the stick, he darkens the big rock formation on the upper right and begins to add some thick, shadowy cracks with the end of the chalk. He also adds another small, dark rock at the extreme right.

Step 5. The blunt end of the chalk is used to darken the side of the rock formation on the upper left with a cluster of parallel strokes. A few more cracks are added. The shadowy sides of the rocks on the lower left are darkened in the same way, so now there's a clear distinction between the lighted top planes and the dark side planes. Short, curving strokes are added to the foreground to suggest foam running down the sides of the rocks and swirling between them. On the right, the artist moves his chalk lightly over the paper to darken the shadow cast by the mass of oncoming foam.

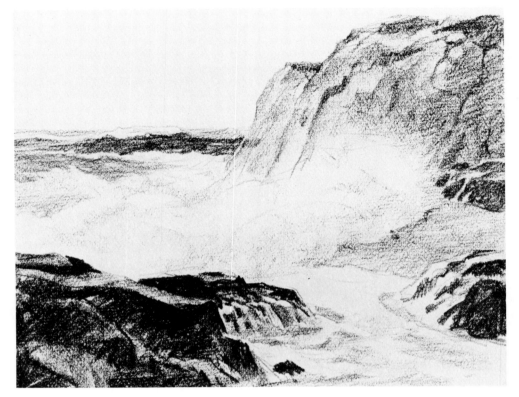

Step 6. The artist moves the flat side of the short chalk along the shadowy face of the foamy mass. Then he blends this tone with a stomp. He also darkens and blends the foamy sea beyond the white mass on the left. In the same way, he darkens and blends the shadow cast by the mass of surf on the right, adding a few dark strokes for detail. He adds some short, curving strokes to the churning foam on the lower right and blends these as well.

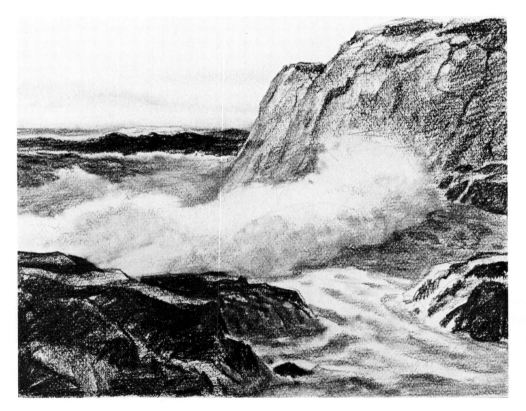

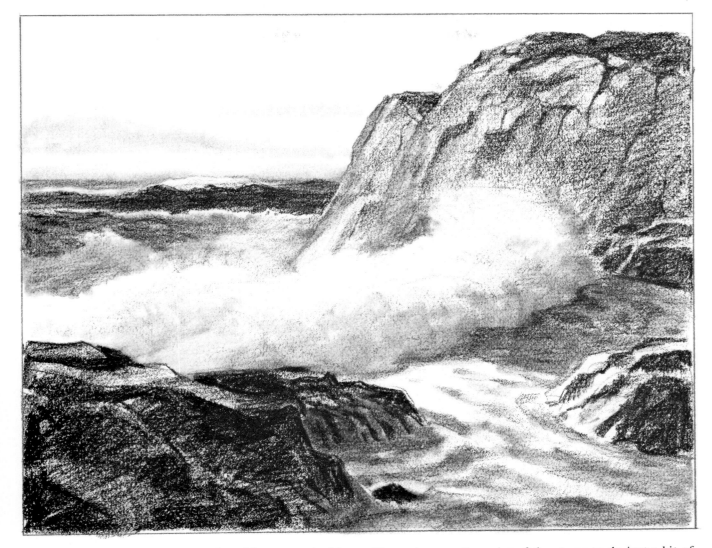

Step 7. As usual, the artist strengthens his tones and adds the last important details at this final stage. He darkens the big rock formation on the upper right by moving the blunt chalk lightly over the paper, and then he adds more cracks and deep shadows with a sharpened stick. With the side of the chalk he adds more tone to the shadowy front of the mass of surf—and to the shadow that the surf casts on the water—blending these tones with short, curving strokes of the stomp. The soft shape of the foam has a clearly defined lighted plane—where the sun strikes the top of the form— and a shadowy side plane. Thus, the foam is as solid and distinct as any other three-dimensional form. The blunt end of the chalk is used to carry long, wavy strokes across the churning foam on the lower right; these strokes are blended with the stomp, leaving gaps of bare paper to suggest sunlight flashing on the white water. The rock formation on the lower right is darkened with another layer of broad, slanted strokes, making these shapes seem still closer to the viewer.

The artist uses the point of the stomp to do just a bit of blending on the distant waves, making their tones seem slightly smoother. The blackened end of the stomp is used like a brush to paint some delicate cloud layers just above the horizon. The sunlit areas of the foam are carefully cleaned with a wad of kneaded rubber that's squeezed to a point to get into the intricate shapes in the lower right. The bare paper of the sunny sky is brightened by pressing the kneaded rubber against the paper and then lifting the eraser away. By now, you've certainly discovered that this drawing is done on a rough-textured sheet of drawing paper. The ragged tooth of the paper roughens the strokes that are used to draw the rocks, thus heightening the rocky texture. At the same time, the irregular surface of the paper softens the strokes of the stomp to produce beautiful, furry tones in the surf and sky. This seascape is a particularly memorable example of the many ways in which chalk can be used in the same drawing.

Step 1. Chalk, like charcoal, blends easily and can be moved around on the drawing paper the way oil paint is moved around on canvas. This atmospheric winter landscape will show you how to make a "black-and-white painting" by blending chalk as if it were wet oil paint. Because the finished drawing will contain many soft, blended tones, the preliminary line drawing is extremely simple. The artist uses the sharp corner of the chalk to draw the silhouettes of the mountain and the tree-covered shore in the distance, as well as the rocky, snow-covered shore of the frozen lake in the foreground. He doesn't indicate individual trees at all, except for a single tree trunk just left of center.

Step 2. Still concentrating on silhouettes, the artist draws the distant mountain and tree-covered shore more carefully, but he doesn't indicate the shape of a single tree in the distance. He draws the shoreline more precisely, adding more rocks and the trunks of a few more trees. But he makes no attempt to define the irregular shapes of the foliage on the trees, since this will be done later with broad strokes of the chalk and the stomp.

Step 3. Since a feeling of distance is important to this landscape, the artist begins to draw the remote forms of the mountains and the tree-covered shore at the far end of the frozen lake. He moves the blunt end of the chalk lightly over the slopes of the mountain and immediately blends the strokes with a stomp. He begins to draw the distant mass of evergreens with vertical strokes and then blends these tones with vertical strokes of the stomp. The stomp is now covered with black chalk, and so he uses this versatile tool to make additional tree strokes that have a particularly soft, magical quality.

Step 4. Continuing to work on the mass of distant evergreens, the artist alternates short, vertical strokes of the blunt chalk with strokes of the stomp. The stomp blends the chalk strokes and then adds its own special kind of soft strokes. The artist begins to add streaky tones to the icy surface of the frozen lake. He moves the chalk lightly over the paper and then blurs the strokes slightly with touches of the stomp. Now you can see clearly that he's working on a rough sheet of drawing paper that's particularly responsive to blending.

Step 5. Having established the soft, misty tone of the most distant elements of the landscape, the artist begins to add the strong darks to make sure that they contrast properly with the paler tones. In the foreground and middleground, he blocks in the shadow sides of the snow-covered rocks and shore, letting the rough texture of the paper show and leaving the strokes unblended. At the extreme left, he draws the trunk and foliage of a clump of evergreens, again leaving the strokes unblended and allowing the pebbly texture of the paper to suggest the detail of the foliage.

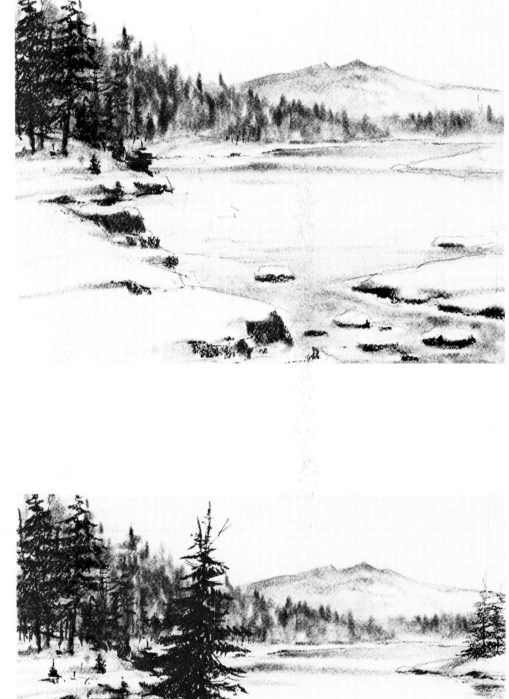

Step 6. Remember the single tree trunk that appeared in Step 1? Now this becomes the focal point of the picture: a dark evergreen that's drawn with clusters of short diagonal strokes to suggest foliage, plus a few slender strokes for the trunk and branches. The artist adds more evergreens on both sides of the lake and leaves the strokes unblended. Now he uses the sandpaper pad and the stomp in a new way. He presses the stomp against the blackened surface of the sandpaper, picks up the dark dust the way a brush would pick up paint, and begins to draw the shadows of the trees across the snowy shore. In the same way, he adds touches of shadow along the edges of the snow banks.

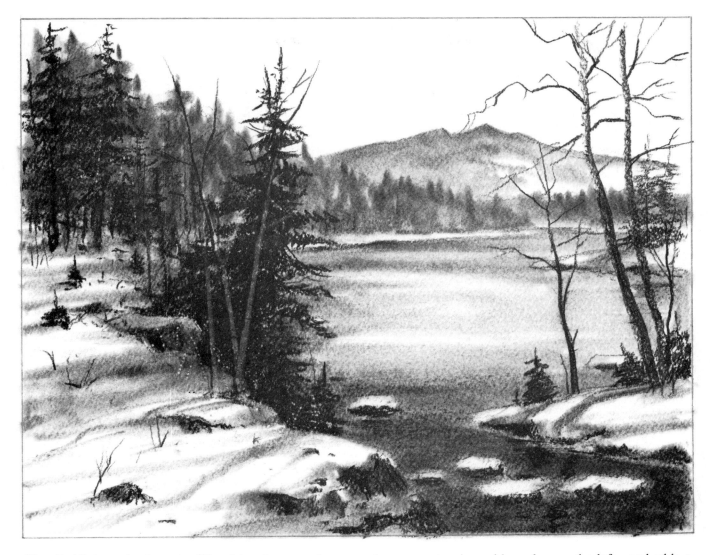

Step 7. All the main elements of the picture have now been placed on the paper. The forms in the foreground, middleground, and distance are all clearly defined. Now the artist can concentrate on enriching his tones and adding detail. He darkens the mountain against the horizon and the mass of evergreens on the distant shore with more strokes of the chalk, which he blends with the stomp. The stomp moves diagonally over the shape of the mountain and vertically over the shapes of the distant trees. The artist glides the squarish end of the chalk lightly across the center of the frozen lake; he applies more pressure to suggest the dark reflections of the trees on the far shore and the reflections of the trees in the immediate foreground. The stomp blends the tones of the lake with long horizontal strokes. The artist darkens the evergreens on the left with a dense network of strokes, pressing hard against the paper and leaving these tones unblended. Then he uses a sharpened stick of chalk to draw more trunks and branches on the left—and adds a whole new group of bare trees on the right. He adds still more evergreens on the low shore at the right. Working with the blunt end of a stick of chalk and the blackened end of the stomp, he draws more lines of shadow across the snow, to indicate shadows cast by the trees. The kneaded rubber moves carefully between the shadows on the snow to brighten the patches of bare paper suggesting sunlight on the shore. The rubber also brightens the tops of the snow-covered rocks in the water and draws pale lines across the center of the lake to suggest sunlight glistening on the ice. The kneaded rubber moves across the sky to pick up any trace of gray that might dim the paper. And finally, the kneaded rubber is squeezed to a sharp point to pick out pale trunks that appear against the dark mass of the evergreens on the left shore.

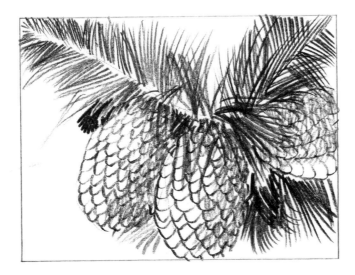

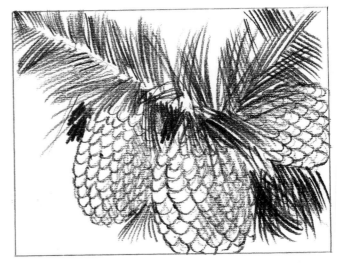

Strokes on Smooth Paper. The sturdy white drawing paper (called cartridge paper in Britain) that's sold in every art-supply store is equally good for drawing in pencil, chalk, and charcoal. Here's a drawing that's made with a medium-grade charcoal pencil on ordinary drawing paper. The sheet has a very slight texture that you can see if you look closely at the strokes, but the marks of the charcoal pencil are sharp and distinct.

Strokes on Rough Paper. As its name suggests, charcoal paper is made specifically for drawing in charcoal—though many artists like it just as well for chalk and graphite pencil. In this drawing of the same subject shown at your left, the strokes show the distinct, ribbed texture of the paper. It's worthwhile to try charcoal paper because you may like the way it breaks up and enlivens your lines and strokes. The surface is also excellent for blending.

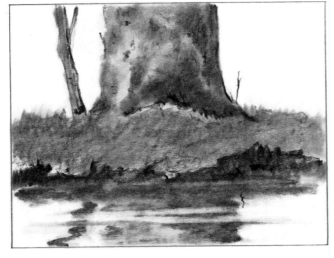

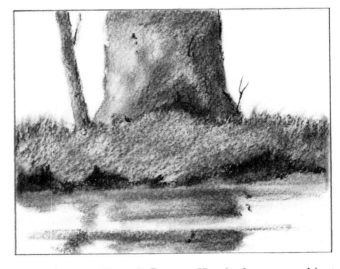

Blending on Smooth Paper. When you blend charcoal strokes on the usual white drawing paper, you get soft, furry gradations that don't show much of the texture of the sheet. In this close-up of a section of a larger landscape, nearly all the charcoal strokes have been blended, but you don't see much evidence of the paper surface. There's a bit of roughness in the grass, but this is produced by the charcoal strokes themselves, which are only partially blended. In the tree trunk and its reflection, the strokes have been blended away to produce smooth, even tones.

Blending on Rough Paper. Here's the same subject drawn on rough paper and blended. Now the ragged texture of the paper is obvious. A charcoal drawing on rough paper—whether the strokes are blended or left alone—has a bold, irregular look. Tonal gradations can be just as subtle as they are on smooth paper, but the tones usually have the broken, pebbly quality you see here. Buy several different kinds of paper, smooth and rough, to discover which surfaces you like best for charcoal drawing.

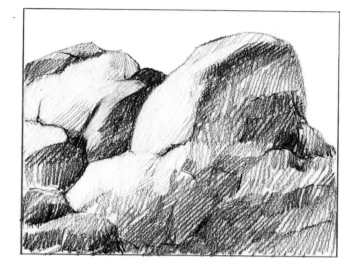

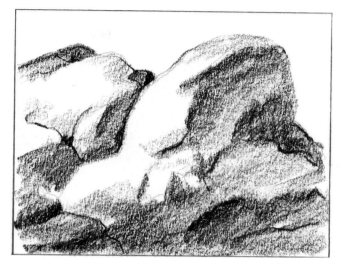

Slender Strokes. People generally think of charcoal as a medium for rough strokes and rich tonal effects. But a sharpened charcoal pencil—or even a sharpened stick of charcoal—can produce slender, expressive lines. In this section of a rocky landscape, the tones are rendered with clusters of parallel lines. Several layers of lines overlap to produce darker tones. And if the tones become too dark in some area, they're easily lightened by pressing a wad of kneaded rubber against the paper—as you see in the sunlit planes of the rocks.

Broad Strokes. This drawing of the same rocks displays the broad strokes that are typical of the way most people use charcoal. The preliminary outline drawing is made with slender lines, but then the tones are rendered with broad strokes of the side of the pencil or charcoal stick. Darker tones are produced simply by pressing harder on the charcoal or by going over the same area several times. Charcoal smudges easily, but the artist leaves the drawing unblended, recognizing that his rough strokes produce a rugged, rocky feeling.

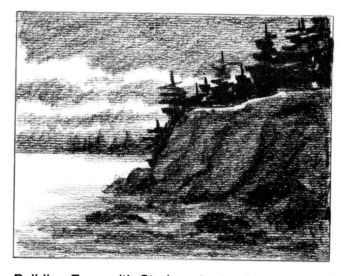

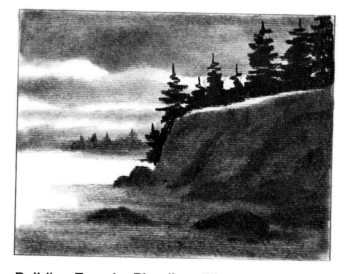

Building Tone with Strokes. On the ribbed surface of charcoal paper, you can build a rich tonal effect entirely with strokes—without blending. As you move the charcoal pencil or the charcoal stick lightly back and forth over the sheet, the tooth of the paper gradually collects the black granules. With each stroke, you build up more tone. In this section of a landscape drawn at sunset, the mark of the drawing tool is obvious only in the trees, which have been drawn with firm, heavy strokes. The rest of the picture has been built up gradually by laying one soft stroke over another.

Building Tone by Blending. What many artists love about charcoal is its soft, crumbly quality, which makes the strokes easy to blend with a fingertip or stomp. Here, the same subject has been drawn on charcoal paper with strokes of soft natural charcoal, blended so that the strokes disappear and become rich, smoky tones. Kneaded rubber brings back the whiteness of the paper, as you see in the sky, the water, and the bright top of the cliff. The trees are drawn with firm, dark strokes and left unblended.

Step 1. To test out the different kinds of lines and strokes you can make with charcoal, find a subject that has a lot of texture and detail, such as a densely wooded landscape. Get yourself several charcoal pencils—hard, medium, and soft. The artist starts this demonstration by drawing the contours of the tree trunks with the sharpened point of a hard charcoal pencil. He defines the path through the woods with a few wavy lines but makes no attempt to draw the contours of the leafy masses, which are so scattered that they have no distinct shape. Later, he will draw the clusters of leaves with clusters of strokes.

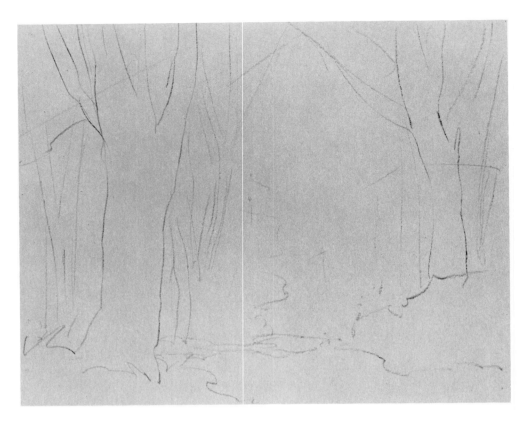

Step 2. Because he wants to create a sense of distance between the dark shapes of the trees in the foreground and the pale, distant trees, the artist begins with the remote tone of the evergreens that appear far off, seen through the opening in the forest. Resting the side of the lead lightly on the paper—which is just ordinary drawing paper—the artist moves the hard charcoal pencil from side to side with an erratic, scribbling motion. The forms of the trees are gradually built up by laying one light stroke over another. The artist presses harder on the pencil when he draws the darker trees on the left.

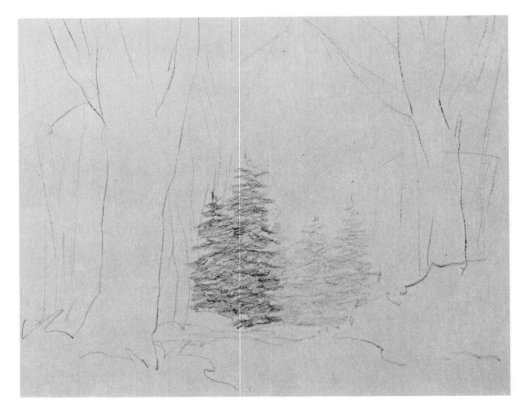

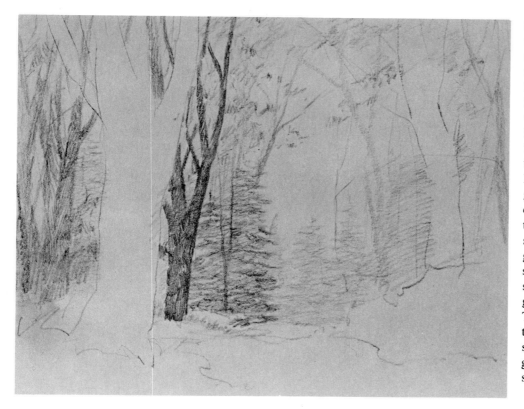

Step 3. Still working with the hard charcoal pencil, the artist begins to work on the tree trunks that are just beyond the big trees in the foreground. Pressing somewhat harder on the pencil, he builds the tone of a darker tree and branches with clusters of parallel strokes. He lets the strokes show to suggest the bark. On the left, he draws paler, more distant trunks and branches in the same way. To the right of the gap in the forest, he suggests shadowy tones and the pale silhouettes of tree trunks with groups of slanted strokes. Toward the top of the picture, the artist begins to suggest sparse foliage with scattered groups of small, scribbly strokes.

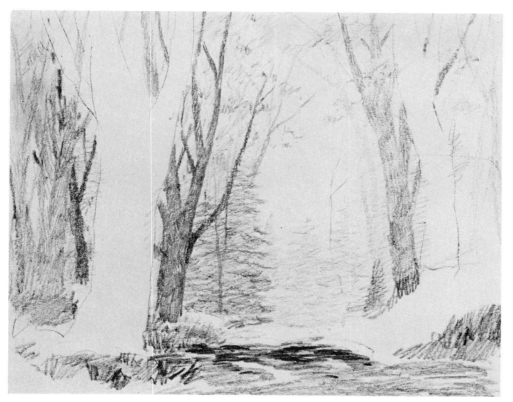

Step 4. On either side of the picture, the artist adds slightly darker trunks with clusters of strokes, still using the hard pencil. Now he moves into the foreground, covering the woodland path with groups of horizontal strokes, and leaving gaps of bare paper to suggest sunlight on the path. He suggests a shadow across the path by pressing harder on the pencil. Clusters of scribbly, slanted strokes indicate the undergrowth. The direction of the strokes varies with the subject: horizontal strokes for the ground; vertical ones for the tree trunks; and slanted strokes, leaning in various directions, for the grasses and weeds.

Step 5. To add darker tones to the foreground, the artist reaches for the medium charcoal pencil. He builds up the clumps of grasses and weeds with groups of spiky, irregular strokes that point erratically in various directions, as the subject does. At the left, he adds touches of dark shadow among the trees. And then he introduces a big, darker trunk and branches at the extreme right, again working with overlapping groups of parallel strokes that suggest the texture of the bark. Around the dark tree, he adds some slender strokes for smaller, younger trees. The grassy strokes beneath the tree are darkened to suggest its shadow.

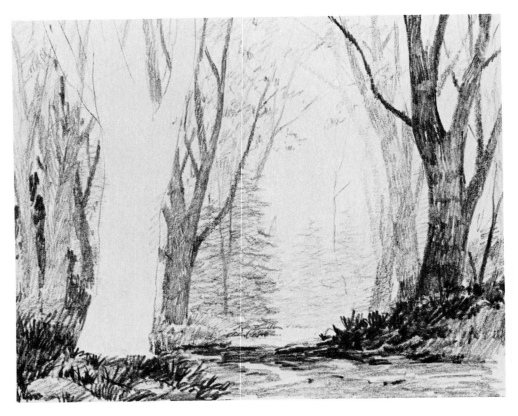

Step 6. The artist uses the flattened tip of the medium pencil to draw the rough, dark shape of the big tree at the left. The clusters of strokes are large and distinct, so that the ragged texture of the bark is obvious. The artist piles stroke upon stroke to darken the branches that reach out from the main trunk—particularly the branch that arches across the center of the picture. Around the big branch, the artist dashes in small, dark strokes with the blunt tip of the pencil to create leaves. In the distance, the hard pencil is used in the same way to suggest paler clusters of leaves. The hard pencil also adds slender trunks and branches in the distance.

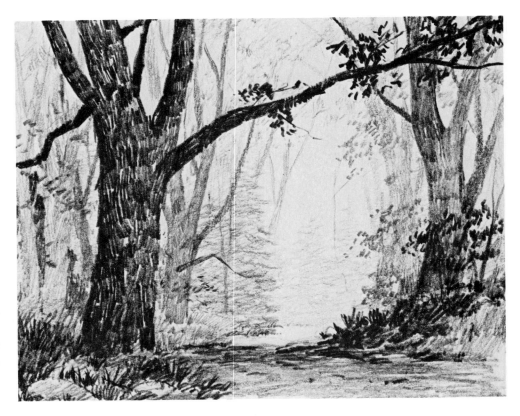

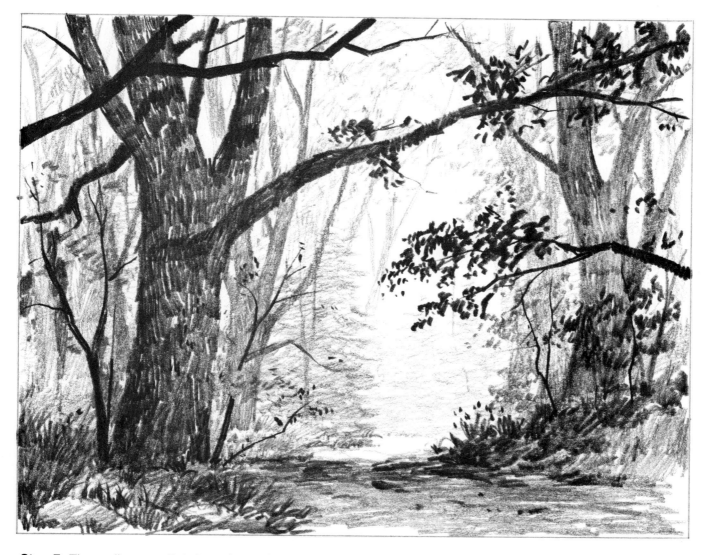

Step 7. The medium pencil darkens the trunks, branches, and foliage of the distant trees, adding small, scattered strokes to suggest more foliage. The trunk and branches of the big tree on the right are darkened with vertical strokes. Strokes are added to the clumps of weeds and grasses on either side of the forest path, so now the growth seems dense and shadowy. Another layer of horizontal strokes is scribbled across the path itself to accentuate the contrast between the shadowy section of the path in the foreground and the sunlit patch in the distance. The deep, dark tone of the soft charcoal pencil is saved for the very end. Now the pencil is sharpened and brought in to add the rich blacks of additional trunks, branches, and foliage on both sides of the picture. The sharpened point of the medium charcoal pencil adds the more delicate lines of the twigs. Study the many different ways in which the charcoal pencil is used to render the varied textures, tones, and details of this complex drawing. And notice that all the subtle effects of light and atmosphere are created entirely with lines and strokes.

Step 1. Now look for a landscape subject that will give you an opportunity to combine slender lines, broad strokes, and smudged tones. For this demonstration, the artist chooses a pond surrounded by trees and rocks. This preliminary line drawing, made with a hard charcoal pencil, simply defines the group of tree trunks on the right, the rocky shorelines across the center of the picture, and the soft shapes of the trees on the far shore. The artist makes no attempt to draw the details of the light and shadow in the water, which he'll block in with broad tones in the next step.

Step 2. The artist has chosen a rough sheet of paper whose texture will suggest the details of foliage and also permit him to do a lot of blending. Working with the side of a medium charcoal pencil, he blocks in the tones of the mass of trees on the far shore, building stroke upon stroke to darken the shadow areas. He also blocks in the shadowy sides of the rocks. Then he begins to draw the dark reflections of the trees in the water, using long horizontal strokes. He blends all these tones lightly with a fingertip but doesn't rub hard enough to obliterate the strokes. He brightens the sunlit tops of the rocks with the kneaded rubber eraser.

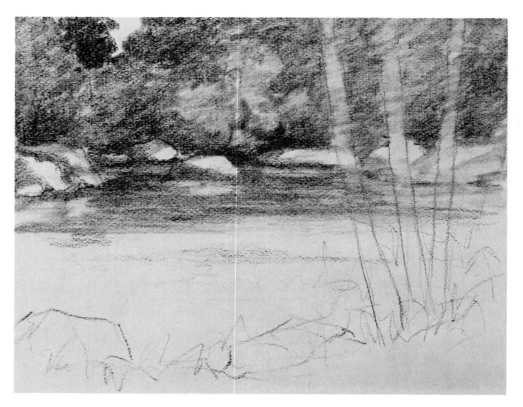

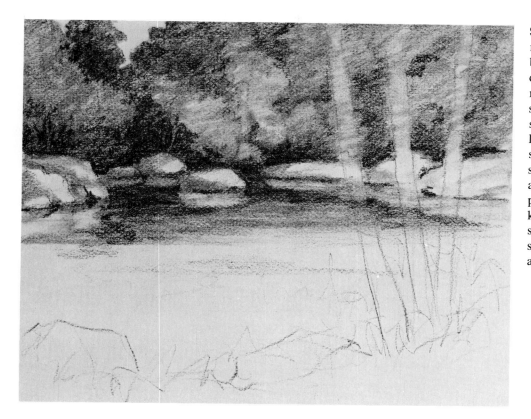

Step 3. Working with the medium charcoal pencil, he blocks in the darks among the distant trees—and their reflections in the water—with short, curving strokes that suggest the character of foliage. He doesn't blend these strokes but allows them to stand out, dark and distinct among the gray tones that appeared in Step 2. He uses the kneaded rubber to lighten some clusters of foliage and suggest patches of sunlight among the trees.

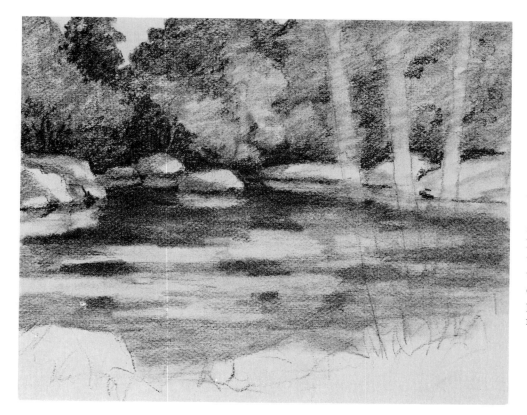

Step 4. Moving down across the water, the artist continues to block in the pattern of light and dark with horizontal strokes. Next he moves his fingertip horizontally across the paper to turn the strokes into subtle, smoky tones. He carries patches of darkness down into the water, suggesting more reflections of the trees on the distant shore. And he wipes away streaks of sunlight on the water with a kneaded rubber eraser. Notice that the lines of the three tree trunks on the right are almost obliterated. But this is no problem; the trees will soon reappear.

Step 5. The artist sharpens the medium pencil on the sandpaper block to draw the crisp, dark detail of the foreground. He fills the dark shapes of the three tree trunks with clusters of parallel strokes, leaving an occasional gap to suggest a flicker of light on the rough bark. The pencil has become blunt once again, which is perfect for making short, thick strokes that suggest foliage at the top of the dark trees. Delicate touches of a sharp, hard pencil suggest the floating lily pads with elliptical lines.

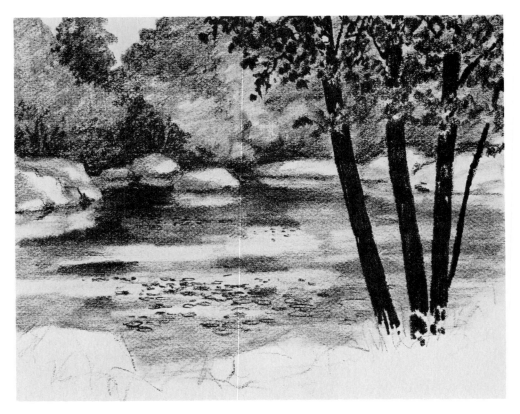

Step 6. The artist covers the ground with broad, rough strokes and blends them lightly with a fingertip. Now the rocks have a blocky, dark silhouette. Sharpening the point once again, he draws the graceful lines of the foreground weeds with arclike movements of the pencil.

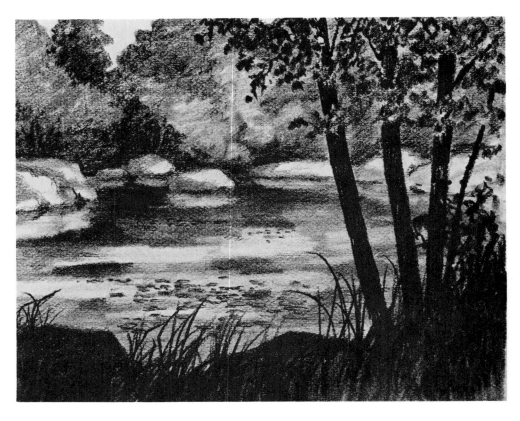

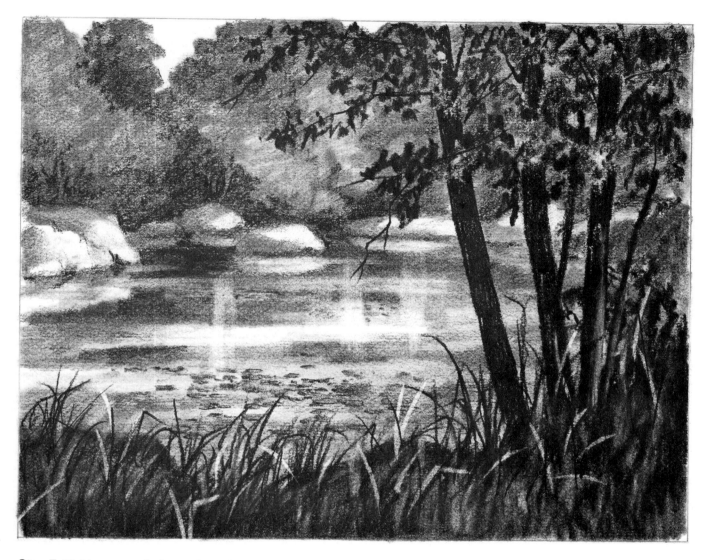

Step 7. Picking up a soft charcoal pencil, the artist moves it lightly over the mass of trees on the far shore and blends the strokes softly with a fingertip to darken the entire area. He then uses his charcoal-covered fingertip to darken the shadows on the rock and the shadowy patches in the water. (If he runs out of charcoal on his fingertip, he can easily blacken his finger again by pressing it against the blackened sandpaper pad.) The tip of the medium charcoal pencil adds more foliage in the upper right with quick, scribbly strokes. The sharp point of the pencil adds more twigs and branches, and then moves down to add more grasses and weeds to the foreground. To strengthen the contrast between light and shadow, the kneaded rubber eraser comes into play. It's squeezed to a sharp point to clean jagged patches of sky and the sunlit areas of the rocks. Then the eraser is moved very lightly across the water—horizontally and then vertically—to add splashes of light on the shadowy surface of the pond. The eraser creates a flash of sunlight on one tree trunk at the extreme right. Squeezing the eraser to a sharp point, the artist picks out some pale lines among the foreground grasses to suggest blades caught in sunlight. Throughout the drawing, the rough texture of the paper adds boldness to the strokes, suggests detail among the distant clumps of foliage, and adds vitality to all the blended tones.

Step 1. For blended tones—with subtle gradations from deep blacks to misty grays—no medium compares with natural charcoal. To demonstrate the beauty of this simplest of all drawing mediums, the artist chooses the soft lights and shadows of dunes on a beach, with a brooding sky overhead. Sharpening a stick of natural charcoal on a sandpaper pad, the artist draws the silhouettes of two big dunes, suggesting patches of beach grass at the top of each dune. He draws a horizontal line for the horizon of the sea in the distance.

Step 2. The blended tones of natural charcoal are particularly beautiful on rough paper, and so the artist has chosen a sheet with a distinct tooth. He blocks in the dark clouds with broad strokes and then blends these strokes with a fingertip, moving his finger across the paper with a wavy motion that suggests the movement of the clouds. He uses his charcoal-covered finger like a brush to add veils of pale gray over the lighter areas of the sky. The dark, inverted triangle of sea, glimpsed between the dunes, is drawn with firm, dark strokes and blended slightly with a quick touch of the finger.

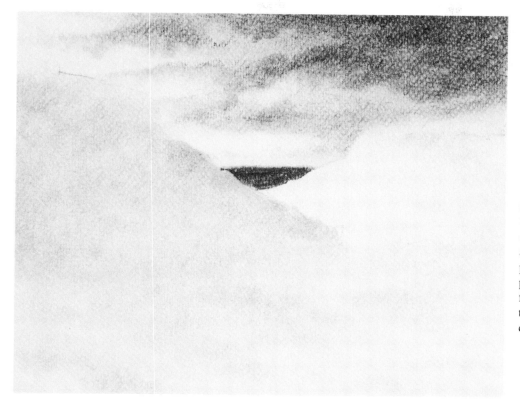

Step 3. The big dune on the left is covered with a soft veil of tone. This is done by passing the side of the charcoal stick very lightly over the paper, applying practically no pressure on the stick, but simply letting it glide over the sheet and deposit the lightest possible strokes. Then the artist moves his finger gently over the paper, softly merging the pale strokes into a misty, continuous tone. The strokes disappear altogether and become a delicate, transparent shadow. To suggest pale shadows on the sandy foreground, the artist touches the paper lightly with his charcoal-covered fingertip.

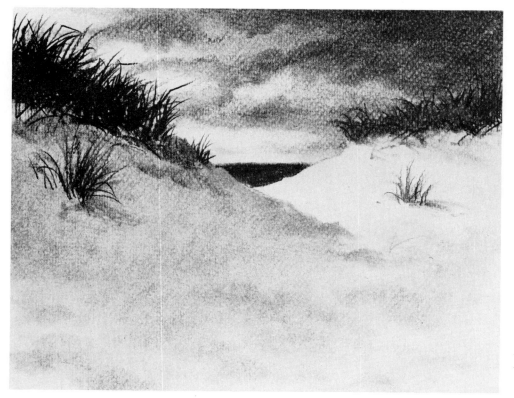

Step 4. Leaving the smaller, more distant dune untouched by the charcoal, the artist allows the bare paper to suggest brilliant sunlight on the sand. Now he scribbles a dark tone at the top of each dune and blends it with his finger to make a smoky blur. Over this blur, he draws dark strokes of beach grass with the sharpened tip of the charcoal stick. Notice that some of the grassy lines curve, while others are spiky diagonals. The artist changes the direction of his strokes for variety. Smaller clusters of beach grass are drawn on the sides of the dunes in the same way. A single sweep of a blackened fingertip suggests shadows at the bases of the clumps of beach grass.

Step 5. Quick, spontaneous touches of the sharpened charcoal stick suggest smaller plants and bits of debris below the clumps of beach grass. Another cluster of beach grass is added at the center of the picture and then slightly blurred with a touch of the fingertip, which creates a shadow. The artist presses his finger against the blackened sandpaper pad to pick up more tone. His finger spreads blobs of tone across the foreground to indicate shadowy curves and irregularities in the beach. Between the dark strokes made by his fingertip, the artist brightens patches of sand with the eraser, suggesting splashes of sunlight.

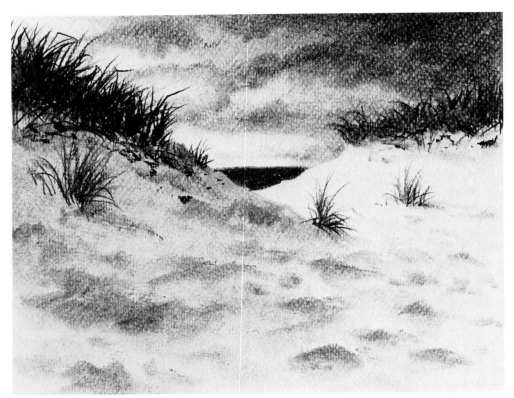

Step 6. Again sharpening the charcoal stick on the sandpaper pad, the artist adds a big clump of beach grass in the foreground. Then, turning the stick on its side, he draws long shadows slanting downward toward the right. He leaves these shadow strokes unblended. Now the charcoal stick moves across the beach, adding blades of beach grass here and there, plus touches to suggest the usual shoreline debris. Except for the shadows cast by the beach grass, the dune at the right remains bare white paper. Surrounded by so much tone, this patch of white paper radiates sunlight.

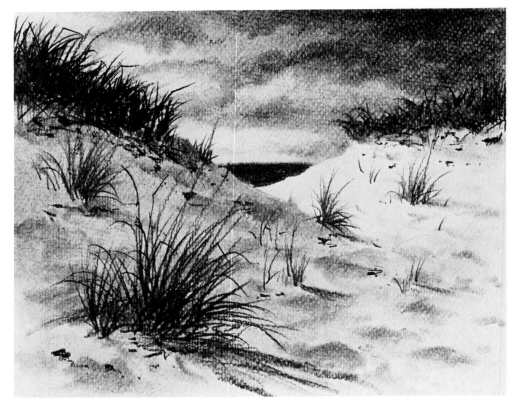

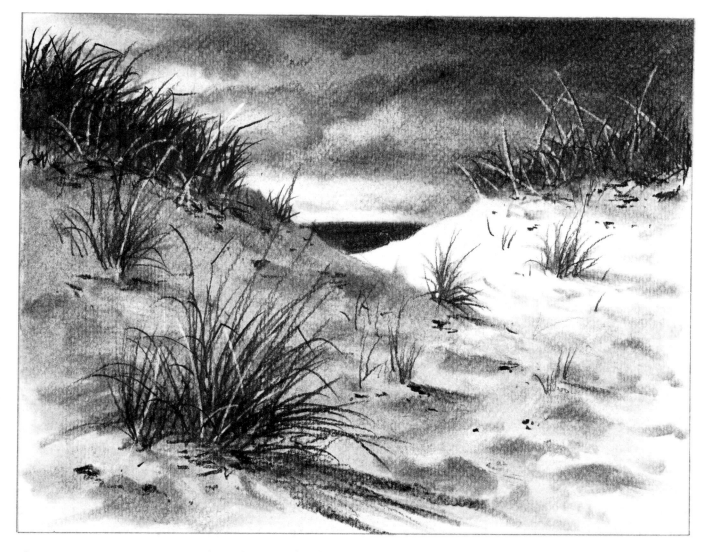

Step 7. To strengthen the darks of the sky, the artist picks up more charcoal dust on his fingertip and softly blends this into the clouds. Working very carefully, he performs the same delicate operation on some of the shadowy areas of the big dune on the left. He adds a few more touches of shadow to the foreground with his finger. To indicate that some of the stalks of beach grass are caught in the bright sunlight, he squeezes the kneaded rubber eraser to a sharp point and picks out slender lines among the clusters of darker strokes. Working carefully with the tip of his little finger, the artist blends the dark, inverted triangle of the sea to make it look smoother and darker; now it contrasts even more dramatically with the sunlit edge of the dune at the right. The kneaded rubber takes a final tour around the drawing, looking for areas of bare paper that have accidentally accumulated a hint of gray from the side of the artist's hand. It's easy to lift tones from the hard surface of the rough paper, so the artist brightens not only the sunlit areas of the dunes but also the strip of sky just above the dark sea. The finished drawing is a dramatic example of the versatility of natural charcoal, which can create everything from soft, smoky tones to crisp, expressive lines.

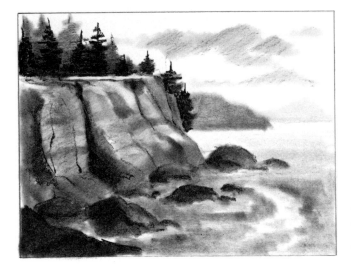

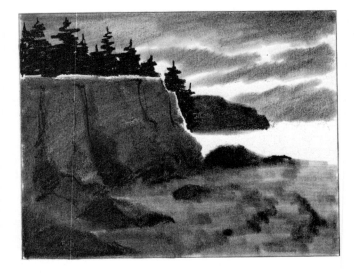

Headland in Three-quarter Light. As the sun moves across the sky, the direction of the light keeps changing; you must work quickly to capture the specific light effect you set out to draw. Here's a headland in three-quarter light, which means that the sun is striking the subject at an angle from above and slightly to one side. On each form, there's a lighted plane on one side and a shadow plane on the other side. Notice the lighted faces of the rocky forms and the shadowy sides. Three-quarter lighting makes the subject look solid and three-dimensional.

Headland in Back Light. Early in the morning and late in the afternoon, the sun is low in the sky and *behind* the shapes of the landscape. This effect is called back light. The fronts of the forms—facing you—tend to be in shadow because the sun hits them from the back. There's often a delicate rim of light around the edges of the shadowy forms. This type of lighting creates strong, dark silhouettes. Many landscape artists treasure this romantic type of lighting and get to work early in the morning to capture the effect before the sun is high in the sky.

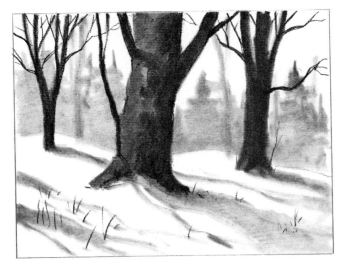

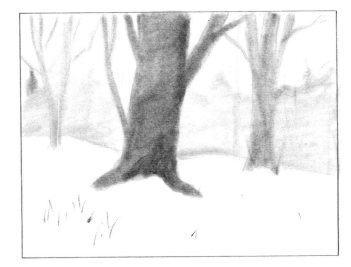

Trees in Strong Sunlight. On a bright, sunny day, you'll find strong contrasts between the tones of the landscape. In this winter landscape, the sun shines brightly on the snow, which contrasts strongly with the dark tree trunks and the slender shadows that the trees cast on the snow. The distant evergreens are paler than the dark trunks in the foreground, but there's still a distinct contrast between their shadowy shapes and the sunlit sky above.

Trees on an Overcast Day. That same subject will change radically on an overcast day, when the sun is hidden behind a layer of clouds. The dark tree trunks grow much paler and there's less contrast between the trees and the snow. The trees cast little or no shadow on the snow, since the sunlight is diffused. The distant mass of evergreens seems to melt away softly into the pale sky. A sunny day and an overcast day are *equally* promising times to draw landscapes. You can go back to the same subject again and again, discovering new magic with every change in the light and weather.

PART THREE

PORTRAIT DRAWING

DRAWINGS BY JOHN LAWN

Portrait Drawing. The human face is so endlessly fascinating, so infinitely diverse, so expressive of the most delicate emotional nuances that many artists have devoted their lives to portraiture. Every sitter is different, presenting a new and fascinating challenge to the artist who must capture not only the form and detail of the sitter's face, but also the unique flavor of the sitter's personality. The same face can change radically with a slight turn of the head or a slight difference in the direction of the light. And as the sitter's mood changes, the emotional content of the portrait changes too. Thus, the expressive possibilities of portraiture are so great that drawing the human head can become an obsession— one of life's most delightful obsessions—and you may find this subject so absorbing that other subjects seem tame. Like so many artists throughout the centuries, you may discover that there's nothing more exciting than watching a real human being come to life on paper. For the artist who's fascinated by people, the human face is the ultimate subject.

Form and Proportion. In the drawings of the great Renaissance masters, the complex form of the human head is often visualized very simply—as an egg shape with guidelines that wrap around the egg to define the placement of the features. In the first few pages of *Portrait Drawing,* you'll learn how to put this elementary diagram of the head to work. You'll learn to draw the egg shape in line and then make it three-dimensional by adding light and shade. You'll learn how to convert that "Renaissance egg" into a variety of male and female heads, seen from various angles: front view, side view, three-quarter view, and finally, a view of the head tilted downward. It's important to memorize this egg shape— and the placement of its guidelines—so that you can then adapt it, with subtle changes in proportion, to any head you may draw.

Drawing the Features. One of the best ways to learn to draw is to look over the shoulder of a skilled professional as he draws, then try it yourself. You'll watch noted artist John Lawn draw each facial feature, step by step, from a variety of angles. You'll see him draw male and female eyes—front, three-quarter, and side views, as well as tilted downward. In the same way, you'll learn to draw the male and female nose and mouth as seen in these same four views. And finally, you'll learn how to draw the ear as seen from the front and side of the head.

Drawing the Complete Head. Having mastered the basic form of the head and learned how to draw the fea-

tures, you'll then watch John Lawn put all this information together into demonstration drawings of complete male and female heads. You'll watch him build the overall form of the head and the forms of the individual features, from the first sketchy guidelines to the final drawing, fully realized in light and shade. The step-by-step demonstrations of the features and the complete head all show four fundamental stages in executing a successful drawing: blocking in the forms with simple guidelines; refining the contours; blocking in the tones in broad masses; and completing the drawing by refining the lines and tones and then adding the last touches of detail.

Complete Portrait Demonstrations. After demonstrating the fundamentals, Lawn goes on to demonstrate, step by step, how to draw ten complete portraits of different types of sitters, including various hair and skin tones, ages, racial and ethnic types. The demonstrations also show how to render diverse lighting effects that accentuate the character, beauty, and expressiveness of the individual head. The demonstrations are grouped according to drawing medium. There are pencil drawings of a blond woman, a brown-haired man, a black man, and a dark-haired woman. Chalk drawings include a dark-haired man, a blond man, and an oriental woman. Finally, there are charcoal drawings of a brown-haired woman, a black woman, and a gray-haired man. Each of these step-by-step demonstrations shows every drawing operation, from the first stroke on the paper to the last. The demonstration section concludes with a brief review of four different types of lighting that are particularly effective in drawing portraits; each type is illustrated with a drawing that explains how the specific method of lighting affects the character of the head.

Drawing Media. Each step-by-step portrait demonstration presents a different method of rendering form, texture, and light and shade in pencil, chalk, and charcoal. You'll see how form is rendered entirely with lines and strokes; how tone can be created by blending, so that pencil, chalk, and charcoal handle like paint; and finally, how lines, strokes, and blending can be combined. The demonstrations are executed on a variety of drawing papers to show you how the drawing surface influences the tone and texture of the portrait. These various techniques, drawing tools, and papers are dramatically illustrated by close-ups of sections of finished drawings, reproduced actual size.

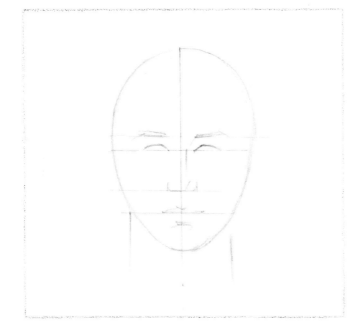

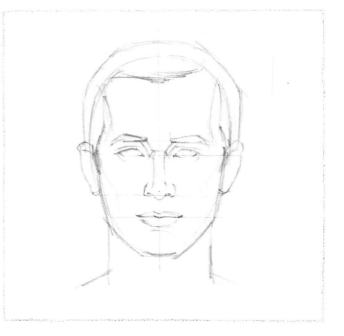

Egg Shape. Seen from the front, the head is shaped like an egg. Many artists actually begin by drawing an egg, as you see here. Drawing a vertical center line helps you to place the features symmetrically. It also helps to draw horizontal guidelines to locate the features on either side of the vertical center line.

Head Shape. When you draw an actual head over the egg, you can see how the guidelines work. The eyes are midway between the chin and crown. The tip of the nose is midway between the eyes and chin. The line between the lips is about one-third of the way down from the tip of the nose to the chin. The ears fall roughly between the guidelines of the eyebrows and nose.

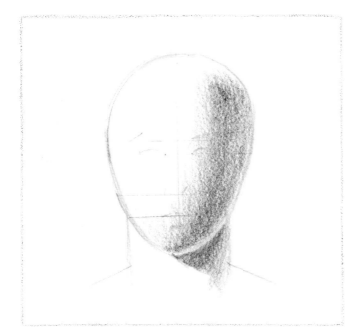

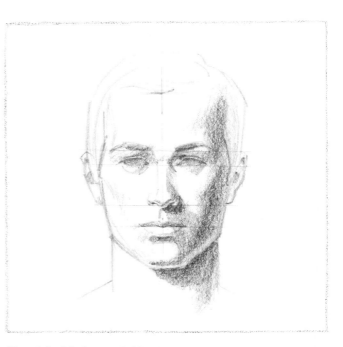

Egg in Light and Shade. When you add tone, it's still helpful to visualize the head as an egg. Looking from left to right, you can see four tonal areas that flow smoothly together: light; halftone (or middletone), where the shape begins to curve away from the light; shadow; and reflected light, where the shadow turns paler. The chin casts a shadow on the neck.

Head in Light and Shade. When you begin to model your line drawing of the head—which means adding tone—you can follow the same sequence of tones that you see on the egg. The gradation of light, halftone, shadow, and reflected light is *most* obvious on the forehead, cheek, and jaw. But you can also see it in the eye sockets and on the underside of the nose.

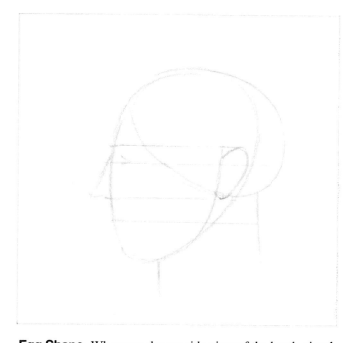

Egg Shape. When you draw a side view of the head, visualize the shape as two overlapping eggs, one vertical and one horizontal. The eggs tilt a bit, as you see here. The ear and the corner of the jaw are just inside the curve of the vertical egg.

Head Shape. The proportions of the head are accurate and lifelike when you draw the head and its features over the eggs and guidelines. Notice that the shape of the hair extends beyond the shape of the egg. The top of the ear aligns with the eyebrow, while the earlobe lines up with the tip of the nose. The corner of the jaw is even with the dividing line between the lips.

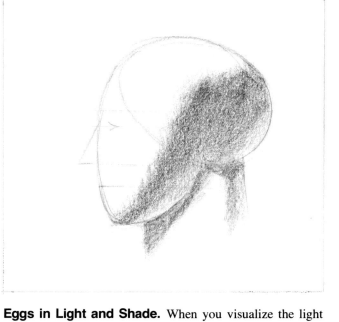

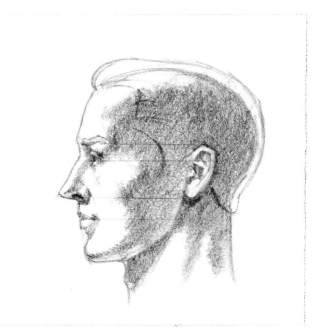

Eggs in Light and Shade. When you visualize the light and shade on the side view of the head, that head is now a *compound* egg shape. The neck is a cylinder. Once again, looking from left to right, you can see the gradation of tones: light, halftone (or middletone), shadow, and reflected light. There's a similar gradation on the right side of the neck.

Head in Light and Shade. Obviously, the forms of the living head are more complex than the compound egg shape and cylinder. But the gradation of tones is essentially the same. You can see the light, halftone, shadow, and reflected light most clearly on the big shapes of the skull, cheek, and jaw. But they also appear in more subtle form on the eye socket, nose, and neck.

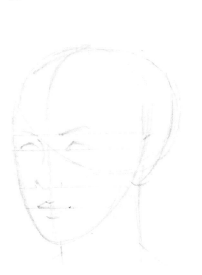

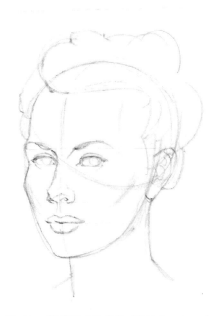

Egg Shapes. When the head turns so that it's midway between a front and side view, it's called a three-quarter view. You still see two overlapping eggs. The vertical egg is obvious. You see less of the horizontal egg, but it's still there. The vertical center line is no longer in the middle of the face, but closer to one edge. The horizontal guidelines are in the same places.

Head Shape. When you draw the actual head, seen in a three-quarter view, the center line becomes particularly important. The features must be placed accurately on either side of this vertical guideline, as you see here. The alignment of the features remains the same: the ear lines up with the brow and nose, while the corner of the jaw aligns with the division between the lips.

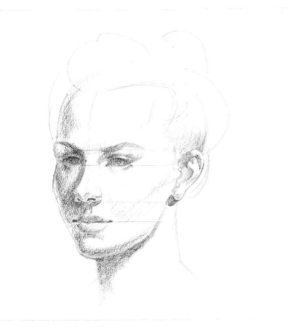

Eggs in Light and Shade. Although the head turns, the gradation of tones remains essentially the same. Now the light comes from the right, so the gradation is from right to left. You can still see the light, halftone, shadow, and reflected light. The artist has also indicated a halftone (or middletone) where the jaw and the underside of the skull turn away from the light.

Head in Light and Shade. By now, the four-step gradation of tone should be familiar. You can see it clearly on the shadow side of the face. It's also obvious on the chin and jaw. The nose casts a shadow on the upper lip, while the earlobe casts a shadow behind the jaw. There's a suggestion of tone on the lighted side of the face, where the underside of the cheek curves away from the light.

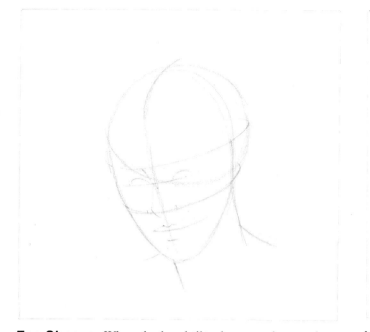

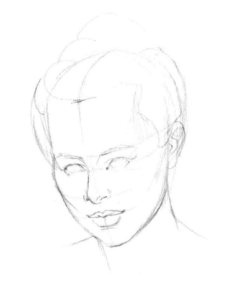

Egg Shapes. When the head tilts downward—or when you're looking at the head from above—the two overlapping egg shapes are still there, but an important change takes place in the guidelines. Notice how they curve. The horizontal guidelines, in particular, wrap around the head in parallel curves.

Head Shape. When the head tilts, the alignments of the features change. For example, the ear and the corner of the jaw seem higher. Straight, horizontal guidelines will no longer work. But if you draw curving guidelines around the egg, you can still establish convincing relationships between the features. You see a bit more of the top of the head, and the hairline starts farther down.

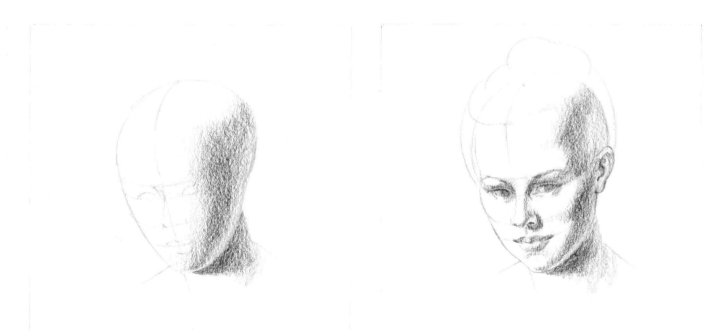

Eggs in Light and Shade. The alignment of the features may change when the head tilts downward, but the gradation of light and shade remains essentially the same on the compound egg shape. Looking from left to right, you can still see the four interlocking tones: light, halftone, shadow, and reflected light on the head, plus the cast shadow on the neck.

Head in Light and Shade. Recalling the gradation of tones on the compound egg shape, you can model the actual head in the same way. Here, the gradation is most apparent on the forehead, cheek, and jaw. But you can also see this gradation on the eye sockets and nose. The light comes from the upper left, and so the nose casts a shadow to the right.

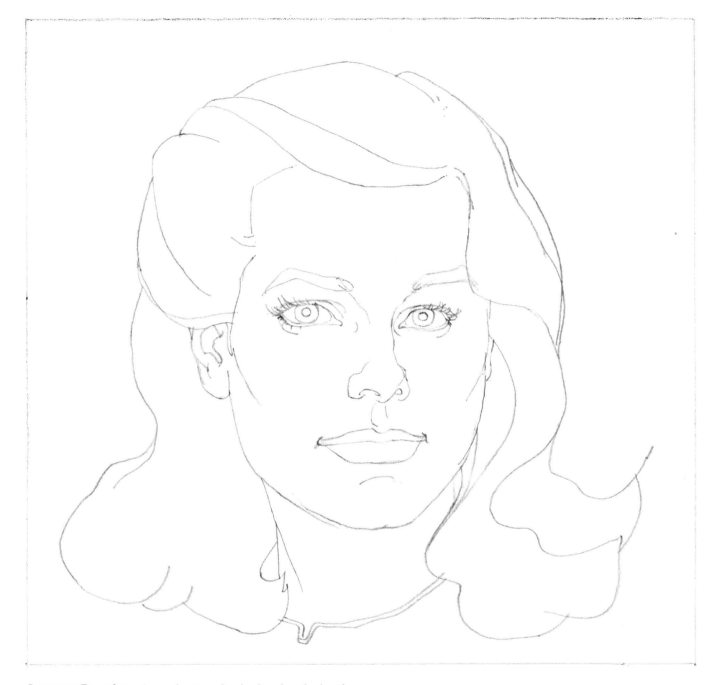

Contour Drawing. A good way to begin drawing the head is to focus on the edges of the shapes—the *contours*. Moving the sharp point of your pencil slowly over the drawing paper, imagine that the pencil is your finger, moving slowly around the outer edges of all the forms of the face. Pay no attention to details. Draw the hair as a big, simple mass, and don't fuss about individual strands that may stick out here or there. Keep the drawing simple. Notice how the artist draws the jaw with just one curving line, the lips with three lines, the eyebrows with just two lines, roughly parallel. Try not to look at your drawing too often, but concentrate your attention on the model, moving your pencil across the paper as your eye moves over the contours of the face. Make lots of contour drawings so you get to know the shapes of the face and learn to visualize them simply.

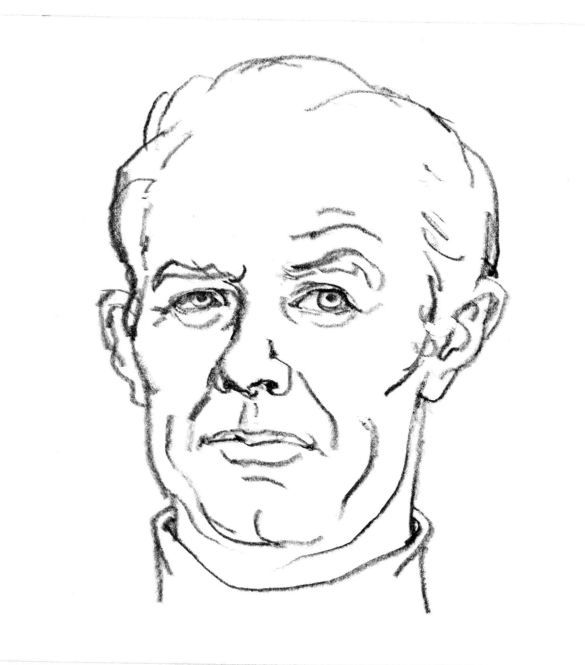

Groping Line. The lines of a contour drawing don't have to be wiry and elegant. They can also be thick and bold. Try making a contour drawing with a thick, blunt pencil. As you move your eye across the model's face, let the pencil grope slowly across the paper like a blind person's fingers gently and carefully exploring a friend's face. (In fact, many artists ask their students to make "blind contour drawings," working in the dark, with only the model illuminated.) The important thing is to look very carefully at the model's face and move your pencil slowly—glancing at the drawing only now and then. Making a contour drawing with this "groping line" will strengthen your powers of observation and encourage you to draw with simple, decisive lines.

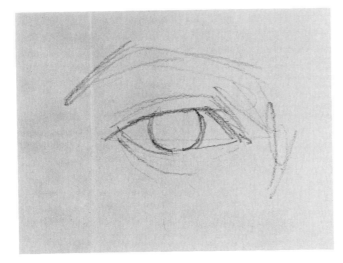

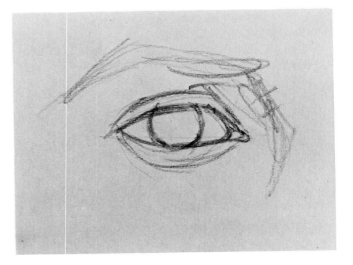

Step 1. The artist begins to draw the eye by indicating the basic contours with a few casual but carefully placed lines. He suggests the complete upper and lower lids, as well as the eyebrow and the corner of the eye socket at the side of the nose. At this stage, the iris is just a circle. Study the contours of the inner edges of the lids. Starting from the outer corner, the top lid follows a long, flattened curve, turning down a bit at the inside corner. The lower lid does just the opposite, starting from the inside as a long, flattened curve and then turning upward at the outside corner.

Step 2. Pressing harder on the point of his pencil, the artist moves back over the casual guidelines of Step 1 to refine the contours. The rather angular lines of Step 1 become rounder and more rhythmic. The eye begins to look more lifelike. The shapes of the lids are more clearly defined. It's particularly important to remember that the upper lid always overlaps the iris, cutting off part of the circle. The lower lid also touches the iris but doesn't overlap quite as much.

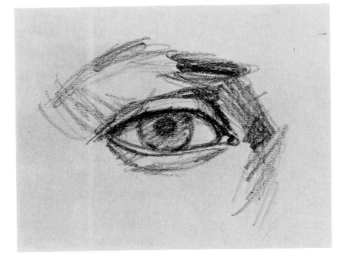

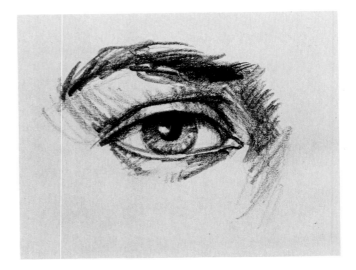

Step 3. Having drawn the contours more accurately, the artist now begins to block in the tones with broad, spontaneous strokes. The tones are actually clusters of parallel strokes, which you can see most clearly in the iris and in the shadow inside the eye socket. The artist suggests the dark spot of the pupil, and he carefully draws the shadow that the upper lid casts across the iris and over the white of the eye. He indicates the shadows at the corners of the lids and then draws the shadowy underside of the lower lid.

Step 4. At the final stage, the artist strengthens his tones and adds the final details. He darkens the shadowy lines around the eyelids and deepens the shadow cast over the eye by the upper lid. He darkens the iris and the pupil, picking out the highlight on the iris with a quick touch of an eraser. More clusters of parallel lines darken the corner of the eye socket alongside the nose. Scribbly, erratic lines suggest the eyebrow. And the sharp point of the pencil carefully retraces the contours of the upper lid and the tear ducts at the corner of the eye.

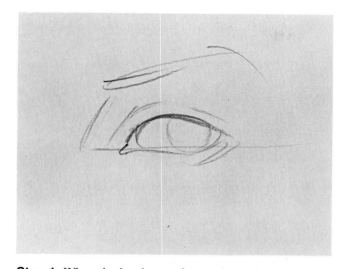

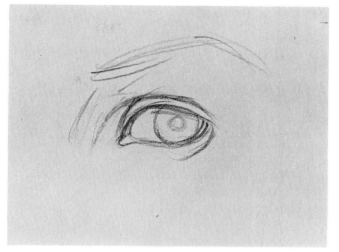

Step 1. When the head turns from a front view to a three-quarter view, the eye turns too, of course, and its shape changes. If the sitter is looking straight at you, the iris moves to the side, as you see here. Once again, the artist begins with quick, casual lines for the main contours of the eyelids, iris, and eyebrow, with a slight suggestion of the eye socket along the side of the nose. Have you noticed the straight horizontal line that crosses the eye? That's the guideline the artist has drawn across the egg shape of the head to locate the eyes.

Step 2. The artist goes over the lines of Step 1 with darker, more precise lines. The curves of the eyelids are defined more carefully. The disc shape of the iris is drawn more precisely, and the pupil is added. In the three-quarter view, the eye doesn't look quite as wide as it does in the front view. But the curving shapes of the lids are essentially the same. From the outer corner, the top lid begins as a long, flattened curve and then turns steeply downward at the inside corner. Conversely, the lower lid starts from the inside corner as a long, flattened curve and then turns sharply upward at the outside corner.

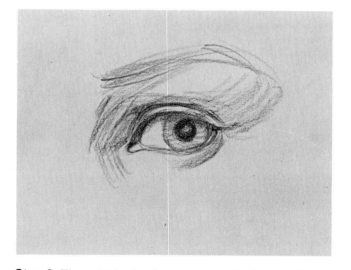

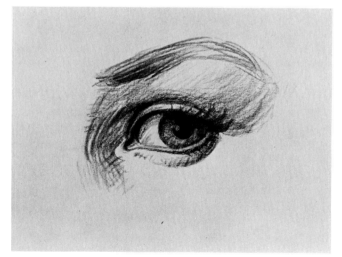

Step 3. The artist begins to suggest the distribution of tones with clusters of parallel strokes. These broad strokes are made with the side of the lead, rather than with the sharp tip. Notice how the strokes tend to curve around the contours of the eye sockets. The shadowy edges of the lids are drawn carefully. Once again, the artist indicates the shadow cast across the eye by the upper lid. The pupil is darkened. The eyebrow is darkened slightly, but the strongest darks are saved for the final step.

Step 4. The artist blackens the pupil, darkens the iris, and strengthens the shadowy edges of the eyelids. More groups of parallel strokes—made by using the side of the lead—curve around the eye socket to darken the tones and make the shape look rounder. On the white of the eye, a touch of shadow is added at the corner. Long, graceful lines suggest the hairs of the eyebrow, while short, curving lines suggest eyelashes. An eraser picks out highlights on the pupil. Compare the soft, rounded character of this female eye with the more angular male eye on the preceding page.

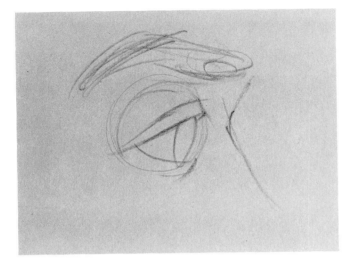

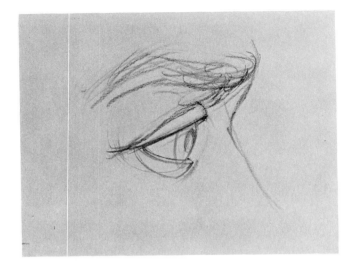

Step 1. The eye is actually a small sphere that rests in the circular cup of the eye socket. It's often a good idea to begin by drawing the complete sphere, as the artist does here. Around the sphere, he wraps the eyelids, which are like two curving bands, and places the iris on the front of the sphere. The eyebrow curves around the edge of the sphere. If you visualize the eye in this way, it looks rounder and more three-dimensional. Later on, you can erase the lines of the sphere, of course.

Step 2. Working with the pencil point, the artist carefully sharpens the lines of the lids, draws the iris more precisely, and adds the pupil. A second line is added to indicate the top of the lower lid. Now you have an even stronger feeling that the eyelids are bands of skin that wrap around the spherical eyeball—although the artist has erased most of the lines of the sphere that he drew in Step 1. The artist begins to strengthen the lines of the eyebrow, which has a distinct S-curve. Compare the upper and lower lids: the upper lid has a steeper slant than the lower lid and juts farther forward.

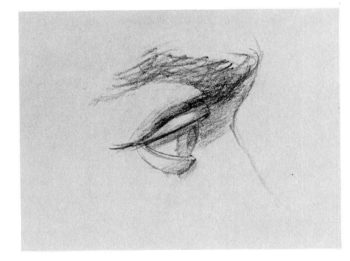

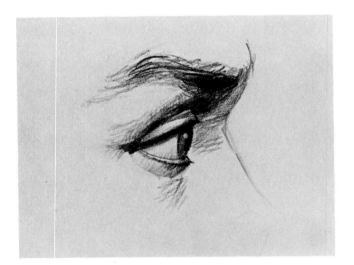

Step 3. Moving the side of the pencil lightly over the paper with parallel strokes, the artist begins to block in the tones. He darkens the eyebrow and indicates the shadow beneath the brow, just above the bridge of the nose. He adds shadows to the edges of the curving eyelids and places a deep shadow in the eye socket, just above the upper lid. The upper lid casts a distinct strip of shadow over the iris and the white of the eye. The artist darkens the iris and the pupil.

Step 4. Still working with the side of the pencil to make broad strokes, the artist darkens the shadows with clusters of parallel strokes. He accentuates the shadows around the eye, making the eye socket seem deeper. He also darkens the shadowy edges of the eyelids and adds a few dark touches to suggest eyelashes. The iris becomes a darker tone and the pupil becomes darker still—highlighted with a white dot made by the tip of a kneaded rubber eraser. Just above the lower lid, a hint of tone makes the white of the eye look rounder. Rhythmic, curving strokes complete the eyebrow.

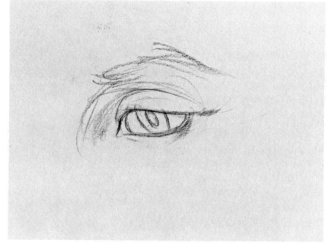

Step 1. When the head tilts downward, the eye tilts downward too. As you can observe in this preliminary sketch, the tilted view of the eye shows you more of the upper lid and less of the lower lid. You also see somewhat less of the iris and the white of the eye because the upper lid seems to come farther down. These first sketchy lines define the curves of the eyelids—wrapping around the ball of the eye—as well as the corner of the eye socket and the typical S-curve of the eyebrow.

Step 2. The artist carefully draws the contours of the eye and eyelids over the sketchy guidelines of Step 1. Because we're looking down at the eye from above, we see a lot of the upper lid, and the shape of the eye itself seems more slender than it looks in a front view. The artist sharpens the lines of the iris and adds the pupil. He draws the tear duct more precisely. And he begins to suggest the inner contours of the eye socket with groups of curving lines that follow the rounded shape of the socket. Notice how the upper lid overlaps the lower lid at the outer corner.

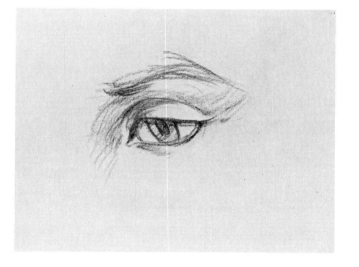

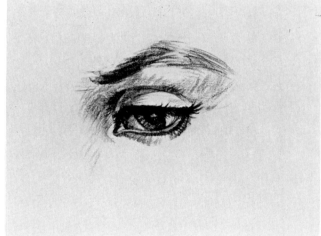

Step 3. To block in the tones, the artist moves the side of the pencil lightly across the paper. Clusters of parallel curved strokes suggest the roundness of the eye socket above the eye and in the corner adjacent to the nose. The shadows on the lids are also executed with curving strokes. The iris is darkened with parallel strokes. The artist presses harder on the pencil to darken the pupil. Horizontal strokes suggest the shadow cast by the upper lid on the iris and on the white of the eye. A deep shadow is placed in the inner corner of the eye. Long, curving, rhythmic strokes suggest the eyebrow.

Step 4. To complete the drawing, the artist builds up the shadow around the eye with thick strokes, using the side of the pencil lead. He strengthens the deep shadow cast by the eye socket on the upper lid, and then he strengthens the shadow beneath the lower lid. He darkens the iris and pupil, deepens the shadow cast by the upper lid, and adds delicate touches of tone to the white of the eye. Most of the eye is in shadow because it turns downward, away from the light. An eraser picks out just a few areas of light. And the point of the pencil adds the details of the lashes and eyebrow.

Step 1. The artist begins to draw the mouth with straight, simple lines. Down the center of the drawing, you can see the vertical center line that helps him construct a symmetrical mouth and chin. The dividing line between the lips is one of the horizontal guidelines that the artist draws across the egg-shaped head. Above this horizontal line, the artist draws just four lines for the upper lip and three lines for the lower lip, plus a scribble to suggest the shadow beneath the lower lip. Notice that he also indicates the groove that travels from the upper lip to the base of the nose.

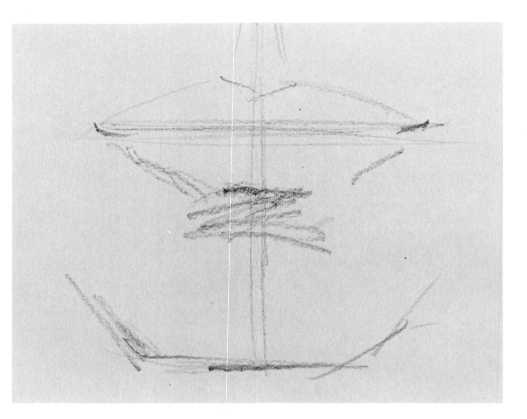

Step 2. The upper lip is actually shaped something like a pair of wings that meet at the center line of the face. The artist redraws the upper lip with firmer strokes to indicate this shape. The lower lip actually consists of a blocky frontal plane and two triangular side planes. The artist adds lines to indicate these planes. He also strengthens the vertical center line to suggest the slight crease that often runs down the center of the lower lip.

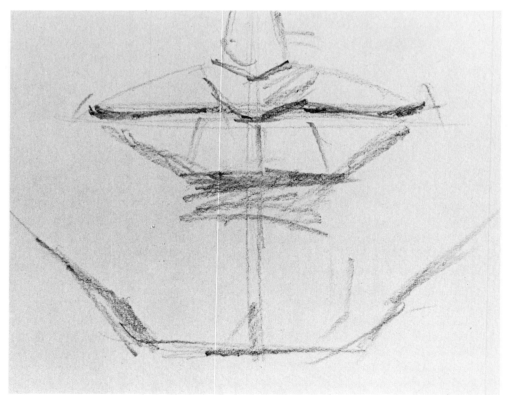

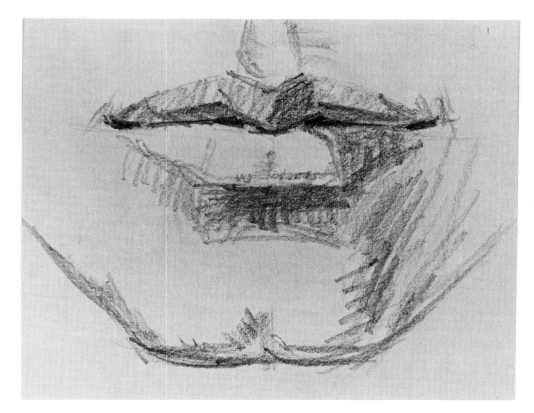

Step 3. Turning the pencil so he can make broad strokes with the side of the lead, the artist begins to block in the tones with groups of parallel strokes. The upper lip is usually in shadow because it turns downward, away from the light. Between the lips, the artist places a line of deep shadow. And there's a pool of shadow beneath the lower lip. The light is coming from the left, so the artist places shadows on the side planes at the right—away from the light. For the same reason, he begins to indicate a shadow on the right side of the chin and suggests a bit of shadow in the groove above the upper lip.

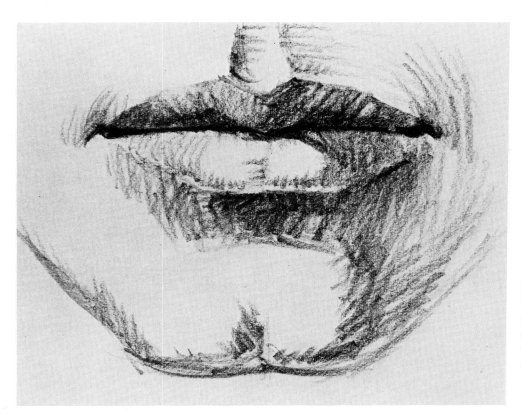

Step 4. Having roughly indicated the pattern of light and shade in Step 3, the artist strengthens all these tones in the final step. He darkens the upper lid, which is just a bit lighter at the left—the lighter side of the face. The lower lip is divided into three tonal areas—halftone at the left, light in the center, and shadow at the right—that correspond to the three planes drawn in Step 2. The artist strengthens the dark line between the lips, builds up the shadow beneath the lower lip, strengthens the modeling on the jaw and chin, and adds more tone to the groove above the upper lip. Notice the strong touches of shadow at the corners of the mouth.

Step 1. The artist draws the wing shape of the upper lip with curving lines to suggest the softness of the female mouth. He draws the full lower lip with a single curve. The horizontal line between the lips is the usual guideline that he draws across the egg shape of the head to indicate the placement of the mouth. The head is turned slightly to the left and so is the mouth; therefore, the vertical center line is also slightly to the left and the mouth is no longer exactly symmetrical. We see more of the right side.

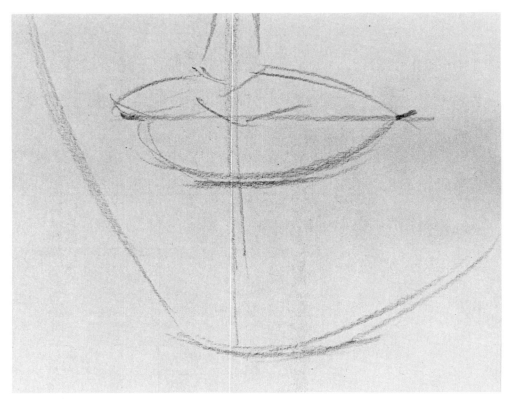

Step 2. Going back over the sketchy lines of Step 1, the artist draws the shapes of the lips more exactly. Study the intricate contours of the wing-shaped upper lip. Notice how the center of the upper lip dips downward over the lower lip. The artist doesn't draw dividing lines for the three planes of the lower lip, but the outer contour is squared up slightly to suggest these three planes. He also refines the shape of the jaw and chin with additional lines.

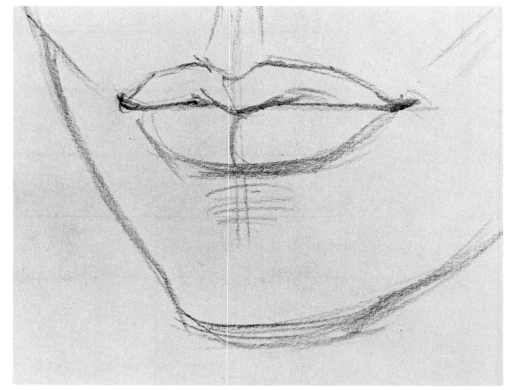

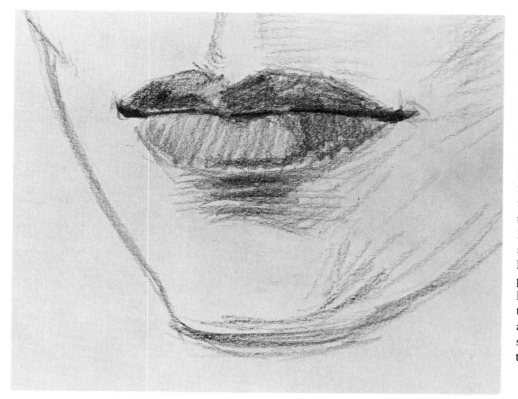

Step 3. The artist begins to darken the upper lip, which is normally in shadow, as you've seen in the preceding demonstrations. He darkens the dividing line between the lips, accentuating the shadows at the corners of the mouth. Just above this dark line, he darkens the shadowy upper lip to emphasize its roundness. He places a light tone on the lower lip, which turns upward and receives the light, but he darkens the shadow plane at the right. Rough strokes darken the pool of shadow beneath the lower lip. He begins to add tone to the side of the chin and jaw. And he adds a heavy shadow to the groove above the upper lip.

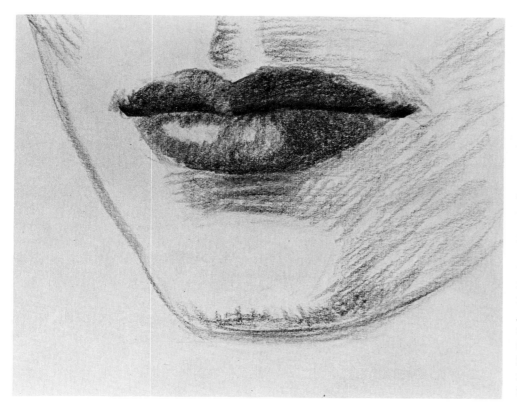

Step 4. The artist continues to darken the shadowy upper lip and strengthens the dividing line between the lips. He adds more tone to the corners of the mouth. Although the lower lip receives more light than the upper one, the lips *are* darker than the surrounding skin—so he adds more tone to the lower lip, leaving just a patch of light for a highlight. He darkens the shadow plane of the lower lip at the right and strengthens the shadowy underside of the lip to make the shape look rounder. Finally, he adds more tone to the chin and jaw, as well as to the groove above the upper lip. Compare the soft, round female mouth in this demonstration with the more angular male mouth in the preceding demonstration.

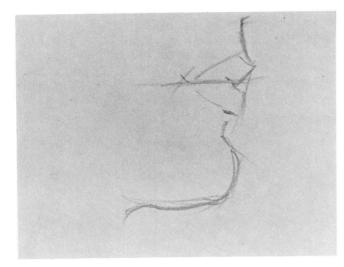

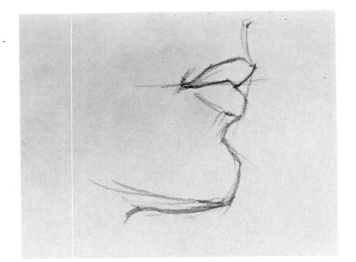

Step 1. Above the horizontal guideline that represents the dividing line between the lips, the artist draws the upper lip with just a few crisp lines, plus a single line for the curve leading upward to the base of the nose. In the same way, he draws the lower lip with a few angular lines and then carefully draws the shape of the chin with curving strokes. Notice the slanted line that touches the tips of the upper and lower lips at the right. This is an important guideline because it indicates the relationship between the lips: the upper lip normally protrudes farther forward.

Step 2. Working carefully over the sketchy lines of Step 1, the artist redefines the shapes of the lips with darker lines. Notice how the upper lip turns down and slightly overlaps the lower lip. The lower lip recedes slightly and is just a bit thicker than the upper lip. The artist also strengthens the lines of the chin and accentuates the shadowy corner of the mouth.

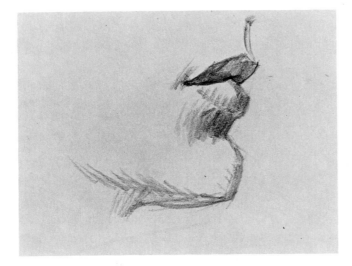

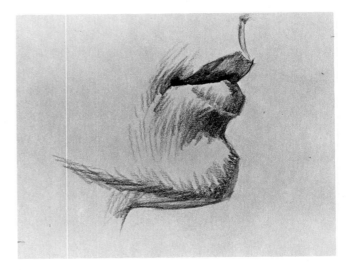

Step 3. The artist adds broad areas of tone with the side of the lead. You can see clearly that the upper lip is in shadow because it slants downward, away from the light. The lower lip is paler because it turns upward and receives the light. The upper lip casts just a hint of shadow across the lower lip; there's also a hint of shadow along the lower edge. Beneath the lower lip is a concave area that curves away from the light and is filled with shadow. The artist adds more shadow at the corner of the mouth and begins to model the tones of the chin and jaw.

Step 4. The artist darkens the upper lip and accentuates the shadow line between the lips, as well as the dark corner of the mouth. He deepens the pool of shadow beneath the lower lip and adds more strokes to model the entire jaw area, which now becomes rounder and more three-dimensional. Finally, he darkens the forward edge of the lower lip, which receives the shadow cast by the overlapping upper lip. It's interesting to study the pattern of the pencil strokes, which gradually change direction to follow the curving forms of the mouth, chin, and jaw.

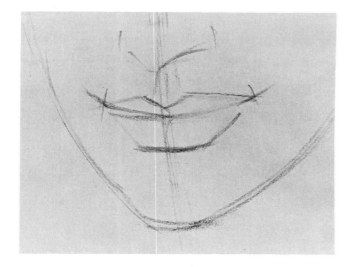

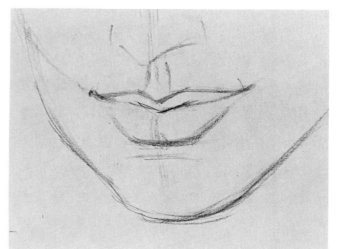

Step 1. When the head turns downward—or when we look at the head from slightly above—we get a different view of the mouth. We see somewhat less of the upper lip and more of the lower lip. (In this drawing, the head is turned slightly to the left, and so we also see more of the right side of the mouth.) As you've seen in previous demonstrations, the preliminary drawing captures the wing shape of the upper lip and the three planes of the lower lip—all with straight, simple lines.

Step 2. The artist redraws the lips with softer, curving lines and gently erases the more angular guidelines of Step 1. Now you see the protruding center of the upper lip, which slightly overlaps the lower lip. The corners of the mouth turn slightly upward and the wing shape of the upper lip becomes more graceful. The artist also strengthens the lines of the chin, the jaw, and the groove between the upper lip and the base of the nose.

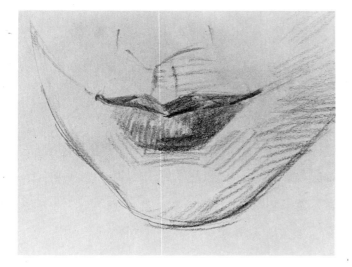

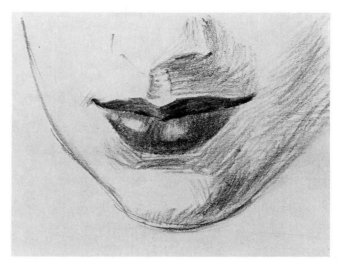

Step 3. The artist darkens the upper lip *selectively*. The upper lip actually has a kind of zigzag shape that's sometimes in light and sometimes in shadow. This is most apparent at the center, where the left plane catches the light and the right plane is in shadow; the artist accentuates the shadow plane to make the shape jut forward. He also darkens the line between the lips, adds tone to the lower lip, darkens the shadow plane at the right, and also darkens the underside of the lower lip to make the shape look rounder. He begins to model the tones on the chin and jaw.

Step 4. As the artist darkens the tones of the lips, it's obvious that the light comes from the left, since the right planes are in shadow. He darkens the right sides of both lips and deepens the shadow line between the lips. He also accentuates the dark corners of the mouth. The shadowy underside of the lower lip is darkened to make the shape look rounder and fuller. An eraser picks out highlights on the rounded lower lip. The artist darkens the shadow area beneath the lower lip and models the soft curves of the chin and jaw.

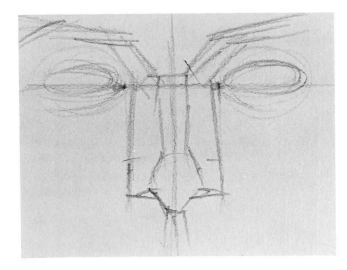

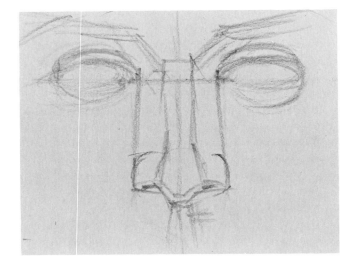

Step 1. The preliminary sketch emphasizes the proportions of the nose in relation to the eyes. The space between the eyes is usually the width of one eye. The artist draws vertical guidelines down from the inner corners of the eyes to indicate the width of the nose—which is about "one eye wide" at the base. These vertical guidelines establish the *outer* edges of the nostrils. Now study the inner guidelines: the diagonals that connect the brow to the bridge; the verticals that define the bridge; and the diagonals that indicate the tip of the nose. The vertical center line aids symmetry.

Step 2. Over the vertical guidelines of Step 1, the artist draws curving lines to define the shapes of the nostrils, plus firm, straight lines to define the tip of the nose more precisely. The artist doesn't draw the nose in isolation but works on the other features at the same time. He begins to define the shapes of the eyes more precisely, since the shape of the nose flows into the eye sockets. He also indicates the shape of the groove leading from the nose to the upper lip.

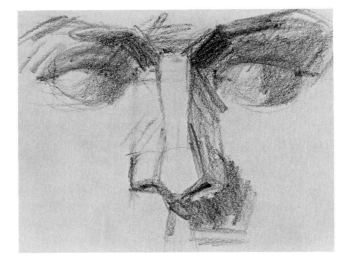

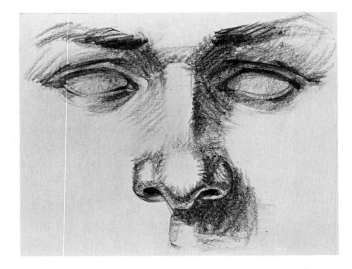

Step 3. With the side of the lead, the artist blocks in the tones with broad strokes. The light comes from the left, and so the right side of the nose is in shadow. Since the nose locks into the eye sockets, the artist adds tone to the sockets at the same time. There's a particularly dark patch of tone in the eye socket at the right, just above the bridge of the nose. The nose also casts a shadow downward toward the right, over the upper lip. The artist erases the guidelines of Step 1, adds tone to the underside of the nose, and darkens the nostrils.

Step 4. The artist now sharpens the contours and builds up the tones. Study the subtle gradation of tone on the shadow side of the nose, as well as the gradations on the tip of the nose and the nostrils. The underside of the nose is in shadow, but there's just enough reflected light within the shadow to define the shapes. Notice how the cast shadow under the nose is paler as the tone recedes downward. There are also deep shadows in the eye sockets on either side of the nose, plus a soft patch of shadow just above the bridge, where the brow slants down, away from the light.

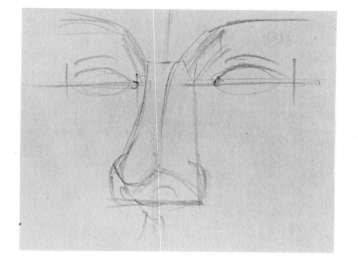

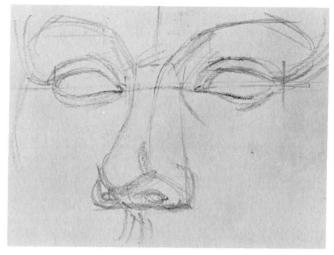

Step 1. When the head turns to a three-quarter view, the nose no longer looks symmetrical; we see more of one side. In this drawing, the head also tilts slightly upward, and so we see more of the underside of the nose. The artist starts with the slanted lines of the brow, leading downward along the eye sockets to the bridge of the nose. The bridge and side plane are indicated by vertical lines that lead down to the base of the nose, which is roughly "one eye wide." Curving lines indicate the nostrils and the tip of the nose. The artist draws the eyes at the same time.

Step 2. Following the guidelines of Step 1, the artist refines the curved shapes of the nostrils, the tip of the nose, and its underside. He also refines the shapes of the eyes and the eye sockets that flow into the sides of the nose.

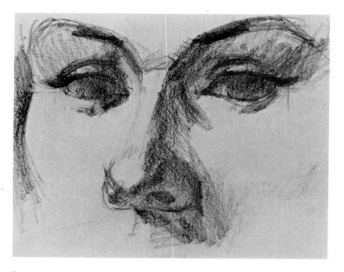

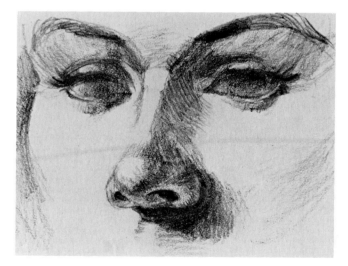

Step 3. The side of the pencil begins to indicate the shapes of the shadows with rough, scribbly strokes. The light comes from the left, and so the right side of the nose is in shadow. So is the underside, which also casts a slanted shadow downward. The artist also begins to model the eye sockets, since their shapes are inseparable from the shape of the nose. You already begin to see the distinction between halftone and shadow on the tip and side of the nose.

Step 4. The artist continues to build up the tones on the shadow side of the nose and around its tip. The wings of the nostrils are clearly defined by darker strokes, as well as by touches of reflected light. Notice that the rounded tip of the nose is modeled as a separate form, very much like a little ball. The artist darkens the eye sockets on either side of the nose to make the bridge stand out more distinctly. He's erased the guidelines of Step 1 and continues to work on the surrounding features as he works on the nose.

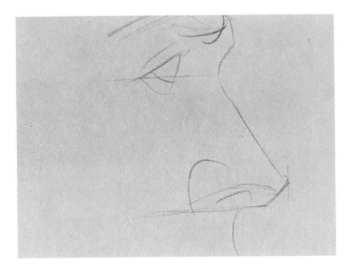

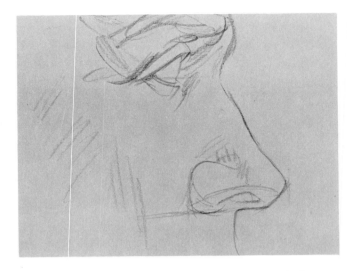

Step 1. Drawing the nose in profile, the artist carefully follows the horizontal guidelines that locate the eye and the base of the nose. He draws the brow and the eye at the same time to establish an accurate relationship between the features. The eye is just above the bridge of the nose and aligns with the concave curve beneath the brow. The back end of the nostril wing lines up roughly with the forward edge of the upper eyelid. The nose itself is drawn with just a few straight lines and a few curves.

Step 2. The artist draws the contours more precisely over the guidelines of Step 1—and then erases most of them. Now there's a distinct S-curve from the bridge of the nose down to the tip. The underside of the nose is clearly defined as a separate plane. The curving shape of the nostril wing is more carefully drawn. The artist also refines the curve of the brow and continues to work on the eye as he draws the nose. A few strokes divide the tip of the nose and the nostril into separate shapes—this division will become more important when tone is added in Steps 3 and 4.

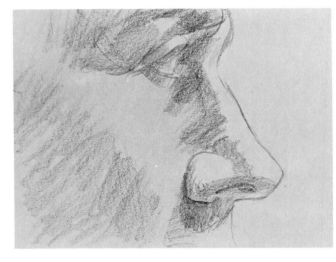

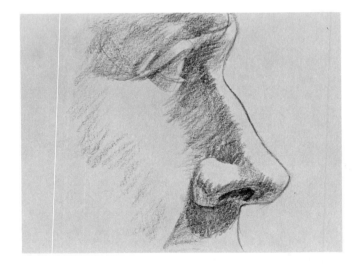

Step 3. The artist begins to block in the tones with broad strokes, using the side of the pencil lead. The light comes from the left, and so the front plane of the nose is in the light, while the side plane is in shadow. The underside of the nose and the back of the nostril are also in shadow, while the front plane of the nostril catches the light. Notice that a patch of shadow now divides the tip of the nose from the nostril. There's also a patch of deep shadow in the eye socket.

Step 4. As the artist strengthens his dark tones, you begin to see a clear distinction between light, halftone, and shadow on the side of the nose and on its underside. The artist deepens the shadow on the eye socket and darkens the nostril. With the sharp point of the pencil, he draws the contours of the brow, nose, and upper lip more exactly. Notice a hint of shadow where the brow turns downward, away from the light. And observe how the slanted strokes of the pencil accentuate the three-dimensional character of the forms.

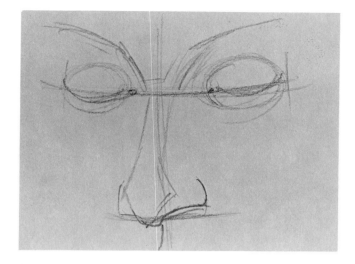

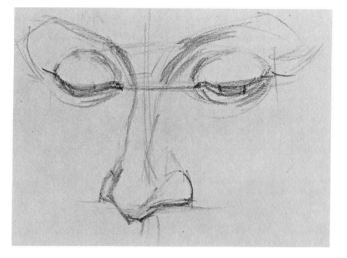

Step 1. In this view of the nose, the head tilts slightly downward, and so we see very little of the underside of the nose. The head is also turned slightly to the left, and so we see more of the right side and very little of the left. In this preliminary sketch, the artist visualizes the tip of the nose as a kind of diamond shape. The undersides of the nostrils look like curves. The outer edges of the nostril wings still align with the inside corners of the eyes.

Step 2. The artist continues to define the rounded shapes of the nostrils more precisely. He sees very little of the nostril on the left and a great deal of the one on the right. The tip of the nose seems to hang downward, since we're looking at it from slightly above. The artist redraws the bridge of the nose, which widens slightly just above the eyes. He works on the eyes at the same time that he draws the nose. Because the head and eyes turn downward, we see a great deal of the upper eyelids.

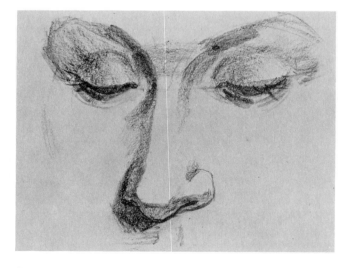

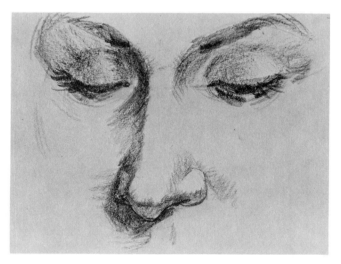

Step 3. The light comes from the right, and so the artist builds up the tones on the left sides of the forms. The left side of the nose is in shadow. So is the underside, which casts a slanted shadow downward toward the upper lip. The artist carefully models the inner curves of the eye sockets, which define the top of the nose. In particular, notice the dark curve of the eye socket at the left, which swings around the bridge of the nose.

Step 4. The artist continues to darken the inner curves of the eye sockets; these tones make the bridge of the nose seem more three-dimensional. He darkens the tone on the shadow side of the nose; now you see a clear gradation of light, halftone, and shadow. He models the tip of the nose as if it's a little ball. He models the nostril at the right as a separate shape, surrounded by tone. The pencil point sharpens the contours of the underside of the nose. At the right of the lighted nostril wing, a hint of tone suggests the inner edge of the cheek.

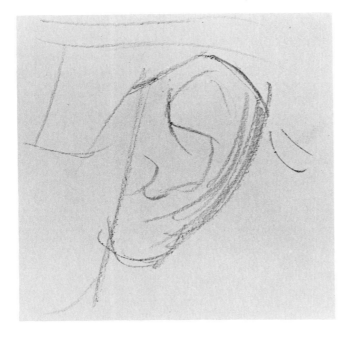

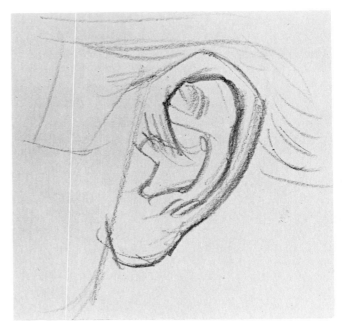

Step 1. The artist begins by drawing a guideline diagonally upward from the jaw. The ear attaches to this line. He draws the top of the ear with two angular lines and then moves downward to draw the back of the ear with a big curve and the lobe with a smaller curve. Carefully observing the inner detail of the ear, he draws the shapes with short, curved strokes.

Step 2. Over the sketchy lines of Step 1, the artist draws the contours of the ear with darker, more precise lines. A dark inner line defines the sinuous shape of the rim, which winds around to the deep "bowl" at the center of the ear. The artist draws the inner shape more exactly.

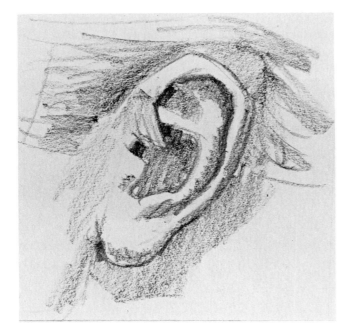

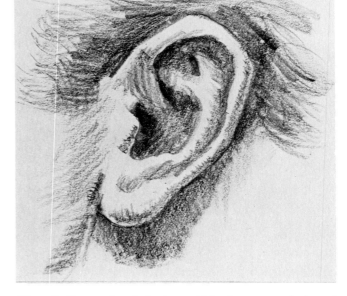

Step 3. The artist adds the pools of shadow within the ear, which is darkest just inside the rim. He moves around the outer edge of the ear and around the lobe, adding touches of shadow that make the shape look three-dimensional. He suggests the hair surrounding the ear and begins to model the cheek and jaw. Notice the tiny pool of shadow where the lobe attaches to the jaw.

Step 4. The pools of shadow within the ear are darkened with heavy strokes. Small parallel strokes strengthen the tones around the edge of the ear; then an eraser brightens the lighted areas. The ear casts a shadow downward on the back of the neck. The artist completes the surrounding hair, making the rounded forms of the ear stand out more boldly.

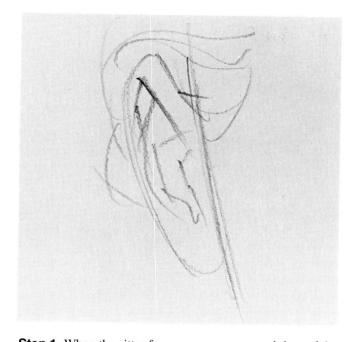

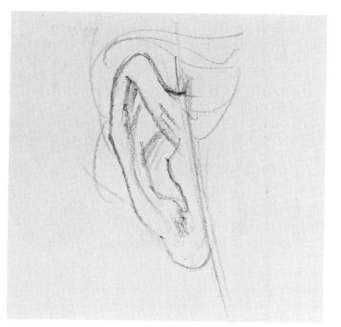

Step 1. When the sitter faces you, you see much less of the ear. The shape grows slender. The artist begins by drawing the slanted line of the jaw and cheek, to which the ear attaches. He draws the outer shape of the ear with just a few straight lines and curves, and then draws the inner shape with shorter lines. He indicates the hair that surrounds the ear.

Step 2. Step 1 is a highly simplified version of the ear, of course. Now the artist goes back over these sketchy lines to define the shapes more precisely. He draws the intricate curves and angles over the guidelines—which he then erases.

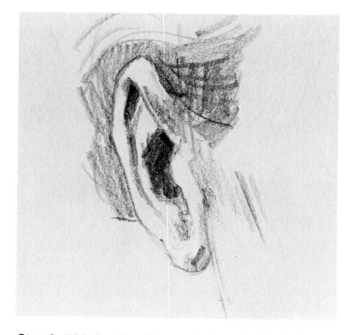

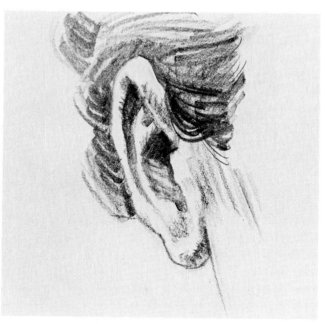

Step 3. With the side of the pencil, the artist blocks in a big pool of shadow at the center of the ear, plus the slender shadow that starts at the top and travels down along the inside of the rim. He begins to model the lobe and the portion of the ear that attaches to the side of the head. The tone of the hair is blocked in to make the lighted edge of the ear stand out.

Step 4. The side of the pencil deepens the inner tones of the ear. Then an eraser lightens the lower half of the big pool of shadow. A few additional touches of tone appear on the rim and lobe of the ear. The tone of the hair is carried carefully around the ear and helps to define its shape. In this view, we see a minimum of detail; the ear is drawn very simply.

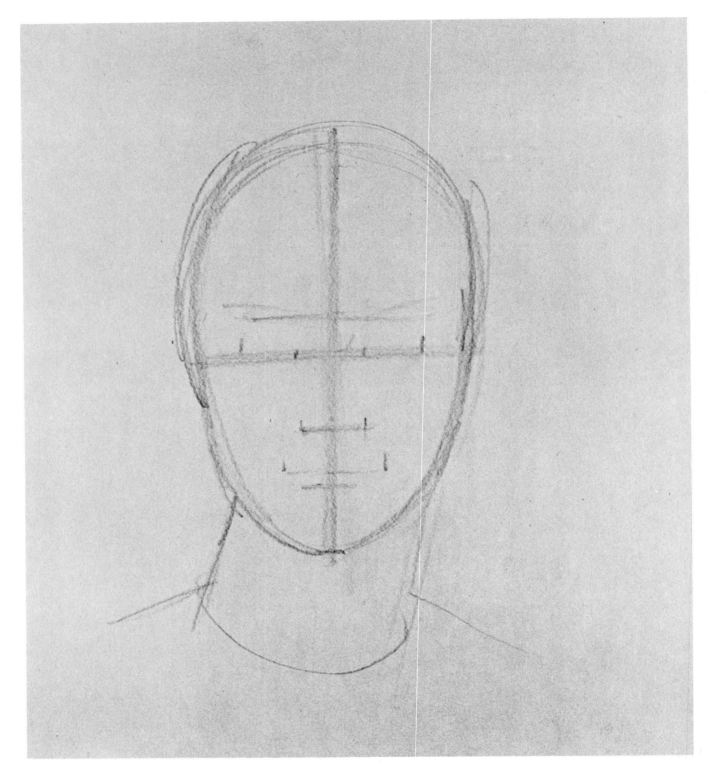

Step 1. Now, to show you how to put together everything you've learned so far, the artist draws a front view of a complete head. He starts out with the traditional egg shape and visualizes the neck as a slightly slanted cylinder. For symmetry, he draws a vertical guideline down the center of the egg. Then he adds horizontal guidelines for the brow, eyes, nose, and mouth. He divides the eye line into five different parts: two of these parts will become eyes, of course, but the space *between* them is also the width of one eye—and so are the spaces on either side of the eyes. The base of the nose is also "one eye wide." The mouth is about "two eyes wide."

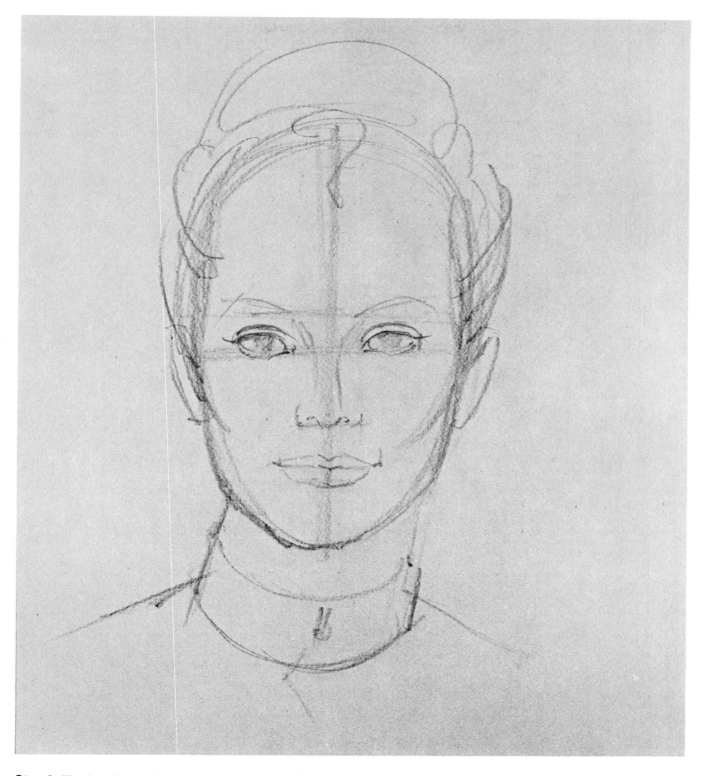

Step 2. The first simple sketch of the features goes directly over the guidelines of Step 1. The artist squares up the jaw just a bit, adds the ears—which align with the nose and eyes—and suggests the shape of the hair, which extends beyond the edges of the egg. He draws the lines of the eyelids and suggests the shape of the iris. He quickly sketches the bridge of the nose, the shapes of the nostrils, and the tip. He draws the characteristic wing shape of the upper lip and the fuller curve of the lower lip. The sitter's collar curves around the cylinder of the neck.

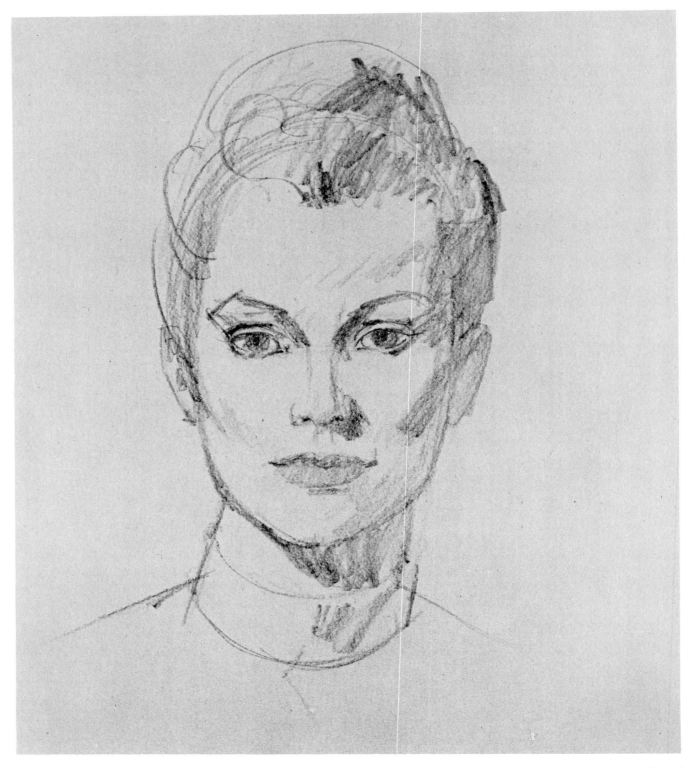

Step 3. Switching from the point of the pencil to the side of the lead, the artist begins to darken his tones with broad parallel strokes. The light comes from the left, and so most of the tones are on the right sides of the shapes. He carries the tone downward over the side of the forehead, cheek, jaw, and chin, adding the shadow on the neck. He adds the first suggestion of tone to each eye socket, iris, and pupil, and then moves downward to add broad, simple tones to the nose and lips. As usual, the upper lip is darker than the lower, and there's a shadow beneath the lower lip. Touches of tone appear on the ears. The hair is visualized as a big, simple mass, lighter on one side than on the other.

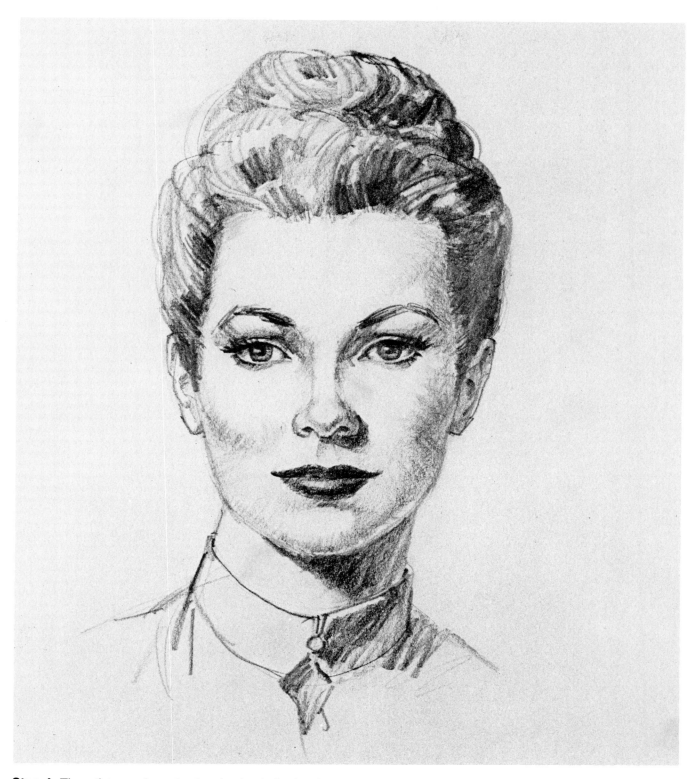

Step 4. The artist completes the drawing by darkening the tones with the side of the pencil and sharpening contours and details with the tips. He builds up the modeling on the shadow side of the face, where you can now see a distinct gradation of light, halftone, shadow, and reflected light. On the lighted side of the face, he adds touches of tone where the cheek and jaw turn away from the light. He darkens the eye sockets, the underside of the nose and nostrils, the lips, the tones within the ears, and the shadow beneath the chin. With the point of the pencil, he sharpens the contours of the ears, emphasizes the detail of the eyes and eyebrows, draws the nostrils more precisely, and suggests the detail of the collar. He completes the hair with broad strokes made with the side of the lead.

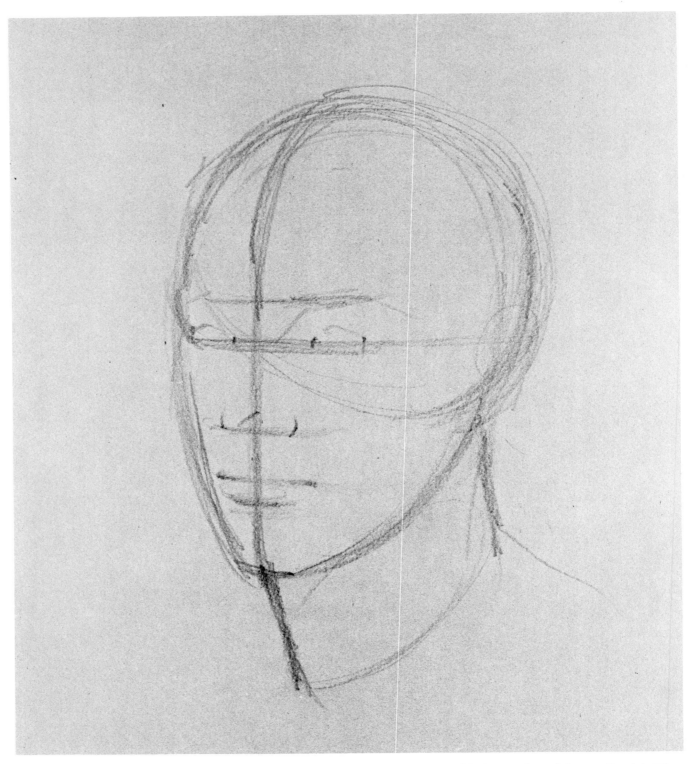

Step 1. The procedure is essentially the same in a three-quarter view. But now the guidelines are a vertical egg overlapped by a horizontal egg. The center line moves as the head turns to the side. The horizontal guidelines are still in the same places, of course. Across the eye line, the artist locates the eyes with tiny touches of the pencil point. Moving down to the line at the base of the nose, he locates the outer edges of the nostrils in the same way. The neck is a slightly slanted cylinder once again. Notice that the back of the head protrudes well beyond the line of the neck.

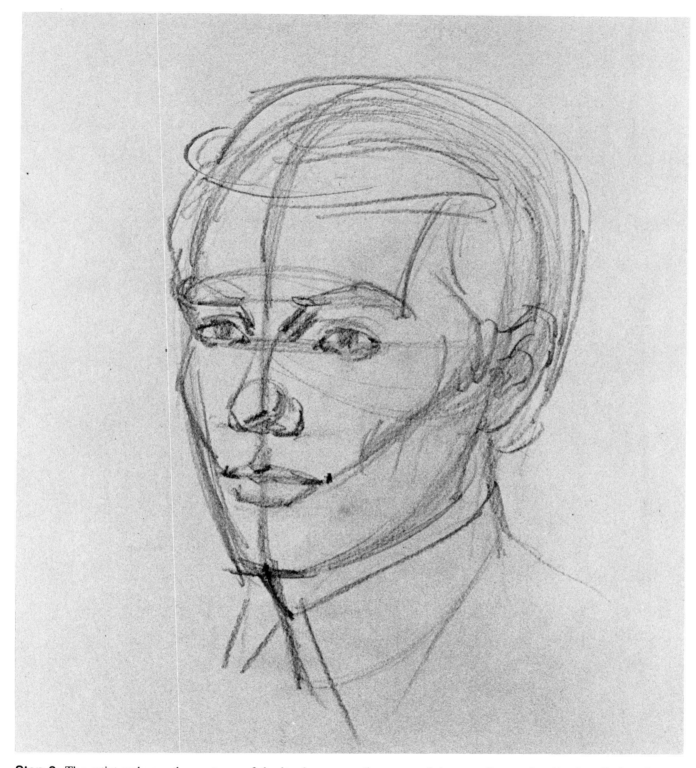

Step 2. The artist reshapes the contours of the head over the original guidelines, adding the angular details of the brow, cheek, chin, and jaw. The features appear in their correct places on the horizontal guidelines. Although the head is turned to a three-quarter view, the ear still aligns roughly with the eyebrow and nose. Notice how the tip of the nose and the nostrils are visualized as distinct forms. The eyelids are clearly drawn, as are the dark patches within the eyes. The upper lip has the distinctive wing shape, while the lower lip looks blocky and masculine. The hair starts just below the crown and extends beyond the guidelines of the upper egg shapes.

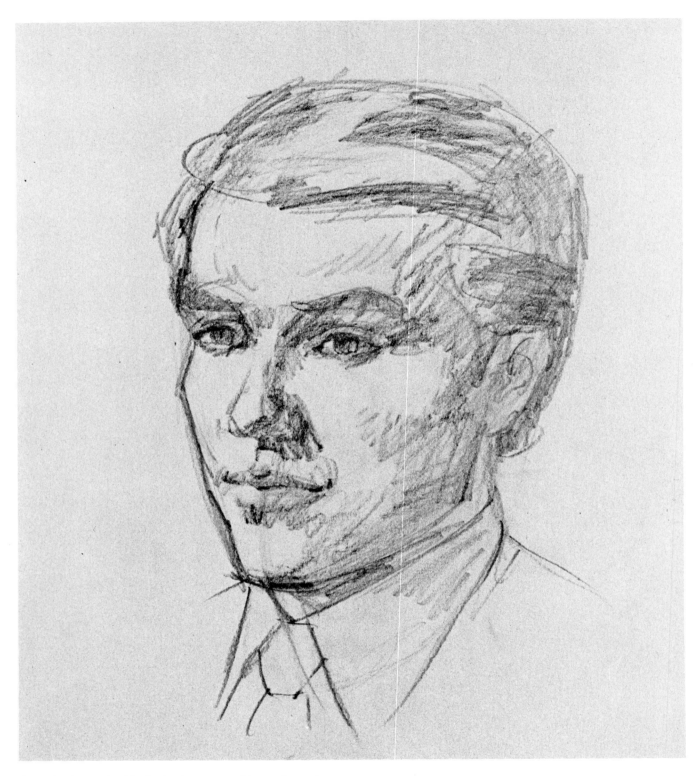

Step 3. The artist blocks in the tones with rough strokes. First he places the biggest tonal shapes on the side of the brow, cheek, jaw, and chin. Then he moves to the features, adding tone to the eye sockets, eyelids, nose, and lips. The nose casts a slanted shadow downward toward the right. As usual, the upper lip is in shadow, the lower lip catches the light, and there's a deep shadow beneath the lower lip.

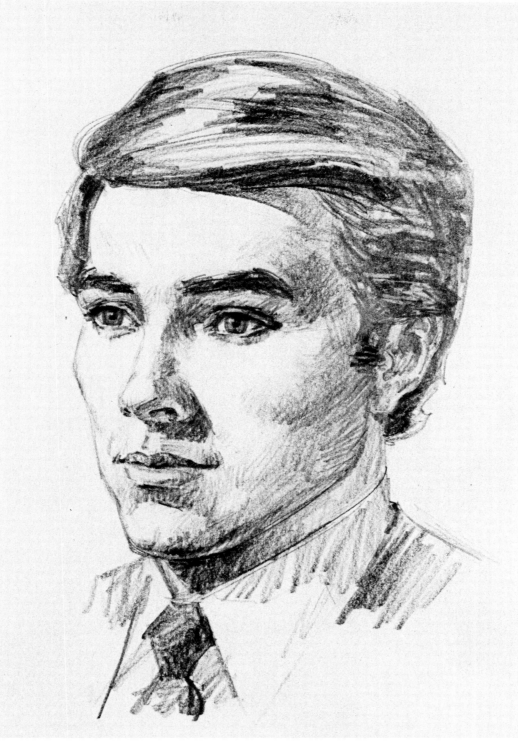

Step 4. The artist finishes the drawing by building up the darks throughout the face and features, and so now you can see the lights, halftones, shadow, and reflected light distinctly. The point of the pencil sharpens the lines and adds the details. Is this four-step process becoming familiar? Good!

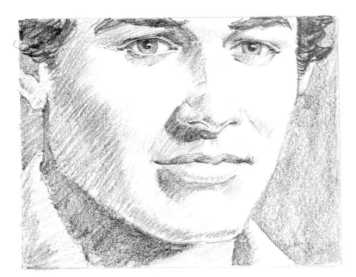

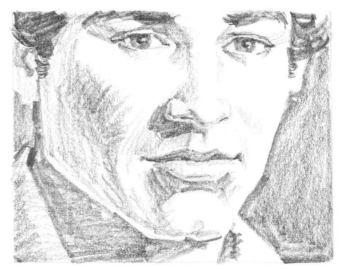

Slender Strokes. Working with the sharp point of the pencil, you can build up the tones of your drawing with groups of slender parallel strokes. The halftones and reflected lights are clusters of fairly pale strokes; the artist has applied only moderate pressure to the pencil. The darker shadows consist of heavier strokes; the artist has pressed harder on the pencil. The strokes are closer together in the shadow areas, while there are more spaces between the strokes in the halftones and reflected lights. Observe how the strokes change direction to suggest the curve of the cheek.

Broad Strokes. Here's the same subject executed with much broader strokes. The artist holds his pencil at an angle so the *side* of the lead touches the paper. He presses harder on the pencil to make the darker strokes, which are closer together than the paler strokes. The pencil moves diagonally (with a slight curve) to suggest the roundness of the cheek. Then the pencil moves vertically downward to suggest the squarish shape of the jaw. And the strokes become slanted again as the pencil follows the angle of the jaw down to the chin.

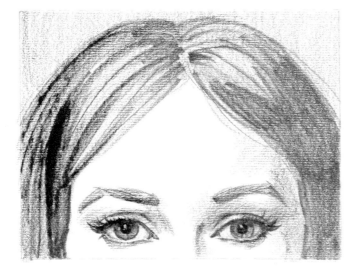

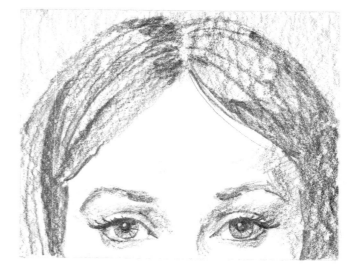

Strokes on Charcoal Paper. Charcoal paper isn't just for charcoal drawing. Its subtle, ribbed surface is equally good for pencil drawing. The delicate *tooth* (as it's called) of the sheet combines with the pencil strokes to produce a lively texture. In this close-up of a woman's portrait, the thick-and-thin pencil strokes in the hair are softened by the textured surface of the paper: tiny flecks of bare paper pop through even the darkest tones, making the strokes vibrate with a kind of inner light. These tiny flecks of bare paper lend softness and transparency to the tones around the eyes.

Strokes on Rough Paper. It's worthwhile to try a variety of textured papers, many of which are rougher and more irregular than charcoal paper. In this portrait of the same woman you see on the left, the artist has used a thick stick of graphite in a plastic holder and drawn on extremely rough paper. The thickness of the drawing tool and the irregular surface of the drawing paper combine to make the strokes look bold and ragged. The marks of the graphite stick look granular, with big flecks of bare paper showing through. The strokes are less precise than those on the charcoal paper, but more dynamic.

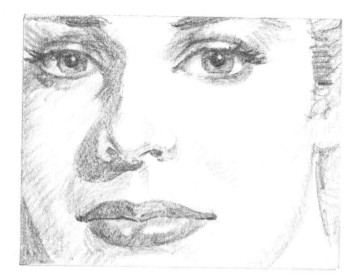

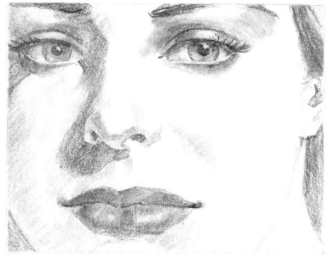

Modeling with Strokes. This woman's face is modeled with delicate strokes that travel carefully over the forms. For example, there are two patches of tone above the right eye socket; each consists of slanted strokes that are carefully angled to express the roundness of the form. Now follow the route of the strokes that model the cheek on the shadow side of the face. In the pale halftone area under the eye, the lines are delicate diagonals. As the cheek turns away from the light, the strokes curve and darken. The entire face is rendered with carefully planned groups of strokes.

Modeling by Blending. Another way to render tone is by blending the strokes of the pencil (or the graphite stick) with the tip of your finger or a paper stomp. Look carefully at this drawing of the same sitter and you'll see that the artist has started with broad, rather casual strokes—not as neat or careful as the ones in the drawing at your left—and smudged them to create soft, velvety tones. The blending doesn't obliterate the strokes completely, but they melt away into smoky areas that look more like patches of paint. The softer grades of pencil are easiest to blend.

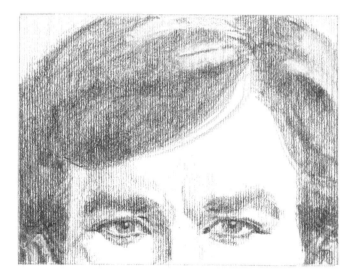

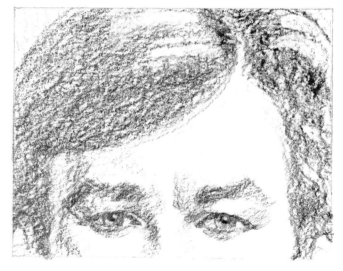

Continuous Tone on Charcoal Paper. Still another way to build up tone on charcoal paper is to rub the side of the lead gently back and forth as if you were sharpening the lead on a piece of sandpaper. The tooth of the paper gradually shaves away microscopic granules of graphite, which slowly pile up to create the tones of the drawing. The more you rub—and the harder—the darker the tones get. For the delicate tones of the eyes, the artist passes his pencil lightly over the paper once or twice. To create the darker tones of the eyebrows and hair, the artist presses harder and moves his pencil back and forth several times.

Continuous Tone on Rough Paper. You can do the same thing on rough paper, which shaves away the granules of graphite more rapidly—like rough sandpaper—and builds up more ragged, irregular tones. Once again, the artist presses harder and moves his pencil back and forth several times for the dark tones, while he just skims the surface of the paper once or twice for the paler tones. He works with a thick, soft pencil—or a graphite stick in a holder.

Step 1. For your first pencil portrait, see what you can do with a combination of slender lines and broad strokes on an ordinary piece of drawing paper. Use the sharp point of the pencil to draw the contours with slender lines. Then use the side of the pencil to build up the tones with strokes of various thicknesses. The artist begins this demonstration by drawing the usual egg shape of the head. Within the egg shape, he draws a vertical center line and four horizontal lines to help him locate the features. Over these guidelines, he draws the eyebrows, eyes, nose, and mouth. The neck is a slightly slanted cylinder around which he draws the curved lines of the collar with swift strokes. A few more lines define the curving contours of the hair, which extends above the egg shape and beyond it on either side. At this stage, the artist works entirely with a sharpened HB pencil.

Step 2. The artist switches to a 2B pencil and holds it so that the side of the lead strikes the paper and makes broad strokes. Moving swiftly over the paper, the artist blocks in the major areas of tone with scribbly parallel strokes. The light comes from the right, and so the artist indicates areas of tone on the left side of the brow, cheek, jaw, and neck. He also places a tone on the left side of the nose and suggests the darkness of the eyes and lips. He models the hair as just a few big shapes, blocking in big tonal areas and paying no attention to individual strands or curls. Finally, he scribbles in a band of shadow along the underside of the collar and a triangle of tone inside the collar. In this step, the artist's purpose is simply to divide the portrait into zones of light and shadow. So far, there's no gradation of tone—no distinction between halftone, shadow, and reflected light.

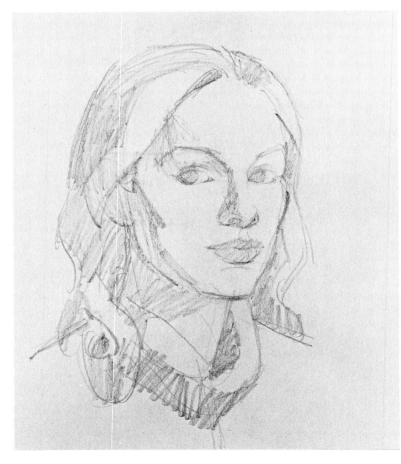

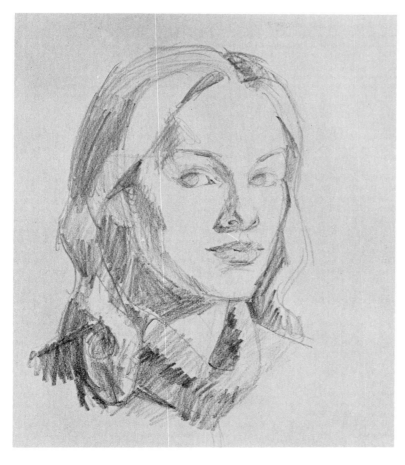

Step 3. Still working with the side of the 2B pencil, the artist begins to darken his tones selectively. He strengthens the shadows on the brow and cheek; around the eyes, nose, and mouth; and on the neck. Now, as usual, the upper lip is in shadow and there's a hint of shadow beneath the lower lip. The tip of the nose casts a small shadow downward toward the corner of the mouth. The artist also darkens some of the tones on the hair and strengthens the tones of the collar. At this point, the artist starts to develop gradations within the tones, and so you begin to see areas of light, halftone, shadow, and reflected light. For example, notice the pale tone at the edge of the jaw, where the shadow gets lighter. The artist still pays very little attention to details, although he does sharpen the corners of the eyelids, nostrils, and mouth.

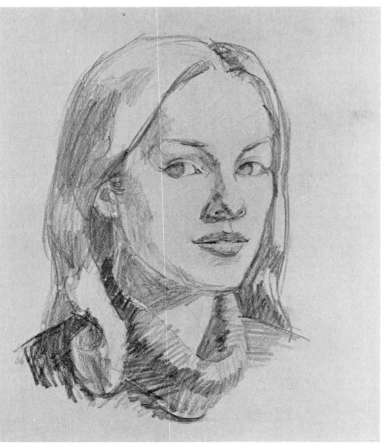

Step 4. Having established the broad distributions of tones in steps 2 and 3, the artist begins to focus his attention on the features. Working with the 2B pencil, he darkens the eyebrows and the eyes, sharpening the lines of the eyelids with the point of the pencil. Moving downward from the eyes, he strengthens the shadow on the side of the nose and the tones around the tip of the nose. He darkens the upper lip and the shadow beneath the lower lip, sharpening the line between the lips. He uses an eraser to pick out a small strip of bare paper to suggest the teeth and the lighted patch at the center of the lower lip. He draws the darkened center of the ear and shapes the contour of the ear more precisely. With the point of the pencil, he sharpens the edge of the face at the right and clears away excess lines with an eraser. He draws the contours of the hair more distinctly—particularly where the hair overlaps the brow—and brightens the top of the hair by erasing a whole cluster of lines that existed in Step 3. And he builds up the shadows on the collar and shoulder.

Step 5. The artist continues to sharpen details and refine tones. With the tip of the pencil, he draws the eyebrows and eyelids more distinctly, adding the pupils and a suggestion of lashes. With clusters of short, slender strokes, he builds up the tones in the eye sockets and along the side of the nose, sharpening the contours of the nose and darkening the nostrils. He defines the shape of the lips more clearly and darkens them with short, slender, curving strokes. With the same type of strokes, he goes over the shadows on the side of the face to make the gradations more distinct; darkens the tone along the chin; and strengthens the shadow on the neck. It's interesting to see how the character of the pencil strokes has changed. In Steps 2, 3, and 4, the artist worked with broad strokes. Now, in Step 5, he goes back over these broad strokes with more delicate, slender touches to refine the tones.

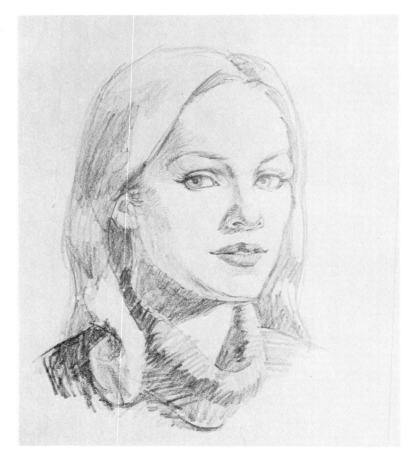

Step 6. At this point, the artist concentrates mainly on detail. He continues to sharpen and darken the contours of the eyes, strengthening the irises and pupils, picking out tiny highlights with a touch of a pointed eraser, and suggesting more lashes. The few additional strokes suggest individual hairs within the eyebrows. Traveling down the side of the nose, he darkens the shadow with delicate strokes and then strengthens the tones around the tip of the nose, where the nostrils and the cast shadow are even more distinct. He darkens the lips and sharpens the contours, paying particular attention to the slender strips of darkness between the lips. With slim, curving strokes, he carries the halftone of the jaw farther upward toward the cheek. Switching back to the sharply pointed HB pencil, he goes over the hair to suggest individual strands with crisp strokes.

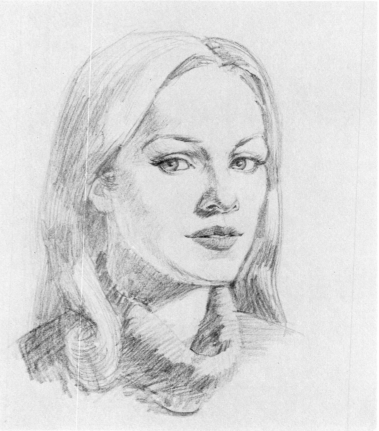

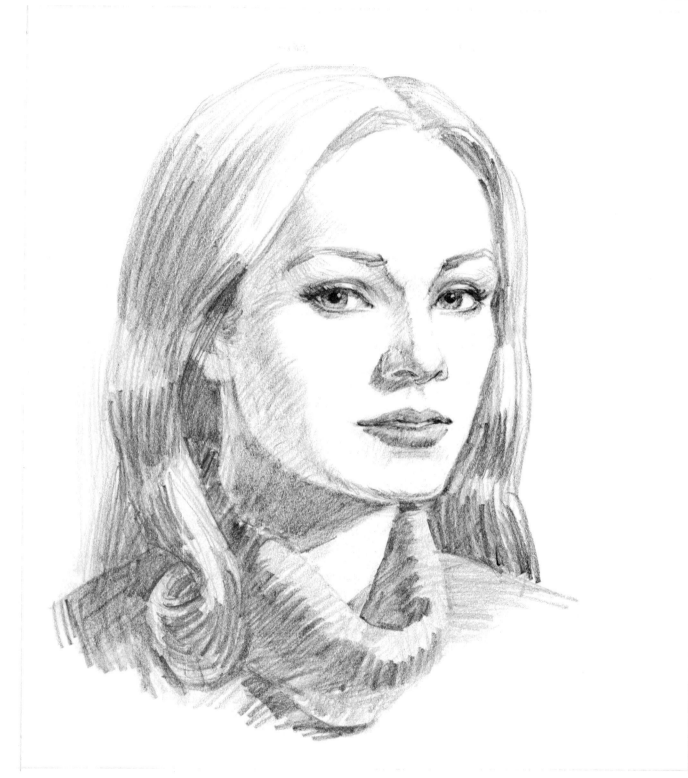

Step 7. The side of the 2B pencil deepens the tones with broad, bold strokes. Clusters of broad strokes move down over the hair to darken the shadow; the strokes are distinct enough to suggest the texture of the hair. The pencil point darkens the contours of the eyes, the tones on the side of the nose, and the tones of the lips; then it picks out more hairs within the eyebrows and more eyelashes. The pupils grow darker, as do the shadows beneath the upper lids. Finally, a kneaded rubber eraser cleans the lighted areas.

Step 1. Now try drawing a pencil portrait that consists mainly of broad, bold strokes. Use a thick, soft pencil or a thick, soft stick of graphite in a holder. In this first step, the artist begins by drawing the side view of the head with the usual overlapping egg shapes, one vertical and one horizontal. Just two lines define the neck as a slanted cylinder. Horizontal guidelines locate the features. The artist works with the sharpened tip of the thick lead.

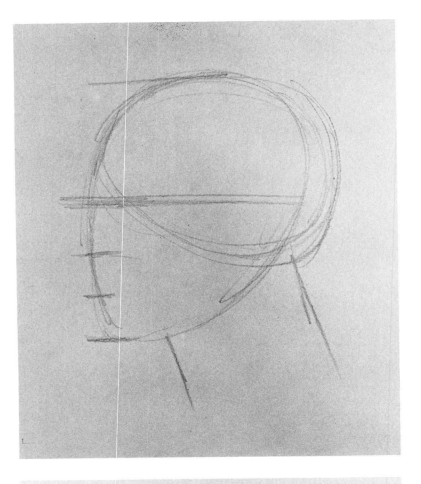

Step 2. Continuing to work with the point of the thick lead, the artist draws the contours of the face over the guidelines of Step 1. He begins by drawing the profile: the brow, nose, lips, and chin. Then he steps inside the profile to place the eyebrow, eye, nostril wing, lips, ear, and corner of the jaw. Just two lines suggest the Adam's apple on the front of the neck. The pencil sweeps around the top and back of the horizontal egg to indicate the shape of the hair. Notice how the ear aligns with the eye and nose, while the sharp corner of the jaw aligns with the mouth.

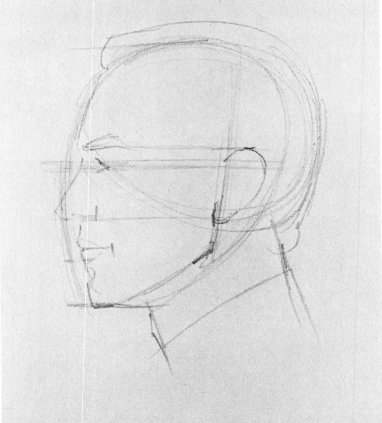

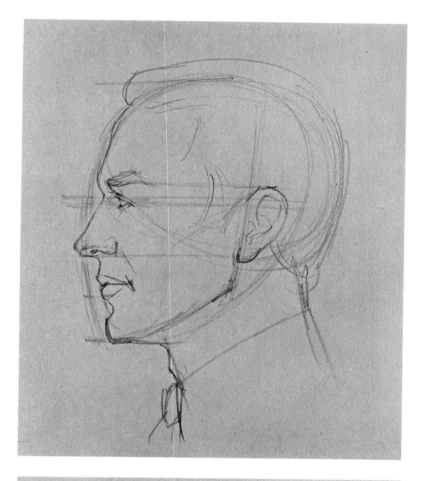

Step 3. Moving more carefully over the lines of Step 2, the artist refines the contours with the tip of the pencil. The sitter has an angular, bony face, which the artist records faithfully. He draws the bulge of the forehead, the sharp brow, the precise S-curve of the nose, the crisp detail of the lips, and the squarish chin. Moving inside the outer edge of the profile, the artist draws the eyebrow, eye, nostril, mouth, and ear with great care. Just a few lines indicate the sideburn and the dividing line between skin and hair on the side of the forehead. Note the internal detail of the ear.

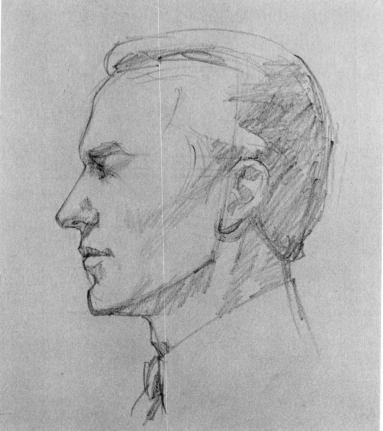

Step 4. With a pink rubber eraser, the artist removes most of the guidelines that appeared in Steps 1, 2, and 3. Now he can see the lines of the profile and features more clearly and begin to block in the tone. Turning the thick pencil on its side, the artist begins to render the tones surrounding the eyes and nose, the cast shadow beneath the nose, the dark tone of the upper lip, and the pool of shadow beneath the lower lip. Broad, free strokes fill the underside of the jaw with shadow, indicating the interlocking patches of shadow that move from the underside of the cheek down to the jaw. Patches of shadow are placed on the hair, within the ear, beneath the ear, and at the back of the neck. All the tones are still quite pale, but the purpose of this fourth step is simply to establish the major areas of light and shade.

Step 5. The artist begins to build up the gradations within the tones. He darkens the eyebrow and the tones within the eye socket, then moves downward to build up the tones of the nose and lips. He sharpens the nostril and the shadow beneath the nose, and then he strengthens the shadow of the upper lip. He also darkens the tones within and around the ear. Focusing on the larger areas of the face, he strengthens the shadows on the cheek, jaw, neck, and hair. The tip of the pencil defines the contours of the ear more precisely and draws the squarish shape of the sideburn.

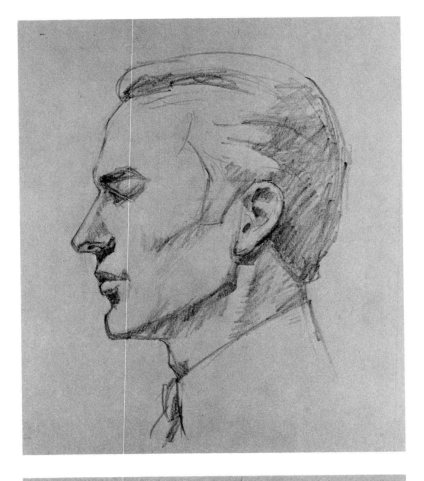

Step 6. Gradually, the strokes of the side of the thick pencil become more distinct as the artist continues to build up the tones. Observe the short, decisive strokes that model the eye sockets, the side of the nose, the corner of the mouth, and the tone that travels downward from the cheek to the jaw. The artist darkens the underside of the jaw with broad, distinct strokes that accentuate the squarish, bony shape. The hair is darkened with thick strokes that suggest texture and detail. With the sharp tip of the pencil, the artist begins to emphasize the features. He darkens the eyebrow and sharpens the lines of the eyelids. He adds crisp touches to define the contours of the nostril, lips, and ear more precisely. Notice the tiny accents of darkness within the nostril, at the corner of the mouth, between the lips, and within the rim of the ear.

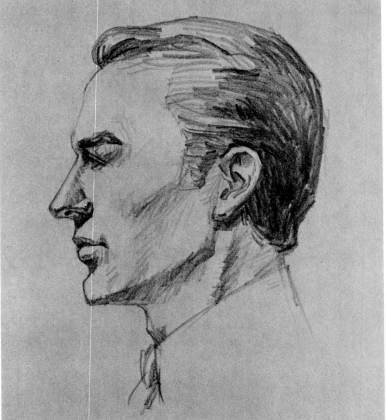

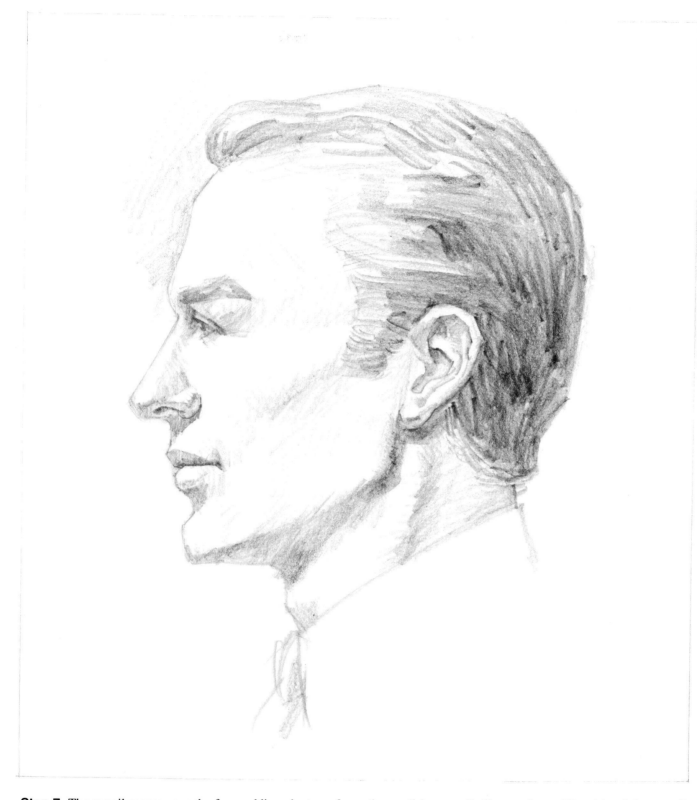

Step 7. The pencil moves over the face, adding clusters of parallel strokes that enrich the tones of the brow, cheek, jaw, and neck. More strokes darken and model the eye socket, nose, lips, and ear. The sharpened point of the pencil delicately retraces the contour of the profile and sharpens the eyelids, nostril, lips, and ear. The side of the pencil darkens the hair with thick strokes and adds a hint of tone on the bare paper along the edge of the brow—accentuating the light on the sitter's bony forehead.

Step 1. The rich skin tones of a black sitter will give you an opportunity to try a pencil-drawing technique that combines strokes with blending. For this technique, a sheet of charcoal paper is particularly suitable, since the delicately ribbed surface softens the strokes and also lends itself beautifully to blended tones executed with a fingertip or a stomp. The artist begins his demonstration with the standard egg shape divided by a vertical center line, plus horizontal lines for the eyes, nose, and mouth. Notice that there's just one horizontal line for the eyes, above which the artist will place the eyebrows. The lowest horizontal line locates the bottom edge of the lower lip, which is halfway between the nose and chin. The artist visualizes the neck as a slightly tilted cylinder. Notice that he doesn't hesitate to go over these guidelines several times until he gets the shape exactly right. Because this demonstration requires so much blending, the artist selects a soft, thick 4B pencil.

Step 2. Working with the sharpened tip of the pencil, the artist locates the eyes on the horizontal guideline that crosses the midpoint of the head, and then he places the brows above this line. On either side of the vertical center line, he establishes the outer contours of the nose, and then he moves down to locate the tip of the nose and the nostrils on the next horizontal guideline. He places the ears between the guidelines of the eyes and nose. On the lowest horizontal guideline, he makes a dark stroke to indicate the deep valley beneath the lower lip. Then he places the dividing line of the lips roughly one-third of the way down from the nose to the chin. He squares up the corners of the jaw, indicates the curves of the cheeks, and swings the line of the collar around the cylindrical shape of the neck. Moving outward from the top and sides of the egg, the artist indicates the shape of the hair.

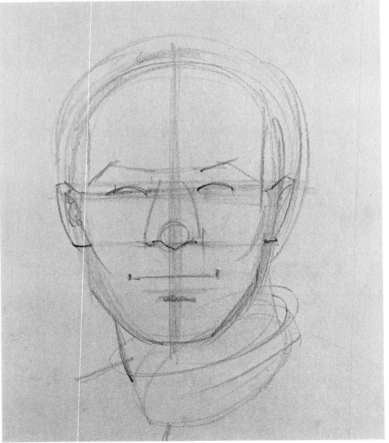

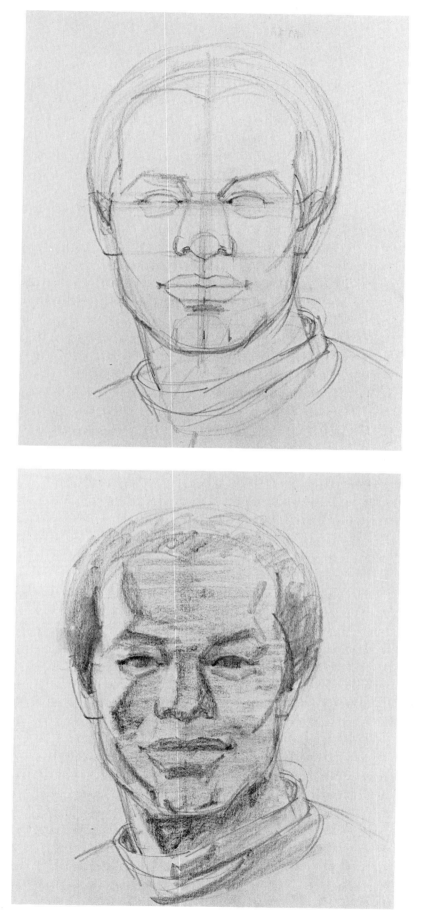

Step 3. With the point of the thick pencil, the artist now defines the shapes of the head and features more exactly. He redraws the contours of the cheeks, jaw, chin, and neck directly over the original guidelines of Steps 1 and 2. The pencil point carefully traces the hairline. Then the artist focuses on the features: he sharpens the contours of the eyebrows and draws the upper and lower lids; defines the shapes of the nostrils and the tip of the nose; constructs the planes of the lips; and emphasizes small, significant details such as the corners of the eyes, the corners of the lips, and the cleft in the chin. Finally, he draws the irregular curves of the collar.

Step 4. Turning the thick pencil on its side, the artist begins to block in the tones with broad strokes. The light comes from the left, placing most of the head in shadow. This head is an example of what artists call *rim lighting*. There's a strip (or rim) of light along one edge of the face, neck, nose, and upper lip, but the rest of the face doesn't receive direct light. There's a dark edge where the light and shadow planes meet; the artist accentuates this by pressing his pencil harder at the edges of the lighted areas on the forehead, cheek, jaw, neck, and nose. He covers the shadowy areas of the face with broad horizontal strokes and then emphasizes the strong darks *within* the shadow areas: the brows, eye sockets, and eyes; the bridge of the nose and the nostrils; the upper lip and the dark tones beneath the lower lip; the chin; and the shadow beneath the neck. The artist also begins to darken the hair and the shadow side of the collar. By the end of this step, there's a clear distinction between the light and shadow areas.

Step 5. The artist begins to deepen the tones by moving the flat side of the pencil back and forth over the face. The broad strokes are most apparent in the forehead and cheek, where you often see big gaps between the strokes—although these gaps will disappear when the artist begins to blend the tones. He strengthens the dark areas where the light and shadow planes meet on the side of the face, nose, and upper lip. He darkens the hair, the shadow on the neck, and the shadow side of the collar. Then he moves inside the face to strengthen the contours and to darken the tones of the eyebrows, eyes, nose, and lips. With the point of the pencil, he emphasizes the dark edges of the eyelids, nostrils, and lips.

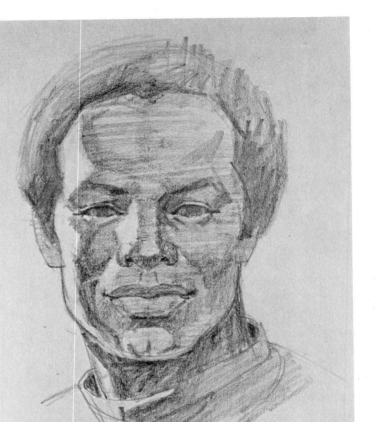

Step 6. Pressing still harder and moving the side of the pencil back and forth over the textured paper, the artist strengthens all the darks within the shadow planes of the face. He darkens the tones within the eye sockets, along the bridge of the nose, beneath the nose and cheeks, within the lips, around the chin, and on the neck. With short, curving, scribbly strokes, he darkens the tone of the hair to suggest its curly texture. And with the tip of the pencil he sharpens all the features, indicating such details as the pupils of the eyes, the shadow lines around the nostrils, and the dark line between the lips.

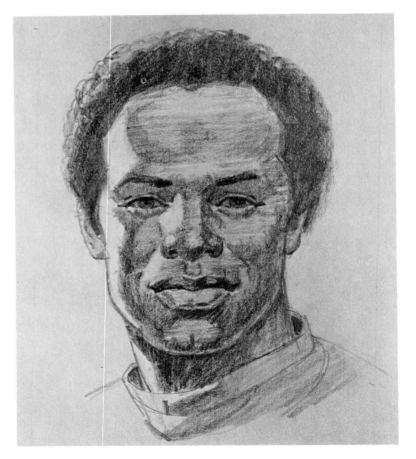

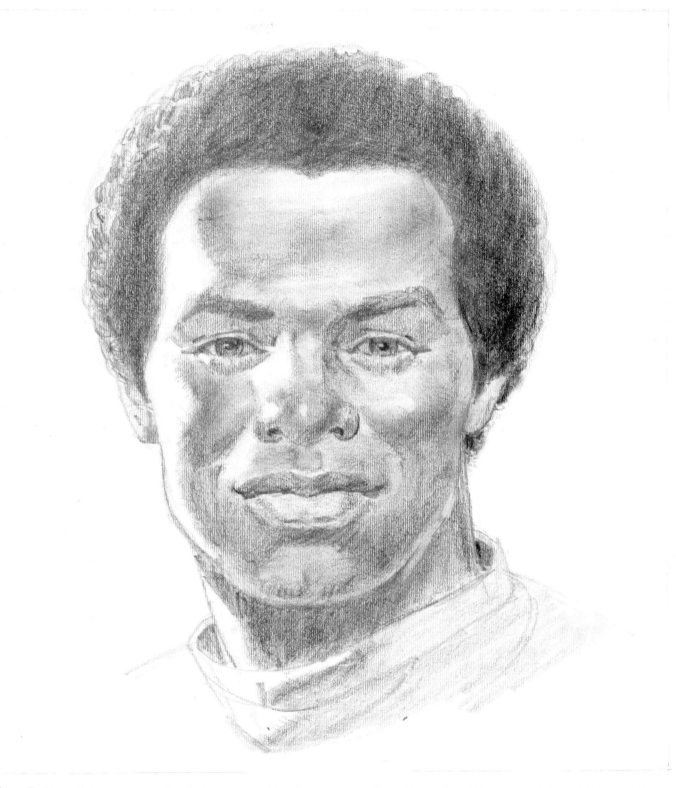

Step 7. The artist moves over the shadow areas with a fingertip, blending the strokes into smooth, glowing tones. The blending is done selectively: the artist concentrates mainly on the forehead, cheeks, nose, upper lip, and chin. A kneaded rubber eraser brightens the lighted areas and picks out highlights on the nose and cheek. The pencil strengthens the darks of the eye sockets and lids, the lips, the undersides of the cheeks, and the sides of the jaws. The tip of the pencil accentuates the contours of the eyelids, irises, and pupils; the nostrils; and the dark dividing line between the lips.

Step 1. Having discovered how easy it is to blend graphite on the hard surface of a sheet of textured paper, you know that a pencil drawing can actually begin to look like a "painting" in black and white. Now you might like to try a pencil portrait in which nearly all the tones are softly blended, so that the strokes of the pencil virtually disappear. For this drawing, the right tool is a thick, soft pencil—or perhaps a stick of graphite in a holder—that might be 4B, 5B, or even 6B. The artist chooses a 5B graphite lead in a plastic holder and works on a sheet of very rough paper with a much more pronounced tooth than the charcoal paper used in the preceding demonstration. He begins by drawing the usual compound egg shape and a tilted cylinder for the neck. The head is turned to a three-quarter view, and so the vertical center line is actually *off* center. Horizontal guidelines locate the features; the artist divides these lines with tiny touches to locate the eyes and the corners of the nose and mouth.

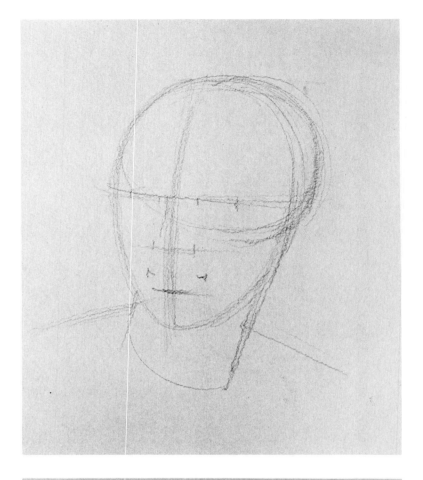

Step 2. The artist draws the outer contours of the face over the egg shape, capturing the curves of the cheeks, jaw, and chin. Swift, curving lines capture the sweep of the hair around the head and over the forehead. He draws the first few lines of the features over the guidelines of Step 1: the curves of the eyebrows and the upper lids; the side and underside of the nose; and the upper and lower lips. The one visible ear is aligned with the eye and nose. As you can see, the roughness of the paper breaks up the pencil stroke and produces a ragged line.

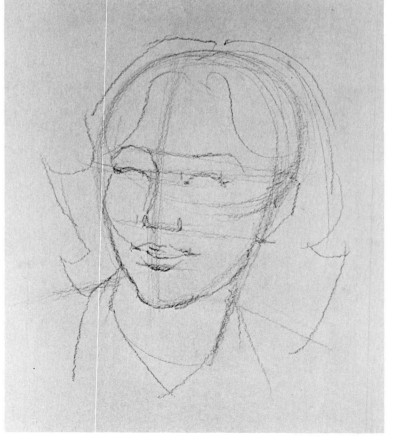

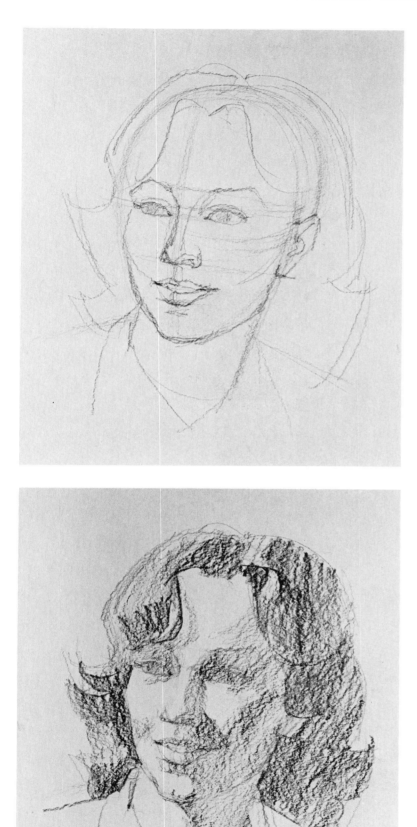

Step 3. The artist completes his preliminary line drawing of the outer contours of the head and the shapes of the features. He strengthens the lines of the jaw and the chin. He draws the ear more precisely and adds the inner contours of the eyes, with a hint of darkness on the irises. He traces the bridge of the nose and constructs the tip of the nose and the nostril wings. He indicates the groove from the base of the nose to the upper lip. As he defines the lips, he darkens the corners of the mouth and indicates the concavity beneath the lower lip with a dark scribble. The outline of the hair is strengthened with quick, casual lines.

Step 4. Now the artist turns the thick lead on its side and moves it swiftly back and forth over the rough surface of the paper to indicate the big tonal areas. The paper is so rough that you can hardly see the individual strokes—the texture of the paper dominates the tones. The lines of Steps 1, 2, and 3 rapidly disappear under the ragged masses of tone. For the paler tones, the artist moves the drawing tool lightly over the paper, pressing harder and piling up additional strokes for the darker areas—such as the eye sockets, the cheeks, the shadow cast by the nose, and the hair. Most of the original lines have disappeared under the tones. The artist erases the others. The main purpose of Step 4 is to establish a clear distinction between the lights (which are just bare paper), the darks, and the middletones (or halftones).

Step 5. The artist begins to blend the tones of the face with a fingertip and with a stomp. He uses his finger to blend the broad tonal areas on the forehead, cheek, jaw, and neck. Then he picks up the pointed stomp to get into tighter spots like the eyes, the side and bottom of the nose, the lips, and the chin. The pencil darkens the eyes and lips a bit more—then the strokes are blended with the stomp once again. The artist softens the right edge of the hair with a few touches of a fingertip.

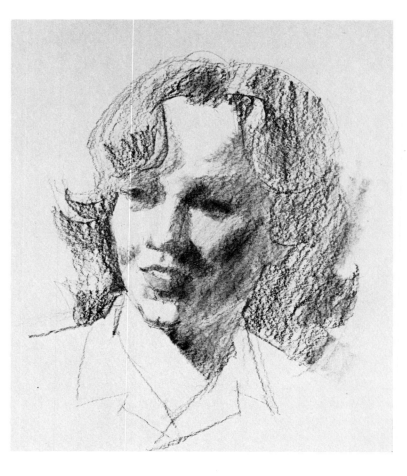

Step 6. At this stage, the artist alternates between working with the pencil and the stomp. He uses the pencil to define the eyebrows; to darken the eyes and the underside of the nose; and to strengthen the tones of the lips. Then he blends these tones with the sharp tip of the stomp. The side of the pencil scribbles broad strokes over the hair; then these strokes are blended with a fingertip. The sharp point of the pencil heightens the darks within the eyes, accentuates the nostrils, and sharpens the corners of the mouth. A few deft touches of the kneaded rubber eraser pick out reflected lights within the shadows on the cheek, jaw, neck, and ear—notice how the edges of these shapes become slightly lighter. The fingertip carries some tone downward to the pit of the neck, over one shoulder, and beneath the collar.

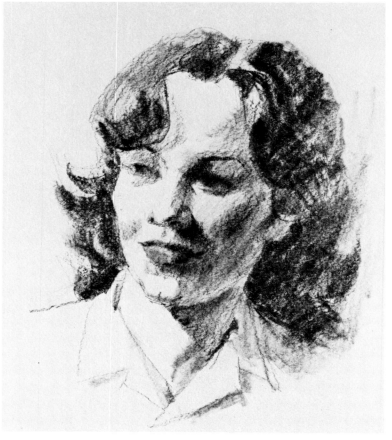

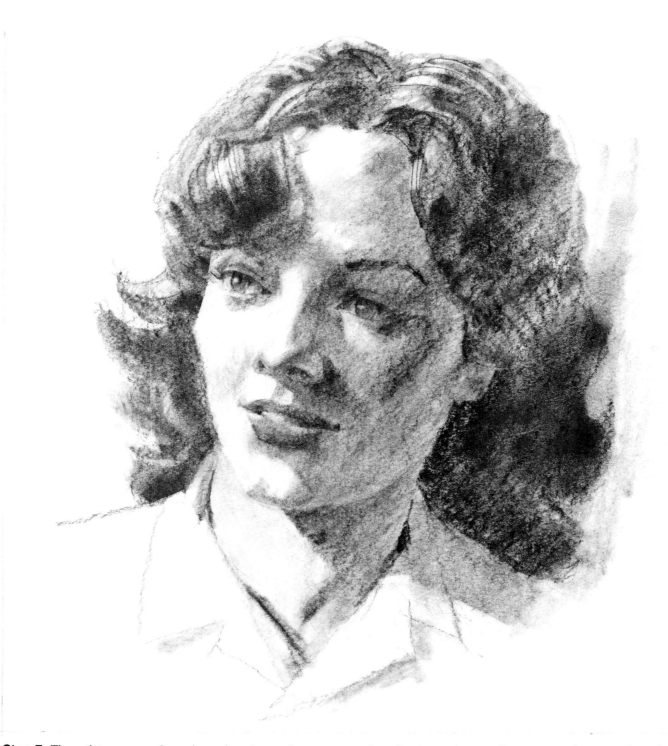

Step 7. The artist presses a fingertip against the sandpaper pad to pick up accumulated graphite dust, which he carefully spreads over the shadowy areas of the face and hair. The tones of the drawing become richer and deeper. The sharp tip of the pencil adds the details of the eyelids, irises, and pupils; draws the nostrils more exactly; strengthens the contours of the lips; and suggests individual strands of hair. Touches of the kneaded rubber eraser brighten the lighted areas of the face and pick out streaks of light in the hair.

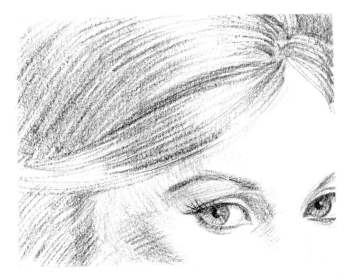

Slender Strokes. A hard stick of chalk can be sharpened to a surprisingly fine tip. So can chalk in pencil form. With a sharpened stick or pencil, you can build up the tones of a portrait with slender strokes like those you see in this close-up. The precise strokes of the drawing tool follow the curve of the hair. The artist presses harder on the chalk and places the strokes closer together in the darker areas. The tones of the cheek and eyelid are rendered with clusters of short, curving parallel strokes. The sharp point of the drawing tool picks out the precise details of the eyes.

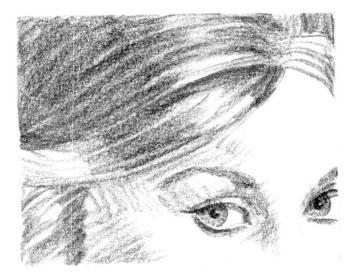

Broad Strokes. With the blunt end of the stick of chalk, you can draw the same subject with broad strokes. The square tip of the stick is used to make the thick, curving strokes that render the sitter's hair, as well as the clusters of short parallel strokes that model the eye socket, brow, and cheek. To render the more precise detail of the eyes, the artist simply turns the chalk so that the sharp corner of the rectangular stick touches the paper. This sharp corner can draw surprisingly precise lines, like those you see in the eyelids, irises, and pupils.

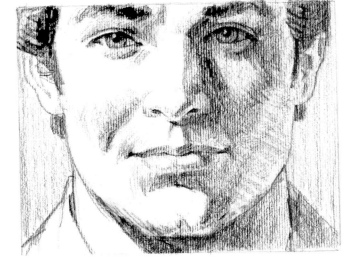

Strokes on Charcoal Paper. The ribbed surface of charcoal paper is excellent for chalk drawing, whether you're working with chalk in stick or pencil form. The charcoal paper softens the stroke and lends its own subtle texture to the drawing. Tiny flecks of bare paper show through the strokes and give the portrait a special kind of luminosity which you can't achieve on any other kind of paper. You can work with broad strokes like those you see on the cheeks. On the other hand, the paper is just smooth enough to lend itself to precise detail like the slender strokes of the features.

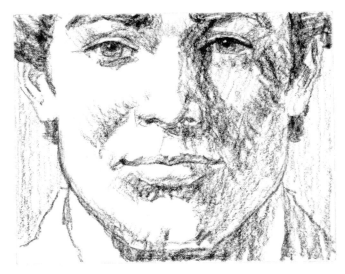

Strokes on Rough Paper. There are much rougher papers than charcoal paper, of course, and it's worthwhile to try these surfaces. A rough sheet is best for bold, broad strokes, made with the squarish end of the chalk. Notice how free and vital the strokes look on the cheeks and jaw. On the other hand, a reasonable amount of precision is possible on rough papers: the eyes are rendered with fairly precise, slender strokes, although these strokes are distinctly rougher than those with which the eyes are rendered on the charcoal paper at the left.

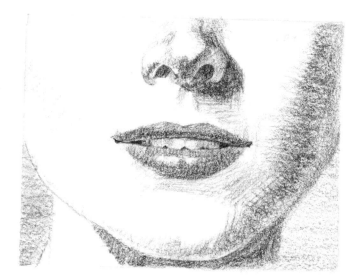

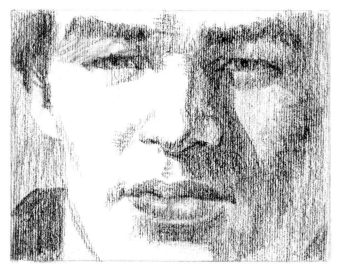

Modeling with Strokes. Working with a sharpened stick of chalk or with chalk in pencil form, you can build three-dimensional form by layering stroke over stroke. On the side of the face, the artist gradually lays one stroke over another, piling up strokes more thickly in the darker areas. The strokes curve slightly to suggest the roundness of the face. The lips and nose are also built up stroke over stroke. The network of strokes is dense in the dark areas, such as the shadow at the side of the nose, while the strokes are fewer and farther apart in the paler tones, such as the delicate gray beneath the lower lip.

Modeling by Blending. A different way to create a strong sense of three-dimensional form is to cover the tonal areas with free, casual strokes and then blend them with a fingertip or a paper stomp. The strokes don't have to be precise because they disappear as you blend them. The blending action converts the strokes to rich, smoky tones like those on the side of the sitter's face. If you blend some strokes, add darks with the chalk, and brighten the lighted areas with the kneaded rubber eraser, you can produce the strong contrast of light and shade that you see on the mouth and nose.

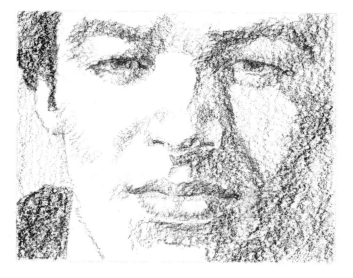

Continuous Tone on Charcoal Paper. Charcoal paper—like all strongly textured paper—has distinct peaks and valleys. As the chalk moves, it tends to strike the peaks and skip over the valleys. The peaks gradually shave away granules of chalk each time you make another stroke—and the tones become darker with successive strokes. Thus, you can build up soft, luminous tones by gently moving the chalk back and forth over the paper, pressing slightly harder and building up more strokes for the darks. Work slowly, and let the tones emerge gradually, and they'll have a unique inner glow.

Continuous Tone on Rough Paper. You can try the same technique on any paper that has a distinct tooth. On the rough sheet of paper shown here, a drawing of the same sitter has a bold, granular quality. Once again, the artist moves the chalk back and forth gradually so that it hits the peaks and skips over the valleys. With each successive movement of the chalk, more granules of chalk pile up and the darks become richer. It's almost impossible to see an individual stroke. The granular texture of the sheet dominates the drawing.

Step 1. When you draw your first portrait in chalk, see what you can do with just lines and strokes—no blending. A hard, fairly slender stick of chalk, such as a Conté crayon, is best for this project. The artist begins by sharpening the stick on a sandpaper pad so that the tool will make slender, distinct lines. He draws the classic egg shape. The portrait is a direct, frontal view, and so the vertical center line divides the face into equal halves. He draws the usual horizontal lines to locate the features—with a double line for the dividing line of the mouth and the underside of the lower lip. Just two vertical lines suggest the cylindrical form of the neck. The artist begins work on the features by placing the ears on either side of the egg, with the tops of the ears aligning with the eyebrows, and the lobes aligning with the underside of the nose.

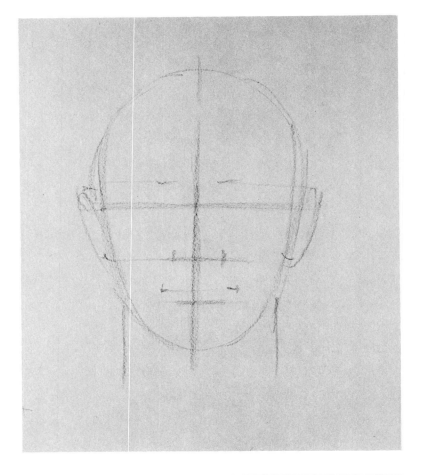

Step 2. Still working with the sharpened tip of the chalk, the artist begins to define the contours of the lower half of the face, starting with the curves of the cheeks and then working downward to the squarish jaw and the rounded chin. He swiftly sketches in the shape of the hair. He strengthens the lines of the neck and suggests the collar. Then he moves inside the egg to indicate the lines of the eyebrows and the upper lids; the bridge of the nose, the tip, and the nostrils; and the upper and lower lips. A scribble indicates the concavity beneath the lower lip. This concavity is always important because it accentuates the roundness of the lower lip.

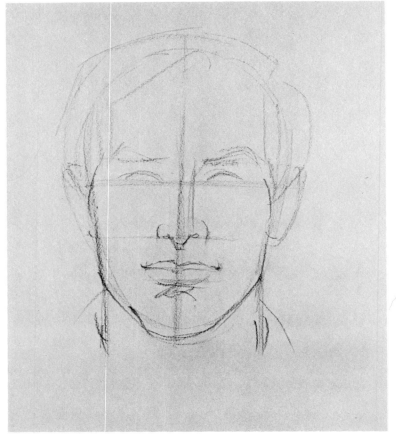

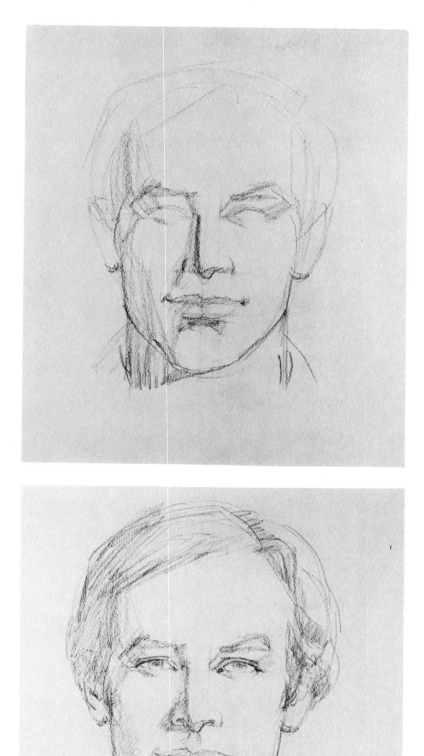

Step 3. By now, the point of the chalk has begun to wear away and the drawing tool is growing slightly blunt, making a thicker stroke. The artist strengthens the forms of the eyebrows and eyelids with thicker lines and then moves downward to solidify the forms of the nose and lips with strokes that are also broader than the slender lines in Steps 1 and 2. He refines the shapes of the ears. Then he uses the blunted point of the chalk to block in the shadow planes on the left side of the face and neck, within the eye sockets, and on the left sides of the features. Most of the face is lighted—the light comes from the right—and there are just slender strips of shadow on the left sides of the forms. Look back at the portrait of the black sitter, in which the effect is just the opposite: most of the face is in shadow with just slender strips of light on one edge of the face.

Step 4. The artist sharpens the stick once again to define the eyelids, the tip of the nose, the nostrils, and the contours of the lips with more exact lines. He also draws the contours of the hair more precisely and indicates the inner detail of the ears. A few lines suggest the collar. As the chalk grows blunt once again, he continues to build up the tonal areas with slightly thicker strokes. He blocks in the tones on the hair and begins to develop subtleties such as the groove between the tip of the nose and the upper lip, the cleft in the chin, and the shadows beneath the earlobes. The guidelines of Steps 1 and 2 have been erased.

Step 5. The blunted tip of the chalk is particularly useful at this stage. Now the artist moves back over all the tones with short parallel strokes, gradually building up the modeling. (These strokes are most obvious in the curve of the cheek.) We begin to see gradations *within* the tones, such as the light of the cheek curving around to the halftone, shadow, and reflected light on the other side of the shadow. Building up these strokes gradually, the artist darkens the eyebrows, the eye sockets, the nose, the shadowy upper lip, and the tone beneath the lower lip. He models the brow and the chin in the same way that he models the cheek and jaw. He builds up distinct shadow shapes within the hair and darkens the shadow on the neck. The sharp corner of the chalk adds dark touches within the eyelids and between the lips.

Step 6. Steadily piling stroke upon stroke, the artist continues to develop the tonal gradations of the brow, cheek, jaw, chin, and neck. He enriches the tones within the eye sockets and then moves downward to darken the side and the underside of the nose, the upper lip, and the pool of shadow beneath the lower lip. He darkens the earlobes, the central shadow in the ears, the nostrils, and the irises. The sharp corner of the chalk accentuates the eyebrows and suggests individual hairs. Turning the chalk around to work with the other end—which he hasn't sharpened—the artist follows the curves of the sitter's dark hair with broad strokes.

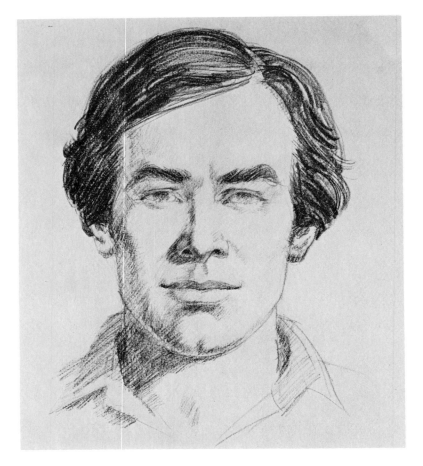

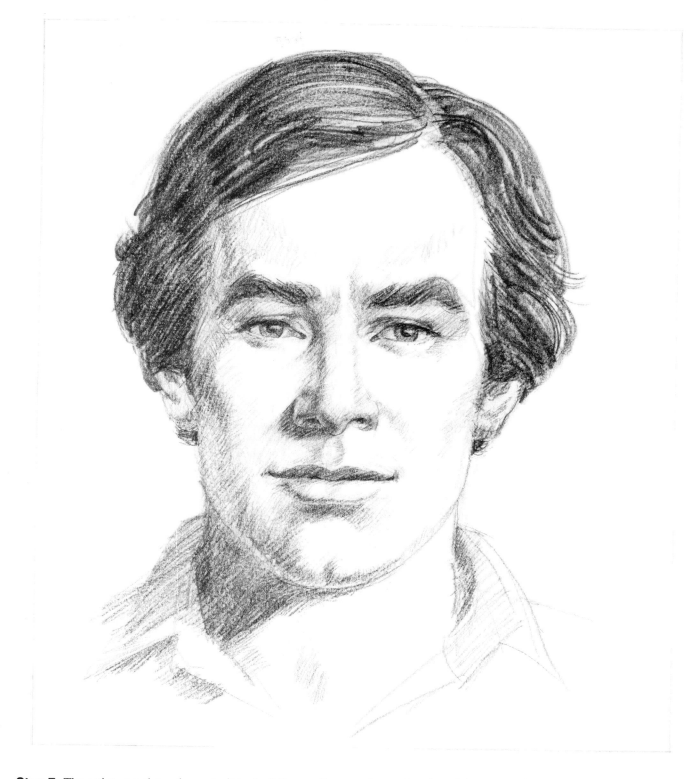

Step 7. The artist completes the portrait by building up the tones of the face with clusters of slender parallel strokes. The tones of the eye sockets, nose, lips, and ears are fully developed. He darkens the hair with a few more broad strokes, made with the unsharpened end of the stick. And, sharpening the stick once again, the artist moves back into the features, drawing the precise details of the eyelids, irises and pupils, nostrils, the winglike shape of the upper lip, and the softer, thicker form of the lower lip.

Step 1. To draw a portrait in which you combine slender lines, broader strokes, and blending, try a stick of hard pastel. A sheet of rough-textured paper will lend itself especially well to blending with a fingertip or a stomp. The artist begins by sharpening a stick of hard pastel on the sandpaper pad. The stick doesn't come to as sharp a point as a pencil, of course, but he's able to draw distinct lines with it. Notice how the rough texture of the paper breaks up the lines of the compound egg shape. Because the model is turned to a three-quarter view, the vertical center line moves to the left of the egg. However, the horizontal guidelines of the eyes, nose, and mouth are in their usual places. On these horizontal lines, the artist makes tiny marks to locate the eyes, nostrils, and corners of the mouth. At the extreme right of the head, he makes two small horizontal marks to align the ears with the eyebrows and the underside of the nose. As usual, the neck is a slanted cylinder.

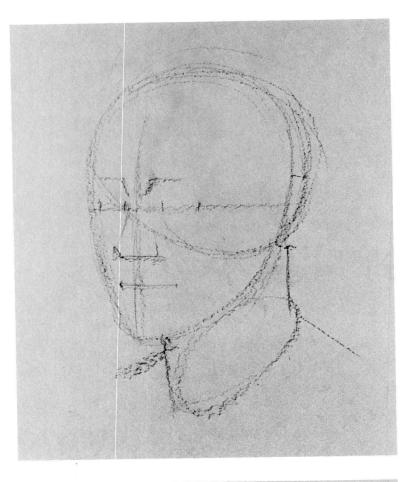

Step 2. By this time, the sharpened stick of hard pastel is growing slightly blunt, and so the artist sharpens it again on the sandpaper pad. Then he draws the angular contours of the head—the brow, cheeks, jaw, chin, and neck—over the guidelines of Step 1. With just a few curving lines, he indicates the shape of the hair, which crosses the forehead and extends above the curve of the skull. He begins to draw the features over the familiar guidelines and completes this stage by suggesting the triangular shape of the collar.

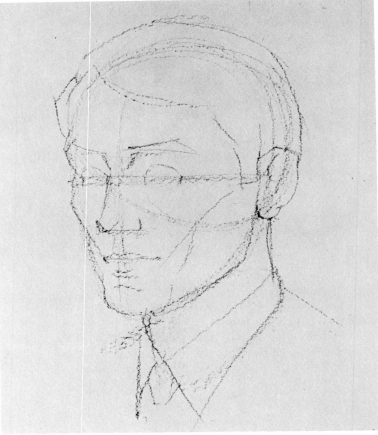

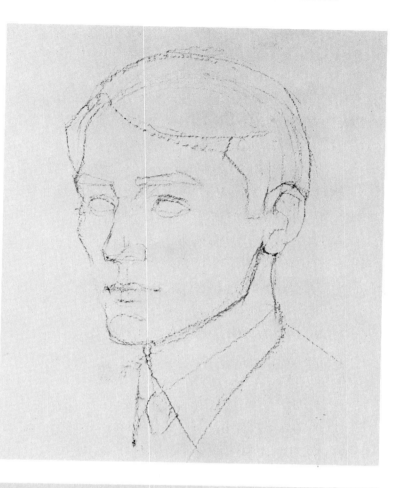

Step 3. Erasing the guidelines of Step 1, the artist begins to define the features more precisely. He draws the slender eyelids and constructs the blocky end of the nose—with the one nostril wing that shows in this three-quarter view. Now you see the familiar winglike shape of the upper lip. The artist adds a curve just above the chin to define the bony shape. He squares up the corner of the jaw and then moves upward to draw the internal detail of the ear. On the hard surface of the paper, chalk sometimes smudges or even disappears; this has happened to the line of the jaw just to the left of the mouth. But the line can be easily redrawn in the next step.

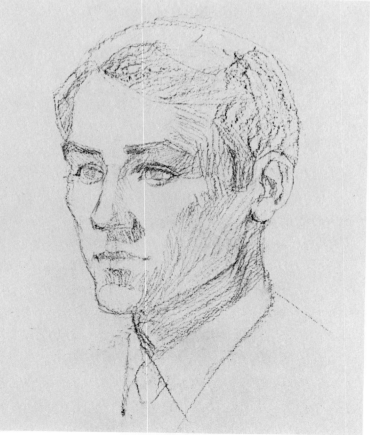

Step 4. The rectangular stick of hard pastel is still fairly sharp, and so now the artist blocks in the tonal areas with clusters of parallel strokes. Notice how the strokes change direction as they move downward from the brow to the cheek to the jaw, following the direction of the form. The tone on the slanted side of the nose is rendered with slanted lines. The artist fills the eye socket with tone; places the shadow beneath the nose; fills the upper lip with shadow; and indicates the deep shadow beneath the lower lip. With the flat side of the stick, he blocks in the tonal areas on the hair. Then, sharpening the stick once again, he adds more detail to the eyes and ear.

Step 5. Moving a fingertip gently over the surface of the drawing, the artist blends the strokes of Step 4 selectively. He gradually blurs the tones on the side of the brow, cheek, jaw, and neck, but doesn't eliminate *all* the strokes. You can still see some of them. In the same way, he gently merges the strokes within the eye sockets, along the side of the nose, and beneath the nose and lower lip. A few broad sweeps of the thumb convert the strokes of the hair into tone. The sharp point of a stomp gets into smaller areas such as the eyebrows and eyes in order to fuse the strokes. Turning the stick of hard pastel to the opposite end and working with the flat tip, the artist adds dark strokes to the hair, eyebrows, eyes, cheek, and jaw, sometimes blending them with a fingertip and sometimes leaving them alone. With the side of the chalk, he adds a dark tone above the head and then blends this with his thumb.

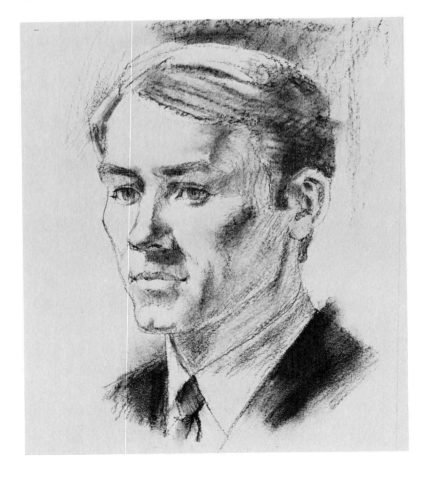

Step 6. The sharpened end of the chalk defines the outer contours of the face more precisely; compare the cheek with Step 5. The artist then draws the eyelids more exactly, adding the pupils and the dark accents at the corners of the eyes. He defines the nostrils and the shape of the upper lip, darkening the corners of the mouth. He adds more darks within the ear. Then he continues to strengthen the darks by adding clusters of short parallel strokes to the eye sockets, the tip of the nose, the brow, and the cheek, blending these with a fingertip or a paper stomp. The side of the chalk darkens the hair and shoulders with broad strokes, which are quickly blended with the thumb.

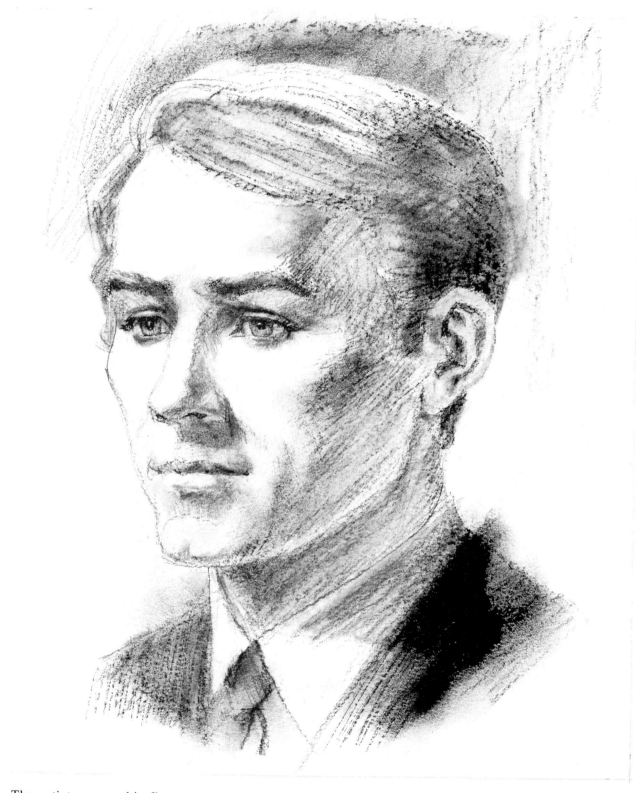

Step 7. The artist presses his fingertip against the sandpaper pad, picks up some chalk dust, and gently spreads this tone over the shadow planes of the face: the forehead, cheek, jaw, neck, eye sockets, nose, and lips. In the same way, he adds tone to the neck, hair, ear, and collar. The point of the chalk darkens the contours of the eyelids, plus the tones of the eyebrows and lips. A kneaded eraser brightens the lighted patches, and a razor blade scratches highlights into the eyes.

Step 1. Chalk smudges so easily that you can blend it like wet oil paint. Now try a portrait that consists almost entirely of soft, blended tones. The artist draws this portrait of an Oriental woman with a stick of hard pastel on a sheet of charcoal paper. This type of paper has a hard, delicately textured surface on which chalk can be blended very smoothly. The tough surface will take a lot of rubbing from a fingertip, a stomp, or an eraser. By now, Step 1 is familiar: the classic egg shape, cylindrical neck, and vertical and horizontal guidelines to locate the features. However, as you look back at the various demonstrations you've seen so far, notice that not all the egg shapes are exactly alike. There are subtle differences in height and width. Some are tall and relatively slender, while others are rounder, like the soft form of this woman's face.

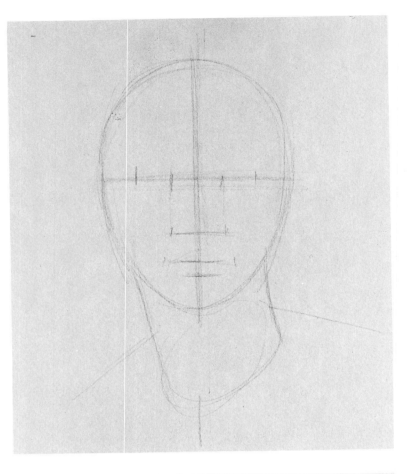

Step 2. Over the guidelines of Step 1, the artist constructs the actual shape of the head and hair. He defines the curves of the cheeks, the squarish shapes of the jaw, and the rounded chin. With long, curving lines, he draws the sweep of the hair that surrounds the entire head and neck. A few slanted lines suggest the collar. The features are hung on the horizontal guidelines within the egg. Notice that he indicates not only the eyes, but also the inside corners of the eye sockets on either side of the nose. The lines in Steps 1 and 2 are executed with the sharp corner of the rectangular stick of chalk. As one corner wears down, the artist turns the chalk in his hand and uses the next corner. The corners stay sharp just long enough to execute the preliminary line drawing.

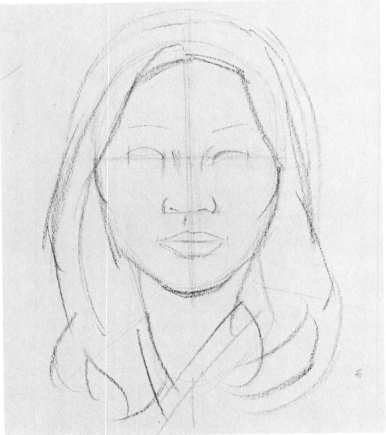

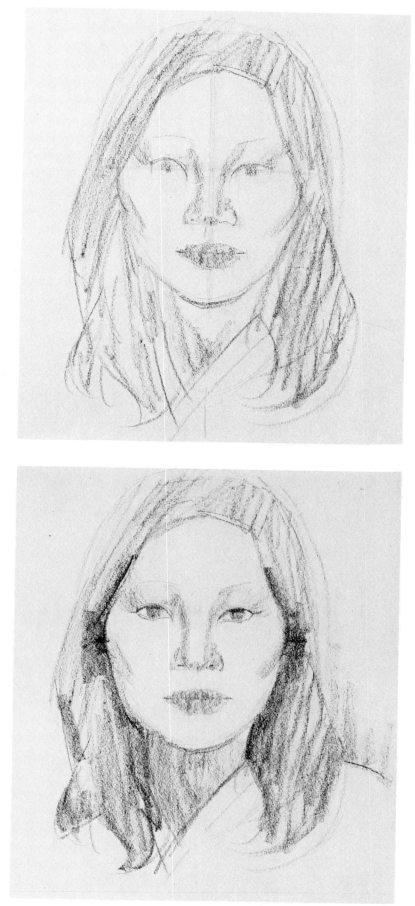

Step 3. The artist uses the square end of the chalk to block in tones with broad strokes. A single curving stroke is placed on either side of the nose. A few more short strokes suggest the shadows around the nostrils and beneath the tip of the nose. Short, broad strokes place the shadows in the outside corners of the eyes, along the cheeks and jaw, and at the pit of the neck. The lips are filled with tone. The dark irises are made with quick touches of the blunt end of the chalk. And then the hair is filled with long, free strokes to indicate the dark tone. At this stage, the chalk glides lightly over the surface of the paper, merely indicating tonal areas that will be developed in later steps.

Step 4. Pressing harder on the square end of the chalk, the artist darkens the irises and extends the shadows on either side of the nose. Then, with the sharp corner of the stick, he draws the dark lines of the eyelids and the nostrils. Moving the blunt end of the stick lightly over the paper, he gradually darkens the tones within the eye sockets. He picks up a short chunk of chalk—perhaps a broken stick or simply one that's worn down—to darken the hair and neck with broad strokes. He uses the flat side of the stick and presses down harder against the paper.

Step 5. Moving a fingertip gently over the paper, the artist begins to smudge the strokes within the eye sockets, beneath the nose, and along the sides of the cheeks. With a kneaded eraser, he lightens the shadows on either side of the nose. He blends the strokes on the neck, blurring the line of the chin. With the flat side of the short chunk of chalk, he darkens the hair and blends this area with his thumb, carrying some of the hair tone into the shadows beneath the cheeks. He blends the lips very slightly. Then he uses the sharp corner of the chalk to redefine the eyebrows, eyes, nostrils, and lips, softening these strokes with a quick touch of a fingertip.

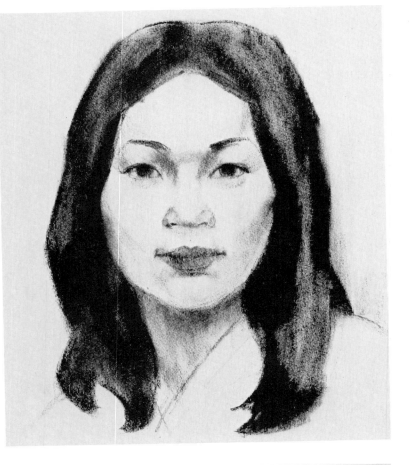

Step 6. The artist's thumb and one or two fingers are now coated with chalk dust. He uses his fingers like a brush to spread tones on the sides of the forehead, beneath the cheeks, along the sides of the jaw, and on the neck, which grows distinctly darker than in Step 5. The finger places very pale tones on either side of the nose and darkens the corners of the eye sockets. Then the sharp corner of the chalk restates the eyebrows, eyelids, nostrils, and lips. Small, precise strokes add pupils to the eyes, sharpen the nostrils, and define the dark corners of the mouth. The flat side of the short chalk sweeps over the hair with long, broad strokes. A kneaded eraser is squeezed to a point to pick out highlights on the pupils, brighten the whites of the eyes, clean the edges of the lips, and create highlights on the lower lip.

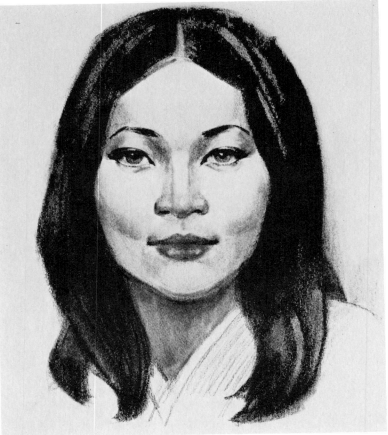

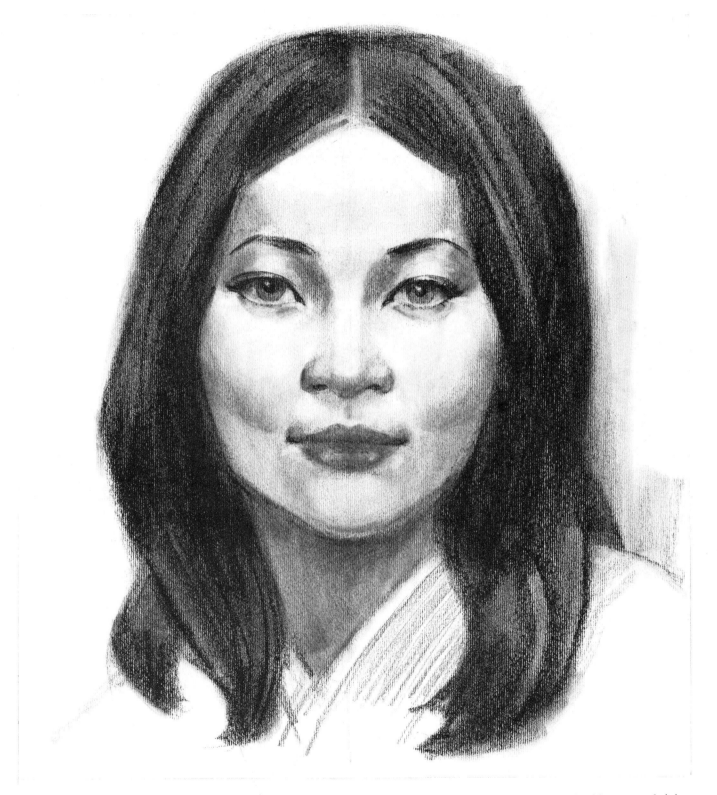

Step 7. The artist blends the tone of the hair with his finger-tips, blurring the contours and adding a few strokes to suggest detail. His fingers are coated with chalk dust, which he carefully spreads over the face to add delicate halftones to the forehead, cheeks, and jaw, and to darken the neck and the underside of the nose. The kneaded rubber eraser brightens the lighted areas of the forehead, eye sockets, cheeks, nose, upper lip, and chin. The sharp corner of the chalk strengthens the upper eyelids and adds a few eyelashes.

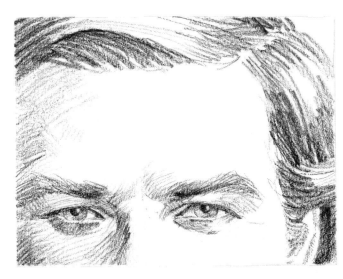

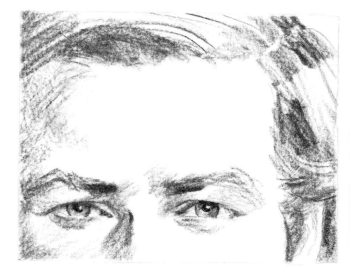

Slender Strokes. A hard or medium charcoal pencil can be sharpened to a fairly precise point to make crisp strokes. The tones of the sitter's hair, forehead, and eyes are built up with clusters of parallel strokes made by the sharp point. The artist builds one cluster of strokes over another to darken the tones within the eye sockets, beneath the eyes, and along the side of the nose. The slender strokes in the hair are made by the point of the pencil, while the broader strokes are made by the side of the lead.

Broad Strokes. A soft charcoal pencil has a thick lead that's suitable for a broad-stroke technique. So does a stick of charcoal—in your hand or in a holder. Compare the wider, rougher strokes in this drawing with the more precise strokes in the drawing at the left. The soft charcoal pencil or the charcoal stick *can* be sharpened to do a certain amount of precise work—such as the slender strokes in the hair and within the eyes—but the point wears down quickly. Artists generally work with the side of the soft pencil or the stick to cover broad areas.

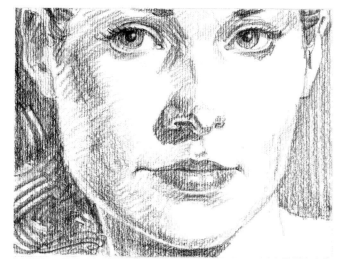

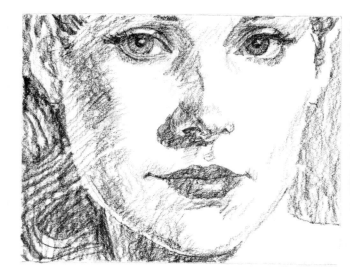

Strokes on Charcoal Paper. The strokes of the hard and medium charcoal pencils are particularly effective on charcoal paper, as you might expect. The ribbed texture of the sheet softens the strokes, which are filled with pinpoints of bare paper. Look at the tones on the side of the nose and cheek, the shadow beneath the nose, and the dark tone of the lips—they seem transparent and filled with inner light. The tiny flecks of bare paper make even the darkest tone look luminous.

Strokes on Rough Paper. The strokes of a charcoal pencil or a stick of charcoal look lively and spontaneous on paper with a ragged texture. The granular texture of the charcoal is accentuated by the coarse surface. The strokes in this portrait are bolder—though less distinct—than the more sharply defined strokes in the drawing at your left. It's worthwhile to try rough paper because it encourages you to work with bold, free strokes. And you have to keep the drawing simple, since you can't build up too much detail.

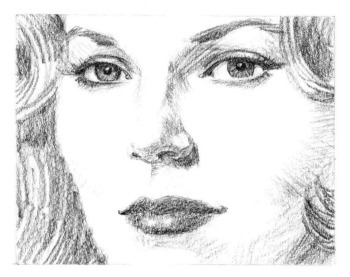

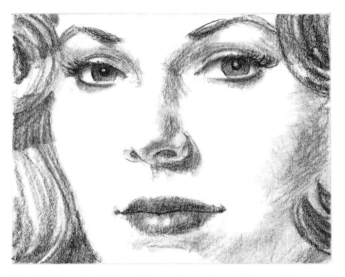

Modeling with Strokes. This face is drawn with hard and medium charcoal pencils. The artist builds up his strokes in clusters which change direction as the form curves. Notice how the strokes wrap around the corners of the eye sockets and slant diagonally down the side of the nose. The groups of strokes gradually change direction as they move around the sides of the cheeks. Don't just dive in and start scribbling! *Plan* your strokes.

Modeling by Blending. A medium charcoal pencil blends easily, while a soft pencil or stick of natural charcoal blends still *more* easily. In this drawing of the same sitter, the artist blocks in the tones with broad, casual strokes and then smudges them with a fingertip to form soft, velvety tones. He doesn't blend the strokes so thoroughly that they disappear, but allows some of them to show through the blurred tones. You can see this most clearly on the cheek, within the eye sockets, and along the side of the nose, where the underlying strokes add solidity to the soft, misty veils of tone.

Strokes and Blending on Charcoal Paper. The hard surface of charcoal paper is ideal for a technique that combines slender lines like those along the bottom of the nose and between the lips; broad strokes like the ones on the shadow side of the face; and blended areas, which you see throughout this close-up of a male portrait. The artist uses a sharply pointed hard charcoal pencil for the precise lines and edges in this drawing, switching to a soft pencil for the broad strokes and then blending the tones with a stomp.

Strokes and Blending on Rough Paper. The granular strokes of a stick of natural charcoal look particularly effective on the ragged surface of a sheet of rough drawing paper. The textures of the paper and the strokes seem to match. When the strokes are blended, natural charcoal behaves like wet oil paint, which you can spread easily over the surface with a fingertip or a stomp. And you can use a sandpaper pad to make the stick just sharp enough to draw lines like those you see on the nose and between the lips.

Step 1. Like graphite pencil and chalk, charcoal handles beautifully on any sturdy white drawing paper that has a moderate amount of texture—just enough to shave off the granules of charcoal as you move the drawing tool across the surface of the sheet. Charcoal blends so easily that it's always tempting to smudge the tones of a charcoal drawing; but resist this temptation and begin with a portrait in which you render the tones entirely with strokes. In this portrait, the artist uses a combination of three charcoal pencils: hard, medium, and soft. He begins with the hard pencil, sharpened to a point, for the preliminary sketch of the compound egg shape, with its vertical and horizontal guidelines. The head is turned to the right, and so the center line moves to the right too. Since the sitter's head is tilted slightly downward, the horizontal lines curve gently around the egg. The artist follows these curves to locate the ear, which seems a little high on the head but actually aligns with the curving guidelines of the eyes and nose.

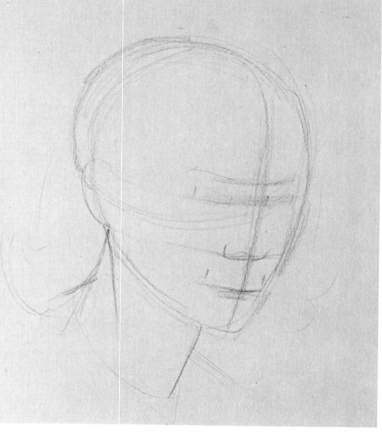

Step 2. The hard charcoal pencil draws the contours of the head and hair with pale lines—the artist doesn't press too hard. The eyebrows, eyes, nose, and mouth are carefully placed on the curving guidelines of Step 1. Because the head tilts slightly downward, the hairline seems to come farther down the forehead and we see more of the top of the head. Curving lines wrap the shape of the hair around the top of the egg and bring the hair down around the sides of the face. Even at this early stage, the upper lip begins to have its characteristic double-wing shape. When the head is turned to a three-quarter view, the vertical center line is particularly important in helping you line up the bridge and underside of the nose, the groove between the nose and upper lip, the center of the lips, and the midpoint of the chin. In this view, the eye at the right is close to the center line, while the eye at the left is farther away.

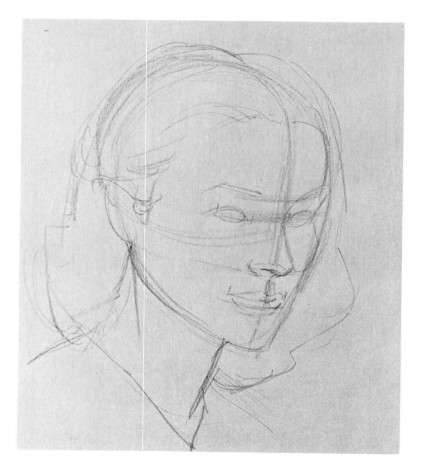

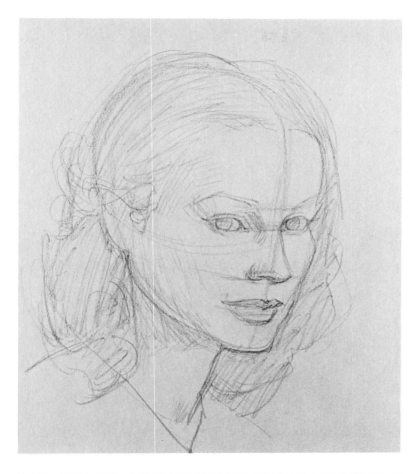

Step 3. The point of the hard charcoal pencil lasts longer than the point on a medium or soft pencil, and so the artist continues to work with it to draw the precise shapes of the eyes, nose, mouth, cheeks, jaw, and chin. Now you can see both lids, the concave corner of one eye socket, the exact shape of the nostril, the winglike shape of the upper lip, and the full, squarish lower lip. Having defined the features, the artist scribbles the point of the hard pencil lightly over the tonal areas of the head: the hair, forehead, cheek, jaw, neck, eye sockets, nose, and lips. By the end of Step 3, he's established a clear distinction between the light and shadow areas of the head.

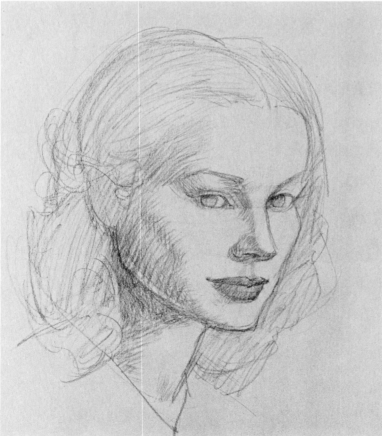

Step 4. Switching to a medium charcoal pencil, the artist starts to build up the tones on the forehead, cheek, jaw, neck, eye sockets, nose, and lips. Notice how he swings the pencil in a short arc so that the strokes match the curves of the sitter's face. These curved strokes are most apparent on the forehead, cheek, and jaw, but there are also smaller ones within the eye sockets and along the side of the nose. Notice how the dark hollow within the cheek is suggested by a second row of slanted strokes that overlap the first cluster. When one cluster of strokes crosses another at an angle—as you see here— this technique is called *hatching*. The sharp point of the medium charcoal pencil strengthens the contours of the eyes, adding a delicate tone beneath the upper lid to suggest the shadow that the lid casts on the eye. The point of the pencil also defines the shape of the lips.

Step 5. Turning the medium charcoal lead on its side, the artist continues to build up the tones with broad, curving strokes. Once again, he goes over the side of the forehead, cheek, jaw, and neck, darkening and solidifying the tones of Steps 3 and 4. (Notice how much broader the strokes are becoming at this stage.) He deepens the tones within the eye sockets and along the underside of the nose. He accentuates the shadow lines around the eyelids and adds the internal detail of the ear. With big, free movements, he darkens the hair by scribbling the pencil back and forth with curving strokes to suggest the texture of the sitter's curls. Where the dark hair silhouettes the lighted side of the face, he strengthens the line of the brow, cheek, jaw, and chin. The head now looks far more three-dimensional than it did in Step 4.

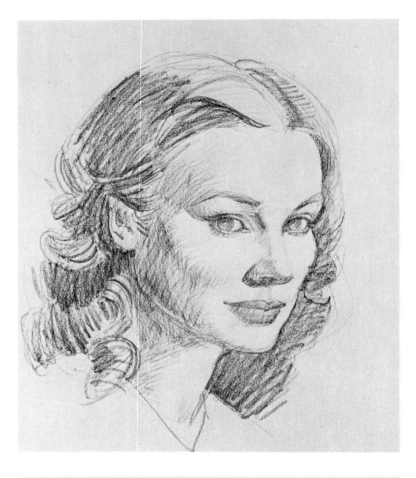

Step 6. The soft charcoal pencil makes a much darker, broader stroke than the hard and medium pencils the artist has used so far. Now he uses a soft pencil to darken the curls of the sitter's hair with clusters of short, thick strokes. Now there's a much stronger contrast between the pale tones of the face and the surrounding darks. The soft pencil is just sharp enough to darken the eyebrows, eyes, nostrils, and the shadow beneath the nose. Notice the hint of shadow beneath the upper eyelids.

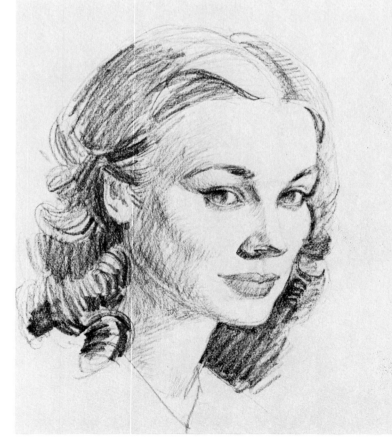

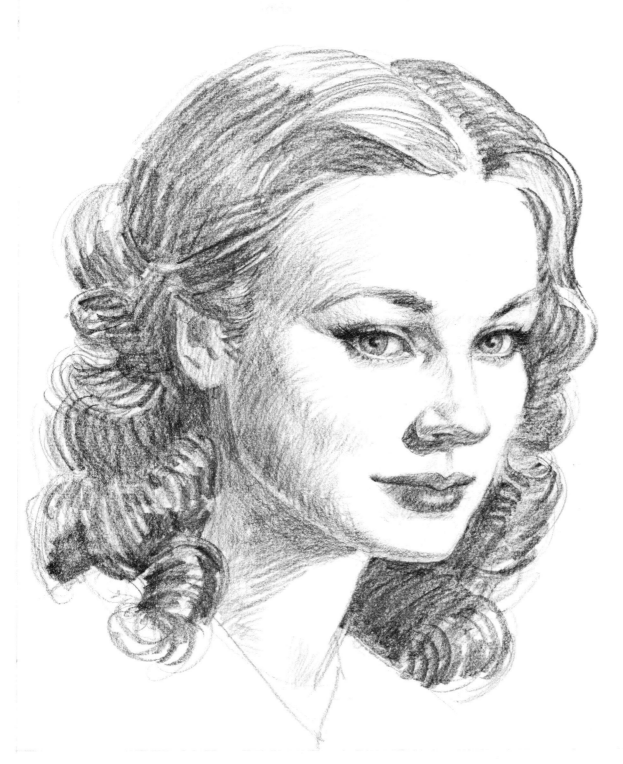

Step 7. The artist darkens the hair with broad, curving strokes of the soft charcoal pencil. The pencil moves over the face to deepen the shadows on the forehead, cheek, jaw, and neck, and to darken the eye sockets, lips, and the tones that surround the nose. The artist focuses on the eyes again, darkening the lines of the eyelids, adding pupils, and suggesting lashes. A kneaded eraser brightens the whites of the eyes, picks out highlights on the pupils, adds touches of light on the lids, and then carefully cleans the lighted areas on the face.

Step 1. To demonstrate a technique that combines strokes with blended tones, the artist chooses an interesting trio of drawing tools. He works with a medium charcoal pencil and two sticks of compressed charcoal, one medium and one soft. Compressed charcoal is made of crushed charcoal granules that have been bonded together under pressure to make a stick that behaves somewhat like hard pastel—in contrast with natural charcoal, which is literally a charred twig. Compressed charcoal makes a more precise stroke that doesn't smudge quite as easily as the natural variety. The artist draws his preliminary guidelines with the medium charcoal pencil on a sheet of charcoal paper, a surface on which blending is particularly effective.

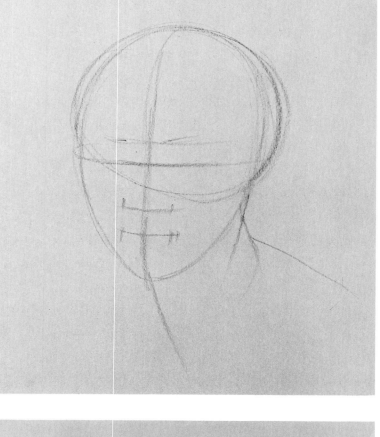

Step 2. The charcoal pencil begins to draw the contours of the face over the guidelines of Step 1. The artist places the features on the horizontal guidelines, aligning the ears with the eyes and nose. He surrounds the head with the circular contour of the sitter's hair. The ribbed surface of the charcoal paper is already apparent at this stage. Since the drawing will be dominated by broad strokes and smudged tones, the artist doesn't want the preliminary lines to be sharp and wiry; the charcoal paper softens the lines so they'll melt away into the tones of the completed drawing.

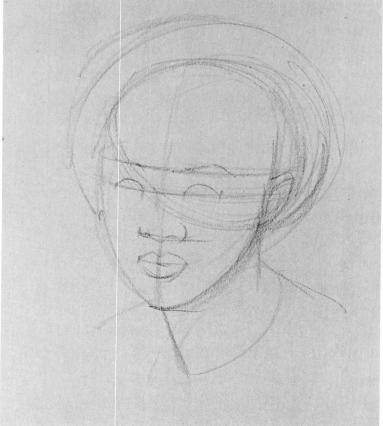

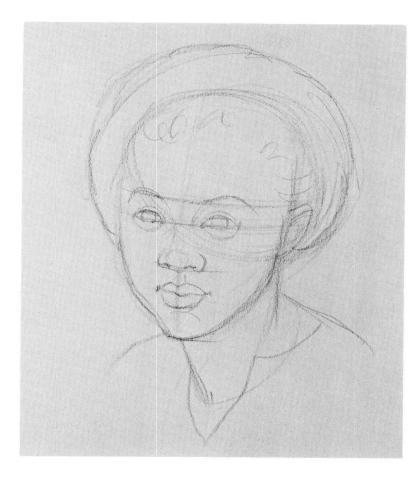

Step 3. The artist develops the curves of the sitter's cheeks, jaw, and chin with the pencil. Then he defines the rounded shapes of the features more exactly. You see the curves of the eyebrows and eyelids, the rounded shapes of the nostrils and the tip of the nose, and the full, sculptural lips. This is the last time we'll see the guidelines of Step 1, which are erased after the completion of Step 3.

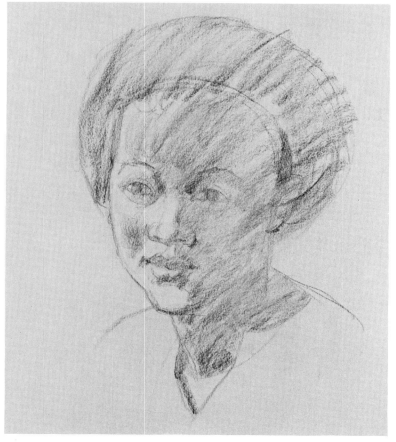

Step 4. Picking up the medium stick of compressed charcoal, the artist blunts the stick on the sandpaper pad so that it will make broad strokes when he holds it at an angle to the paper. Then the artist sweeps the tool diagonally across the drawing, filling the hair and face with thick, irregular strokes. Moving around the features, he darkens the eye sockets, eyes, nose, and lips with broad strokes. At this stage, the thick compressed charcoal moves very lightly over the paper, since the artist's purpose is simply to establish the major areas of light and shadow. Although at this stage the drawing is quite pale, the artist has already recorded the dramatic lighting.

Step 5. Moving his thumb firmly over the drawing—since compressed charcoal needs some pressure to blend—the artist softens and fuses the strokes of Step 4 on the forehead, within the eye sockets, on the cheeks and jaw, and on the neck and shoulder. Picking up the medium charcoal stick again, he darkens the hair with scribbly strokes that begin to suggest the texture of the sitter's curls. The blunt charcoal stick darkens the forehead; adds more tone to the eye sockets; accentuates the irises and the shadows beneath the eyes; builds up the tones around the nose and lips; and adds stronger darks to the side of the face, neck, and shoulder. The lighter side of the cheek is dramatized by a touch of darkness on the left.

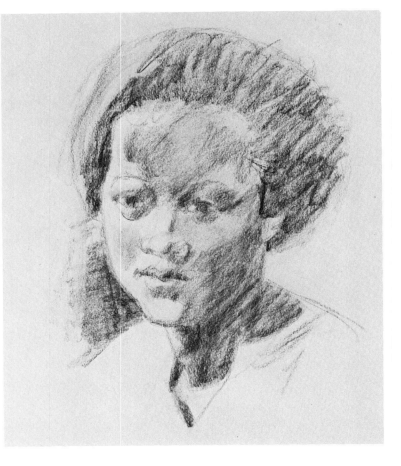

Step 6. Now the artist reaches for the soft stick of compressed charcoal to intensify the darks throughout the drawing. He presses hard on the stick to enrich the hair with short, curving strokes. He darkens the tones around the features with broad strokes and then blends them with a stomp, which gets into these tight spots more easily than a fingertip. Sharpening the compressed charcoal stick—which holds a point better than a stick of natural charcoal—he adds crisp, dark strokes to the eyebrows, eyes, nostrils, and lips. So far, the features have all been soft and indistinct; now they come into sharp focus. Broad strokes darken the cheek and the shadow beneath the chin, and the artist blends them with a fingertip.

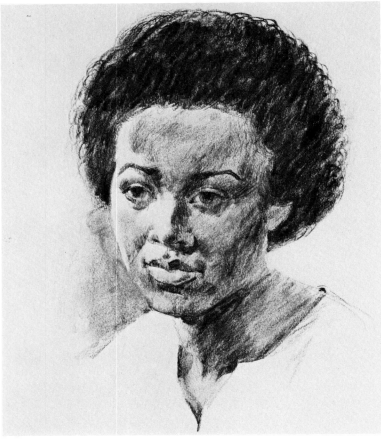

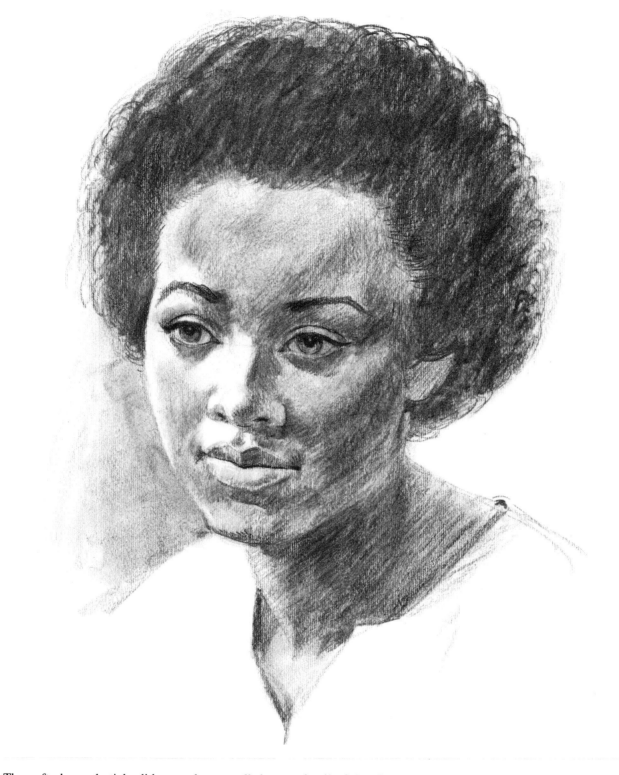

Step 7. The soft charcoal stick glides gently over all the tonal areas of the face, making broad, soft strokes that you can see most clearly in the cheek, jaw, and neck. The artist blends these strokes with his thumb, slowly building up the dramatic effect of light and shade. Thick strokes are added to the hair and partially blended with the thumb, allowing the strokes to remain distinct enough to communicate the detail of the sitter's hair. The point of the charcoal stick strengthens the edges of the features with sharp lines that heighten the contours of the eyelids, nostrils, and lips. A wad of kneaded rubber cleans the lighted areas of the face. The finished drawing retains the vitality of the bold strokes, which the artist blends but never eradicates.

Step 1. The ancient stick of natural charcoal—which is just a twig that's been heated until it turns black—is one of the humankind's most miraculous drawing instruments. That black, crumbly twig delivers an extraordinary range of smoky tones that you can blend with a fingertip to "paint" a black-and-white portrait as rich and subtle as any oil painting. For this final demonstration, the artist chooses an extremely rough sheet of paper with a hard, ragged surface that's excellent for blending. Sharpening a stick of natural charcoal on a sandpaper pad, the artist draws a compound egg shape that is turned to a three-quarter view. You see the usual guidelines. The lines made by the charcoal stick are rough and bold, but they'll quickly disappear with a mere touch of the fingertip as the artist begins to blend his tones.

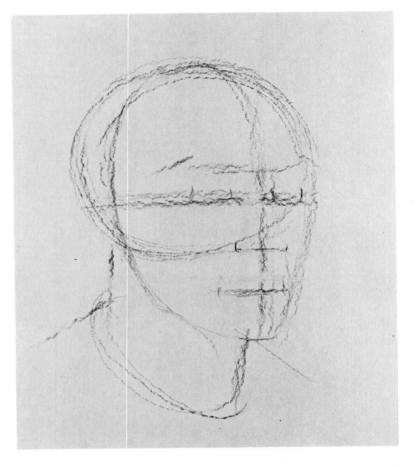

Step 2. A natural charcoal stick is never quite as sharp as a charcoal pencil, so the lines always have a broad, irregular quality—which is part of their beauty. The artist begins to draw the contours of the head with quick, rhythmic strokes, letting the stick coast lightly over the rough surface of the paper. The lines aren't neat and precise, but they're full of vitality. The artist doesn't draw too carefully, since these lines will melt away when he begins to blend the tones in later steps. Notice how the irregular surface of the paper breaks up the lines.

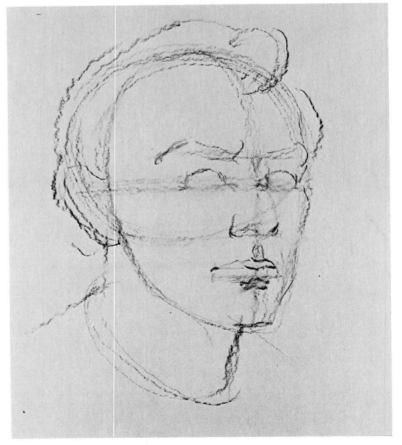

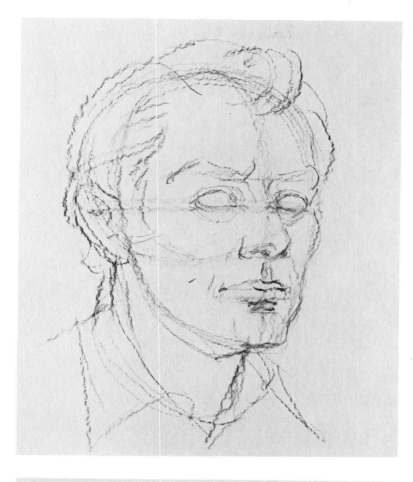

Step 3. The line drawing of the face and features is completed. Although the lines are granular and broken, the artist defines the shapes of the eyelids, nose, lips, and ear. He reshapes the contours of the cheeks, jaw, and chin. He develops the distinctive shape of the hair and suggests the collar with just a few strokes. Aside from establishing a reasonable likeness, the purpose of this line drawing is to provide a guide for the big masses of tone that will come next—and bury the lines!

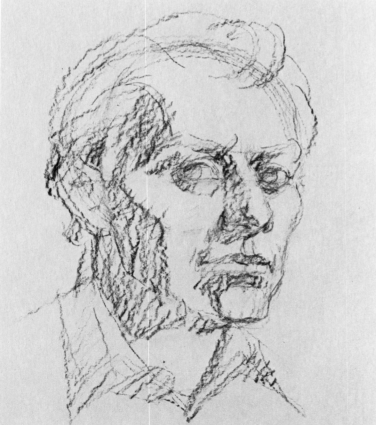

Step 4. Holding the charcoal stick at an angle to the paper, the artist blocks in the big masses of tone with broad, irregular strokes. He works swiftly and decisively, leaving big gaps between the strokes. The gaps don't matter because the strokes will soon be blended to form smooth tones. The head suddenly becomes boldly three-dimensional as the artist places big shadows on the side planes of the brow, cheek, jaw, neck, eyes, nose, and chin. The upper lip turns away from the light into darkness. The nose casts a shadow downward toward the upper lip. And there are jagged shadows within the collar. Even at this early stage, the drawing has the simplicity and power which are unique to natural charcoal. The artist *could* stop here, but he goes on because the purpose of this demonstration is to show the rich tonal possibilities of the medium.

Step 5. The artist lets his fingertip glide lightly over the tonal areas of Step 4, gently fusing the rough strokes into soft, smoky tones. Suddenly, we have a totally new drawing! The lines and strokes of the first four steps have practically disappeared as the artist transforms them into subtle shades of gray. Then the charcoal stick moves back over the smoky tones to sharpen certain details, such as the inner shapes of the ear, the corners of the eyes, the underside of the nose, the square contour of the jaw, and the shapes of the lips.

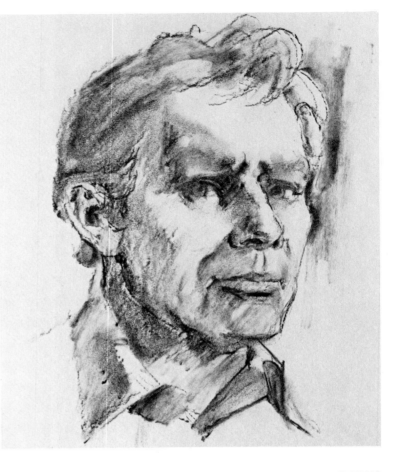

Step 6. Now the artist keeps switching back and forth between the charcoal stick and his fingertip. Short, thick strokes darken the eyebrows, eye sockets, nose, lips, cheek, and chin. The artist blends these strokes very gently with a fingertip—or with a stomp when the area is too small for his fingertip. The technique is to make a few strokes and blend them, and then make a few more strokes and blend them, gradually building up the tones and accentuating the details. Sharpening the stick on a sandpaper pad, the artist draws crisp lines within the eyes, blackens the pupils, and deftly picks out highlights within the pupils with the sharp corner of a razor blade. Dark, slender lines redefine the shapes of the nose and chin. The artist strengthens the corners of the mouth and adds a few wisps of hair over the ear. He adds detail very selectively, without overdoing it.

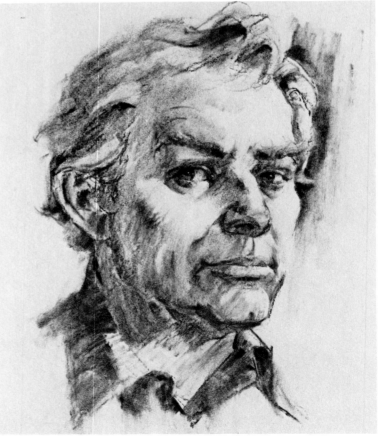

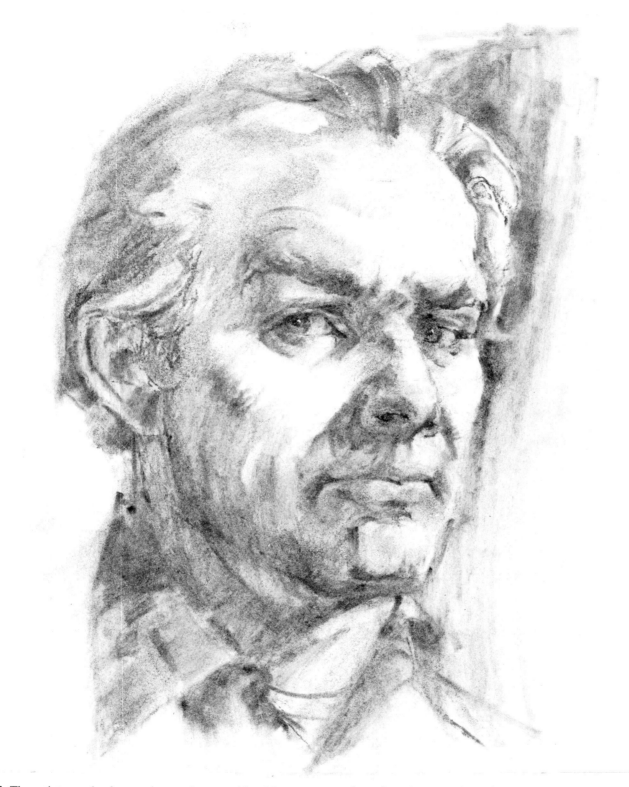

Step 7. The artist goes back over the tonal areas with additional strokes and blends them with his finger, gradually darkening the shadows until there's a powerful contrast between the dark and light sides of the forms. In Step 6, you saw sharp lines surrounding many of the features; now these lines are softly blended so that they fuse with the surrounding shadows. There are almost no lines in the final drawing, except for a few sharp touches of the charcoal stick within the eyes and ear, inside the nostrils, and between the lips. The kneaded eraser brightens the forehead, cheeks, nose, and chin, "draws" some wrinkles in the cheek on the left, and lifts some patches of light out of the hair. The corner of the razor blade scratches some white lines into the hair and brightens the highlights on the pupils.

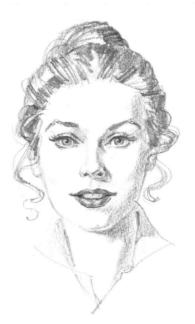

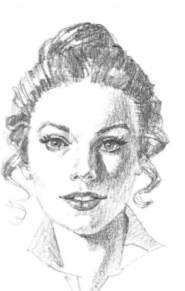

Three-quarter Lighting. Learn to identify the direction of the light before you start to draw a portrait. Here, the light comes from the left side, over your shoulder. Most of the face is brightly lit, but there are narrow strips of shadow on the right sides of all the forms. This is a flattering light for most sitters.

Side Lighting. The light no longer comes over your left shoulder, but seems to be at the sitter's side, placing more of the face in shadow. Most of the right side is dark, with a small, bright triangle on the cheek that curves forward to catch the light. The protruding nose casts a dark shadow on its right side. The eye sockets are also in deeper shadow.

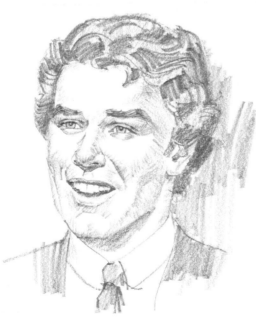

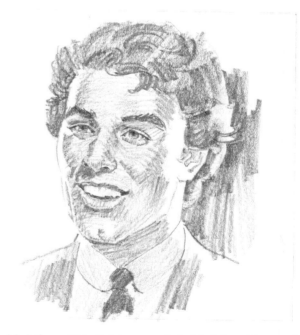

Frontal Lighting. When the light hits the sitter directly in the middle of his face, there are big patches of light in the centers of all the forms, with shadows around the edges. Thus, the forehead is bright in the middle and shadowy at the sides. So are the nose, cheeks, and chin. The chin and jaw cast a strong shadow down the center of the neck.

Rim Lighting. This light source is behind the sitter, and most of his face is in shadow. But the light creeps around the edges (or the rims) of the face. Although the front of the face is in darkness, there's a distinct contrast between the shadows and the halftones that define the features. Shadows are rarely pitch-black; they're filled with subtle light.

PART FOUR

FIGURE DRAWING

DRAWINGS BY ULDIS KLAVINS

Figure Drawing. From the time of the ancient Greeks, artists have regarded the male and female nude figure as the ultimate statement of humanity's ideals of heroism and beauty. Many great artists have devoted their entire lives to painting, sculpting, and drawing the nude figure. For the forms of the human body are endlessly fascinating. Every pose, gesture, and view presents a new challenge. Thus, artists love to draw the nude not only because the beauty of the human body is so hypnotic, but because there's always something new to learn. In fact, many teachers feel that drawing the nude is the *best* way to learn how to draw.

Proportions. Before you begin to draw the figure, it's important to establish a clear mental image of the proportions of the male and female bodies. The traditional system is to measure in head lengths. The figure drawings in this book are based on the rule that the height of the figure is roughly eight times the length of the head. Artists usually say that the figure is "eight heads tall." The legs, arms, and other sections of the body are also measured in heads. *Figure Drawing* begins by presenting this system of proportions in a series of drawings of standing male and female figures, seen from different angles.

Learning to Draw the Body. Next, you'll watch noted artist Uldis Klavins demonstrate how to draw the various parts of the body step by step. Looking at the body from various views—front, three-quarter, and side—Klavins demonstrates how to draw the male and female torso, head, arm and hand, and leg and foot.

Drawing the Total Figure. Having shown how to draw the components of the figure, Klavins then goes on to demonstrate how to assemble all this information in complete drawings of the male and female figure. You'll watch him construct all the forms of the figure from head to toe, applying the systems of proportion and the step-by-step drawing methods you've learned in earlier pages. These complete figure demonstrations, like the preceding demonstrations of the various parts of the body, show the four fundamental stages in executing a figure drawing. First Klavins shows you how to establish the major forms with simple guidelines. Then he shows you how to refine these lines to make the forms more accurate. He blocks in the broad areas of shadow. And then he completes the drawing by refining contours, strengthening the shadows, and adding details.

Step-by-Step Demonstrations. In a series of more detailed demonstrations, Klavins then shows you how to draw ten different figures step by step. He begins with simple poses, gradually introducing more complex ones. The first three demonstrations are pencil drawings of standing male and female figures, and a seated female figure. The next three demonstrations are chalk drawings: a bending male and a kneeling female figure, and a back view of a seated female figure. And the last four demonstrations are charcoal drawings of a twisting male figure, a crouching male figure, a reclining female figure, and a seated male figure. The ten demonstrations show every drawing operation in precise detail.

Drawing Media. These ten step-by-step demonstrations are executed in a variety of pencil, chalk, and charcoal techniques to reveal the full range of possibilities in these versatile media. You'll see how to build contour, form, and light and shade with various combinations of lines, strokes, and blended tones. And the drawings are executed on a variety of papers to show you the effects of varied drawing surfaces.

Finding Models. As most artists and art students have discovered, people aren't nearly as shy as they used to be. Members of your family, friends, and acquaintances are accustomed to today's revealing beachwear and resort fashions, and so they're often flattered by an invitation to pose. If you prefer to draw a professional model, check your nearest art school, college, or university to see whether they've got a so-called life class which you can join. Sometimes a life-drawing class includes the services of an instructor, but it's also common for a school to hire a professional model and simply provide a studio in which a group of students or serious amateurs can draw for several hours, merely paying a modest admission fee. You can also form your own life class with friends, working in someone's home and sharing the cost of the model's fee. To find a professional model for your own life class, you might call your local art school, college, or university to find out where they get their models. Professional artists often contact dance or drama schools whose students are willing to model to finance their professional training. The important thing is to work from the living figure—not from photographs—and to draw as often as you can. If you join a life class—or form your own—be sure to go at least once a week. When you go to the beach or to the swimming pool, take your sketch pad. Ask permission to make drawings at dance classes and the local gym. If there's a museum nearby whose collection includes Greek or Roman sculpture, you're especially lucky: you can draw beautifully proportioned models who never get tired and never move!

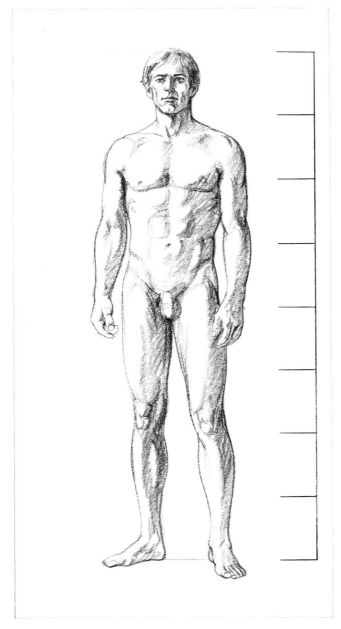

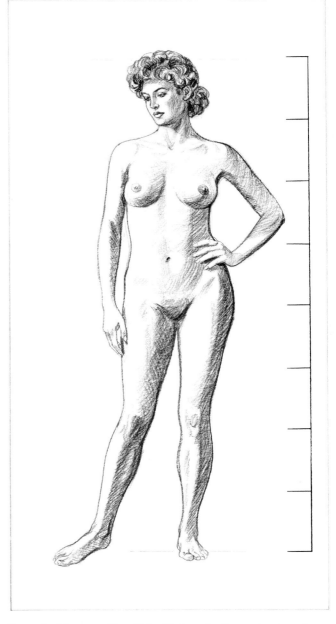

Male Figure. Although no two models are exactly alike, it's helpful to memorize the proportions of an "ideal" figure and keep these proportions in mind as you draw. Most artists use the head as the unit of measurement. They generally visualize a figure that's eight heads tall. The torso is about three heads tall from the chin to the crotch, divided into thirds at the nipples and navel. The upper leg is two heads tall and so is the lower leg. At its widest point, the shoulders, the "ideal" male figure measures just over two head lengths.

Female Figure. The "ideal" female figure is also about eight heads tall, though you can see that she's just a bit shorter than the "ideal" male figure at your left. At the two widest points, the shoulders and hips, she measures about two head lengths. In both these figures, notice that the elbows are approximately three heads down from the top of the head, aligning with the narrowest point of the waist, while the wrists align with the crotch. Naturally, these alignments change when the model bends her arm.

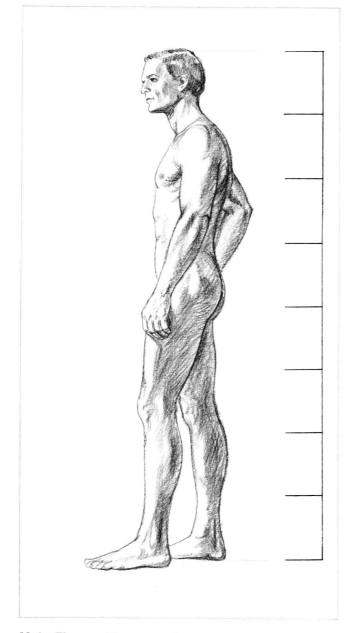

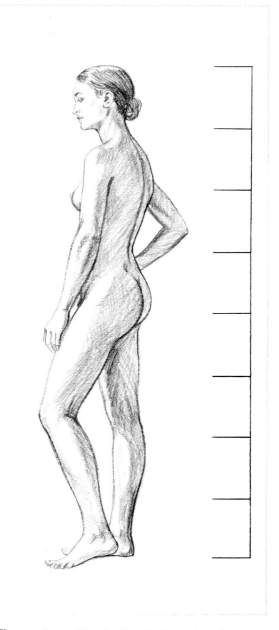

Male Figure. The proportions are essentially the same when you see the figure from the side. Notice that the lower edge of the chest muscle comes about halfway down the upper arm. The lower edge of the buttock is slightly more than four heads down from the top of the figure—a bit farther down than the crotch. As the model bends his arms, the elbows no longer align with the waist, but rise farther up. Seen from the side, the foot measures slightly more than one head length.

Female Figure. In profile, the female figure has the same proportions, although she's slightly smaller than the comparable male figure. Once again, you can see that the breast comes about halfway down the upper arm, and the lower edge of the buttock is just below the midpoint of the figure. From the shoulder to the wrist, the arm is a shade under three heads in length. This means that the upper and lower arms should each measure roughly one and one-half heads. As it is in the male figure, the female foot is just over one head length. The outstretched hand is slightly less than one head length.

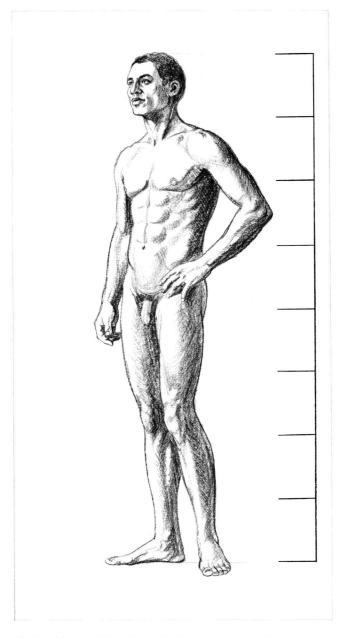

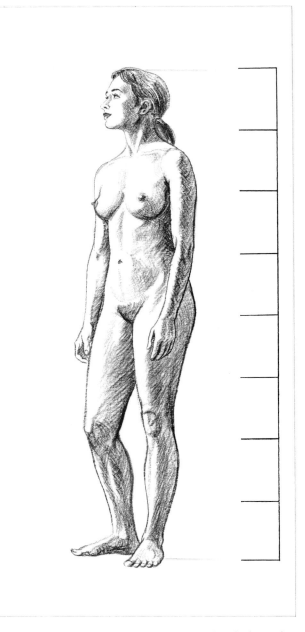

Male Figure. When the male figure turns to a three-quarter view, the vertical proportions remain the same, but the horizontal proportions obviously change. The shoulders are less than two heads wide, and the entire torso narrows slightly. Study the proportions of the bent arm: the upper and lower arms are each approximately one and one-half head lengths, while the hand is just under a head length. As the arm bends, the elbow rises above the midpoint of the figure, and the wrist no longer aligns with the crotch. When one leg bends and the other remains straight, the knee of the bent leg tends to drop slightly.

Female Figure. Here you can see very clearly how the knee drops slightly as the leg bends. In the three-quarter view, the shoulders and hips are no longer two heads wide, but become narrower. As the model keeps turning toward the side view, those dimensions will become narrower still. The lower edge of the breast comes about halfway down the upper arm. The elbows align, more or less, with the navel, although the female navel is usually slightly lower than that of the male. The lower edge of the knee is two heads up from the heel.

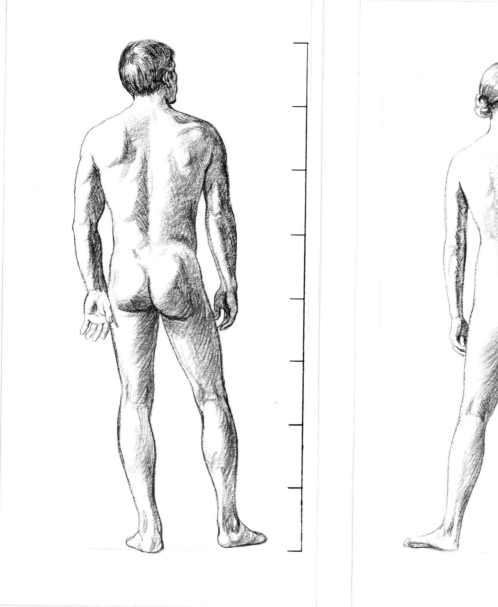

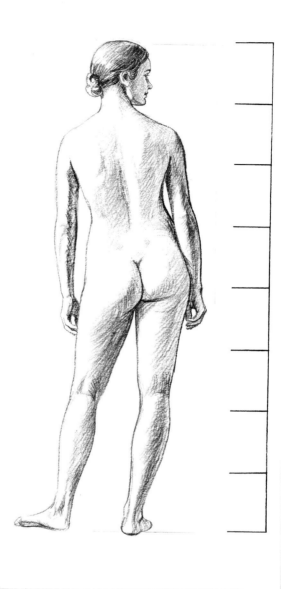

Male Figure. Seen from behind, the figure displays the same proportions as the front view—with some subtle differences. The lower edges of the buttocks fall slightly below the midpoint of the figure—unlike the crotch, which is usually just four heads down from the top of the head. The horizontal creases at the backs of the knees, dividing the upper and lower legs, are slightly more than two heads up from the heel—in contrast with the lower edges of the knees, which are a bit farther down in the front view. Notice that the lower edges of the shoulder blades are two heads down from the top of the figure, which means one head down from the neck. The shoulders measure a shade over two head lengths, while the hips measure about one and one-half.

Female Figure. In this view, you can see one of the major differences between the male and female figures. In the male figure at your left, the shoulders are distinctly wider than the hips, while the female figure is equally wide at both points—roughly two head lengths. Once again, you can see that the crease that divides the upper and lower legs is distinctly higher than the lower edge of the knee, which you saw in the front view of the figure. Obviously, not every model will have the "ideal" proportions you see in these drawings, but if you stay *reasonably* close to these measurements, making some adaptations to suit each model, the proportions of your figures will always be convincing.

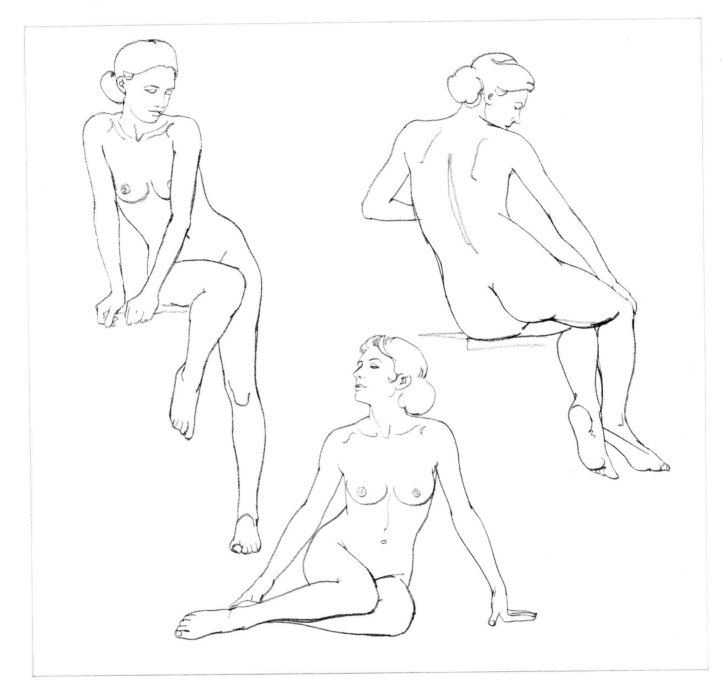

Contour Drawing. In figure-drawing classes around the world, one of the classic warm-up exercises is *contour drawing*. Sharpen an HB pencil so that it makes a thin, wiry line, and work on a fairly smooth sheet of ordinary drawing paper. Move your eye slowly along the contours of the model—the way your eye might follow the coastline of a landmass on a map—and move the point of your pencil over the paper as your eye travels over the figure. Try to pretend that your pencil point is, in fact, your eye moving carefully around the shapes of the figure. Don't look too often at the drawing, but focus your attention on the model. Work slowly and decisively, trying not to go over the same line too many times. If you're not satisfied with the drawing, don't bother to erase and redraw it—just start another drawing. The more drawings you do, the better. Each time you draw a "map" of the figure in a different pose, you develop your ability to draw the figure simply and decisively, and you gradually engrave the shapes of the figure in your memory.

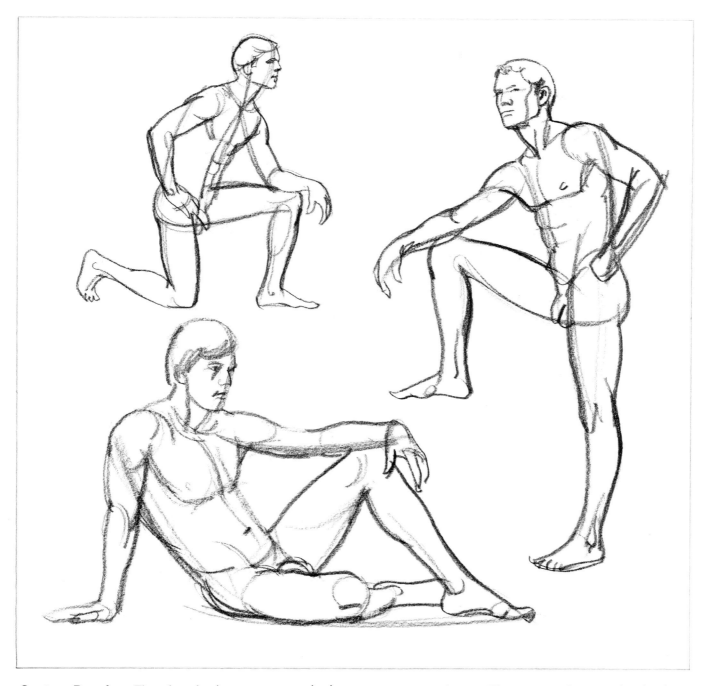

Gesture Drawing. The other classic warm-up exercise is *gesture drawing*—which is just the opposite of contour drawing in many ways. Work with a thick, dark pencil, perhaps a 4B or 6B, worn down to a blunt tip that makes a thick line. The idea is to draw with rapid, swinging movements. Let the pencil glide swiftly around the figure—and within it—trying to capture the movement of the forms. Of course, the model isn't *literally* moving. It's your *eye* that moves, sweeping rhythmically over the curves of the human form. In this sense, the subject *does* communicate a sense of movement to the eye. The purpose of gesture drawing is to let the pencil sweep over the figure just as the eye does. Don't pause to render precise contours, but let the pencil move with free, spontaneous gestures, scribbling one line over another and letting the lines flow into one another. Notice how the artist runs big, curving lines straight through the figure, connecting one form with another. Forget about the precision and elegance of contour drawing. What you'll learn from gesture drawing is how to communicate the dynamism of the human figure with bold strokes.

Step 1. The artist begins by drawing a vertical oblong box. The top line of the box connects the shoulders, while other horizontal guidelines locate the nipples, navel, crotch, and the abdominal muscles. He runs a vertical center line from the pit of the neck to the crotch. The center line obviously follows the shallow groove that actually runs through the torso; the line also helps the artist locate the shapes that are placed symmetrically on either side of the groove. Above the top line of the box, the artist draws two slanted lines for the sloping shoulders, two verticals for the neck, and two diagonals for the muscles that run upward from the pit of the neck. Moving down the torso, he indicates the squarish shapes of the chest muscles, the domelike underside of the rib cage, the navel, and the shapes of the stomach muscles, waist muscles, and crotch. Notice that the shoulders are indicated as egg shapes, while the crotch is a simple triangle.

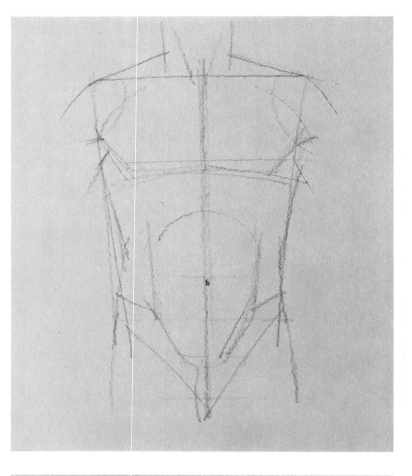

Step 2. Step 1 provided a kind of "diagram" over which the artist now constructs a realistic line drawing of the living body. The "diagram" consists mainly of straight lines. These are gradually replaced with curving lines that look more lifelike, but which really follow the guidelines quite faithfully. The vertical lines of the neck and the slanted lines of the shoulders now flow softly together, ending in the egglike shapes of the large shoulder muscles. The squarish chest muscles are rounded off, and the nipples are placed on the horizontal guideline. Along the outer edges of the torso, the pencil traces the curves of the rib cage, the waist, and the beginning of the thighs. Like the muscles of the chest, the abdominal muscles are like squares with slightly rounded edges. Along the horizontal line that connects the shoulders in Step 1, the artist suggests the details of the collarbones and the muscles that move diagonally upward from the pit of the neck.

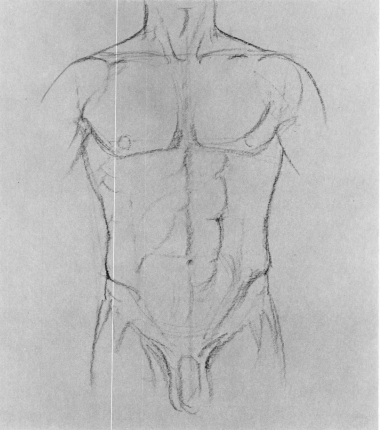

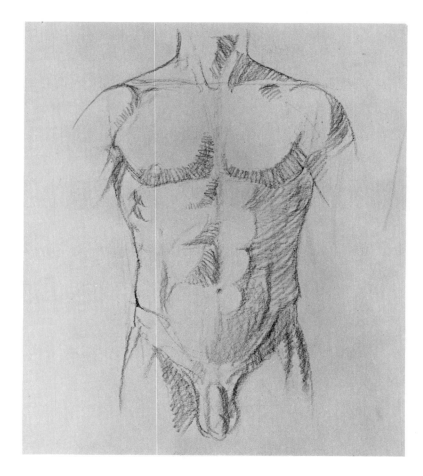

Step 3. Turning the pencil so that it strikes the paper at an angle, the artist blocks in the tonal areas with the side of the lead. The side makes broader, rougher strokes than the tip. He works with clusters of parallel strokes to fill in the tones on the shadow sides of all the forms. Since the light comes from the left and from slightly above, the right sides of the forms are in shadow—and so are the undersides. Thus, tones appear on the right sides of the neck and shoulders, chest muscles, abdominal muscles, thighs, and on the entire right side of the lower torso. There are also strips of shadow beneath the chest muscles and along the lower edges of the abdominal muscles. The purpose of this step is to establish a clear distinction between the light and shadow areas of the forms.

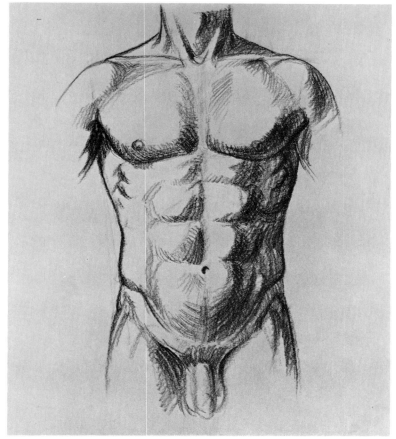

Step 4. In the final stage, the artist strengthens all the tones with the side of the lead and then sharpens all the contours of the forms with the pencil point. The figure contains four distinct tones: the lights, which are just bare paper; the halftones (or middletones), which are the pale strokes within the lights or between the lights and shadows; the shadows, which are the darkest areas in the drawing; and the reflected lights, which are the slightly paler tones within the shadows. Reflected lights are usually produced by some secondary light source, such as a remote window, which adds a hint of luminosity to the dark side of the form. This full range of tones makes the form look round and three-dimensional.

Step 1. Once again, the artist begins with a simple linear "diagram" of the torso. He visualizes the female torso as a pair of blocky shapes that taper inward to meet at the waist. Along the topmost line that connects the shoulders, the artist draws the neck, the sloping curve of the collarbones, and the slanted lines of the shoulders, connecting with the egglike shapes of the big shoulder muscles. Working downward, the artist places horizontal guidelines at the nipples, along the lower edges of the breasts, at the waist and navel, and at the crotch. He uses these horizontal guidelines to locate the circular forms of the breasts and the triangular form of the crotch. Notice how the vertical center line helps him draw a symmetrical figure.

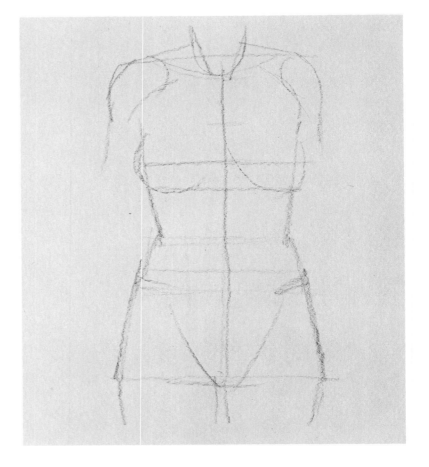

Step 2. Following the same sequence of operations you've already seen in the preceding demonstration, the artist constructs the curving contours of the living figure over the simple, geometric guidelines of Step 1. The neck flows softly into the sloping shoulder muscles, ending at the big, rounded forms at either end of the collarbone. The nipples and the spherical shapes of the breasts are placed carefully over the next set of horizontal guidelines. In the same way, the navel and crotch are placed on their own guidelines. The artist follows the wedge shape of Step 1 as he draws the tapering lines of the hips and thighs. Notice that the widest points of the shoulders align with the widest points of the hips. Within the shapes of the breasts, abdomen, and hips, the artist suggests the edge of the shadow area that will appear in Step 3.

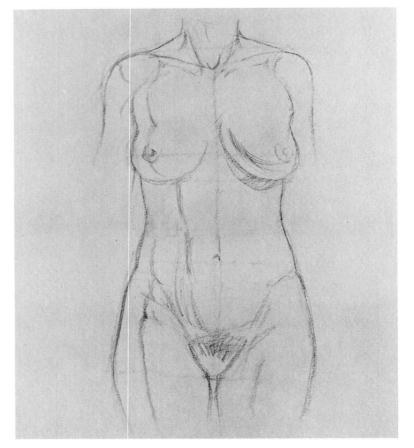

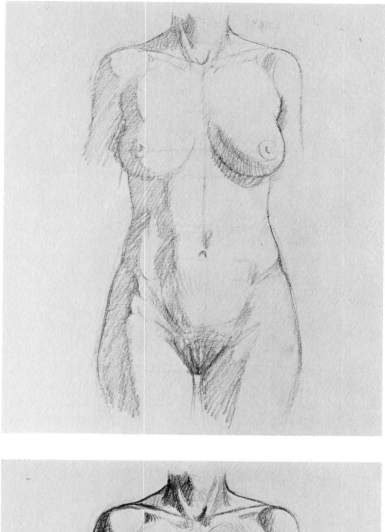

Step 3. The artist blocks in the big shapes of the shadows with groups of parallel strokes, made with the side of the lead. It's important to note that the shadows have distinct shapes—they're not just amorphous blurs of tone—that follow the curves of the forms. When you draw the figure, study these shapes and draw them as precisely as you draw the solid forms of the body. The light comes from the right, and so the left sides of the forms are in shadow. On the lighted side of the body, the breast casts a circular shadow downward over the midriff.

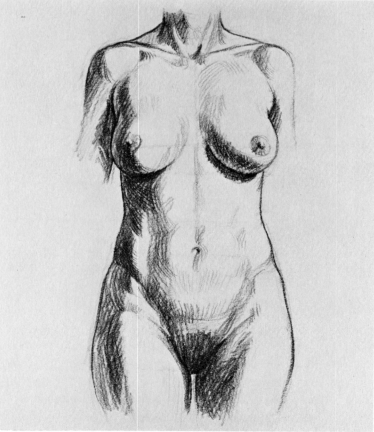

Step 4. The artist builds up the tones of the figure by placing stroke over stroke. The darkest areas contain the heaviest concentration of strokes—and that's where the artist presses hardest on the pencil. The shadows are darkest at the point where light and shadow meet, turning paler as they begin to pick up reflected light from some distant light source. You can see this most clearly in the breast on the lighted side of the figure: looking from right to left, you see the light, a hint of halftone where the breast begins to curve away from the light, the darkest area of shadow, and finally the reflected light along the lower edge of the shadow—plus the shadow that the breast casts on the midriff. Remember these five tones: they're the essential elements in rendering light and shade.

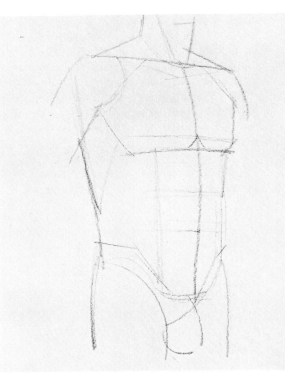

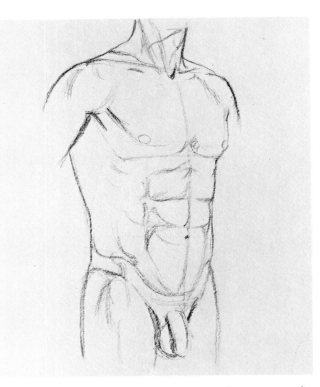

Step 1. As the torso turns, the center line moves off center and the boxy shape of the figure becomes narrower than the front view. The artist works with the usual guidelines to construct the basic "diagram."

Step 2. When realistic contours are drawn over the guidelines, the alignments remain the same. The pit of the neck, the division between the chest and stomach muscles, the navel, and the crotch are all on the same vertical line.

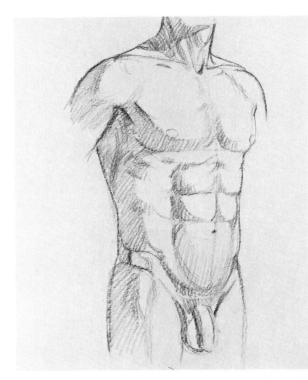

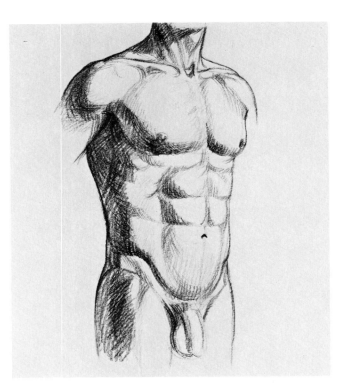

Step 3. The light comes from the right and from slightly above, and so the shadow planes are on the left sides of the forms and along the undersides. The artist blocks in the shapes of the shadows with clusters of parallel strokes, as usual.

Step 4. By now, you should be able to identify the four basic tones in the finished drawing. The light, halftone (or middletone), shadow, and reflected light are apparent on the chest muscle and thigh.

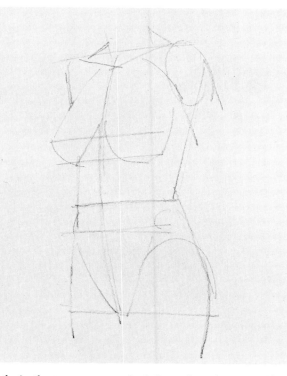

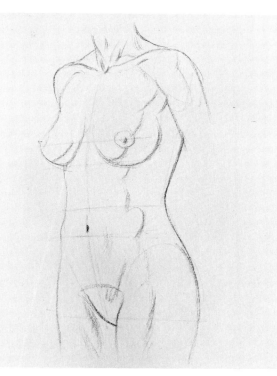

Step 1. As the torso turns to the left, so does the center line. The upper and lower halves taper to the waist. The artist places the usual horizontal guidelines and visualizes the shoulder as an egg shape.

Step 2. The shape of the body changes as it turns and the center line curves slightly, but the most important alignments remain the same in the realistic line drawing. For example, the shoulders still align with the hips.

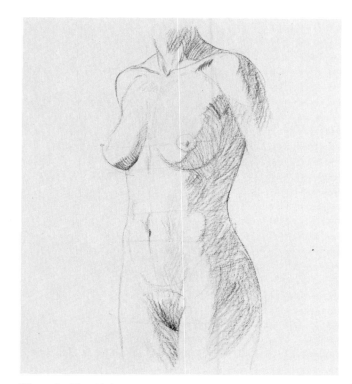

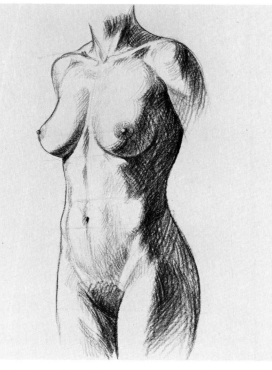

Step 3. The light source is at the left, and so the artist blocks in the big shadow zones on the right sides of the forms. He places a delicate halftone where the abdomen curves away from the light.

Step 4. As the artist builds up the tones, stroke over stroke, he plans the directions of the strokes to follow the forms and accentuate their roundness. He applies less pressure to the pencil in the halftone areas.

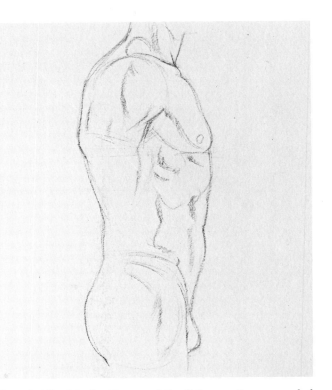

Step 1. The torso is a tapering box, with a slanted rectangle for the chest muscle and egg shapes for the shoulder and hip. The back curves at the shoulder, in at the waist, and then out again at the buttocks.

Step 2. The blocky shapes of the "diagram" are rounded off in the realistic line drawing. The neck normally leans forward, the upper torso slants backward, and the lower torso tilts slightly forward again to meet the upper torso.

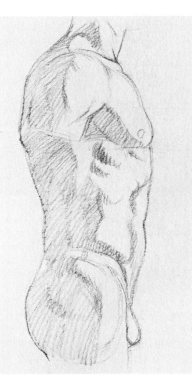

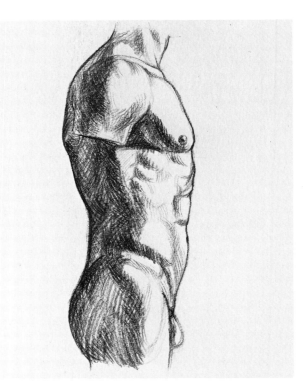

Step 3. The light comes from the right, placing the left sides of the forms in shadow, which the artist blocks in with parallel strokes. Study the alignments: the point of the shoulder is directly above the center of the hip.

Step 4. When the artist builds up the tones—accentuating the contours with the pencil point—you see particularly good examples of tonal gradation within the shadows on the chest muscle, shoulder, and hip.

Step 1. The female figure shows the same angular "movement" as that of the male. The neck tilts forward, the upper torso leans back, and the lower torso tilts forward to meet the upper torso at the waist.

Step 2. The pencil point defines the edges of the forms and the contours of the shadows within the forms. The female buttocks protrude more than those of the male, but the center of the shoulder still aligns with the center of the hip.

Step 3. The light source is at the left, illuminating the front of the figure and placing the back—as well as much of the side—in shadow. The artist follows the shadow guidelines of Step 2 as he blocks in the tones.

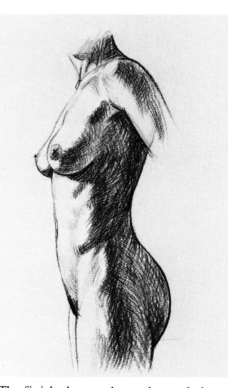

Step 4. The finished torso shows the gradation of light, halftone, shadow, and reflected light, plus the cast shadow beneath the breast. Within the lighted abdomen, halftones suggest anatomical detail.

Step 1. The artist draws an egg shape with a vertical center line. Horizontal lines locate the features: the eyes are halfway down; the underside of the nose is midway between eyes and chin; the division between the lips is one-third down from nose to chin. Over these guidelines, he places the features, squares up the jaw, and indicates the hair.

Step 2. Study the proportions of the realistic head, drawn over the guidelines of Step 1. The height of the head, from chin to crown, is one and one-half times the width from cheek to cheek. At its midpoint, the head is "five eyes wide." The space between the eyes, and the underside of the nose, are both "one eye wide." The ears align with the eyes (or eyebrows) and mouth.

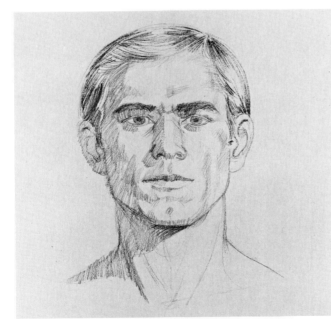

Step 3. The artist blocks in the shadows, following the guidelines you saw in Step 2. The light comes from the right, and so the shadow is on the left side of the head. The eye sockets and upper lip curve away from the light, and so they contain deep shadows. The corner of the nose casts a slanted shadow to the left; the chin casts a shadow across the neck in the same direction.

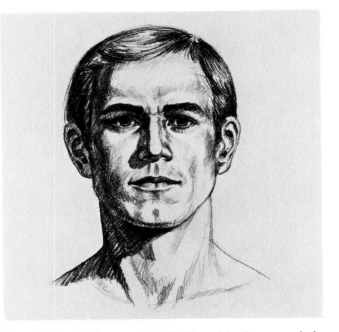

Step 4. The shadows on the left sides of the forms are darkened. So are the undersides of the forms that curve inward, away from the light: the eye sockets, bottom of the nose, upper lip, underside of the lower lip, and chin. The artist strengthens the halftones in the lighted areas, defines the details of the features, and reinforces the outer contours.

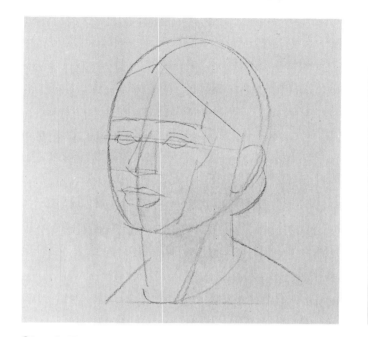

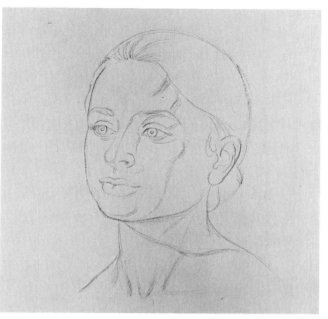

Step 1. The head is turned slightly to the left in this three-quarter view. Again, the artist draws an egg shape with a vertical center line—which moves to the left as the head turns—plus horizontal lines to locate the features. Then the features go over these guidelines. The artist indicates the shape of the shadow that runs down the forehead, cheek, and jaw.

Step 2. Over the egg, the artist traces the curves of the forehead, cheek, jaw, and chin; defines the eyebrows and eyelids, adding the irises and pupils; indicates the tip of the nose and the nostril wing as separate, rounded shapes. He draws the wing shapes of the upper lip; the fuller, lower lip; and the internal detail of the ear.

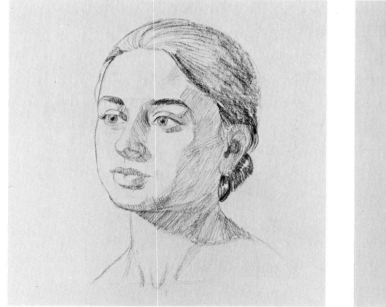

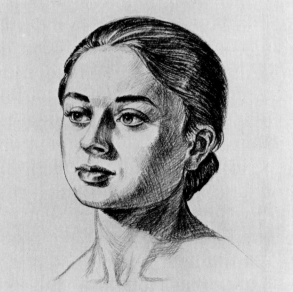

Step 3. The light comes from the left, and so the artist blocks in the big shadow that runs down the right side of the head, including the ear. He places shadows in the corners of the eye sockets; on one side of the nose and beneath it; on the upper lip, which tilts away from the light; beneath the lower lip; and at the tip of the chin. Finally, he darkens the hair.

Step 4. The artist reinforces the shadow shapes, faithfully following the shadow edge that first appeared in Step 1. With clusters of curving strokes, he darkens the big shadow shape on the side of the head and then intensifies the shadows on the features. The pencil point completes the hair, adds the details of the features, and reinforces the contours.

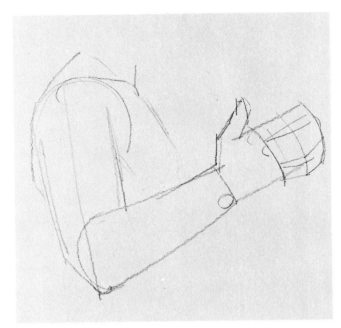

Step 1. The artist visualizes the upper and lower arms as cylinders. He draws a center line through the upper arm to align the elbow and the center of the shoulder—which he defines as a sphere. The back of the hand is drawn as a square from which the thumb projects. Straight lines define the fingers. Parallel guidelines align the knuckles.

Step 2. When the artist draws the realistic contours, he retains the spherical form of the shoulder muscle and the tapering shape of the lower arm, adding the curves of the other muscles. As he draws the hand, he follows the curving guidelines of the knuckles. The thumb is only half the length of the hand; the tip of the thumb stops where the fingers begin.

Step 3. Blocking in the shadows, the artist follows the curves of the spherical shoulder muscle, the rounded back of the upper arm, and the tapered cylinder of the forearm. In this view, the back of the hand and the first joints of the fingers bend away from the light, so they're in shadow. The light strikes the protruding knuckles, plus the second and third joints.

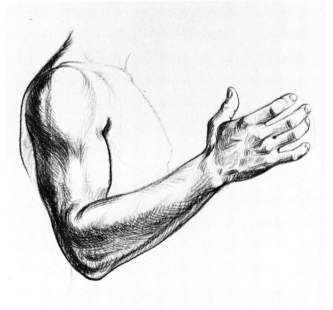

Step 4. The artist renders the shadow as a continuous, flowing shape that follows the curves of the muscles down to the protruding knob of the wrist, which catches the light. He accentuates the shadows on the back of the hand and behind the knuckles. The pencil point reinforces the contours of the arm and hand, and then sharpens the details of the knuckles and fingernails.

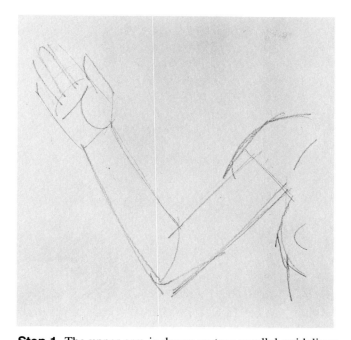

Step 1. The upper arm is drawn as two parallel guidelines with a curve for the shoulder. The lines of the forearm taper to the wrist. The palm is a boxlike shape; a curve defines the bulge of the muscle that connects to the thumb. Parallel lines locate the fingers. The palm and fingers are crossed by curving lines that locate the creases behind the knuckles.

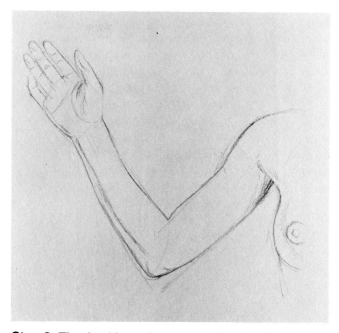

Step 2. The shoulder and upper arm flow together in a single curving line. The shoulder muscle overlaps the upper arm and flows into the breast. The forearm isn't exactly straight, but bends slightly as it approaches the wrist. The curves of the fingers follow the guidelines of Step 1, as do the creases that cross the hand. The length of the thumb is roughly equivalent to the palm.

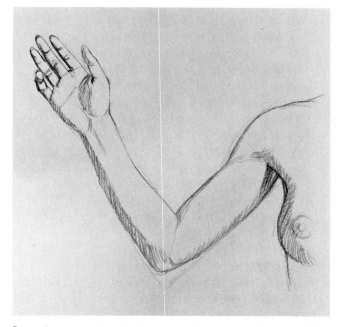

Step 3. A slender shadow runs along the underside of the arm, continuing along the edge of the hand. The shadowy edge of the chest muscle flows into the breast. A strong shadow emphasizes the roundness of the big muscle that connects to the thumb. The fingers begin to look cylindrical as the artist adds hints of shadow to their edges.

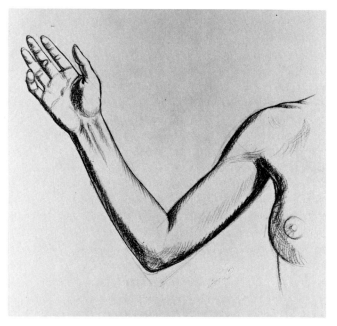

Step 4. The artist darkens the shadowy edges and then adds subtle halftones in the lighted areas to suggest additional detail such as the inner edges of the shoulder muscle and the slender cords of the wrist. The fingers become rounder as he intensifies the shadows. The pencil point reinforces the creases in the palm, the insides of the knuckles, and the fingernails.

Step 1. The preliminary line drawing visualizes the upper and lower legs as cylinders that taper toward the knees and ankles. In this pose, one knee is slightly lower than the other; the artist draws a sloping line between the knees to establish this relationship. As seen from the side, the foot is a triangle with a blocky heel and a circular knob for the protruding anklebone. The other foot, seen from the front, is a short, blocky wedge. Notice how the artist adds vertical center lines to both thighs and to one lower leg, just as he does when he draws the head or torso.

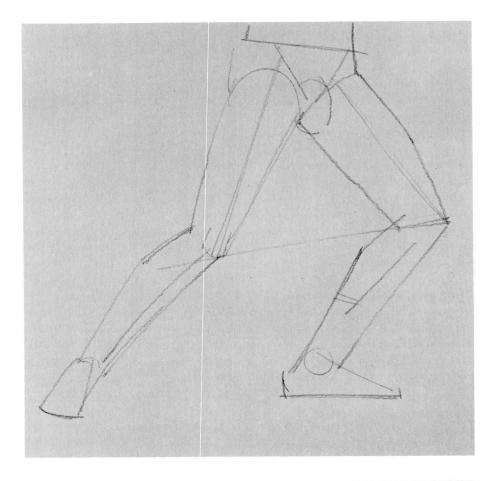

Step 2. The realistic line drawing emphasizes the muscular bulges of the thighs and the characteristic curves of the lower legs. The bulging muscles of the inner thigh and inner calf are particularly important in making a lifelike drawing of the leg. In drawing the feet, the artist rounds off the heels as separate shapes and emphasizes the bulge behind the big toe. Notice how the toes of the foot at the left all come down to the curving guideline that defined the end of the foot in Step 1.

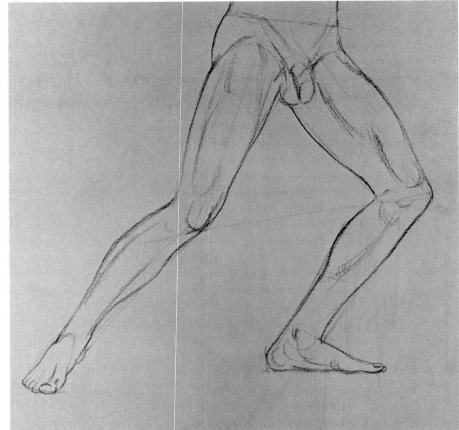

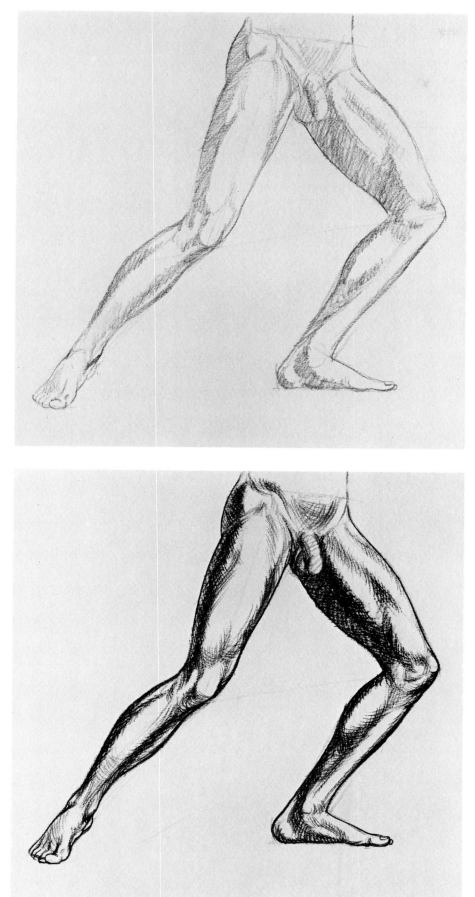

Step 3. The light comes from the upper right, and so the left sides of the forms are in shadow. The artist blocks in the big shadow planes of the thighs and the slimmer ones of the lower legs with broad parallel strokes, using the side of the lead. The bending leg on the right also has slender troughs of shadow within the thigh and calf; the artist emphasizes these to make the masses of muscle round and three-dimensional. In the knee on the left, notice how the top plane receives the light, while the underside turns away into shadow.

Step 4. In the final step, the artist builds up not only the shadows along the edges of the forms, but also the strips of shadow *within* the upper and lower legs, thus emphasizing the individual muscle masses. Notice the egglike shapes of the muscles above the knees, as well as the prominent muscle behind the calf. On the leg on the left, a slender strip of shadow runs from the knee to the inner ankle, dramatizing the curve of the muscle that protrudes from the inner edge of the calf. The sharp point of the pencil restates all the contours and emphasizes such details as the toes and the small bones of the ankle.

Step 1. When the legs bend more sharply, the forms of the knees are more rounded; the artist emphasizes their spherical forms in this preliminary line drawing. Once again, he represents the upper and lower legs as cylinders that taper inward toward the knees and ankles. Even at this stage, the female legs look less angular and more rounded than the male legs in the preceding demonstration. Seen from the side, one foot is essentially triangular—with a slight dip in the arch—while the foot that's seen from the front view is a tapering wedge with a rounded guideline to show the alignment of the tips of the toes.

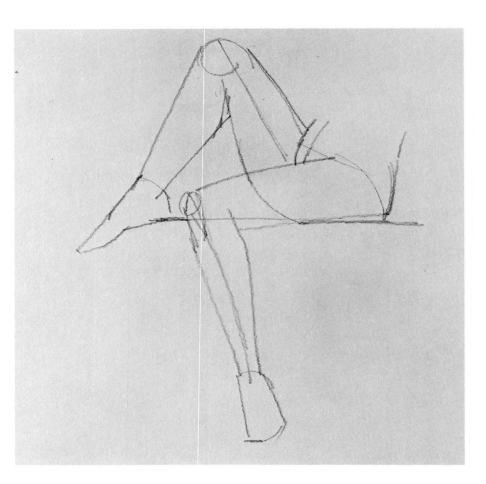

Step 2. The roundness of the knees becomes even more obvious in the realistic line drawing. The curves of the female legs are more subtle than the more muscular contours of the male legs. The front and back of each thigh are single curving lines, while the lower legs are drawn as compound S-curves. The foot in profile is faithful to the original triangular shape. The toes of the other foot carefully follow the curving guideline of Step 1. Notice how the calf muscle swells in the leg that's more sharply bent.

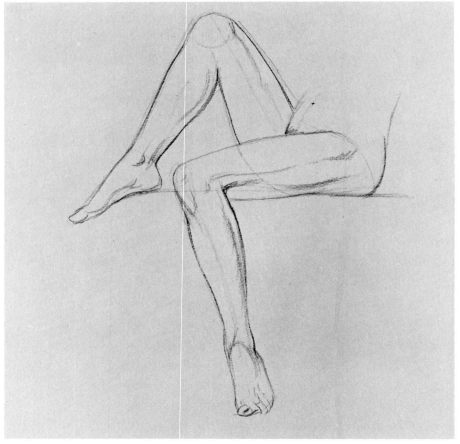

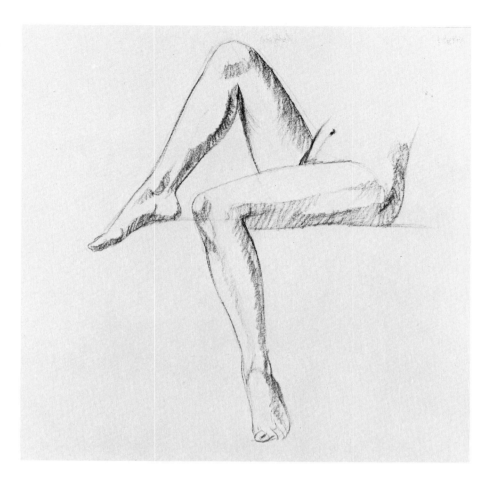

Step 3. The light comes from the left and from slightly above, and so the right sides of the forms—and the undersides—are in shadow. The artist blocks in the shadow edges of the upper and lower legs. He models curving shadows around the knees, emphasizing the rounded shapes. A delicate shadow moves down the sharp edge of the bone that runs from the knee to the ankle of the leg in the lower half of the picture. A curving shadow emphasizes the shape of the buttock. Small, curving shadows also accentuate the roundness of the heel and the bulge behind the toe of the foot that's seen in profile.

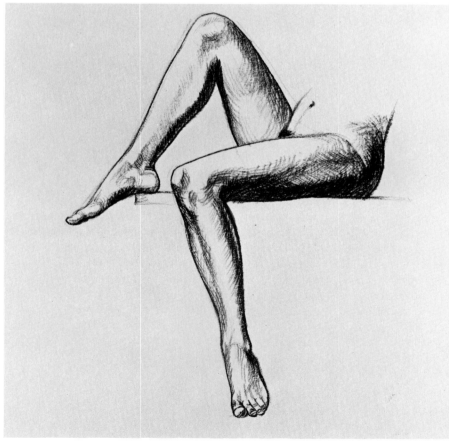

Step 4. In the final step, the artist darkens the strong shadows along the right sides and undersides of the upper and lower legs. He then adds pale strips of halftone to suggest the divisions between the groups of muscles within the lower legs. The curving pencil strokes express the roundness of forms. The four major tones—light, halftone, shadow, and reflected light—are all clearly defined and give the leg a feeling of solidity.

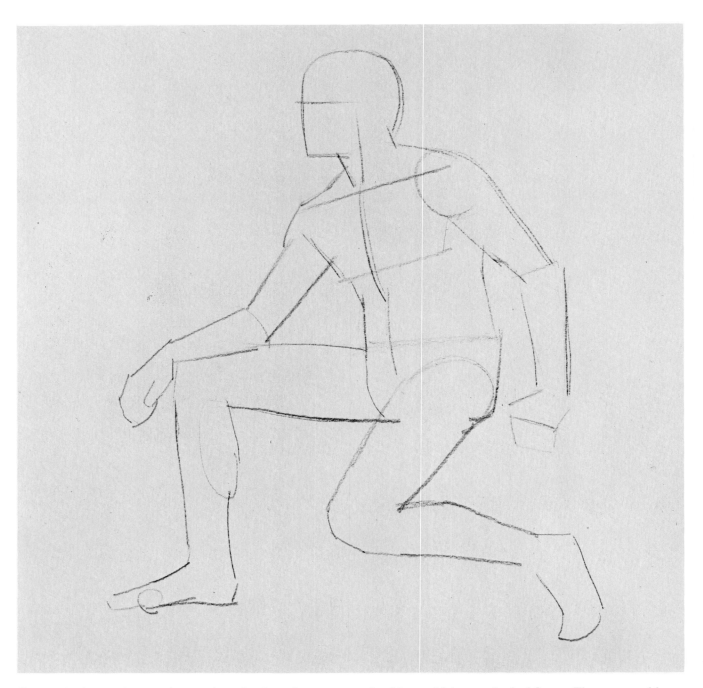

Step 1. So far, you've seen how to draw the figure in parts; now the artist puts together everything you've learned and demonstrates how to draw a complete male figure. The preliminary line drawing combines the same sort of simple shapes and guidelines you've studied in the preceding pages. The head is essentially an egg shape, squared up at the chin. The neck is a tilted cylinder, represented by two parallel lines, plus a third line to indicate the neck muscle. The torso is a tapered, boxlike shape divided by a vertical center line, plus horizontal guidelines at the shoulders, nipples, and navel. Two slanted lines connect the neck to the shoulders, which are spherical forms. The upper and lower arms are tapering cylinders. The hand on the right consists of two square shapes, one for the back of the hand and the other for the group of fingers. The hand on the left is an adaptation of that shape; again the fingers are visualized as a single mass with a curving line to indicate the tips. The upper and lower legs (like the arms) are tapering cylinders with a bulge behind the calf and a rounded shape at the bent knee. The feet are tapered wedges; the bent toes of the foot on the right are indicated as a single curving shape.

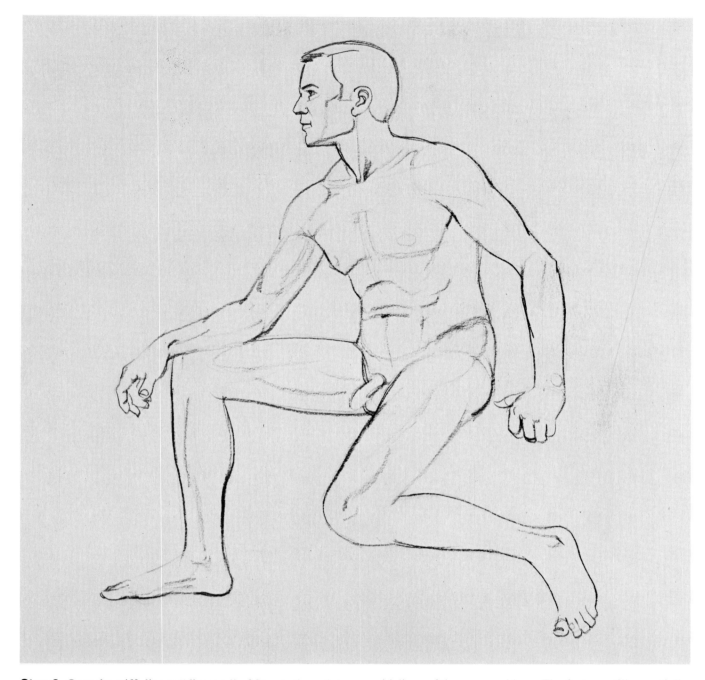

Step 2. Over the stiff, linear "diagram" of Step 1, the artist draws the lifelike curves of the body. The facial features and the anatomy of the neck are drawn faithfully over the original guidelines. The guidelines of the torso are followed to align the shoulders, draw the rectangular shapes of the chest muscles, and locate the navel and the abdominal muscles. The bulges of the muscles are placed over the original guidelines of the arms and legs. The feet are still essentially wedge-shaped, but the artist has rounded the heels, accentuated the bulge behind the toes, and drawn the individual toes. In the foot on the right, notice how the toes follow the curve of the guideline of Step 1. And study how the simple, blocky shapes of Step 1 have been converted into fingers—again following the original guidelines faithfully.

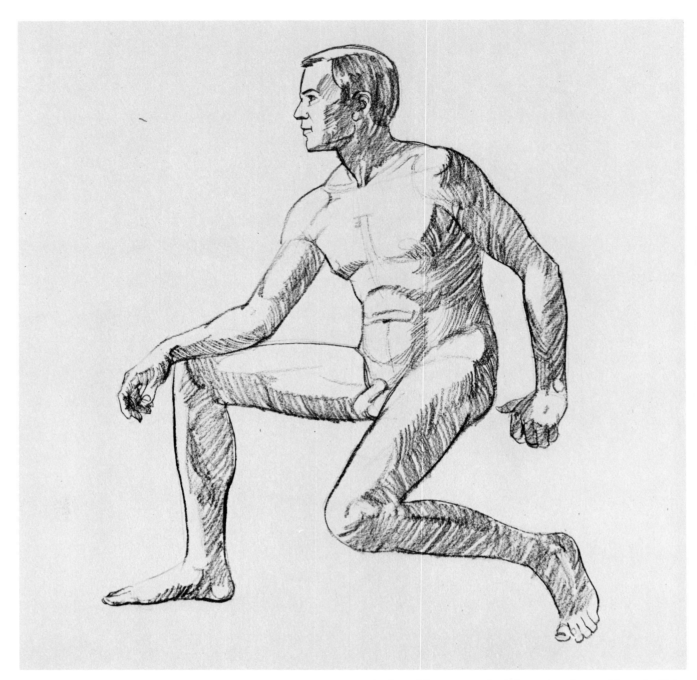

Step 3. The artist observes the direction of the light, which comes from the left and from slightly above. Thus, the right sides of the shapes, and the undersides, are in shadow. The artist blocks in the broad shadow areas with the pencil held at an angle to the paper so that the side of the lead makes broad strokes. The shadow runs down the brow, cheek, and jaw. Because the light comes from slightly above, the chin throws the entire neck into shadow. The tops of the shoulders, as well as the front planes of the chest muscles, rib cage, and abdomen turn up and meet the light. The undersides of the chest muscles and rib cage, as well as the side planes of the abdomen and the entire torso, turn away into shadow. The arm on the left reaches forward into the light, and so all of the undersides of the shapes are in shadow. But the arm on the right leans back, away from the light, and so the shapes are mainly in shadow, except for the bulge of the forearm and the back of the hand, which turn upward and receive the light. On the leg at the left, the top plane of the thigh and foot, as well as the front plane of the lower leg, turn toward the light; the underside of the thigh and foot, as well as the back plane of the lower leg, turn away into shadow. On the leg on the right, only the top plane of the thigh faces the light, while the rest of the leg is in shadow.

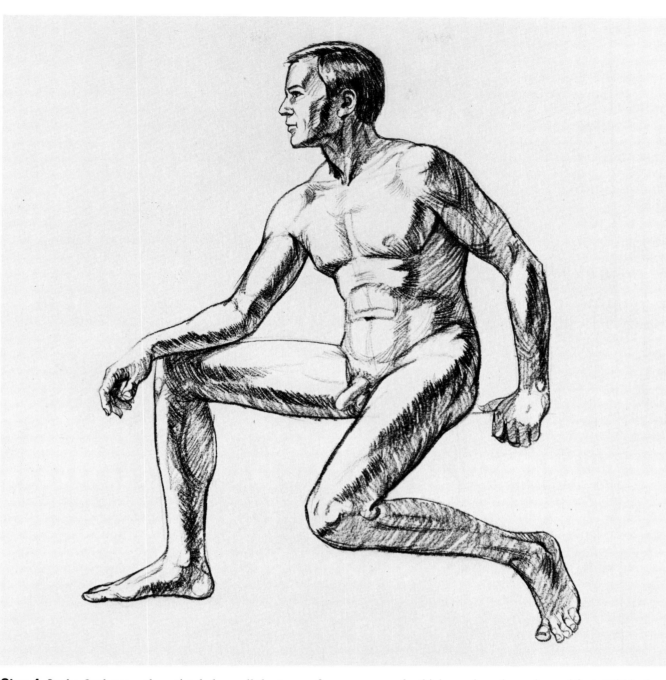

Step 4. In the final stage, the artist darkens all the tones of the figure with the side of the lead, building up these tones with parallel strokes. With the sharp point of the pencil, he accentuates all the linear contours of the shapes. In the completed drawing, we see the four essential tones that produce a round, three-dimensional figure. Bare paper represents the sides of the forms that face the light: the front of the head and the top and front planes of the shoulders, chest, abdomen, one arm, the thighs, and one lower leg and foot. Within these lighted planes, the anatomical details are suggested by halftones—clusters of pale pencil strokes. As the backs and the undersides of the forms turn away from the light, we see the shadows—the darkest tones in the drawing. And as the forms continue to turn away from the light, the shadows grow slightly paler as they pick up reflected light from some remote light source, such as a distant window.

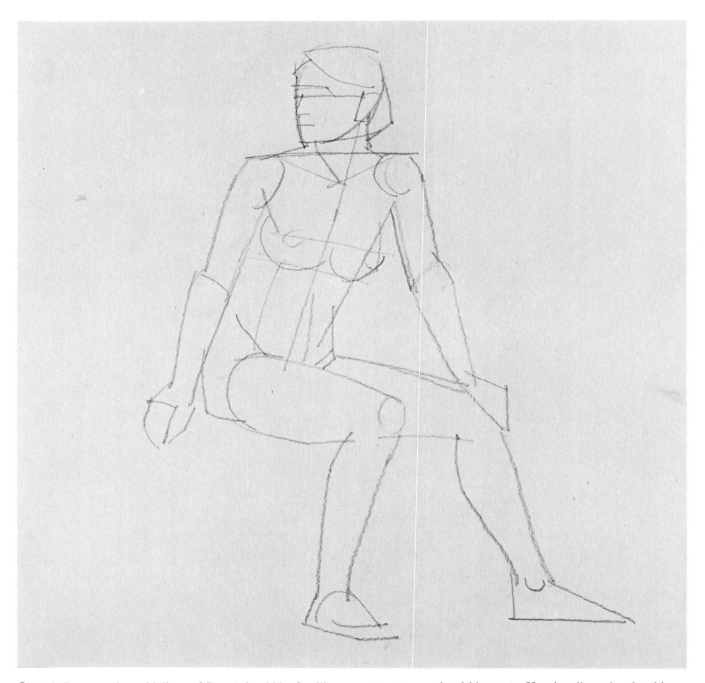

Step 1. By now, the guidelines of Step 1 should be familiar to you. The egg shape of the head is crossed by guidelines that locate the eyes, nose, and mouth, as well as the ear, which aligns roughly with the eyes and nose. On the tapering, rectangular shape of the torso, a center line drops from the pit of the neck to the navel and the unseen crotch. Horizontal guidelines connect the shoulders and locate the nipples and the undersides of the breasts. The artist omits the guideline that locates the navel, but he sees it in his mind's eye, as *you* should by now. He visualizes the shoulders, breasts, and knees as circular forms. The upper and lower arms are tapering cylinders, while the hands are blocky shapes, divided into two planes at the knuckles where the fingers meet the back of the hand. The legs are also tapering cylinders, with a slight bulge for the calf muscles. The feet are triangular, with a circular guideline to suggest the bulge of the anklebone.

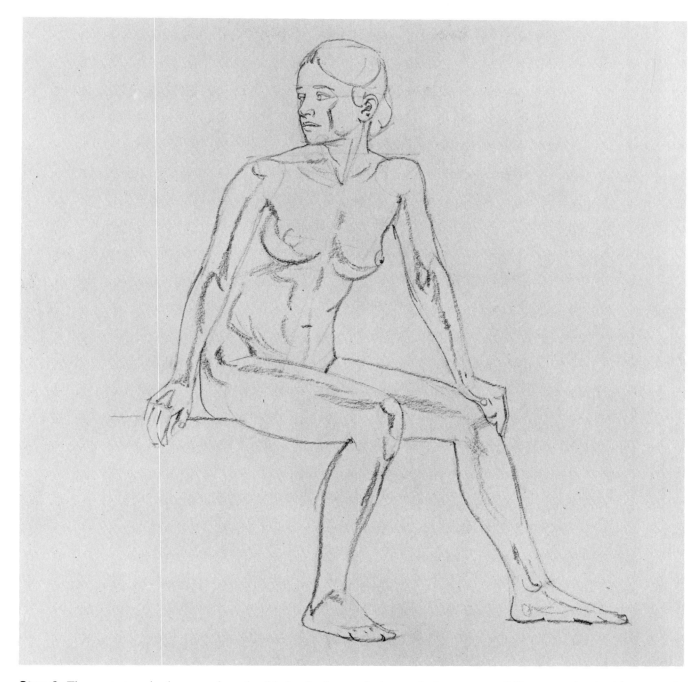

Step 2. The next stage in the procedure should also be familiar. The artist draws the curves of the living figure over the stiff lines of the "diagram" of Step 1, and then he begins to erase those guidelines. Within the shapes, he suggests the edges of shadows which will appear in Step 3. Whenever you draw the figure, it's important to watch the alignments of the forms. Which forms align with which, either horizontally or vertically? And which alignments are unexpected, but nevertheless accurate? For example, in this pose, the shoulder on the right seems unexpectedly high, and it's important to figure out why. The model is leaning forward, resting one hand on her knee and putting the weight of her torso on that arm alone, thus forcing the shoulder upward. The alignment of the shoulders often varies in this way, depending upon where the model places the weight of her body.

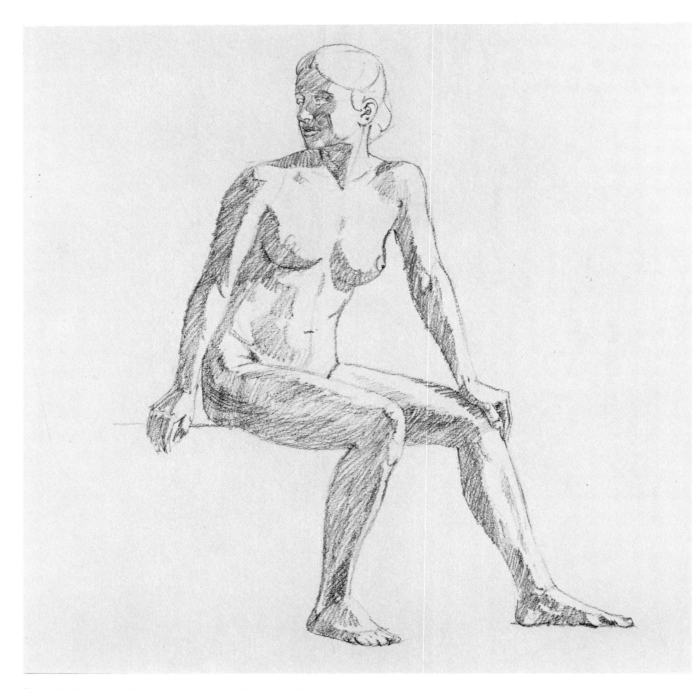

Step 3. The artist observes that the light is coming from the upper right. The tops and right sides of the forms face the light, while the left sides and undersides turn away into shadow. You can see this most clearly in the head, where the face turns away from the light and all the features are in shadow; the light strikes only one side of the forehead, cheek, and jaw, as well as the ear and the very tip of the nose, which juts out of the shadow to pick up a small triangle of light. In the same way, the breasts turn upward and receive the light, but their undersides curve downward and away from the light, producing crescent-shaped shadows. The artist blocks in all the shadow shapes with the side of the lead, holding the pencil at an angle to the paper.

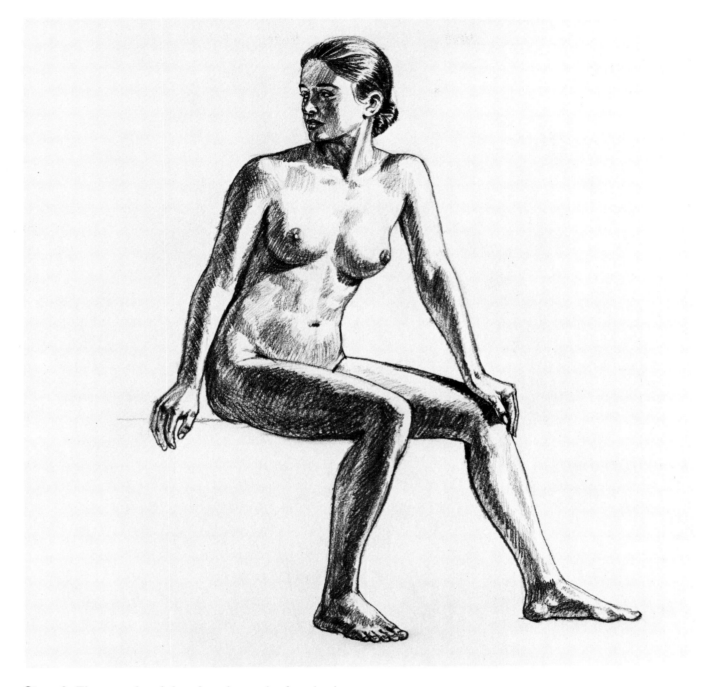

Step 4. The completed drawing shows the four basic tones—light, halftone (or middletone), shadow, and reflected light—as well as a fifth tone that appears frequently, the cast shadow. You can see the gradation of four tones very clearly on the thigh at your left: the lighted top of the thigh, curving downward to a hint of halftone that quickly merges with the shadow, and finally the reflected light within the shadow along the lower edge of the thigh. You can see a similar gradation on the breasts, whose rounded forms cast dark shadows downward over the rib cage. Remember that the tones within the lighted planes are usually halftones—distinctly paler than the darks on the shadow side of the figure.

Slender Strokes. A simple and effective way to draw with the common graphite pencil is to work entirely with the sharpened point. The point draws the contours of the shapes and then blocks in the tones with slender strokes, drawn in parallel clusters like those you see here. To darken the tones, you can build stroke over stroke or just press harder on the pencil. To accentuate the roundness of the figure, the pencil strokes curve with the forms. The individual strokes "mix" in the eye of the viewer to create a sense of light and shade.

Broad Strokes. An equally effective way to draw the same subject is to turn the pencil at an angle to the paper and draw with the *side* of the lead, producing broader strokes than you can make with the sharpened tip. Or you can take a thick, soft pencil in the 4B–6B range and shape the lead to a broad, blunt point that makes wide strokes. The pencil behaves something like a flat brush, depositing large areas of tone with just a few strokes. Press harder or place one stroke over another to produce a darker tone like the edge of the shadow on the arm or the cast shadow beneath the breast.

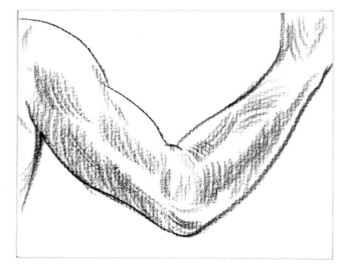

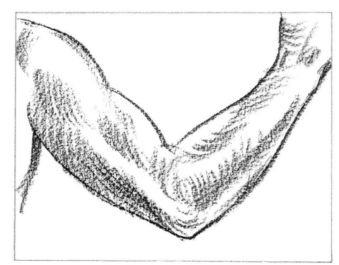

Strokes on Charcoal Paper. The delicately ribbed surface of the charcoal paper is just as effective for pencil drawing as it is for charcoal. The *tooth* of the paper, as it's called, breaks up and softens the stroke. Tiny flecks of bare paper show through the strokes. On smoother paper, these bold strokes, made with the thick lead of a 4B pencil, might look harsh; but they look subtle and luminous on charcoal paper. Charcoal paper has a remarkable way of adding vitality to the pencil stroke.

Strokes on Rough Paper. There are much rougher papers than charcoal paper. The pebbly texture of rough paper tends to break up the pencil stroke into a granular tone that looks rich and luminous because of all the tiny dots of bare paper that show through. The ragged tooth of the paper also forces you to work with big, bold strokes. Slender, elegant lines and precise details won't work on this drawing surface. It's good experience to work on rough paper because the drawing surface forces you to work boldly and simply. A few big, decisive strokes must do the job.

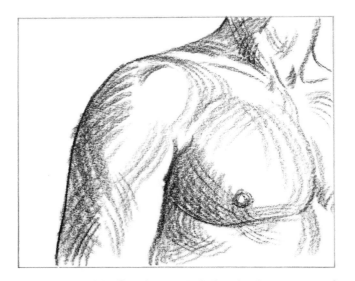

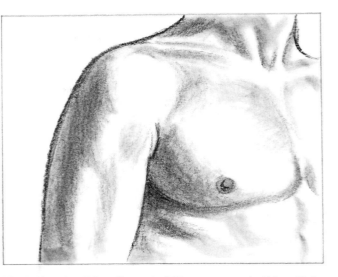

Modeling with Strokes. Modeling is the process of building up tone to create the illusion of three-dimensional form. (The term *modeling* is derived from sculpture, as you might guess.) One method is to build up a pattern of pencil strokes that move over and around the forms the way a sculptor's chisel moves over and around the stony shapes. In this drawing, notice how the artist uses the side of the lead to render halftones and shadows with curving strokes that follow the roundness of the chest and shoulder muscles.

Modeling by Blending. A different way to build up light and shade is to begin with pencil strokes and then blend these strokes together with your fingertip or a paper stomp. In this study, the artist begins by letting the side of a 2B lead glide lightly over the paper. Then he moves his fingertip back and forth over the paper, smudging the pencil strokes until they merge into soft tones. He alternates between these two drawing tools—the pencil and his fingertip—gradually adding more strokes and blending them until he achieves the full tonal range.

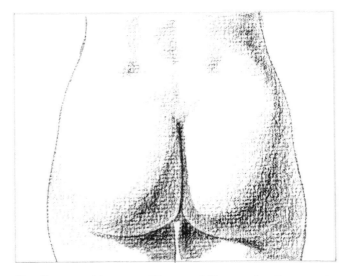

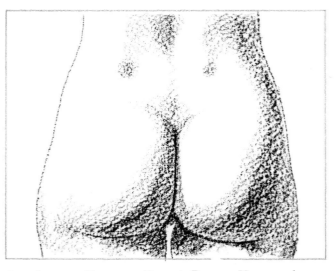

Continuous Tone on Charcoal Paper. Another way to create soft, sculptural tones is to move the pencil lightly back and forth over the textured surface of charcoal paper, never pressing hard enough to register a distinct stroke, but simply letting the tooth of the paper shave off the granules of graphite—as if the charcoal paper were a very fine grade of sandpaper. As the pencil glides back and forth over the same area, the tone gradually darkens as the paper shaves off more granules of graphite. The gradual buildup of tone gives the drawing its beautiful rounded form.

Continuous Tone on Rough Paper. You can do exactly the same thing on any paper that has a distinct tooth. Rough paper will shave off the granules of graphite more rapidly, of course, so it takes fewer back-and-forth movements of the pencil to build up the tones. It's important to know when to stop. Just a few movements of the pencil are enough to produce the halftones—don't let them get too dark. And just a few more movements of the pencil, with a bit more pressure, will produce the darks.

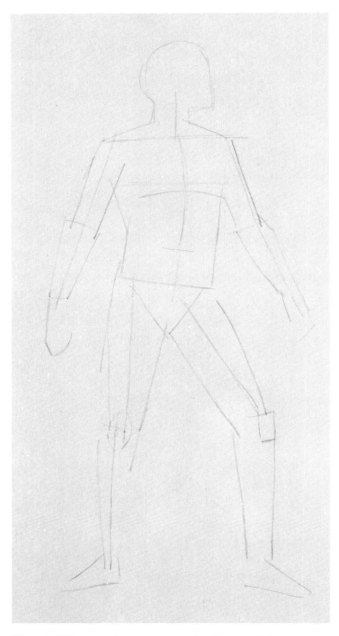

Step 1. When you begin to draw the figure, it's best to start with a simple standing pose in which it's easy to see all the shapes clearly. And it's worthwhile to start with the simplest pencil drawing technique—drawing the contours with the sharpened tip of the pencil and building up the tones with clusters of slender strokes. In this demonstration, the artist begins with the familiar guidelines. The "diagram" of the male figure consists mainly of simple straight lines. At this stage, the drawing is only a bit more elaborate than the "stick figure" that children draw. This "diagram" is worth memorizing because it's a very efficient, functional way to start a figure drawing.

Step 2. The artist uses the guidelines of Step 1 as a kind of map over which the point of the HB pencil travels to construct the living forms of the figure. Always study the alignments of the forms at this stage. Some alignments remain essentially the same, like the *landmarks* (as artists call them) along the center line of the torso: the pit of the neck, the division between chest muscles, the navel, and the crotch. But every pose also has its own unique set of alignments. If you get these right, the drawing will be accurate. For example, in this pose, the shoulders fall directly above the heels, the hands are directly above the toes, and the center line of the torso continues downward along the inner edge of the leg on the left.

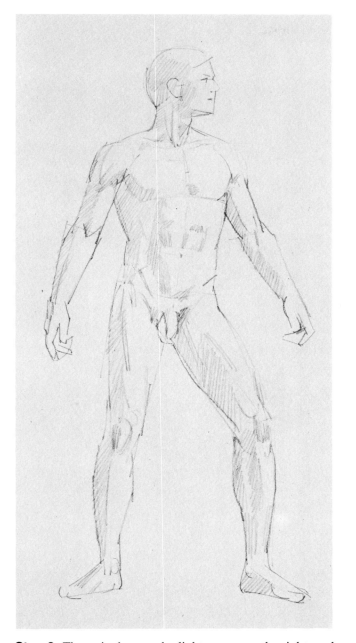

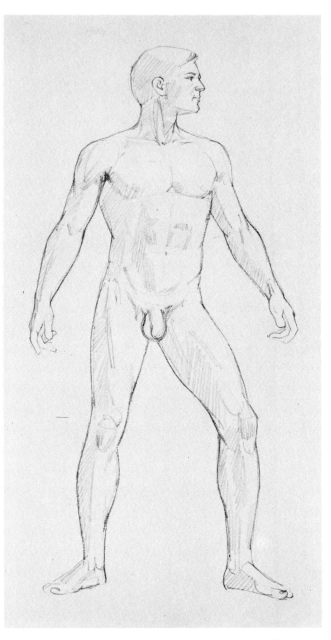

Step 3. The artist locates the light source on the right, and so he builds up the shadows on the left sides of the forms. He works with slender parallel strokes in clusters. At this stage, his purpose is just to establish simple divisions between the lighted planes and the shadow planes of the figure. However, he bears in mind that each shadow has its own distinct shape, which it's important to record accurately. For example, the shadows on the sides of the limbs tend to be long, slender strips, but along the inside of the thigh on the right, the shadow is a zigzag shape. The shadows curve around the shoulder and chest muscles.

Step 4. Up to this point, the artist has been working with simplified, rather angular lines to define the contours of the figure. Having established these essential outlines, and the shapes of the shadows, he now begins to refine them with curving lines that make the body more lifelike. Working with the sharp point of the HB pencil, he develops the features and the facial contours, and then he works downward to redraw the outlines of the shoulders, torso, arms and hands, and legs and feet. He concentrates on the outer edges of the forms. The inner shapes will come next.

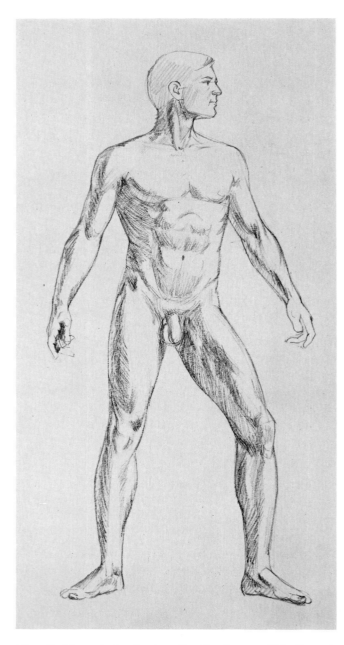

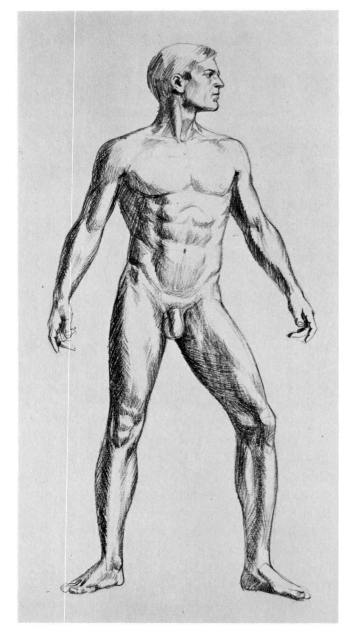

Step 5. The artist begins to refine the shapes within the outline by building up the tones. In Step 2, he indicated the tones with parallel straight lines that merely define the shapes of the shadows. Now he works with clusters of strokes that follow the curves of the forms. The angular shadow shapes of Step 3 are gradually converted into rounded ones as the artist models each muscle or muscle group. Look again at the zigzag shape of the shadow on the thigh in Step 3 and see how this is developed in Step 5. For the first time, you also begin to see some suggestions of the distinctions between halftone, shadow, and reflected light.

Step 6. Building stroke over stroke, the artist continues to darken the tones. He works with clusters of strokes, running a series of parallel strokes around the curve of the chest muscle, for example, or down the edge of the leg. He doesn't just place a stroke here and there, at random, but works over the entire shape of the shadow so the strokes become masses of tone. He also begins to sharpen the contours and details of the head, hands, and feet. Notice how one shadow shape flows into another, such as the continuous strip of tone that runs down from the shoulder to the arm on the left, or the long series of interlocking shadows that start at the armpit and continue down to the ankle on the left.

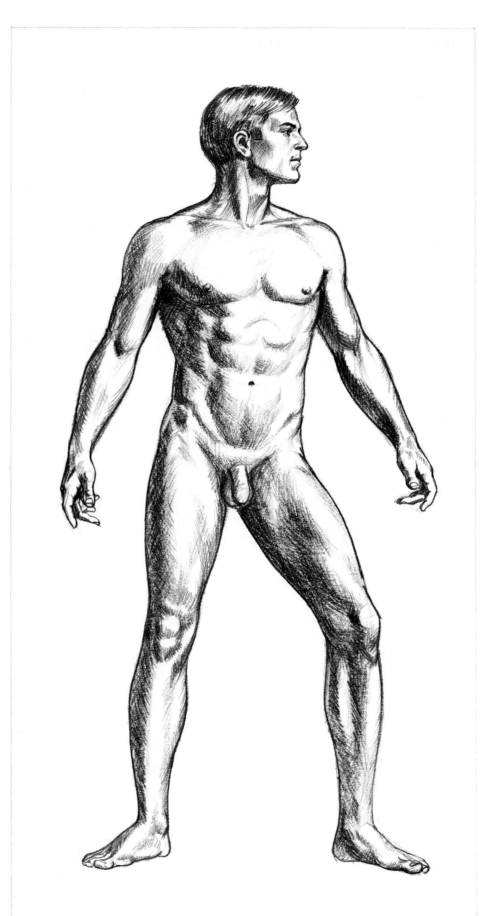

Step 7. In the final stage, the artist builds up the tones to their full richness, gradually piling stroke over stroke in the shadow areas and using halftones to suggest anatomical details within the lighted areas—particularly in the chest and abdomen. Now you see the full range of lights, halftones, shadows, and reflected lights. The sharp point of the pencil moves over the entire figure, accentuating all the outlines and defining such details as the facial features, fingers, and toes. Until now, all the figure-drawing demonstrations have taken you through four essential stages: drawing the preliminary "diagram" of the figure; constructing a lifelike line drawing over it; blocking in the tones; and finally, building up the full range of tones and redefining the outlines. However, as you see in this seven-step demonstration, there are many operations within these four basic steps. Like the demonstration you've just seen, the remaining demonstrations in this book will break these operations down into seven stages so you can follow the drawing process in greater detail.

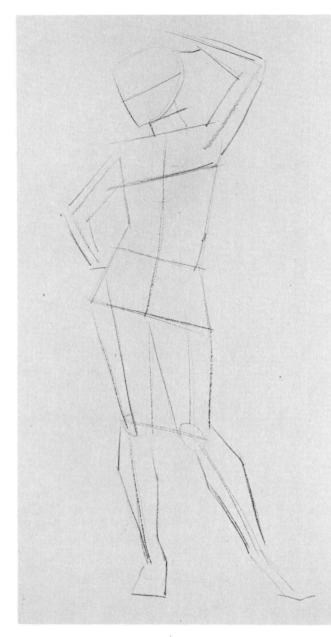

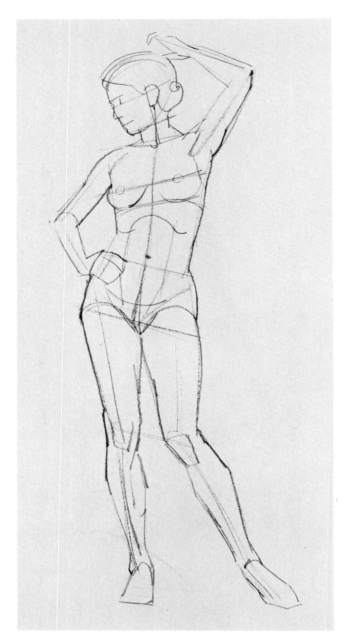

Step 1. The artist begins with the familiar linear "diagram" of the model. But the guidelines reveal some important changes in the alignments of the forms. The model's weight rests on the foot at the left, while the other foot carries less weight. At the same time, one arm bends at the elbow while the hand rests on the hip, and the other arm is raised as the model's hand adjusts her hair. All the shapes tend toward the diagonal. Thus, the guidelines show that one hip is higher than the other in this pose. In the same way, the guidelines at the shoulder and nipples show that one shoulder is higher than the other.

Step 2. When the artist constructs the contours of the living figure over the "diagram" of Step 1, these new alignments become even more obvious. The center lines of the torso, arms, and legs are all slanted ones—which the artist follows faithfully in drawing the slanted movements of the forms. There are also some surprises in the vertical alignments. On the left, the shoulder, knee, and ankle all line up above one another. On the right, however, it's the elbow that's directly above the ankle, while the shoulder is directly above the knee. The nipples are directly above the knees, but one knee is higher than the other. Always look for these alignments when you construct a figure.

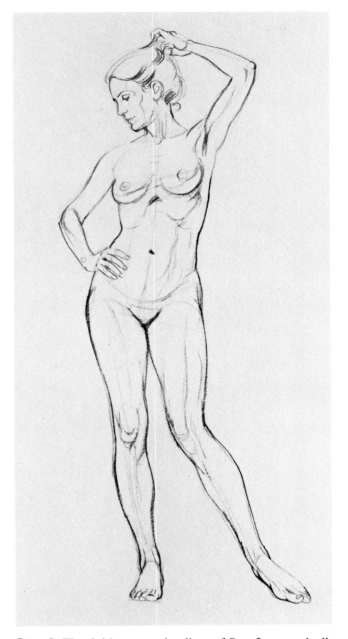

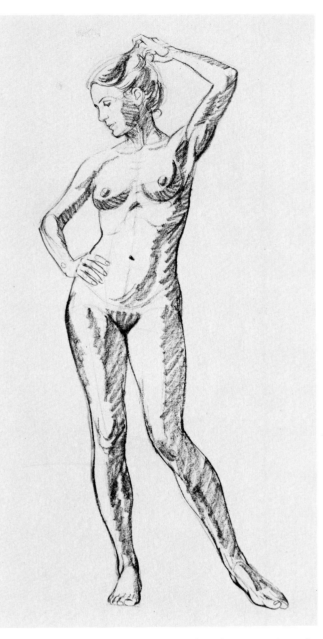

Step 3. The rigid construction lines of Step 2 are gradually erased as the artist draws the curves of the living figure. In these early stages, the artist works with the sharpened point of an HB pencil, moving his whole arm rhythmically—and so the lines are fluid and rhythmic too. To capture the grace of the model, the artist looks for lines that flow into one another. For example, notice how the inner line of the upraised arm continues down into the chest muscle and from there into the curve of the breast. In the same way, the inner curves of the thighs sweep around the knees and down into the lower legs in a series of interlocking S-curves.

Step 4. In contrast with the preceding demonstration, the artist builds his tones with broad strokes, made with the side of the lead as he holds the pencil at an angle to the paper. He also switches from an HB to a 2B pencil. Working with groups of parallel strokes, he moves rapidly down the forms, observing the shapes of the shadows and filling them with tone. The light comes from the left and from slightly above, and so the right sides of the forms are in shadow, as are the undersides of shapes such as the breasts, abdomen, and knees. He studies the shapes of the shadows carefully, such as the S-curve of the shadow that travels upward from the abdomen to the rib cage, and the crescent shapes of the shadows beneath the breasts.

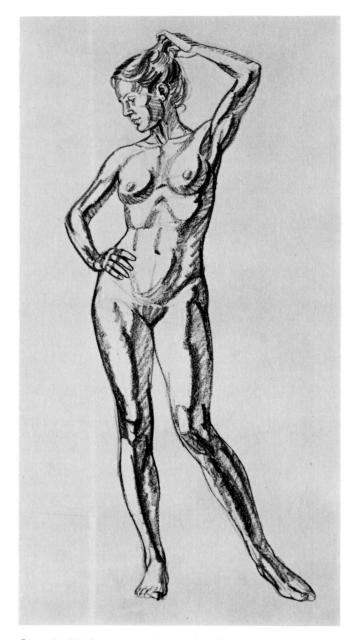

Step 5. Picking up a softer, darker 4B pencil that makes a thick stroke, the artist starts to deepen the shadows. With the broad side of the lead, he darkens the edge where each shadow meets the light, and so now we see shadow *and* reflected light on the dark side of each form. With the sharpened point of the soft, dark pencil, he begins to sharpen the details of the head. Then he refines certain contours, such as the arms, the hips, and the shadow side of the torso.

Step 6. Still working with the thick pencil, the artist continues to build up the shadows with short, curving strokes that wrap around the forms. You can see these strokes most clearly within the shadows on the raised arm, breasts, rib cage, abdomen, thighs, and lower leg. With the tip of the pencil, he accentuates such details as the features, nipples, and toes. We begin to see the full gradation of tones.

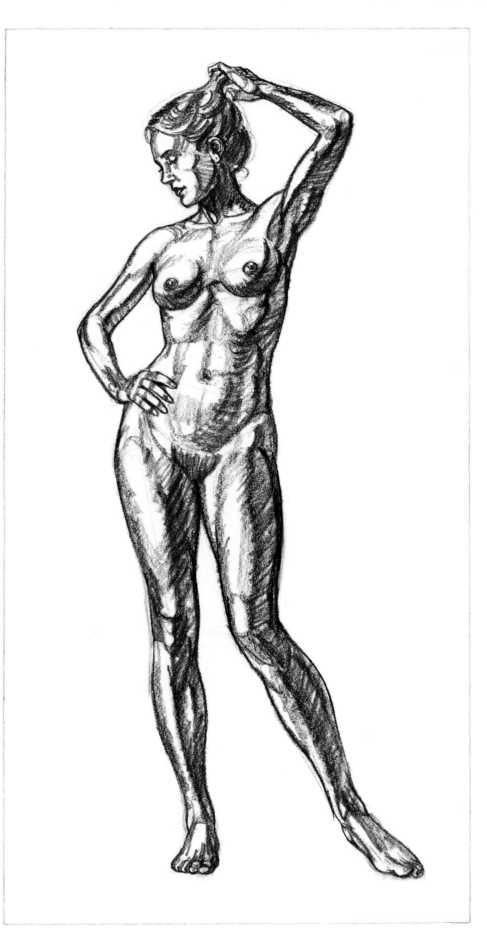

Step 7. The artist deepens the tones of the shadows with short, curving strokes, made by using the side of the 4B lead. (The rich, dark tones of the soft pencil are ideal for building up strong lights and shadows.) Then he moves into the lighted areas to develop anatomical details such as the rib cage, abdomen, and thigh muscles with halftones. Sharpening the pencil point on a sandpaper block, he again goes over the outlines of the figure to define them more precisely. He reinforces the details of the features, hands, and feet. Compare the broad-stroke technique of this demonstration with the slender strokes used to develop the tones of the preceding demonstration. Try both methods to explore the full range of pencil-stroke techniques. And keep drawing simple standing figures to memorize the basic forms of the male and female bodies. Then, when you feel ready, go on to more complex poses.

Step 1. A seated figure is still fairly easy to draw and is a good pose to try next. In this demonstration, the artist shows you how to use slender pencil lines for the contours, plus a combination of broad strokes and blended tones for the modeling of the light and shade. The preliminary "diagram" includes most of the usual guidelines, omitting a few that the artist obviously carries in his head. As you've seen by now, every pose has its own unique set of alignments. The corner of the near shoulder aligns vertically with the curve of the buttock and the heel. The corner of the far shoulder is directly above the corner where the torso meets the far thigh. The elbow of the straight arm comes down to the waist, but the elbow of the bent arm is above the waist.

Step 2. When the artist constructs the forms of the body over the "diagram," other alignments become apparent. The inner curve of the near shoulder is directly above the angle of the waist. The model's nose is directly above the corner of the far shoulder, while her ear is directly above the pit of the neck. The back of the model's neck is a slanted line that runs parallel to the lines of the upper arm on the right. Even when you draw a relatively simple pose like this one, look for these relationships; they're the key to achieving accurate proportions and capturing the "movement" of the pose.

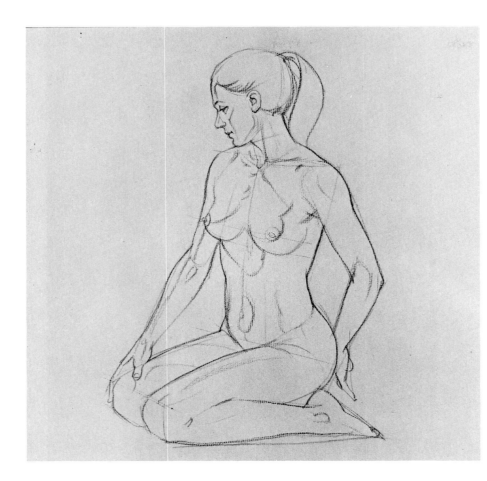

Step 3. As he draws the lifelike contours of the figure over the construction lines of Step 2, the artist not only studies the model for anatomical accuracy, but also looks for the connections *between* the lines. Notice how the line at the back of the model's neck flows into the curve of the shoulder and then down into the contour along the back of the upper arm. The artist also looks for more subtle connections between lines, such as the upper edge of the near thigh, which flows around into the waistline. The actual line that links the thigh and waist will disappear beneath the modeling of Step 4, but the viewer will still sense the connection without knowing it. These connections between lines, sometimes visible and sometimes invisible, give the figure a feeling of internal rhythm and grace.

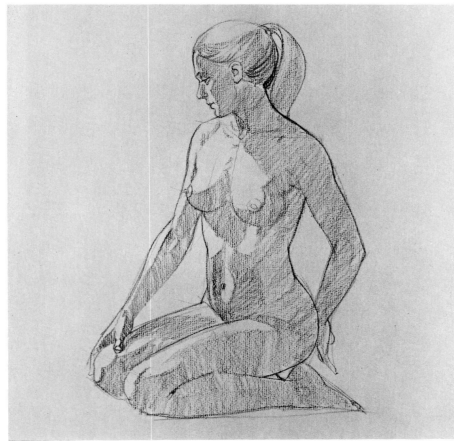

Step 4. Up to this point, the artist has been working with the sharp point of a 2B pencil. Now he picks up a thick, soft 4B pencil—he could also use a stick of graphite—and holds the drawing tool at an angle to block in the tonal areas with broad strokes. Now it's obvious that he's working on a sheet of charcoal paper, which lends its distinct texture to the strokes. The light comes from the left and is somewhat behind the model, and so most of the figure is in shadow. There are just a few patches of light. Each patch of light and shadow has its own distinct shape, which the artist observes and draws carefully. Look back at Step 3 and you'll see that the line drawing includes the edges of these light and shadow shapes.

Step 5. The artist moves a fingertip lightly back and forth over the shadow areas to blend the tones. Charcoal paper has a hard surface that allows the fingertip—or a stomp—to glide smoothly over it and push the graphite around like wet oil paint. The artist doesn't want to obliterate the strokes of Step 4 completely, and so he moves his finger lightly over the paper, softly merging the tones but allowing some of the strokes to show. He darkens the abdomen and breasts with a few more strokes and blends them softly to accentuate the roundness of the forms. With the sharp point of the 2B pencil, he strengthens a few contours, such as the back of the neck and the waistline.

Step 6. Working with the soft, dark 4B pencil again, the artist begins to build up the darks with clusters of parallel strokes. He emphasizes the dark edges of the shadow shapes where they meet the light. You can see this effect most clearly on the cheeks, the straight arm, the breasts, and the abdomen. The shadow shapes glow with rich darks and reflected lights. The sharp point of the 2B pencil begins to reinforce the features, the texture of the hair, the lines of the neck, the hands and foot, the line of the straight arm, and the curves of the chest muscles.

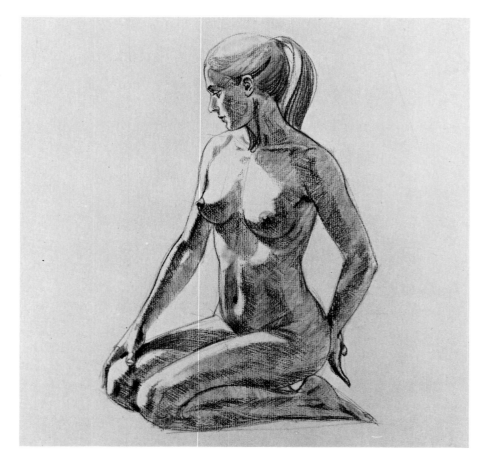

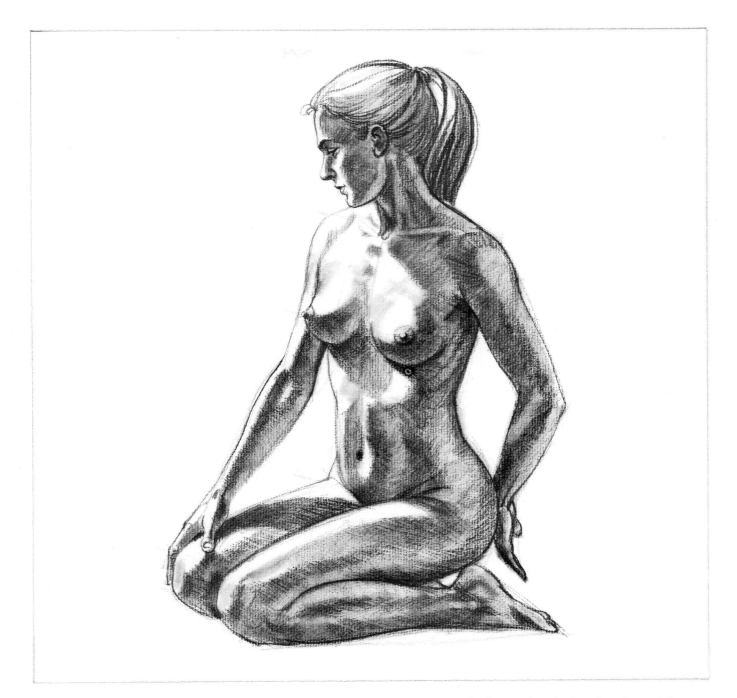

Step 7. The artist moves a fingertip over the dark pencil strokes of Step 6 to blend them into the shadows. Within the shadows, the darks and the reflected lights now flow together more smoothly. Wherever an area needs darkening, the artist first adds a few broad strokes with the 4B pencil and then merges them with his fingertip. However, he doesn't fuse all the strokes, but often allows them to remain intact; you can see these strokes most clearly on the thigh and calf of the leg, where the artist uses unblended strokes to build up anatomical detail. Wherever he wants a particularly strong dark note, he leaves the strokes unblended, as you can see in the curving shadow that the straight arm casts over the lighted top of the thigh. For touches of halftone such as the soft grays on the chest, the artist simply presses his graphite-coated fingertip against the bare paper. Finally, the sharp point of the 2B pencil moves around the contours of the figure to sharpen the lines. The point of the pencil also accentuates the features, adds a bit more detail to the hair, and focuses on such precise details as the nipples, fingers, and toes. It's always best to save these details for the very end.

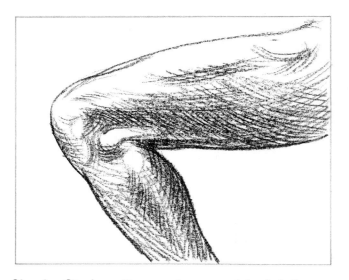

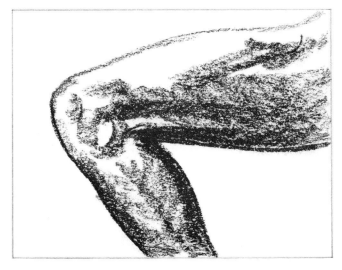

Slender Strokes. You can sharpen a stick of chalk on a sandpaper pad to make slender, precise strokes. Even if you don't bother to sharpen that rectangular stick of chalk, you can make fairly crisp strokes with the sharp corner of the stick. Or you can buy chalk in the form of a pencil that will make even more precise lines. This close-up of a muscular leg is drawn with the sharpened tip of a Conté crayon. The artist first draws the outer contours of the leg with a few decisive strokes. Then he builds up the tones within the leg with clusters of parallel strokes.

Broad Strokes. The square, unsharpened end of a stick of hard pastel will make bold, broad strokes. Here, the artist uses the sharp corner of the rectangular stick to draw the linear contours of the leg. Then he uses the square tip to build up the tones with wider strokes. The chalk moves lightly over the paper to produce the paler tones, and presses harder for the darks along the undersides of the forms. Hard pastel breaks easily; build up the darks by moving the chalk back and forth over the paper several times—don't apply too much pressure to the stick.

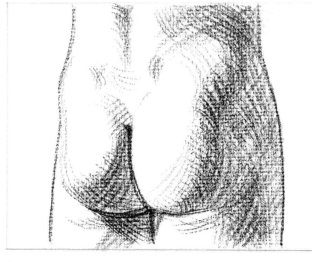

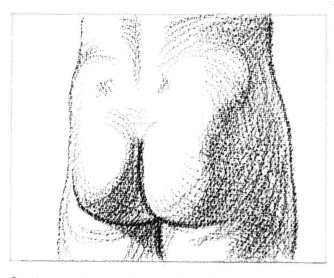

Strokes on Charcoal Paper. Chalk or pastel in pencil form will make precise strokes like those you see in this study of muscular male buttocks. However, the texture of charcoal paper will soften and break up the strokes so that they seem to blend—even though the strokes aren't actually touched by a fingertip or a stomp. If the artist builds one curving stroke over another, the texture of the paper has a unifying effect: the strokes merge and become masses of tone.

Strokes on Rough Paper. This effect is even more pronounced on rougher paper. As the chalk pencil moves over the ragged surface of the sheet, the pebbly texture of the paper takes over. The individual stroke loses its identity and merges with the other strokes to form a rough, granular tone. The rich tonal effect is achieved without blending. The strokes seem to "mix" in the eye of the viewer.

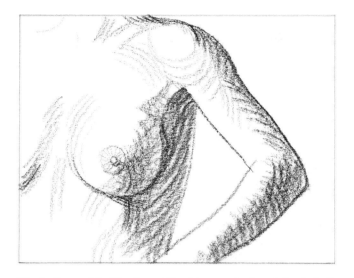

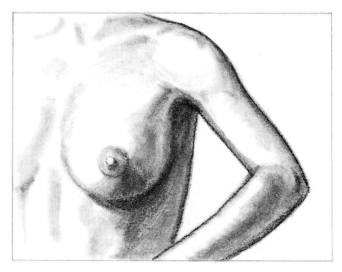

Modeling with Strokes. The blunt end of a stick of chalk builds up the tones with thick, curving strokes that follow the rounded contours of the forms. Notice how the strokes on the forearm, for example, actually curve around the cylindrical shape. In the same way, the strokes of the chalk wrap around the torso and breast. The artist piles one curving stroke over another to create stronger darks. The rounded, three-dimensional forms are created entirely by this buildup of curving strokes.

Modeling by Blending. Those same strokes can be blended with a fingertip or a paper stomp to create smooth, velvety tones. The artist begins by blocking in the tones with broad strokes, which he then merges with a back-and-forth movement of his fingertip. To strengthen the darks, he adds more strokes and blends these too. The stomp is used to get into tight corners, such as the shadowy armpit. A kneaded rubber eraser lifts away unnecessary tones to brighten the lighted areas. And the sharp corner of the rectangular chalk reinforces the contours with dark, slender lines.

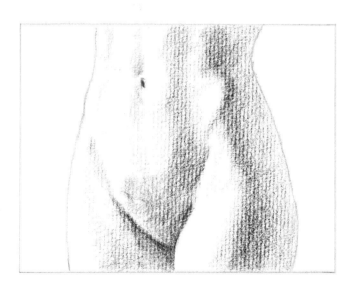

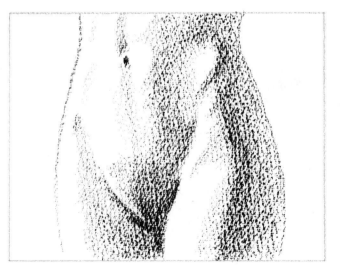

Continuous Tone on Charcoal Paper. A sheet of charcoal paper has an intricate pattern of peaks and valleys. If you move a stick of chalk—or chalk in pencil form—lightly over the paper, the drawing tool hits only the peaks and skips over the valleys. If you don't press too hard and keep moving the drawing tool lightly back and forth, not a single stroke will show, but the granules of chalk will slowly build up. Rich, luminous tones will magically emerge, like the lights and shadows on this close-up of a female torso.

Continuous Tone on Rough Paper. You can achieve the same effect on any sheet of paper that has a pronounced tooth. The rougher the paper, the more quickly the tones will build up as you move the chalk back and forth, hitting the jagged peaks and skipping over the valleys. The blunt end of the chalk is used to build up the tone, while the sharp corner of the rectangular stick draws the linear contours of the hips.

Step 1. A bending male figure—only a bit harder than an upright pose—will give you an opportunity to draw a complete figure in chalk. For this demonstration, the artist chooses a cylindrical stick of chalk in a plastic holder. The chalk is fairly thick, but it's easily sharpened on a sandpaper pad to make the slender lines of the preliminary "diagram." You'll notice that the guidelines are growing simpler. By now, many of these lines should be in your head; there's no need to place them all on paper unless you feel that they're necessary for a particular pose. Notice that nearly all the lines in this pose are diagonals; this is usually true when the model takes an active pose. The shoulder that leans forward is almost directly above the jutting knee of the leg on the left. The high shoulder on the right is above the crotch, while the elbow of the arm that swings backward is directly above the hip. An active pose won't be hard to draw if you record all these relationships correctly.

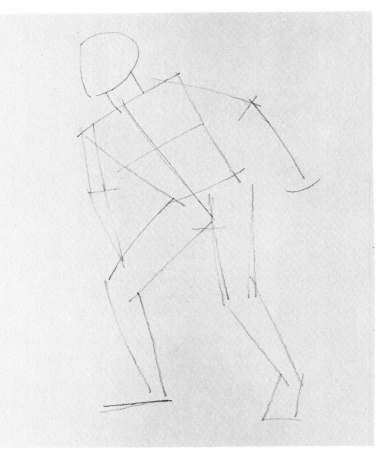

Step 2. When the artist constructs the forms of the figure over the "diagram" of Step 1, he reveals other relationships between the forms. The clenched fist is directly above the heel on the right, while the head is directly above the foot on the left. The undersides of the chest muscles align with the elbows of both arms, while the line of the crotch aligns, more or less, with the wrists. Although many alignments change with the pose, others tend to stay the same—and these are important too. For example, the guidelines that cross the torso to connect the shoulders, chest muscles, and hips are usually (though not always) parallel. And the pit of the neck, the division between the chest muscles, the navel, and the crotch *always* fall on the center line of the torso, even though that center line may curve slightly in some poses.

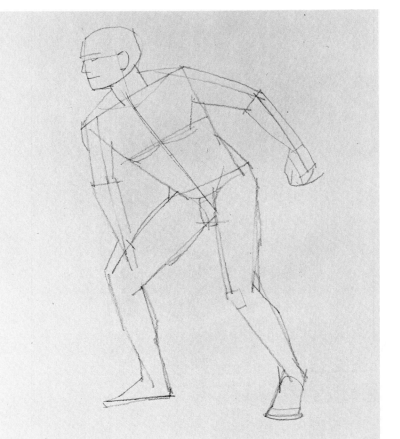

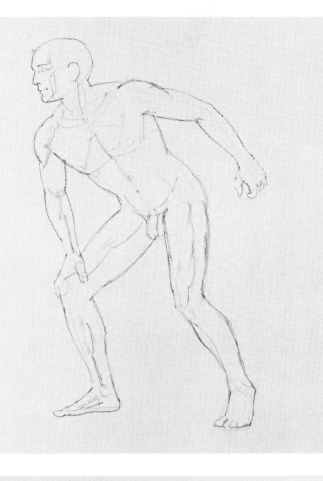

Step 3. As usual, the artist executes a realistic line drawing of the figure over the construction lines of Step 2. He's still working with the sharpened tip of the cylindrical stick of chalk. The thick chalk doesn't make as neat a line as a graphite pencil, but the ragged line has its own kind of beauty. The angular contours of Step 2 become rounded, lifelike shapes in this step. To capture the vitality of the figure, the artist looks for lines that flow—or *seem* to flow—into one another. On the right side of the figure, for example, a single, rhythmic contour flows from the armpit, down along the torso, around the thigh, and down the lower leg to the heel, where the line finally ends at the angular, bony shape. It's also important to watch for those places where one contour overlaps another, signifying the fact that one form comes forward while the other goes behind it. At the right, the rounded bulge of the shoulder comes forward, while the contours of the muscles on either side move behind the bulge. These overlapping contours enhance the drawing's three-dimensional quality.

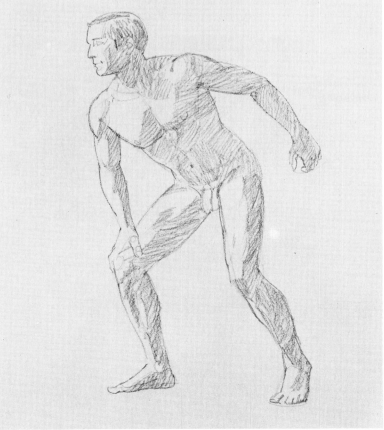

Step 4. The artist sees that the light source is to the left and slightly above the figure. Thus, the left sides of the forms—and some of their tops—catch the light. This is most obvious on the arm that leans on the knee, and on the chest and thighs. The right sides of many of the forms are in shadow, and so are the undersides of the forms that lean away from the light. Thus, the lower part of the torso, from the chest down to the crotch, bends away from the light and is entirely in shadow, as are the free-swinging arm and the lower leg on the right, which bends in the same direction away from the light. By the end of Step 4, the sharp point of the chalk has begun to wear down. Now the artist uses the blunt end of the chalk to block in the shadow shapes with thick parallel strokes. The strokes have a ragged, slightly granular quality that's typical of chalk.

Step 5. Concentrating now on the shadow areas of the figure, the artist builds up the darks with thick, firm strokes, made by using the blunt tip of the stick of chalk. He pays particular attention to the strips of darkness where the light and shadow planes meet. These dark edges are most apparent on the head, chest, thighs, feet, and the straight arm on the lighted side of the figure. The tonal areas begin to show a distinct contrast between the shadows and reflected lights within the shadows. The typically rough texture of the chalk stroke becomes even more obvious as the drawing progresses. The dark, heavy strokes follow the curves of the model's muscles. Toward the end of this step, the artist sharpens the point of the chalk on the sandpaper block once again and begins to strengthen details such as the features, the hand on the knee, and the foot on the left.

Step 6. Moving carefully around the forms with the sharpened chalk, the artist reinforces all the contours. It's important to notice that some lines are thicker and darker, while others are thinner and paler. He tends to press harder on the chalk, making a heavier line, when a contour comes forward. Conversely, he exerts less pressure on the chalk to make a more delicate line when the contour moves back. Once again, look at the arm that leans on the knee. The bulge at the shoulder moves forward and its contour is drawn with a dark, heavy line. But the muscle beneath is drawn with a lighter line because its contour moves around to the back of the bulging shoulder muscle. In the same way, the protruding bulge of the lower arm is drawn with a darker line than the wrist. Of course, sometimes the artist accentuates a line for a purely expressive reason: the inside of that same arm is drawn with thick lines to give you a sense of weight pressing downward on the knee. Throughout the figure, the artist avoids wiry, mechanical lines, changing the density of the line by altering the pressure on the chalk.

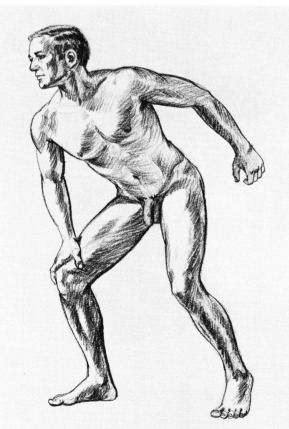

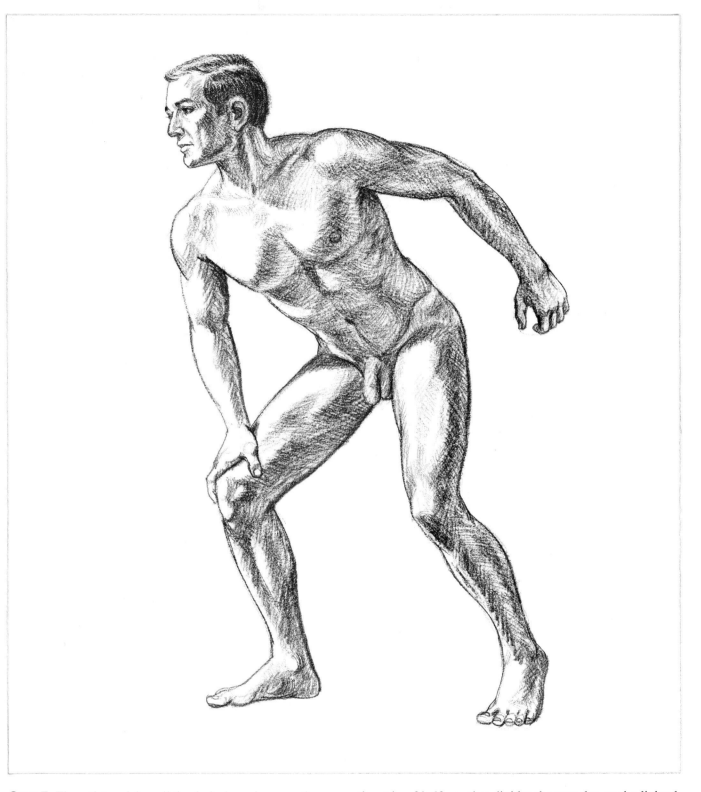

Step 7. The artist enriches all the darks by going over these areas with short, curving strokes that follow the rounded forms. Notice how he builds up the big shadows of the forms that bend away from the light: the lower half of the torso, the arm that swings back, and the lower leg on the right. Within the lighted areas, he builds up the anatomical detail with halftones; a particularly good example of this is the strip of halftone that divides the muscles on the lighted plane of the thigh on the right. When he's completed the halftones, shadow, and reflected lights, the artist sharpens the chalk one last time to accentuate the features, the texture of the hair, and the details of the hands and feet. If a stray smudge of tone finds its way into a lighted area, it's quickly lifted away with a touch of the kneaded rubber eraser.

Step 1. Chalk smudges very easily and can produce wonderful, smoky tones when you blend the strokes with your fingertip or a paper stomp. Now try a drawing in which you combine sharp lines with selectively blended tones. For this demonstration, the artist chooses a sheet of charcoal paper, whose delicately textured surface is particularly good for blending the strokes of the chalk. He chooses two drawing tools: a pastel pencil for the precise line work, and a stick of hard pastel for the broader strokes that will be blended into tones. As always, he starts with a few simple guidelines—and he looks for the most important alignments in the figure. For example, the point of the chin is directly above the vertical thigh and the knee that rests on the floor. The shoulder of the straight arm is directly above the angle where the thigh and the calf meet. The knee of this leg aligns with the underside of the foot at the right. See what other alignments you can discover.

Step 2. As he builds a more complete set of construction lines over the guidelines of Step 1, the artist continues to look for the alignments that are typical of this pose. Notice how the center line of the head curves downward and runs into the curving center line of the torso. The wrist of the straight arm aligns with the underside of the thigh on the right. It's also important to study the shapes of the so-called negative spaces—the gaps between the forms. The artist carefully defines the triangular shape of the space between the straight arm and the waist, as well as the bent triangle of space between the other arm and the outstretched thigh. The negative space between the two legs is also important: it's essentially a rectangle that tapers slightly as the sides move downward to the floor. These negative shapes are part of the figure!

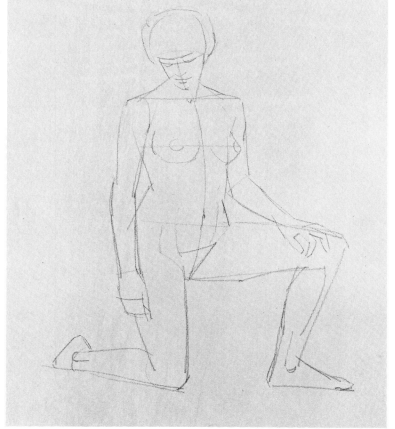

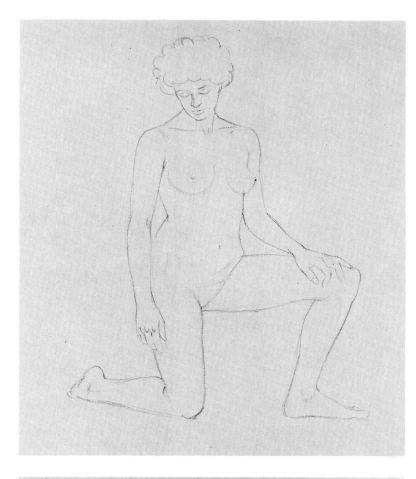

Step 3. Still working with the sharp point of the pastel pencil, the artist draws the contours of the body more realistically and erases the guidelines of Steps 1 and 2. He looks for those places where one contour overlaps another. Notice how the lines of the undersides of the thighs overlap those of the calves. He also looks for those places where one line seems to flow into another. On the right side of the torso, the contour of the chest muscle is interrupted by the breast, but then it seems to continue down over the midriff and hip, ending at the thigh. In the same way, the back of the straight arm flows downward into the back of the thigh, interrupted only by the hand. As your eye travels around the contours of the figure, you can see how the texture of the charcoal paper breaks up and softens the line of the pastel pencil.

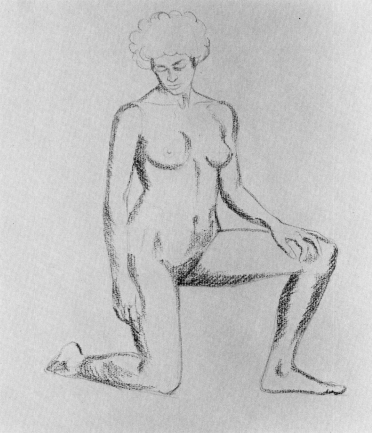

Step 4. The artist puts aside the pastel pencil and picks up the rectangular stick of hard pastel. The squarish end of the stick has been worn down to a blunt shape, and so it makes a thick, soft stroke. The artist studies the direction of the light, which comes from directly in front of the figure. Thus, the fronts of all the shapes are illuminated, while the edges of the shapes are in shadow as they turn away from the light. All the shadows are narrow strips of tone, which the artist indicates by running short parallel strokes around the contours. At this point, the rough texture of the charcoal paper is obvious. All the strokes are broken up by the ribbed surface of the paper. Most of the sharp lines of Step 3 disappear at this stage, but they'll reappear later on.

Step 5. Moving his fingertip gently over the shadow strokes of Step 4, the artist softly blends the chalk marks. He doesn't obliterate the strokes completely, but fuses them into soft, furry tones. Now his fingertip is coated with black chalk, and he uses it like a brush to spread delicate halftones over the lighted areas. In this way, he defines the curves of the shoulder and chest muscles, the side of the rib cage, and the curve along the bottom of the abdomen. The strips of shadow are too slender to show much reflected light. Instead, there's a soft gradation from light to halftone to shadow, which you can see most clearly on the rounded shapes of the breasts and on the cylindrical shapes of the arms and legs.

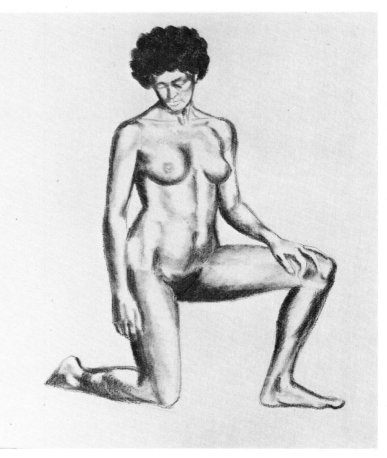

Step 6. Switching back to the pastel pencil, the artist builds up the shadows with parallel strokes that move around all the dark edges of the figure. The strokes look rough and granular because they're broken up by the texture of the charcoal paper. He strengthens the cast shadow beneath the chin. He also adds a cast shadow below the hand that rests on the outstretched thigh. And he begins to define the features more precisely with the sharpened point of the pastel pencil.

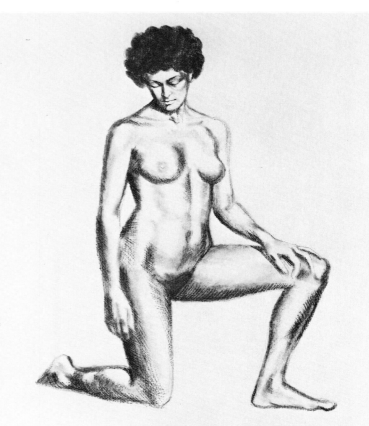

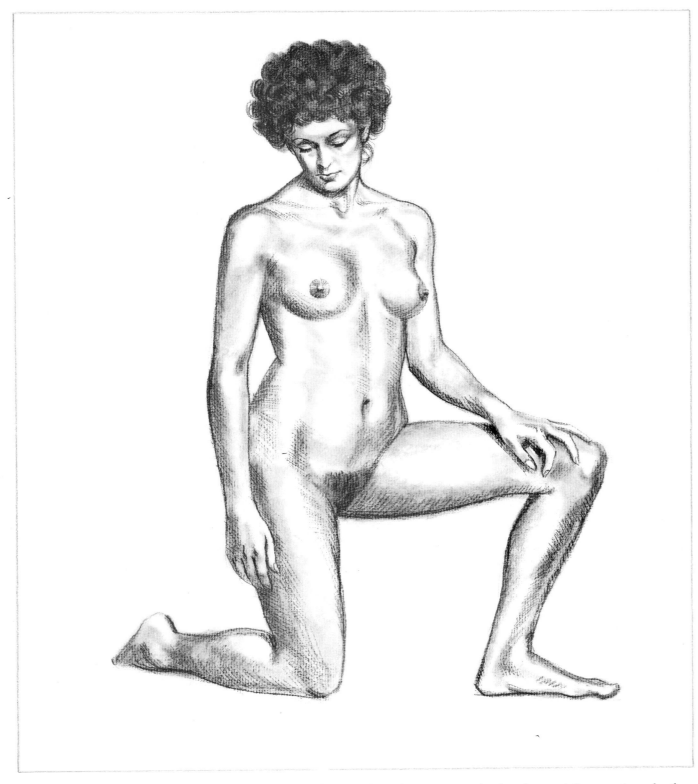

Step 7. The artist runs his fingertip over the edges, blending the narrow clusters of pencil strokes that reinforce the shadows of Step 6. He doesn't blend the strokes totally, but just softens them a bit. The pencil travels around all the edges, redefining the lines that were temporarily lost beneath the blended tones. The rhythmic contours emerge sharply. A fingertip picks up some chalk dust from the sandpaper pad and moves carefully over the halftones within the lighted areas, strengthening these subtle grays to make the skin tones look more luminous. A wad of kneaded rubber is pressed carefully against the lighted areas to remove any hint of gray from the bare paper. Now the skin has a wonderful inner glow. Finally, the sharp pencil point accents the model's curls, features, neck muscles, nipples, navel, hands, and feet.

Step 1. As a change of pace, try drawing a back view. When seen from behind, the female torso is still a pair of blocky shapes that taper to meet at the waist. The shoulders are connected by a horizontal guideline. A vertical center line runs down the spine and curves as the figure bends slightly. The vertical center line locates the center of the neck, travels down the spine, and terminates in the division between the buttocks. The artist places a horizontal guideline at the wide point of the hips. He still visualizes the arms and legs as tapering cylinders. The hand of the straight arm, the buttocks, and one foot all line up firmly on the floor. The heel of the foot on the right aligns with the big toe of the other foot. The chin aligns, more or less, with the edge of the upper torso on the right. One shoulder is a bit higher than the other—and so is one hip—because the model leans slightly to the left.

Step 2. Compare the construction lines in this step with the simple "diagram" of Step 1. Now just a few lines divide the shape of the flat hand into fingers. In the same way, a single curving line and a few short lines define the toes of the foot tucked under the buttocks. The other, outstretched foot is seen in perspective, and so it was drawn as a shortened triangle in Step 1; now, with just a few more lines, the artist transforms it into a foot by adding the anklebone and the curve of the toes. In Step 1, the hip on the left was a single curving line; now an extra line squares up the hip and accentuates the bony bulge of the pelvis. The artist places the features carefully over the egg shape of the head and defines the mass of the hair with a few curving strokes. He locates the shoulder blades with two short lines that run downward across the horizontal guidelines between the shoulders. So far, all this linear work is done with a pastel pencil.

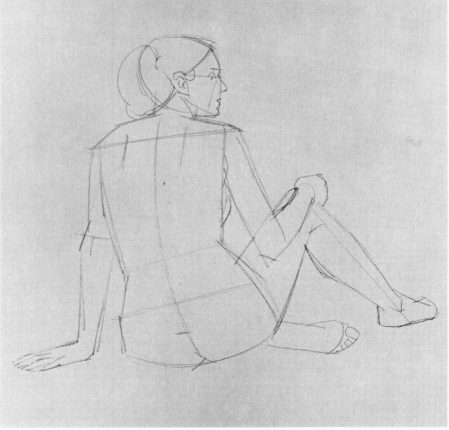

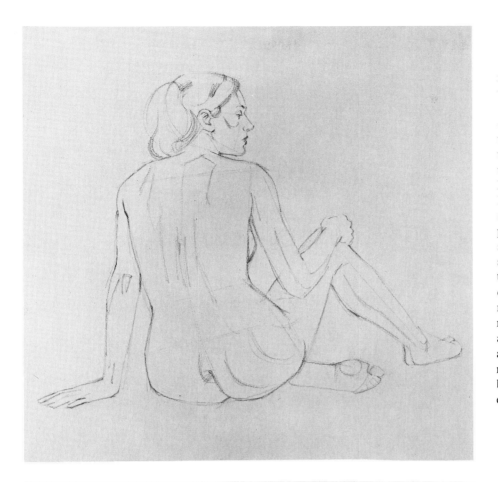

Step 3. The artist moves back over the straight lines of Step 2, gradually replacing them with flowing, rhythmic ones. He looks for contours that flow into one another. One continuous line—with subtle changes in direction—travels from the wrist on the left all the way up the arm and across the shoulder, terminating at the back of the neck. In the same way, the contours of the left side of the torso merge into a single line that flows from the armpit over the back and hip, finally swinging around to end at the division of the buttocks. The curve of the other buttock swings upward counterclockwise, disappearing momentarily at the thigh and then reappearing at the hip and running along the side of the torso up to the armpit. On the arm and leg at the right, as well as on the back, you begin to see lines that indicate the edges of the shadow shapes.

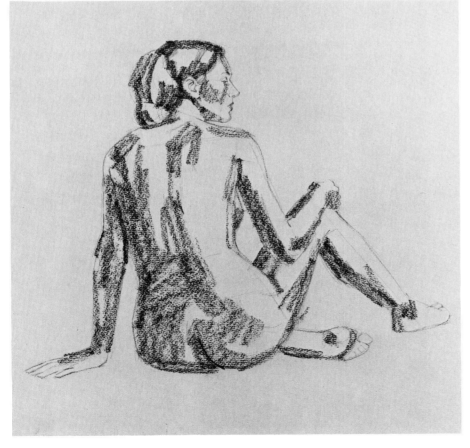

Step 4. This demonstration will show you how to make a drawing almost entirely of blended tones. The artist blocks in the tones with the square end of a stick of hard pastel, which makes broad, rather rectangular strokes. Just a few strokes cover a great deal of territory. The light comes from the right, and so the left sides of the forms are in shadow. Because the torso blocks the light, the arm on the left is totally in shadow; only a bit of the hand protrudes into the light. The spine curves away from the light, and so a slender shadow runs down the important center line. The edges of the shoulder blades also curve away from the light; the artist indicates the slender shadow on each shoulder blade with a single stroke. Study the touches of shadow on the smaller forms: the hollow of the cheek, the underside of the foot, and beneath the anklebone of the other foot.

Step 5. The artist picks up a large stomp and holds it at an angle to the paper. Thus, he works with the slanted side, rather than with its pointed tip. With vigorous strokes, he sweeps the stomp back and forth over the irregular drawing surface, blending the strokes that appeared in Step 4. These strokes quickly become dark, velvety tones as the granular chalk marks are blurred by the stomp. To blend smaller areas—particularly on the face, hands, and feet—the artist uses the sharp point of the stomp. Then, when the stomp is coated with chalk dust, he uses the cylindrical tool like a brush to add touches of halftone within the lighted areas of the figure. You can see these halftones around the shoulder blades and along the edge of the shadow that travels down the spine. He also adds a hint of halftone along the lighted edge of the leg and foot at the right.

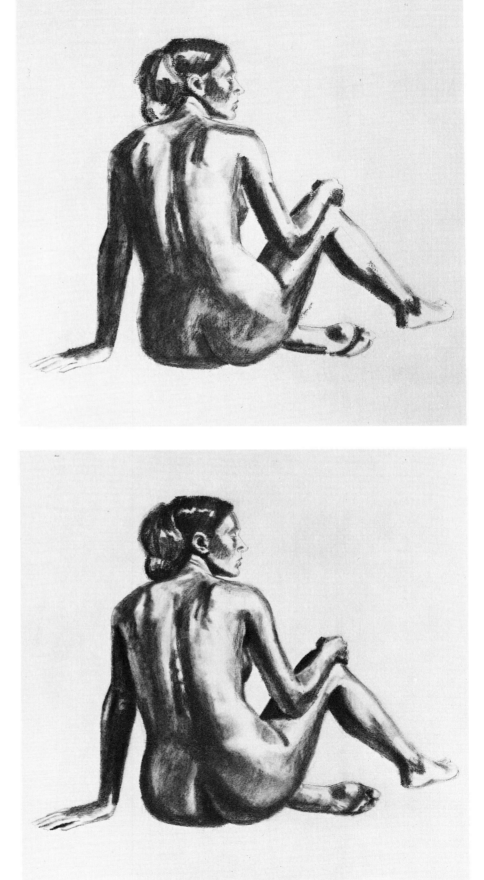

Step 6. With a fingertip, the artist blends the rough tones of Step 5 more smoothly, producing more delicate gradations. The effect is obvious along the edges of the shadows, which now merge more softly with the lighted planes. He moves back into the shadows with a kneaded rubber eraser to create reflected lights. He squeezes the eraser to a rounded tip and presses it very gently against the shadow areas, lifting off small quantities of chalk. Then he goes over these areas with his finger to blend them once again. Now there are luminous reflected lights within the big shadow shapes of the back and the slender shadow shapes on the arms and legs. Squeezing the kneaded rubber to a sharp point, he picks out smaller areas of light, such as the elbow of the arm at the left and the bones of the spine. And he begins to reinforce selected darks with the chalk—in the hair, within the ear, beneath the chin, on the left arm, and along the outstretched leg.

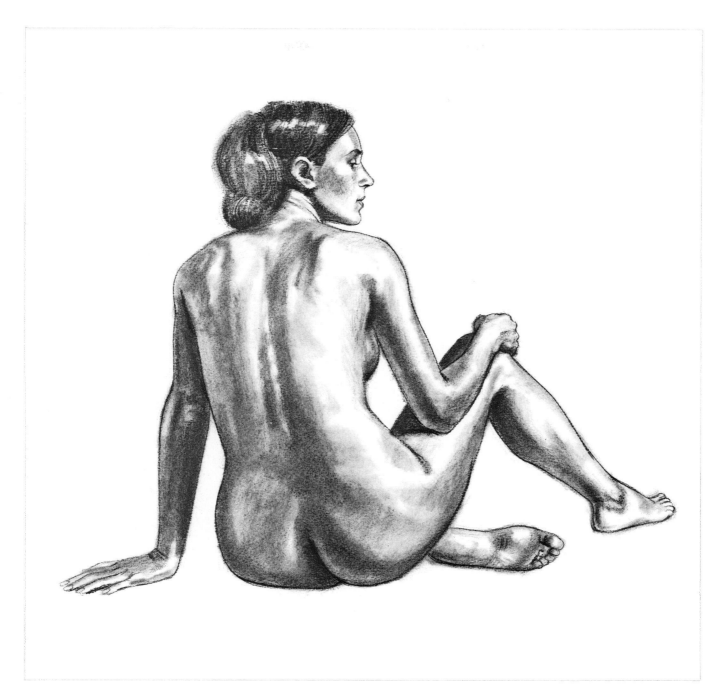

Step 7. In the process of blending, the original contours tend to disappear. The artist restates them now with the sharpened pastel pencil. He redefines the profile and features and adds some lines to the hair. For the last time, his fingertip travels gently over the shadows, blending them more smoothly and carrying a few more halftones into the lighted areas—particularly the lighted planes to the right of the spine and on the outstretched leg. He squeezes a kneaded rubber eraser to a point to brighten these lighted areas; now the completed drawing has a strong contrast between the lights and shadows. To heighten the impact of the dark figure against the white paper, the kneaded rubber moves around the outer edges of the figure, eliminating any stray tones that might soil the clean surface of the sheet.

Slender Strokes. Hard and medium charcoal pencils can be sharpened to a point to draw the contours of the figure with slim lines like those you see around the outer edges. With the point or the side of the lead, you can also build up tones with clusters of parallel lines like those you see in the shadow areas of the model's back and arms. Tones can be darkened by building one layer of strokes over another and pressing harder on the pencil, as in the shadow under the breast.

Broad Strokes. A cylindrical stick of natural charcoal, the thick lead of a soft charcoal pencil, and a thick charcoal lead in a holder will each make rough, broad strokes. Here, the same female torso is drawn with a soft charcoal pencil. Even when the pencil is sharpened, it has a slightly blunt tip that outlines the figure with a thick, slightly broken line. To render the tones, the pencil is held at an angle to make broad strokes. The shadow areas are quickly covered with a few sweeps of the thick lead.

Strokes on Charcoal Paper. As the name suggests, charcoal paper is made specifically for this drawing medium. This leg is drawn with a sharpened medium charcoal pencil. Where the pencil glides lightly over the paper— as in the buttock—the texture of the sheet breaks up the stroke into flecks of black and white to suggest luminous halftones. Where the pencil presses harder against the paper—as in the outlines and the shadows—the stroke still has a lively, irregular quality. All the tones are penetrated by pinpoints of bare paper, which make the halftones and shadows look transparent.

Strokes on Rough Paper. The strokes of the charcoal pencil—or the charcoal stick—become *more* pebbly and irregular on a rougher sheet. The tooth of the paper tends to break up the stroke into a granular pattern of dark flecks. The outlines of this leg have a ragged quality, while the tones look like a pattern of dark granules, showing very few distinct strokes. A charcoal drawing on rough paper can't be as precise as a drawing on a smoother sheet, but it *does* have a special boldness and power.

Modeling with Strokes. Charcoal is particularly effective for creating subtle gradations of tone. One way to do this is to gradually build up clusters of curving strokes that "mix" in the viewer's eye to become tones. A series of parallel strokes with slender spaces between them can suggest a halftone like the soft gray area on the side of the buttock or along the thigh. A second or third layer of strokes, placed close together, will produce a darker tone like the shadowy curve of that same buttock or the underside of the thigh.

Modeling by Blending. If you move your fingertip over the strokes you see at your left, they gradually disappear, fusing into smoky tones. For this blending technique, it's best to work with a medium or soft charcoal pencil, or with a stick of natural charcoal. To build up the dark contours along the undersides of the buttocks and breasts, the artist piles on more strokes and blends them with his fingertip. To create the halftones on the side of the buttocks and thigh, he just touches the paper with a few light strokes and blends them with a fingertip.

Strokes and Blending on Charcoal Paper. The outline of the shoulder is drawn with the sharp point of a medium charcoal pencil. The side of the lead blocks in the tones with broad strokes, blended by a fingertip. The pencil goes over these blended areas with parallel strokes that strengthen the shadows and accentuate the forms. You can see these blended tones, heightened with pencil strokes, along the shadowy edges of the arm and chest muscles. The strong darks along the neck and beneath the armpit are clusters of firm, unblended strokes.

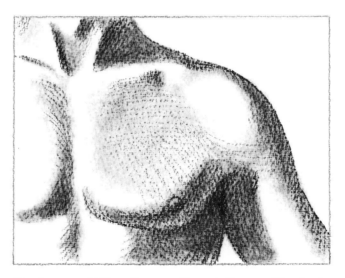

Strokes and Blending on Rough Paper. Here's the same technique on a rougher sheet. Again, the artist draws the outlines with a medium charcoal pencil and then blocks in the tones with the side of the lead. He blends the tones with a stomp and reinforces the darks with the pencil. Thus, the darks along the side of the neck and shoulder, as well as those surrounding the armpit, have a particularly deep, powerful tone. The subtle halftone on the chest muscle is a soft blur, which the artist darkens slightly by letting his pencil glide lightly over the paper.

Step 1. Charcoal blends so easily that it's tempting to smudge every stroke to produce those wonderful, velvety tones, but it's best to begin by exploring what you can do with unblended lines and strokes. Try drawing some figures in which you render the contours with slender lines, made with the sharpened tip of the charcoal pencil, and render the tones with broad strokes by using the side of the lead. An action pose can be hard to draw, but the job becomes a lot easier if you plan the preliminary "diagram" carefully. The key to the pose is the curving center line that moves downward from the neck through the chest and navel to the crotch. Reflecting the curve of the center line, the edge of the torso at the right moves in the same direction—from the armpit all the way down to the knee. The inner line of that same thigh repeats the curve of the center line. The edge of the outstretched lower leg doesn't *curve* in the same direction, but it's roughly parallel with the side of the body. The lines of the upper arms all travel in the same direction.

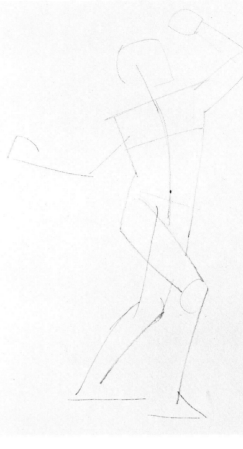

Step 2. The artist begins to build up the anatomical forms. He draws the bulges of the shoulders over the connecting guideline and then defines the square shapes of the chest muscles that connect with the shoulders. On the abdomen, he indicates the lines of the stomach muscles on either side of the navel. He suggests the rounded form of the knee with a curving line. He accentuates the triangular shapes of the feet. Notice how the fists are divided into two halves to represent the palms and the group of clenched fingers. Finally, he adds more lines to stress the alignment of the jaw, neck muscle, pit of the neck, breastbone (where the chest muscles meet), navel, and crotch along the curving center line. This center line will continue to be the key to the action.

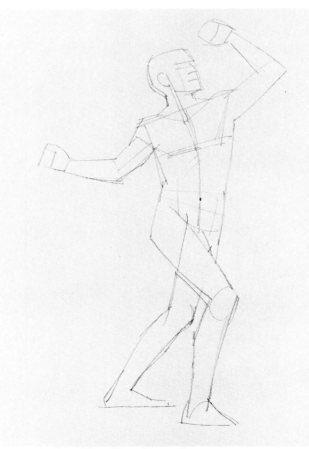

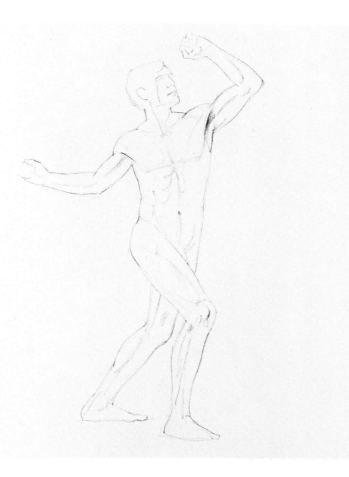

Step 3. The artist looks for the internal rhythms of the contours when he transforms the rigid lines of Step 2 into curving, springy lines. The edge of the torso on the right is a single contour that moves from the armpit down to the knee, interrupted only by the opposite thigh. The top of the protruding thigh curves around the egg-shaped hip muscle and then runs upward along the left side of the torso to the armpit. There are also some less obvious connections that lend rhythm to the pose. For example, look at the line of the underside of the outstretched arm at the left: this line swings upward to the armpit, disappears behind the chest muscles, and then reappears in the curve of the opposite shoulder.

Step 4. The artist sees that the light comes from the left and from slightly above the figure. Thus, the left sides of the forms catch the light and the right sides turn away into darkness; you can see this most clearly on the torso, the lower legs, and the forearm that's raised above the head. The light also touches the tops of some forms and throws the undersides into shadow— as in the outstretched arm on the left and the upper arm on the right. So far, the artist has been working with the sharpened point of a medium charcoal pencil. Now he blocks in the shadows with broad strokes, using the side of the lead. Even as he blocks in the shadows, the artist preserves the curving center line of the torso, which is so important to the movement of the figure. Notice how the shadow of the corner at the jaw, the edge of the shadow at the neck, the strip of light between the chest muscles, and the stomach muscles all follow this center line. If you continue to move your eye downward, this center line reappears as the edge of shadow on the leg that moves backward behind the figure.

Step 5. Pressing harder on the side of the lead of the medium charcoal pencil, the artist darkens the edges of the shadows where they meet the lighted planes of the figure. Suddenly, the figure grows more luminous as each shadow contains two tones: the dark and the reflected light. The artist works with bold, curving strokes, moving rapidly down the form. Sometimes the *shadow accent* (as the dark edge of the shadow is often called) is a single, thick, curving stroke, like those on the abdominal muscles. At other times, it's a series of short strokes placed side by side, as you can see on the upraised arm, the thighs, and the lower legs. The artist keeps focusing attention on that all-important center line, which he darkens with a series of strokes that start at the neck muscle, move down between the chest muscles and between the abdominal muscles, and then continue along the edge of the shadow on the rear leg.

Step 6. The sharpened tip of the charcoal pencil now moves around the contours of the figure, redefining the outlines. The artist pays particular attention to those places where one contour overlaps another, such as the shoulders, the biceps, and the inside corners of the elbows. These overlapping contours suggest that one form moves forward while another form moves behind it; thus, the body looks more solid and three-dimensional. The point of the pencil also begins to accentuate the details of the face, fingers, and toes. This is one of those drawings in which the artist could easily stop at this point: although not every part of the drawing is finished, there's just enough detail and just enough tone to make a lively, powerful drawing. But he goes on to Step 7 to show you the full range of tone that's possible with a medium-grade charcoal pencil.

Step 7. With short, closely packed parallel strokes, the artist deepens all the shadows. Now there's a powerful contrast between the lighted and shadow sides of all the forms. The figure not only looks more solid, but the stronger shadows accentuate the inner rhythms of the figure. The dark strip of shadow dramatizes the curve of the outstretched arm, for example, while the center line of the torso stands out more dramatically because of the contrast of light and shadow. Within the lighted areas of the figure, the artist develops halftones that define the anatomical details more clearly; look at the muscles of the thigh. Finally, the sharp point of the pencil heightens such details as the hair, features, fingers, nipples, anklebones, and toes.

Step 1. Try a combination of lines for the contours, plus strokes and selective blending for the tones. The artist works with hard and medium charcoal pencils, plus a natural charcoal stick, on a sheet of rough paper. The hard charcoal pencil executes an extremely simplified "diagram" of this action pose. To draw a dynamic pose like this crouching male figure, the most important thing is to record the directions of the lines accurately. It's often best to begin with the line of the back—a steep slant in this pose. The lines of the forward leg are almost horizontal and vertical, but not quite. Because the figure leans forward, the line of the shoulders is also slanted. In the leg that reaches back, we see only a bit of the thigh—which is in perspective—but we see most of the lower leg.

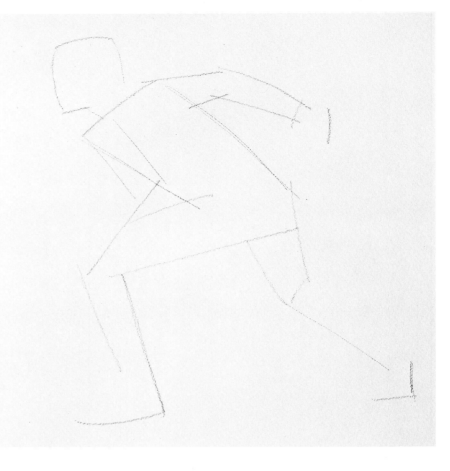

Step 2. As the artist builds up the construction lines of the figure, we see the shapes of the body more clearly, though they're still highly simplified. As always, the artist looks for alignments. The wrist of the upraised arm is directly above the line of the buttock and thigh. The chin is above the outstretched knee. The slanted line along the underside of the outstretched lower leg is parallel to the sloping line that runs along the underside of the torso; this torso line points to the tip of the chin. The top of the outstretched arm is parallel to the thigh of the outstretched leg. All the major lines of the figure are slanted, though some are steeper than others.

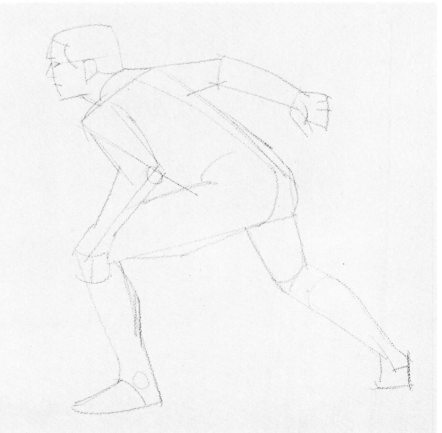

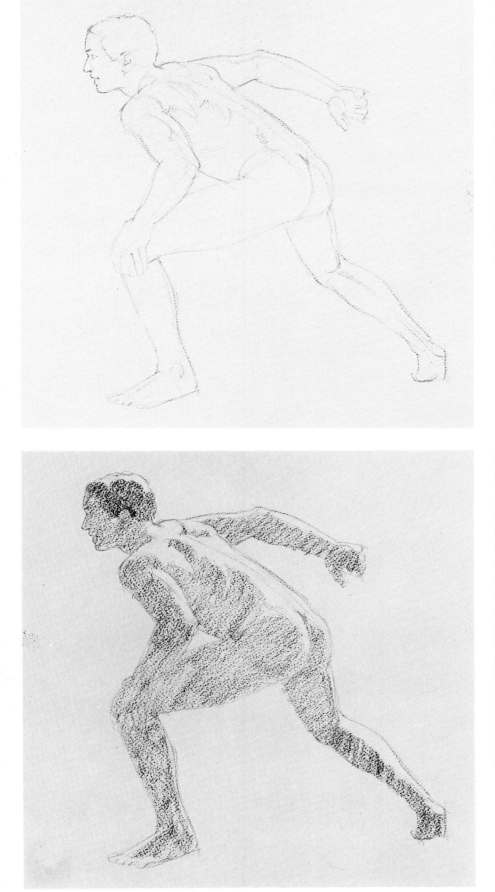

Step 3. The point of the hard charcoal pencil curves around the shapes of the body, recording the anatomical forms and searching for rhythmic connections between lines. For example, the underside of the outstretched thigh is represented by a line that divides into two lines at the buttocks: one line curves around at the division between the buttocks and travels upward to become the spine, terminating at the back of the neck. The other line continues around the far buttock and travels along the far side of the back, flowing into the shoulder. Such big, flowing lines give the figure a feeling of dynamic rhythm.

Step 4. The light source is on the right, above and behind the figure. This creates an effect that's often called *rim lighting*. Most of the figure is in shadow, with just a bit of light creeping around the *rims* of the forms. With a stick of charcoal, the artist blocks in the big shapes of the shadows, letting the stick glide lightly over the roughly textured paper. The charcoal hits the high points of the pebbly surface; the tones become broken and granular, obliterating many of the lines of Step 3. Of course, these lines will reappear later on. The artist studies the shapes of the shadows carefully, paying particular attention to the zigzag shadow on the back, and the jagged shapes of the shadows on the shoulders.

Step 5. A fingertip moves lightly over the granular tones of Step 4, softly fusing them into smoky shadows. The artist blends the smaller shapes—the profile of the face, the protruding finger, and the back muscles—with the tip of a stomp. Where the shape of a shadow needs to be defined more carefully, the artist squeezes the kneaded rubber eraser to a sharp point and moves the soft rubber around the edge. He does this on the intricate shadow shapes on the shoulders and he also brightens the back of the arm that rests on the knee. When you blend the tones of natural charcoal, it's important not to press too hard against the paper or you'll wipe off the charcoal, rather than simply spreading it around.

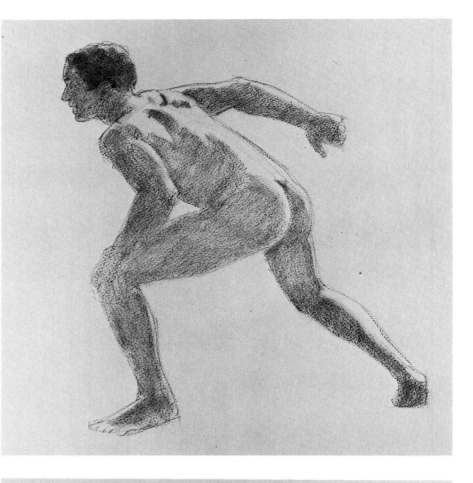

Step 6. The artist redefines the contours of the figure with sharp lines made by the point of a medium charcoal pencil. As he records the anatomical forms of the living model, he looks for those overlapping contours that make the muscles round and solid: the curve of the buttock overlaps the outstretched thigh, for example. These overlaps aren't always predictable; they vary from one pose to another. You can't just make them up—you've got to see them on the model! With the side of the lead, the artist builds up the edges of the shadows where they meet the lighted planes of the body. Now each shadow area contains darks and reflected lights. The point of the pencil also begins to define the details of the features, hands, and feet.

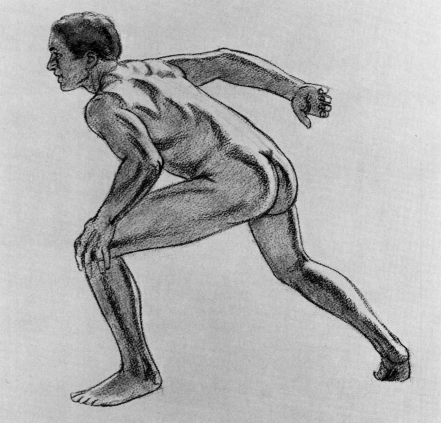

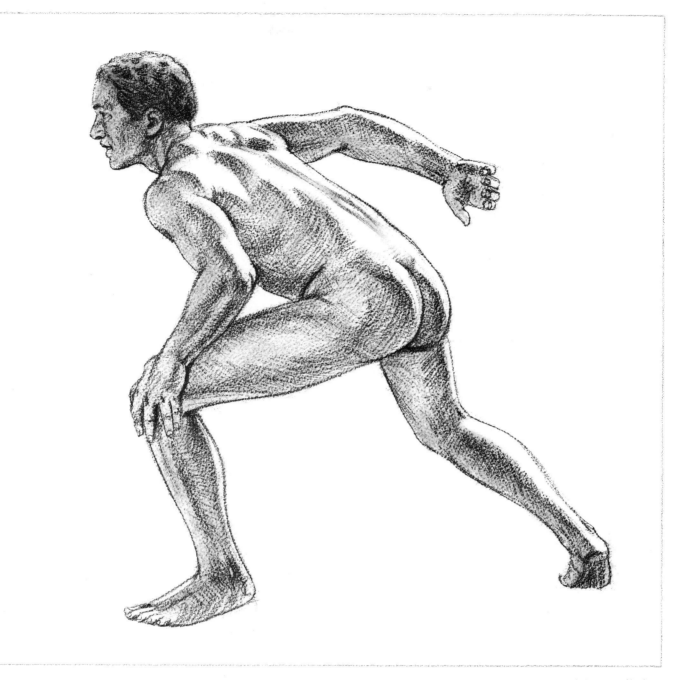

Step 7. Moving the side of the medium charcoal pencil lightly back and forth over the smoky shadows, the artist gradually strengthens and unifies the dark planes. He also defines the edges of the shadows more precisely. He doesn't blend these strokes, but allows them to retain the granular texture of the rough paper. As the shadow areas become darker, the figure becomes more three-dimensional because of the stronger contrast between light and shadow. You may have noticed that the line of the spine has gradually disappeared; the tilt of the spine is important to the action of the figure, and so now the artist redraws the slender, shadowy trough at the center of the back and carefully blends the tone with the sharp tip of the stomp. The point of the pencil also adds sharp touches of darkness in small but critical areas such as the underside of the nose, ear, and chin; the underside of the hand that rests on the knee; the crease at the waist; and the underside of the buttock above the out-stretched rear leg. These crisp blacks add sparkle to the drawing. Finally, the tip of the pencil completes the details of the features, hands, and feet. A few more touches of the kneaded rubber eraser brighten the lighted areas of the body and clean away any smudges of gray that may have strayed onto the white paper surrounding the figure.

Step 1. At first glance, a reclining figure looks difficult to draw because all the normal relationships between the parts of the body seem to be askew. But the essential problems are the same: you've just got to get the proportions, alignments, and directions of the lines right. In this pose, the underside of the arm on the floor flows into the underside of the adjacent leg. The torso still consists of two interlocking, blocky forms with the usual guidelines. Because the torso curves slightly, the center line also curves a bit, while the guidelines across the body tilt a little more than usual. The lower torso presses against the floor, and so one hip rises into the air.

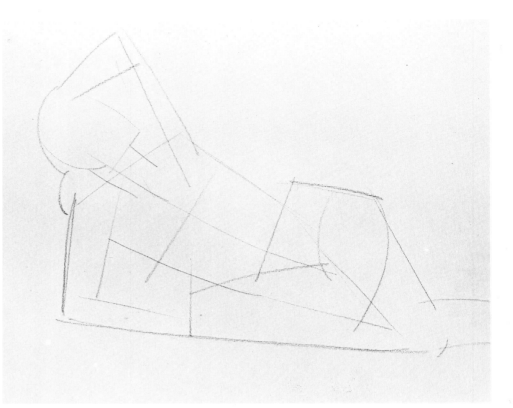

Step 2. As the artist constructs the simplified forms of the body, he discovers other relationships that are helpful in visualizing the figure. On the side of the torso closest to the floor, the line of the upper torso flows into the inner line of the calf. On the other side of the body, the line of the torso curves into the line that defines the inside of the thigh. The shoulders tilt because the weight is on one arm, but the breasts, navel, and crotch are still in their usual places along the center line of the torso.

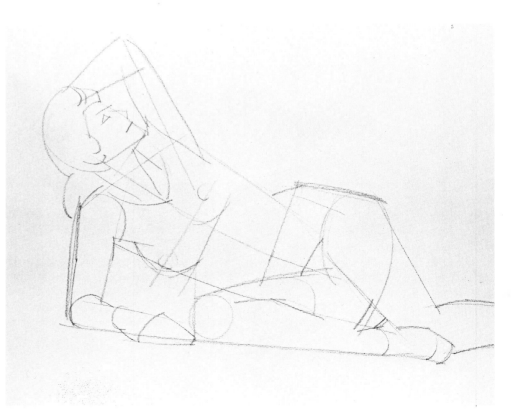

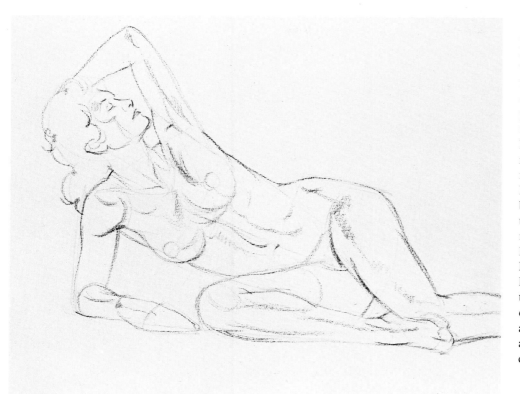

Step 3. The purpose of this demonstration is to show you how to combine linear contours with blended tones for the shadows. The artist has chosen a sheet of charcoal paper and started work with a medium charcoal pencil. Now he switches to a stick of natural charcoal that makes a rougher, more irregular line. He redraws the contours with big, swinging arm motions that give a particular roundness to the forms and a lovely, loose quality to the lines. Notice how a single flowing line moves from the point of the upraised elbow all the way down to the angle of the knee at the lower right. The artist also begins to suggest the edges of the shadows.

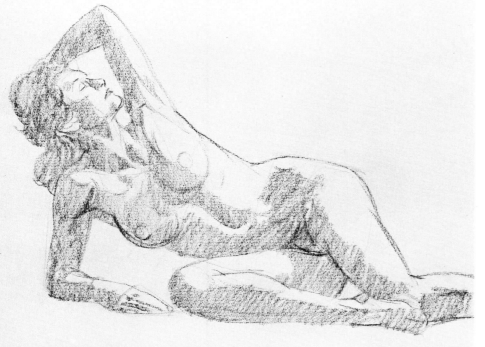

Step 4. Holding the natural charcoal at an angle and letting it brush lightly over the textured surface, the artist blocks in the shadows with loose back-and-forth movements, producing clusters of broad parallel strokes. The artist pays particular attention to the curving shapes of the shadows that accentuate the rhythm of the figure. For example, a single strip of shadow curves downward from the point of the raised elbow, over the arm, around the breast, and down through the center line of the torso. The light source is above the figure and slightly to the right, and so the left sides of the forms and their undersides are in shadow.

Step 5. The strokes that fill the shadow areas are blended with light touches of a fingertip. The artist rubs just hard enough to merge the charcoal strokes into smoky tones, but *not* hard enough to obliterate the roughness of the strokes entirely. He moves his fingertip cautiously around the lighted areas to avoid any danger of obscuring the shapes of the lights. He uses his charcoal-coated fingertip to place a delicate touch of halftone on the lighted side of the midriff, suggesting the details of the ribs, which stand out in this pose. The original outlines are beginning to disappear beneath the blended tones. They'll soon reappear.

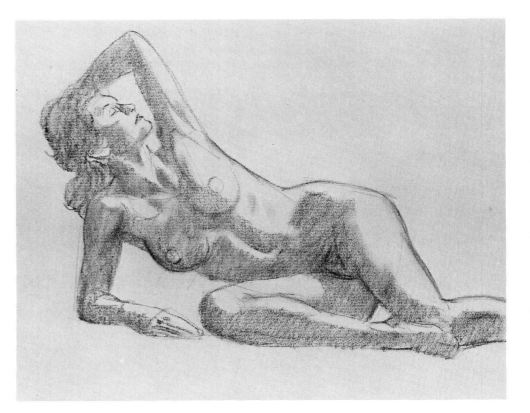

Step 6. Again holding the stick of natural charcoal at an angle to the paper, the artist builds up the dark edges of the shadows—the shadow accents—where they meet the light. Then he blends these darkened edges with his fingertip, being careful not to spread darkness into the paler areas of the shadows, which are the important reflected lights. Now there are three distinct tones flowing together—light, shadow, and reflected light—which you can see most clearly on the breasts beneath the upraised arm. The artist sharpens the charcoal stick to suggest the details of the sitter's curls and the shadows between the fingers.

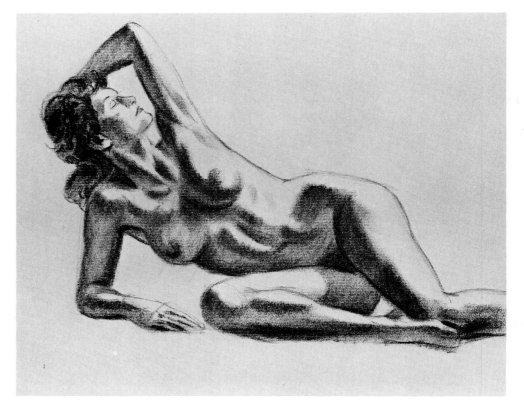

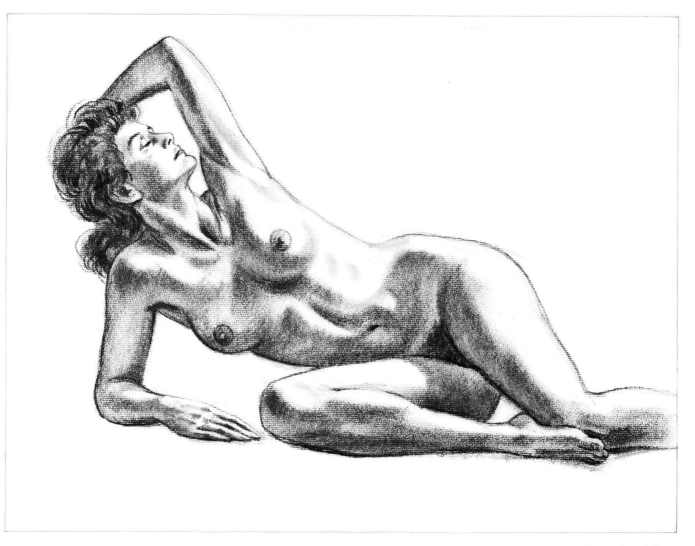

Step 7. A lot of contours have disappeared or just become indistinct as the artist blended the tones with his finger. Now he sharpens the stick of charcoal on the sandpaper pad—not pressing too hard, in order to avoid breaking the fragile stick—and carefully redraws the lines that surround the forms. He rests the charcoal stick lightly against the paper and pulls the tool along without exerting too much pressure, following the contours accurately, but lettting the lines simply "happen." Thus, the lines have a springy, casual quality. Notice that the lines are thicker and darker along the shadow sides of the forms, thinner and paler along the lighter sides. The artist darkens selected spots—such as the upraised forearm and the abdomen—by gradually adding more strokes and blending them with a fingertip. Other areas—such as the outstretched thigh—are lightened with gentle touches of the kneaded rubber eraser, followed by gentle blending with the fingertip. As the artist blends the dark edges of the shadows, delicate halftones appear between the light and shadow planes. The blackened fingertip also adds halftones to suggest additional detail within the lighted side of the upraised arm, alongside the chest muscle, and beneath the breast. To add the last sharp details of the features and hair, the artist switches back to the medium charcoal pencil. The kneaded rubber eraser brightens the lighted areas of the figure and cleans the bare paper that surrounds the forms.

Step 1. In this final demonstration, the artist shows you the full richness of blended tones that you can achieve with a complete "palette" of charcoal pencils, blended with the finger and stomp, and brightened with that miraculous kneaded rubber eraser. As you'll see in a moment, he chooses a figure that's in deep shadow, with just a few touches of bright light; within these deep shadows, there will be rich variations of tone. The preliminary "diagram" of the figure is drawn with the sharpened point of a hard charcoal pencil. There are very few guidelines now—they should really be in your head.

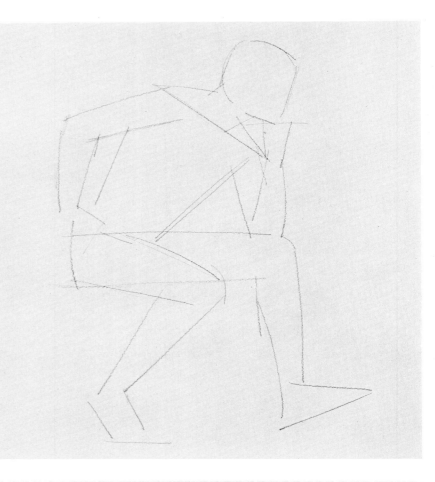

Step 2. The sharp point of the hard charcoal pencil completes the construction lines. Now you can see the alignments more clearly. The forward edge of the leaning torso runs parallel with the forward edge of the lower leg at the left; both are diagonals. The inner edge of the other calf runs upward into the inner edge of the arm that rests on the knee. Both elbows align with the undersides of the chest muscles. On the right, the forehead, nose, fist, and forearm all align with the forward edge of the lower leg. At the left, the inner edge of the forearm continues down into the buttocks, whose curving line points toward the heel. As you study the drawing, you'll discover still other alignments like these.

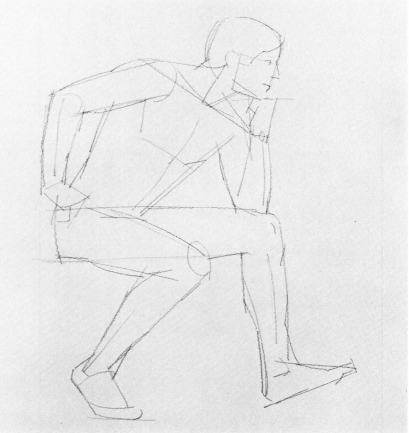

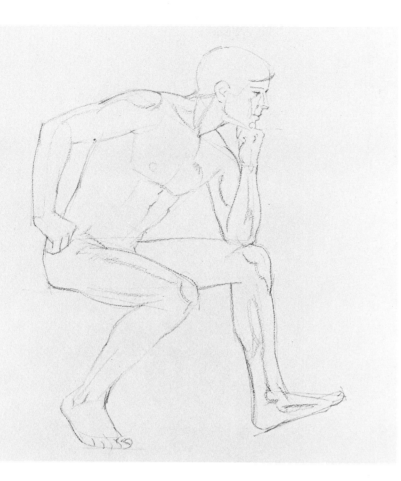

Step 3. The realistic contours are redrawn with the hard charcoal pencil. Notice the line that starts at the point of the elbow on the left, flowing upward over the back of the arm, into the shoulder, and then continuing behind the neck over the opposite shoulder. The back of the lower leg on the left flows diagonally upward, disappears briefly at the knee, and then reappears as the line along the underside of the thigh at the right. The small patches of light are particularly important in this shadowy figure. You can see their outlines along the top of the upraised shoulder, on the opposite shoulder and chest, along the edges of the arm and lower leg at the right, along the top of the other thigh, and on the front of the head.

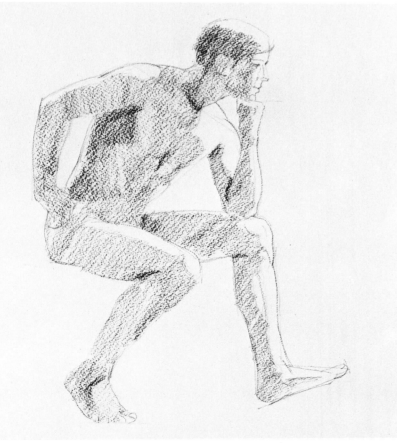

Step 4. Switching to a medium charcoal pencil, the artist flattens the side of the lead by rubbing it against the sandpaper pad. Then he blocks in the shadows with broad parallel strokes. The medium charcoal pencil is softer and darker than the hard pencil, and the pebbly tooth of the paper shaves off big granules. At this stage, the shadows have a ragged, broken texture. To accentuate the shadows along the left side of the torso, the dark tone of the hair, and the other touches of darkness at the pit of the neck, between the chest muscles, and at the joints, the artist presses the pencil more firmly against the paper, building heavier strokes over the original strokes. Notice how methodically the artist follows the shapes of the shadows that are defined by the line of Step 3.

Step 5. The artist blends the strokes of Step 4 with back-and-forth movements of his fingertip. He presses just hard enough to spread the tones without obliterating the rough texture of the original strokes. Thus, the shadows retain the texture of the rough paper. Notice how the dark patch along the back of the torso blends softly into the lighter shadow area. With his charcoal-coated fingertip, the artist adds a halftone along the inner edge of the muscle of the calf at the right. To blend the areas that need a more precise touch—such as the darks in the facial features and in the joints—the artist uses the tip of a stomp. He carefully maneuvers the fingertip and the stomp around the lighted areas.

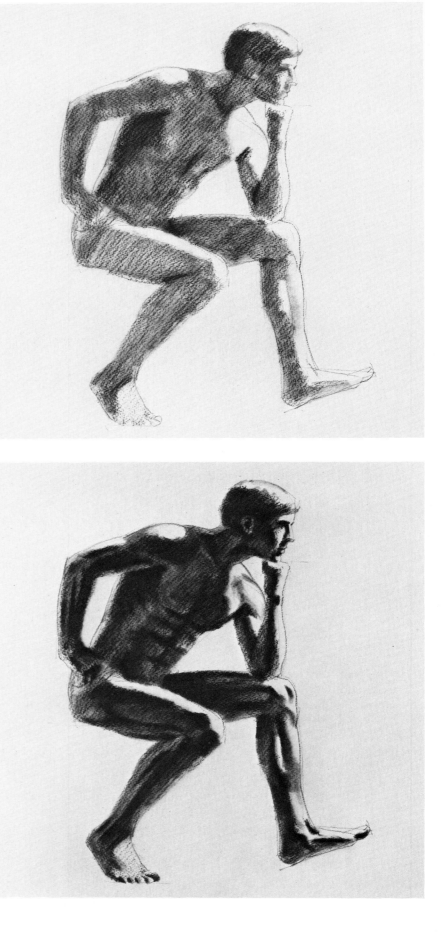

Step 6. A dramatic change takes place in the shadows when the artist switches from the medium charcoal pencils to the thick black lead of the soft charcoal pencils. This new drawing tool moves along the edges of the shadows—where they meet the light—and then the artist blends these dark edges carefully with his fingertip, cautiously avoiding those precious strips of light. Then the soft pencil moves into the shadow areas to add such anatomical details as the abdominal, arm, and leg muscles. Touches of darkness are deftly added to the features, hands, feet, and the knee beneath the elbow. The stomp blends these deep blacks. Now the figure begins to develop the full richness of tone that only charcoal can achieve.

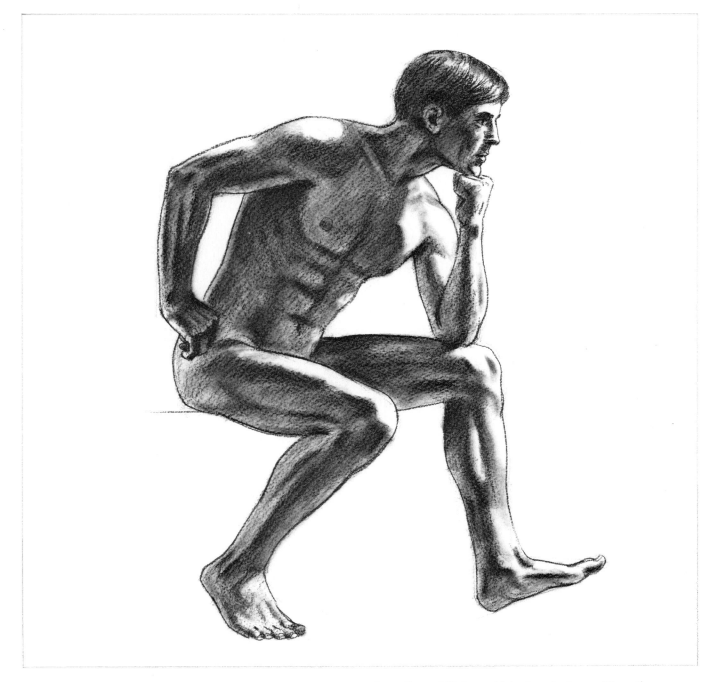

Step 7. The artist refines the tones by working alternately with the soft charcoal pencil, his fingertip, the stomp, and the kneaded rubber eraser. The fingertip travels gently over all the shadow areas, blending and softening the tones so that they flow together more smoothly. As the fingertip continues to blend the shadows, they grow slightly lighter. The soft pencil darkens the edges where necessary. The stomp blends such small tonal areas as the features, hands, and feet. The pencil defines the shadowy edges of the chest muscles more precisely and these are blended with the tip of the stomp. The blackened stomp also strokes in the half-tones in the lighter areas of the arm that leans on the knee. The kneaded rubber eraser gently lifts a hint of tone from the reflected lights within the shadows. Then the eraser brightens the patches of light that contrast brilliantly with the surrounding darks. The medium charcoal pencil redraws the contours, adds lines to the dark blur of the hair, defines the features more exactly, and finishes the hands and feet. Blended tones always tend to creep out over the white paper. Squeezing the kneaded rubber eraser to a sharp point, the artist moves the eraser gently around the outer edges of the figure to restore the brightness of the white paper. Notice how the kneaded rubber eraser also picks out a few touches of light on the abdomen, along the edge of the arm at the left, and at the heels.

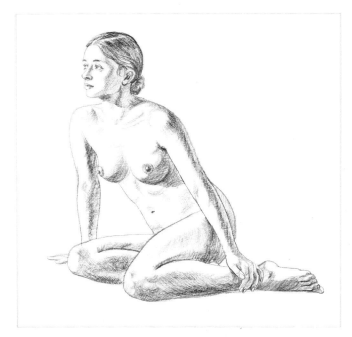

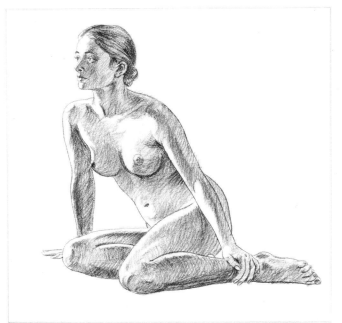

Three-quarter Lighting. Always determine where the light is coming from. This is a familiar type of lighting in which the light comes from the side and from slightly in front of the figure, as if the sun were shining over your left shoulder. The left sides and the fronts of forms catch the light; the right edges are in shadow.

Side Lighting. In this example of extreme side lighting, the light comes from the left and slightly behind the figure. Only the left edges of the forms catch the light. Everything else is in shadow. Protruding forms such as the forehead, breast, and abdomen catch a bit more light.

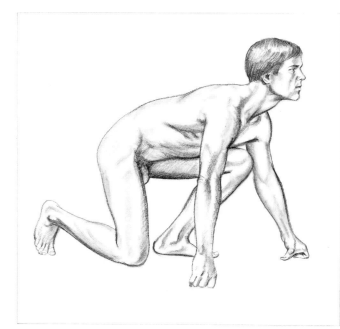

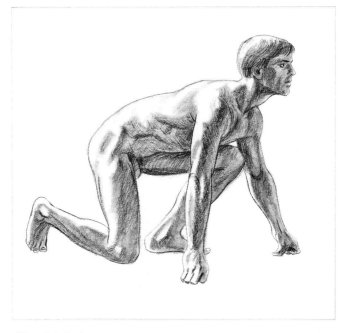

Frontal Lighting. This is the most delicate kind of lighting—as if the light source were directly in front of you, hitting each form of the model's body right in the center. Thus, the center of the form catches the light and the sides curve away into shadow. Slender strips of shadow appear around the edges of the forms.

Rim Lighting. The most dramatic lighting is rim lighting—often called back lighting. The light is behind the model. The figure is a dark silhouette with a bit of light creeping around the edges (or the rims) of the forms. As you can see, a change in the light source can transform the same figure into a totally new drawing problem.